# THE
# ROYAL COLLEGE
## OF ART One Hundred & Fifty
Years of Art & Design

# THE ROYAL COLLEGE OF ART
## One Hundred & Fifty Years of Art & Design

**CHRISTOPHER FRAYLING**

WITH RESEARCH BY JOHN PHYSICK,
HILARY WATSON, AND BERNARD MYERS

BARRIE & JENKINS

LONDON

This book has been made possible
through the generous support of
Fletcher King Associates

*The Royal College of Art: 150 Years of Art and
Design* was conceived, edited, and designed by
Lion and Unicorn Press/Mobius International

First published in Great Britain in 1987 by
Barrie & Jenkins Ltd
289 Westbourne Grove, London W11 2QA

British Library Cataloguing in Publication Data

Frayling, Christopher
     The Royal College of Art: 150 years
     of art and design.
     1. Royal College of Art—History
     I. Title
     707′.1142132     N333.G73L/

     ISBN 0-7126-1799-X
     ISBN 0-7126-1820-1 Pbk

Typesetting by Dorchester Typesetting Group
Limited
Reproduction by Regent Publishing Services
Limited, London
Printed and bound in the Netherlands by
Royal Smeets Offset, BV, Weert

Front cover: *The Diploma* by David Hockney,
1962. Back cover: Fashion designs by Ossie
Clark, 1965. Styling for Audi Quattro by Martin
Smith. Book illustration by Walter Crane for
*Aladdin or the Wonderful Lamp*, 1874. Book
jacket by John Minton, 1948. Detail of silk shawl
by Cressida Bell, 1986. *Standing Woman*, 1923,
by Henry Moore.

# CONTENTS

To all students of the Royal College of Art – past and present – and especially to those many thousands who do not appear by name in this history. . . .

One of the messages which Prince Albert tried so hard to get across was that Art and Manufacture had to go together. He realised that industrial manufacture was simply a method of making things more cheaply but it still required the art and design of the craftsman to give the products the practical and aesthetic qualities that a discriminating customer would be looking for. In these days we refer to this process as Industrial Design and we have come to realise that it is fundamental to all manufacturing industries.

For the last 150 years the Royal College of Art has been training talented students in the very demanding disciplines of art and design. Not everyone of its graduates has achieved international fame but enough of them have been sufficiently successful to prove that the College has been doing a good job. Unfortunately it is equally evident that there are altogether too many British manufacturers who have failed to appreciate the vital importance of good industrial design and the commercial value of well trained and imaginative designers.

Manufacturing has to be a co-operative business and one of the most essential partners is the creative designer. I hope that the 150th Anniversary Celebrations of the Royal College of Art will help to draw much greater attention to its activities and also to the original work of its past and present graduates.

Philip

1987

# Introduction

The one and only time I met Sir Robin Darwin was in autumn 1972. He had retired from the Rectorship of the Royal College of Art but still looked in every now and again, at lunchtimes, to sit at what he called "the Painters' table" in the Senior Common Room. The day I met him was my first day of teaching at the College.

"What do you teach?" he snapped.

"I'm an historian."

He paused. "Always remember," he said, "the College is about the future, not the past."

Then he turned to an engraving of the Duke of Wellington's funeral car, which at that time hung on the wall of the Common Room, and added, with evident pride, "I suppose you know that that was made by College students and designed by the staff."

It was only when I read, much later, his lecture at the Royal Society of Arts *The Dodo and the Phoenix* (February 1954), that the contradiction between these two statements really struck me. The man who had said that "the College is about the future" had also written of:

*the spirit which hallows all universities and gives to them their timeless traditions, and I believe something of this spirit has begun to move within the Royal College of Art.*

Since then, the attitude of the College – staff and students – towards "the past" has changed dramatically. The last of the card-carrying Modernists has gone, and no-one seriously believes any more that history begins today. Originality, for many students, has become the re-arrangement of past solutions – this time round with irony. The Department of Cultural History – whose main role is to put contemporary student-work, in art, design and communications, into a tradition, through teaching and research – has come to play an essential part in College life. Indeed, one of the great pleasures of writing this book has been the realization that the research work of students in the Department, over the last 15 years, has built up into a substantial body of knowledge about the history of art and design

education: Stuart Durant on Christopher Dresser, Elizabeth Rycroft on Lewis Day, David Brett on nineteenth-century design theory, Lucy Bullivant on exhibition design, and, among today's students, Alex Seago on popular music and art colleges, Graham McLaren on the teaching of ceramics, Caroline Pullee on the South Kensington pillar-box, and the weekly research seminars of the joint Royal College of Art/Victoria and Albert Museum MA course on the history of design.

But still, that conversation with Sir Robin Darwin has kept re-surfacing in my mind.

Clearly, the history of the RCA (and antecedents) can shed light on many of the issues which are high on the agenda today. Consider these three statements:

*An institution like this has often been recommended upon considerations merely mercantile; but an Academy, founded upon such principles, can never effect even its narrow purposes. If it has an origin no higher, no taste can ever be formed in manufactures; but if the higher Arts of Design flourish, these inferior ends will be answered of course.*
– Sir Joshua Reynolds *First Discourse* 1769

*When will England learn that even for the purposes of commerce Art is useful – and that where the higher and nobler Arts are assiduously cultivated, the inferior and industrial ones are also sure to flourish?*
*The Art Journal* iii 1851

*If students are to be given the full advantages of a high level education in and through the visual arts, they should not be preoccupied with a narrow, and for most, an unrealistic vocationalism. A broader experience in most courses, some of them perhaps fusing art with design or other studies, would surely equip many more students at this level to enter diverse areas of professional life . . .*
National Advisory Body for Higher Education
*Discussion Document* 1986

In other words, we have been arguing about Reynolds's casual "of course" for at least one hundred and fifty years and we still can't make up our minds about the relationship between "the fine arts" and "the applied arts" or "design".

Meanwhile, we have adopted various teaching models – of which the most significant are the normative (with its "grammars", "rules" and "systems") and the critical (with its "craft", "self-fulfilment" and even "social change") – to give substance to what we *do* teach. The pendulum has swung this way and that and it is still swinging.

The Royal College of Art (or rather, the Government School of Design as it was then called) was established in 1837, one year before the accession of Queen Victoria, as the result of a government decision to make the training of designers for industry a national responsibility. In this sense it was a radical new departure, although academies of art date back as far as 1488 – when Lorenzo dei Medici gathered talented young people together in the garden of his palace to copy antique sculpture.

The School of Design was based at that time on two premises – both of them negative; first and foremost, that France and Bavaria were better at design than Britain, probably because of their educational arrangements; and second, that design students should never be allowed to experience the joys of practice in "the fine arts". Everyone involved seems to have known what they *shouldn't* be doing, but they spent the next sixty years arguing about what they *should*. Eventually they came to the conclusion that it is quite easy to half-educate people in an attempt to educate them wholly; what is more difficult, is to half-educate people by intention.

One long-term result of the circumstances which gave birth to the RCA, was that all the innovative Headmasters, Principals and Rectors who ever administered the College, signalled their arrival by claiming that they were posing these questions for the first time and that every single achievement of the previous regime was a complete waste of time and effort: this goes equally for William Dyce (in the late 1830s), Henry Cole (in the 1850s), Walter Crane (in the 1890s), William Rothenstein (in the 1920s) and Robin Darwin (in the late 1940s). It helps to explain why the same arguments have turned up, in slightly different forms, ever since the Select Committee of 1836 and why the basic questions in design education have come to resemble the Irish Question in *1066 and All That*: every time you get an answer, they tend to re-phrase the question. Since an education in design was, from the start, parallel to and separate from an education in anything else, it also helps to explain the autodidactic quality of so many utterances on the subject. "The College is about the future."

There is a great temptation, when writing the history of such an institution, to adopt a "top down" approach – to chronicle the attempts to get the administration right, and to avoid discussing the experience of actually *being there*; after all, most of the formal documents provide fairly precise information on day-to-day management (and, by definition, emphasize the "crises" and difficulties) and very little else. I have tried, as far as possible, to balance this material with reminiscences of students and teachers – and details of where they had been before as well as where they went afterwards. The "bottom up" approach shows, quite clearly, that we *haven't* in fact been going round and round in circles for the last 150 years. On the contrary, our teachers and students have often been synonymous with the history and development of the best of British art and design in the same period – and, equally clearly, that there *are* no final solutions to the problem first enunciated in 1837. It's just that administrators keep saying there are.

At one level, the story of the RCA is the story of a series of attempts to legislate *the* way to teach design – by the Head School of Design (1837-51), the Department of Practical Art (1852), the Department of Science and Art (1853-99), the Board of Education (1899-1944), the Ministry of Education (1944-64), and the Department of Education and Science (1964-   ) – and of generations of teachers and students who have together found their own ways of learning about it, to great effect.

The result of these various tensions has been the history you are about to read. The tensions may not have seemed particularly creative at the time, but, in retrospect, they must have been: for, whether one considers the history of design, the history of communications *or* the history of "the fine arts", the Royal College of Art has been at the centre of things ever since Lord Melbourne coined the immortal phrase, "God help the Minister that meddles with Art". It may have operated under different names – such as "the Government School of Design", "the Head School of Design", "the National Art Training School" and "the Royal College of Art" – but it has always remained at the pinnacle of the national system, and very often deservedly so.

This book has in every sense been a collective project. I have already mentioned the inspiration of my students. Of the staff in the Department of Cultural History, I would like especially to thank Gillian Naylor, Frank Whitford and Penny Sparke

9

for their advice on specialist areas; of the scholars and critics who have written about aspects of this history, Bill Packer, Richard Cork, Ken Baynes, Michael Kennedy, Justin Howes and Professor Christopher Cornford (my predecessor at the RCA) who came to my rescue at key moments; of the ex-students, Henry Hammond and Leslie Duxbury, who kindly agreed to be interviewed. The Library staffs at the RCA (in particular Hans Brill and Anne George) and at the Victoria and Albert Museum (in particular Elizabeth Estève-Coll and David Wright) were extraordinarily level-headed and helpful throughout. So was Gillian Plummer, my secretary, who typed the final text under very difficult circumstances.

Each part of the book was based on initial research among the primary sources by a different researcher: the first part was researched in this way by Dr John Physick, who, after serving on the staff of the Victoria and Albert Museum for over thirty years, wrote the definitive book on *The Victoria and Albert Museum – the history of its building* (V&A, 1982), and who knows more about the origins of "South Kensington" than anyone else alive; the second was researched by Hilary Watson, who is a graduate of the Department of Cultural History and is currently preparing a doctoral thesis at Sheffield Polytechnic on *The Royal College of Art from 1900-1948* – a much-neglected area; and the third was re-searched by Professor Bernard Myers, who, as a student, a tutor and a senior tutor at the College, has been a much respected colleague at the RCA since the early 1950s. Their work laid the factual foundations for the final text and they will see from the result just how significant were their respective contributions.

Finally, a word of heartfelt thanks to my wife Helen. This book caused chaos at home for six months and she coped with it all incredibly well: the text would never have been written had it not been for her support, understanding and counsel.

"The College is about the future, not the past." Of course it is and always should be. But if this book helps even in a small way to encourage art and design educators everywhere – and their students – *not* to reinvent the wheel every generation it will have been well worthwhile. As W. R. Lethaby so wisely put it, "out of the critical use of past tradition, students must build up a tradition of their own". That seems to me a very suitable sentiment for the 150th birthday of the Royal College of Art and of public-sector art and design education in this country.

Professor Christopher Frayling
Department of Cultural History
Royal College of Art

March 1987

# PART ONE

## "GOD HELP THE MINISTER
THAT MEDDLES WITH ART"

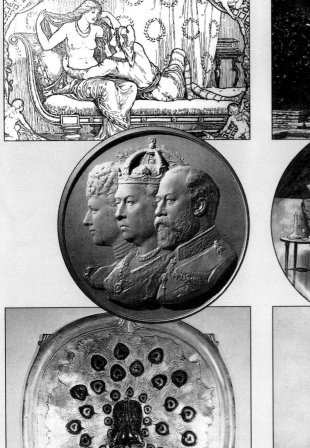

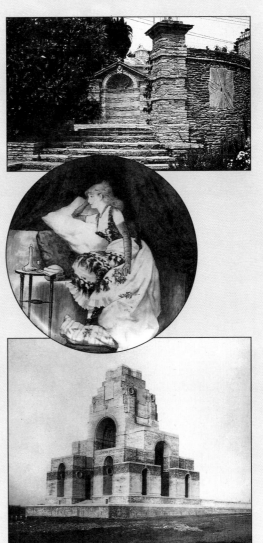

Top *Detail of advertisement for Pears soap by Walter Crane.* Centre *Tower Bridge Medal, 1894, by Frank Bowcher.* Bottom *Lighting sconce designed by Alexander Fisher in 1896.*

Top *Hestercombe, Somerset, by Edwin Lutyens.* Centre *Plaque painted by Herbert William Foster, 1879.* Bottom *Memorial to the Missing of the Somme by Edwin Lutyens, 1927-32.*

11

# SOMERSET HOUSE

*September 24th 1834 – Called on Lord Melbourne; was very glad to see him and he me. We had a regular set-to about Art. I went on purpose. I said for twenty-five years I have been at all the Lords of the Treasury without effect. The First Lord who has courage to establish a system for the public encouragement of High Art will be remembered with gratitude by the English people. He said, "What d'ye want?" "£2000 a year." "Ah!" said Lord Melbourne, shaking his head and looking with his arch eyes, "God help the Minister that meddles with Art." "Why, my Lord?" "He will get the whole Academy on his back." "I have had them on mine, who am not a minister and a nobleman, and here I am. . . Now, my dear Lord, do be serious about it." "I will," said he, looking archly grave, with his handsome face, and fine naked neck, for he was just out of his bed, in his dressing gown. Gad, it is something to get him to say he will really listen.*

From the *Diary* of Benjamin Robert Haydon.

## A SELECT COMMITTEE

When the British government decided to devote funds to the School of Design, in 1837, it was only a couple of years after they had given the first grant to any English educational establishment. And, as a network of "branch schools" was established steadily afterwards, in major towns and cities all over England, each of them linked to the School of Design in the centre, the national system of art and design education in fact pre-dated the national system in any other subject. So it is clear that in the early Victorian period a very great importance was attached to visual education – to the links between an education in "design" and industrial growth – and to the role of "design" in British culture. It is also clear that from the outset visual education was treated as an entirely separate thing from education in any other area.

Benjamin Robert Haydon, painter of historical scenes, had been conducting a one-man crusade to persuade successive governments to fund "the

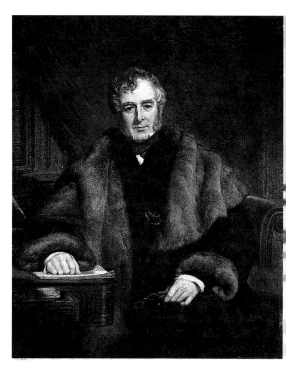

Above *John Partridge's portrait, dating from 1844, of Lord Melbourne, the first Minister to recognize the need for a National School of Design.*

public encouragement of High Art", ever since 1823, when the idea first came to him as he reflected on the state of British visual culture in the King's Bench prison for debtors (whence he returned, at fairly regular intervals, throughout his adult career). "Well, I am in prison. So were Bacon, Raleigh and Cervantes – vanity! vanity! Here's a consolation!" His motives for the crusade were mixed. He detested the Royal Academy to the point of obsession; he felt that painters of inspiring historical tableaux should be given incentives to hang their work in public places; and he considered – from bitter experience – that the development of "High Art" was far too important to be left to the whims of private patronage. In 1832, Haydon made use of a series

of portrait sessions with politicians (he had been commissioned to paint *The Reform Banquet at the Guildhall*) to put over to his captive and distinguished sitters the value of state support for "High Art". At first, he tried the argument that the quality of a country's painting was a clear indicator of the state of that country's cultural and moral health – but he quickly realized that he would need a tougher argument than that. Then he tried the argument that "the nobility, and all who are educated to direct the State machine, are educated by men brought up at colleges, where there are no professors of painting or sculpture, and consequently cannot, and do not, impress on the minds of their pupils the importance to a country of correct design": the point was that university-educated officials were not necessarily the best judges of the most effective policy for the promotion of "High Art". But, not surprisingly, that argument failed to convince as well – although it did encourage Haydon to think about placing art education in what today we would call the university sector. Finally, he hit upon the one argument which seemed to get a reaction – that an education in "High Art" could improve the performance of manufacturing industry, increase wealth and refine the minds of a nation: it was, of course, this argument which encouraged Lord Melbourne, the Prime Minister of the day, to say that Haydon's case was "not hopeless".

At the same time as Haydon was conducting his tireless and eccentric crusade, a few politicians with experience of the value of "pictorial design" in the textile industry, such as Sir Robert Peel, were trying to persuade the government to found a National Art Collection to educate producer and consumer alike. In fact, Haydon makes reference to this campaign in one of his discussions with Lord Melbourne: "it came out in committee, and Peel acknowledged our general ignorance in design was the reason of our inferiority". So it is likely that Haydon's killing argument was derived from Sir Robert Peel, and from Joseph Hume, the economist and radical MP, who in 1832 had directly attributed the relative success of French textile designs to the quality of teaching at the Lyons school of design.

In the event (although Haydon was later to claim that he had persuaded the government single-handed, just as he was later to say how much he regretted the result), it was the Peel initiative, coming as it did from a man who had made his money from the mechanization of the textile industry, which won the day. Concern over Britain's trade and its competitiveness, especially against the main European rivals France, Prussia and Bavaria, led the House of Commons to set up a Select Committee to enquire "into the best

means of extending a knowledge of the Arts and the Principles of Design among the People (especially the Manufacturing Population) of the Country; also to inquire into the Constitution, Management and Effects of Institutions connected with the Arts . . ." The dual function of the Committee – to study the relationship between design and economic performance, and to examine the entirely separate issue of the affairs of the Royal Academy – was to lead to much confusion and acrimony, and was to effect the "shape" which the School of Design finally took.

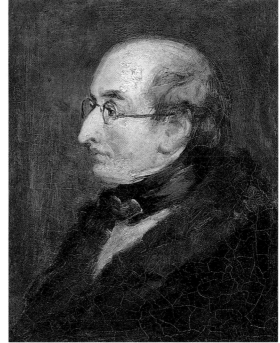

Above *Self-portrait of around 1845 by Benjamin Haydon, propagandist for a National School of Design and implacable foe of the Royal Academy.*

This Select Committee consisted of just under fifty members (five constituted a quorum, which as it happened was just as well), among whom were William Ewart, the MP for Liverpool, Sir Robert Peel, Lord John Russell, John Bowring, an expert on foreign manufacturing industries, and Charles Poulett Thomson, MP for Manchester and soon to be the President of the Board of Trade. Between July 1835 and August 1836 its members listened to a wide range of interests in the form of over sixty witnesses. These included architects, sculptors, manufacturers, and painters – including Benjamin Robert Haydon, who wrote in his *Diary* "O God, I ask only for justice and truth to triumph. Amen", and proceeded to have a stand-up row with the President of the Royal

13

Academy, Sir Martin Arthur Shee. Other witnesses included John Smith, an iron-founder from Sheffield, Thomas Gibson, a silkmaker of Spitalfields, Samuel Wiley of Jennings and Betteridge, who traded in japanned goods, John Millward, a lace manufacturer of Olney, Bucks, Thomas James, a textile wholesaler, and James Nasmyth, engineer and inventor of the steam hammer. Nasmyth was, in fact, the only spokesman from the industrial sector who had personal experience of art education. A member of his family had attended the Edinburgh Academy at the end of the eighteenth century, and had thought that the shortage of plaster casts there was a severe restriction on his training: when Alexander Nasmyth had complained about drawing from the Laocöon for the sixth time, his drawing master had apparently grabbed hold of the cast and turned it upside down, shouting "I'll give you another subject". The Committee also heard from three overseas witnesses: Professor Gustave Waagen, Director of the Royal Gallery in Berlin (who stressed the importance of training in a workshop or a guild, rather than in "an academy"), Baron von Klenze of Bavaria, and Claude Guillotte, a maker of Jacquard looms. The qualifications and experiences of the Committee's witnesses varied considerably: one George Foggo insisted on being given a hearing because "there are very few departments of art I have not applied myself to, but more particularly to the historical . . .".

The most consistent theme throughout the deliberations was that the United Kingdom was at a great disadvantage especially when compared with France:

*Art is comparatively dear in England. In France it is cheap... In England a wealthy manufacturer has no difficulty in procuring superior designs. But the manufacturer of cheap plate and inferior jewellery cannot procure designs equal to those in France, without incurring an expense disproportionate to the value of the article... According to the evidence of M. Guillotte ... a French capitalist employs three or four artists, where in England one artist would supply eight or ten manufacturers ... it appears that in England the designer of the pattern and the person who applies it to the manufacture are distinct persons. In France the workman is himself the artist.*

The Select Committee's Second Report commented that much importance had justly been attributed to the Schools of Design in France:

*The schools (in number about 80) are superintended by the Government. The free, open and popular system of instruction (prevalent in France since the days of Colbert), and the extreme accessibility of their museums, libraries and exhibitions, have greatly tended to the diffusion of a love of art, as well as of literature, among the poorer classes of the French.*

There was nothing like it in England.

The Committee also heard that there was no copyright protection given to designs; one Sheffield manufacturer said that his business was seriously affected by unauthorized copying, or piracy. But it was much more concerned about the wholesale copying of French designs as a substitute for developing original work at home.

Whilst the Select Committee noted with satisfaction that the government had "for the first time" proposed a Vote in the Estimates for a Normal School of Design, they felt that "in the formation of such an institution, not mere theoretical instruction only, but the direct practical application of the Arts to Manufactures ought to be deemed an essential element. . . Unless the Arts and Manufactures be practically combined, the unsuccessful aspirants after the higher branches of the Arts will be infinitely multiplied, and the deficiency of manufacturing-artists will not be supplied". Even at this very early stage, by referring to the Fine Arts as the "higher branches", the Select Committee was sowing the seeds of future discord, by implying that the Decorative Arts somehow fell into a secondary or lower category. "But", they continued, "the interposition of the Government should not extend to interference; it should aim at the development and extension of art; but it should neither control its action, nor force its cultivation".

In addition, the government was recommended to aid the foundation of "open Public Galleries or Museums" throughout the country as "we can scarcely boast of any"; and they should be open after working hours and be free, as even a small charge was a virtual prohibition.

The Report was published in August 1836, and the government instead of building upon the network of Mechanics' Institutions already in existence throughout the country, acted swiftly in another direction. Within three months, Charles Poulett Thomson set up a meeting on 19 December in order to discuss the creation of a School of Design in Ornamental Art (for which he had a grant of £1500, wrested from the Treasury), "in consequence of the present low condition of the art in this country". Of the twenty prominent men invited, only seven attended. Four of these were Royal Academicians, two painters, Augustus Wall Callcott and Charles Lock Eastlake; Sir Francis Chantrey, a sculptor; and an architect, Charles Robert Cockerell. The other three were William Copeland, MP, a ceramic manufacturer; Henry

Left *Design for a portfolio stand executed in 1828 by the architect John Buonarotti Papworth, who was later to become the first Director of the School of Design. Papworth's son was appointed at the same time Librarian and Secretary.*

Below *Somerset House, the Strand, the first home of the School of Design. The portion of the building taken by the School was made available by the transfer of the Royal Academy to the National Gallery's new building in Trafalgar Square.*

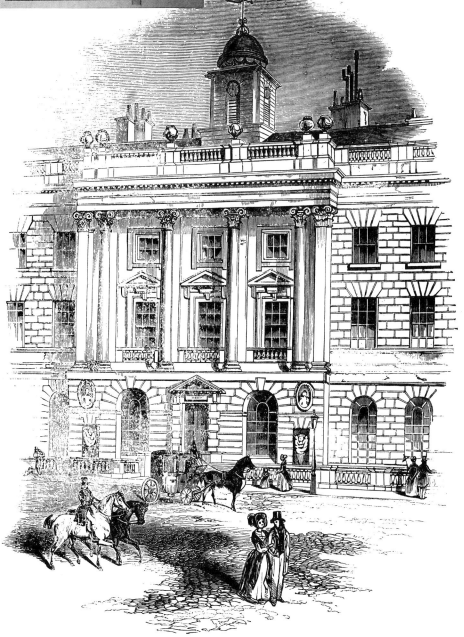

1837-1852

Bellenden Ker, a barrister; and Apsley Pellatt, a manufacturer of glass. These gentlemen formed the embryonic Council of the proposed School of Design, and between themselves created two committees. One consisted of the Academicians together with Ker and Pellatt and was charged to consider the curriculum, while the other, of the four Academicians only, was to "consider what casts, examples, books &c. should be provided. . ." Both these committees were to consult with another architect, John Buonarotti Papworth. Benjamin Robert Haydon was, predictably, furious that the Royal Academy had managed to muscle in on the act, since he was convinced that the RAs were there to ensure that the School could never compete with the Academy, and that it would always have an inferior status.

At their second meeting, held on 14 April 1837, the Council agreed to appoint Papworth as the part-time Director of the School, and he was instructed to supply a list of names of suitable teachers. In the meantime, he was also to make preparations to move into Somerset House, in the Strand, part of which was becoming vacant as the Royal Academy moved into the National Gallery's new building in Trafalgar Square.

By the beginning of May, Bellenden Ker was able to tell the Council that his committee had considered Papworth's nominations for masters, and recommended the appointment of a Mr Lambelette as the principal drawing master, together with a Mr Spratt as assistant. These memorably unmemorable gentlemen were accordingly appointed, the former at an annual salary of £200 (£150 to be paid by the government), and the latter at £150 (£125 from official funds), the remainder to be made up from students' fees (if any). The Committee of Instruction additionally recommended that James Leigh (later founder of Heatherly's Art School) should be appointed as "Modeller" at either £70 for a six-day week, or £40 if only for three days (again only a proportion of his salary to come from official funds). These three men have a place in history, however, as they were the first art-masters ever to be paid by the government, even if it were, initially, on only a year's engagement. Papworth's son was made the School's Librarian and Secretary at £70 a year.

Papworth senior reported that the rooms in Somerset House were ready, so Callcott, Cockerell, Ker, and Eastlake were directed to draw up rules and regulations for the government of the school, as well as to draft an advertisement to be placed in various journals, among them *The Times,* the *Athenaeum,* the *Spectator,* the *Herald,* the *Globe,* and the *Literary Gazette.* The stage was set for the Government's great experiment.

## THE GREAT EXPERIMENT

At the beginning, the School of Design could be nothing more than an experiment, for no one seems to have had any idea of what it was to teach. In spite of the Select Committee's criticism of the Royal Academy's restrictive practices and lack of accountability, and in spite of the Academy's admitted neglect of architecture and exclusion of engraving, to whom could the government turn for advice on a School of Design? The School's Committee of Instruction comprised a majority of Royal Academicians who, naturally, took care to ensure that instruction at Somerset House would not conflict with the Academy's own schools. Therefore, the teaching of Fine Art was not to be its business. But if its business *was* to teach something which would be of use to manufacturers, then what should it teach instead? Haydon had been convinced that the School should teach the "Higher Arts" (and, in particular, figure drawing), and that this would help to "educate youth to design" – but Haydon had not been appointed to the Council, and the other critics of the Royal Academy were also excluded from the running of the School. Consequently, the School had to teach what everyone called "design" – but unfortunately, since there was little consensus about the exact meaning of the term, no one knew how to set about teaching it, and in the end the emphasis was put almost exclusively on copying motifs from architectural detail. Less than a month after the School's opening, the Council decided categorically that "drawing from the human figure should *not* be taught".

In France, the much-praised *Ecoles de Dessin* were, in fact, schools of drawing, and the original meaning of "design" (to intend, to plan, to draw) derived from the same root: the Italian "disegno", too, implied the making of drawings to serve as models. It has been said, rather scurrilously, that the originator of the phrase "School of Design" chose "Design" because he couldn't be bothered to look up the English for "Dessin". Whatever the truth of this, most of the witnesses used the word in the restricted sense of a medium of communication between the ornamentist, or the artisan concerned with the processes of ornament, and the manufacturer – design as a kind of language. And they assumed that if contributors to the manufacturing process were proficient in this language (its principles and its historical usage), then the quality of the resulting manufactures would rise. The Select Committee Reports made two further assumptions about this, which were to affect the form which the Government School took in its first year.

1837-1852

First, the assumption that "the cultivation of the more exalted branches of art ... tends to advance the humblest pursuits of industry": this basically meant that drawing – and in particular drawing copies of plaster casts (the old Academy model) – was the most effective training for the ornamentist. And second, the assumption that the purpose of this training was to produce a multi-purpose ornamentist, able to "apply" ornament drawn "on the flat" to virtually any surface that presented itself. So the School's curriculum (if that isn't too strong a word) consisted of drawing classes which weren't allowed to become *life* drawing classes, put on for those potential contributors to the manufacturing process who were expected to communicate visually as part of their work in any medium. "Dessin" for the purposes of "Design". It was all very confusing. And the confusions have plagued discussions of "design" in Britain ever since: but the modern usage of "design" does seem to date from the muddled discussions of 1837.

Admission was not free; fees were fixed at four shillings a week to be paid monthly in advance, a significant sum for artisans and apprentices to find. In addition, as teaching took place during the day between 10 am and 4 pm, the very people for whom the School was intended could not benefit without giving up work. Within two months, the Council was forced to establish a series of classes in the evening from 6 pm and lasting for three hours.

---

### HUMBLE BEGINNINGS

Slowly, but very slowly, the number of students began to grow. During 1837, there were 12 in June, and 17 in September, but this figure had fallen to 15 by December. The more popular evening classes had 45 students by the end of the year. Most of these had barely reached their teens. When Haydon wrote to the President of the Board of Trade in January 1838, he referred to *"Nine poor boys drawing paltry patterns"*, and earlier in the same month had complained to Lord Melbourne about the "Beautiful School of Design in London – £1500 a year to keep the mechanic as ignorant as before".

---

Incensed by the decision to appoint academicians, rather than true artists, to the Council, and convinced that the exclusion of life classes was an example of the Government "preventing mechanics from acquiring knowledge", the indefatigable Haydon toured the Mechanics' Institutes and the boardrooms of Britain with a series of outspoken lectures on the advantages of teaching the "Higher Arts" to artisans. He would walk around the Institutes and their lecture theatres accompanied by "the naked truth" (as he called his nude life model) and on one occasion produced two wrestlers on the platform to demonstrate the laws of muscular action: when the audience had the temerity to laugh at this, he responded "You fools! Observe and admire, with more respect for God's handiwork". Sadly, to judge by Haydon's collected *Correspondence* from early 1838 onwards, politicians of all persuasions had ceased to take him seriously.

A small library was begun, which later formed the nucleus of the present National Art Library. Among the first gifts was a set of engravings of Raphael's decoration of the Vatican loggie, and with the gift of twelve jugs, a cast of Flaxman's *Shield of Achilles* and what were described as "four casts from the Alhambra", a small collection of exemplars was started, which eventually became the Victoria and Albert Museum.

But as the end of the rather dismal and unsatisfactory first year approached, it was quite obviously necessary to undertake an assessment of the School. In April, the Council felt that until that had been done, they could not re-engage any of the masters after 1 May, for a period longer than three months. In June they re-assigned various duties, in order to obtain "efficiency and economy". The part-time Directorship was abolished, and his duties were to be assumed by a Professor or teacher who would also take on those of the secretary. Papworth senior and junior both had to go; to soften the blow, the elder Papworth was appointed to the Council. Lambelette was told that he could stay to teach in the evening classes, and Spratt in the Morning School, both at reduced salaries. To simplify the accounting system, teachers were in future to receive a fixed salary, and no longer would part of this be dependent upon fee income.

All these changes were due to a letter from William Dyce to the Trustees of the Academy for the Encouragement of Art and Manufactures in Edinburgh, which had been made available to the London Council, and which had encouraged them to suggest that Dyce went to France and Germany to report on the systems of education in art and design that he found in those countries.

## A GRAND TOUR

The Trustees of the Edinburgh Academy had been established since 1727, and had founded a drawing academy during the 1760s. William Dyce, a painter who had for a time been strongly influenced by the German Nazarene group, was

17

its present Master, and he and a younger col-league, Charles Heath Wilson, set off in 1837. Just before he left, Dyce spent a day among the silk looms of Spitalfields, a day in a glass manufactory, and a day in a porcelain ware-house: these three days (the first fact-finding mission ever undertaken by a teacher of design in Britain) merely succeeded in making him "appal-led at the quantity of information which to do justice to my mission I ought to possess". Their final report did not make comfortable reading for the Council of the School of Design. Dyce noted that in France, for instance, industrial artists were held in "high estimation" and that a pattern designer was looked upon in his sphere precisely in the same light as a professor of fine art. "You may employ him or not as you think fit, but having given him the commission, it is he, not you, who is responsible for the merits of his performance; and this does not terminate in the design merely – his taste and judgement must be equally allowed to control the manner and process or reproduction."

What a contrast with England, Dyce observed. He was convinced that:

*if there is one cause more than another which has contributed to retard, or which now presents an obstacle to the progress of taste in British manufacture, it is the degraded position which pattern designers occupy – a position in which their talents find no scope for development, and their taste and judgement as artists are set at naught.*

The result was, that "if a youth of natural ability thinks he has any prospect whatever of succeed-ing in the higher walks of art he will rather take his chance in this than submit to the thankless drudgery to which he was exposed as a pattern maker". If this were not so, how was it that no well-known artist devoted himself to industrial design? A young and talented designer in Lyons, for example, would be made a partner of the firm, and his financial reward would be "beyond the conception" of the British. The reason was obvious to Dyce: the French manufacturer did not have to buy expensive foreign designs, nor did he suffer from having his own designs pirated.

But this was not all, for British work practices left much to be desired as well. Dyce told of the French wallpaper manufacturer who, with his designer, came to England to set up in business, full of hope. His designer, accustomed to the French method, insisted that the tints employed should exactly correspond to those in his design, and that if the colouring were to be changed the alteration should be according to his judgement. Could anything be more reasonable? But what

was the result? The workmen went on strike; the Frenchmen packed their bags and went home.

Dyce was impressed by the Académie des Beaux Arts in Lyons, which had departments teaching painting, sculpture, architecture, orna-ment, engraving and botany, and whose students had to undertake a preliminary course in painting and drawing, including the life class, before moving on to one of the main departments. In Germany, Dyce and Wilson visited the kingdoms of Prussia and Bavaria, and though each had a different system, Dyce was even more impressed by them than he had been by the French. Prussia had set up regional trade schools, with a central school and museum in Berlin, which received the best students. Emphasis was on practical train-ing, and this was even more the case in Bavaria, where, for instance, the school in Nuremberg concentrated on metal casting, in Augsburg on calico printing, and on stained glass, wood-carving and metalwork in Munich. In addition, every primary school had classes in drawing. If Dyce were to have the choice between the Bavarian system (derived from the model of an engineering workshop) and the French system (derived from the model of a painter's studio), he would go with the Bavarians.

For in these schools, Dyce observed:

*Design and manufacture are the elements which are to be brought together. The foreign schools of design deal with artists or designers as if they were to become workmen, and with the work-men as if they intended to be artists; the designer is brought down to the level of the workman by the practical study of industry, and the workman is elevated to the level of the artist by the study of art... To effect this, we find in all the schools a department for the practical study of industry, termed in the Prussian and Bavarian schools the* werkstadt, *and in the French the* atelier; *and I do not see how the Government school can answer all the ends for which it has been established without the help of a department of instruction of this kind...*

Both the Council of the School of Design and the Board of Trade were so impressed by Dyce's report that they offered him the post of Superin-tendent and Professor, which had been created following the departure of Papworth. Dyce accepted, just in time for the new session, about to begin in the autumn of 1838. In the history of the School (or, come to that, the College), there were to be several other authors of papers which were highly critical of the governance of the place, who suggested – as a conclusion – that they were uniquely qualified to take it over. And they proceeded to do so.

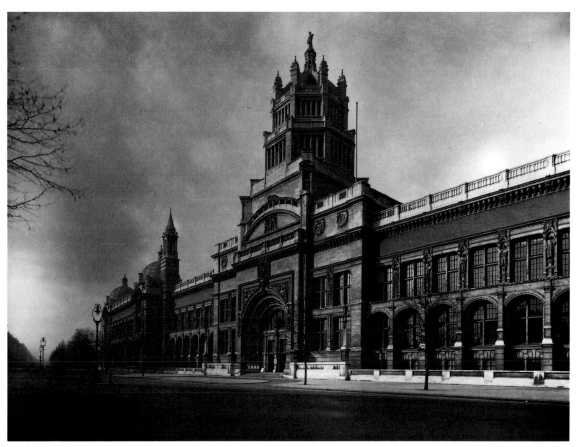

Above *Sir Aston Webb's central tower of the Victoria and Albert Museum. The tower was originally to house the Royal College of Art.*

## DYCE AT SOMERSET HOUSE

*Not only is the present Council too large for a Working Committee but there are in it men who are not very desirable associates in the transaction of public business. Note: I was almost about to say not very desirable associates for gentlemen. Mr Cockerell says the Council is sometimes more like a bear garden than a meeting of gentlemen. In my hearing, one member called another a* damned *fool – one termed another a charlatan and so on. A third who offered to become treasurer and was unguardedly appointed by Mr Labouchere, it was found necessary immediately to deprive of the office, because it appeared that as a tradesman he had not been distinguished for accuracy in money matters.*

From a *Letter* of William Dyce to the Vice-President of the Board of Trade, Mr Gladstone, October 1841.

Dyce's first act was to introduce a life class, although he defined its purpose as strictly for "the purpose of ornament". But at this period, the School was at a pretty low ebb. There were only eight students during the day and twenty-four in the evening, a total of only thirty-two. During the autumn, numbers dropped and had risen to only thirty-five by the end of the year. During 1839, they rose gradually, but were never more than sixty-eight, which was achieved in April.

Instruction at Somerset House was now divided into two sections: (a) Elementary, outline drawing of ornament and the human figure, shadowing, drawing from plaster casts, modelling and colouring, and (b) Instruction in design for industry, which included the study of fabrics, and processes, the history of taste in manufacture, styles of ornament, and "such theoretical knowledge as is calculated to improve the tastes of the pupil, and to add to their general acquaintance with art". The only practical training introduced by the Council was the study of the manufacture of silk. To that end the Council acquired a Jacquard loom and engaged a M. Trenel to instruct in weaving and the design of woven fabrics. The experiment was a total failure: so few of the students were interested that the experiment was brought to a close at the end of the year. It was not until 1849 that the School dared to invest in any further equipment.

19

The number of students very slowly increased during 1840, with the result that the Council was encouraged to turn to other objectives. They hoped to collect moulds of ornament, from which casts could be taken to sell to manufacturers. Funds at their disposal, however, were inadequate for a start to be made, but they were able to enhance their small collection of books, prints, plaster casts and "specimens of manufacture", and to commission from Dyce a drawing book of ornamental designs which they trusted would serve as a handbook of styles for the use of designers. The Council was able also to found a branch school at Spitalfields, as well as, in November 1841, a special class of senior students who were supposed to become instructors. Six men were awarded exhibitions of £30 a year, for three years. The first Exhibitioners included George Wallis, later in the century to become Keeper of Art in the South Kensington Museum. By setting up this Normal Class ("normal" in the sense of setting standards for the Schools, through the training of instructors) the Council was obviously turning its collective mind to the formation of regional Schools of Design, which had been one of the recommendations of the 1836 Select Committee. The government authorized a grant-in-aid of £100,000, to be disbursed at about half the cost of running a school, the remainder to be found by the town concerned. At the meeting of the Council held on 16 March 1842, they considered an application from a privately maintained school in Manchester that wanted to be designated a Government School of Design. The Council agreed, as they did to applications from Coventry, Norwich and Birmingham, provided these towns were able to guarantee half the running costs, as well as committing themselves to accepting that all instruction would conform to what was laid down by the Council in London. Students of the first Normal Class at Somerset House were eventually appointed as Masters at Sheffield, York, Nottingham, and Manchester.

A month later, on 27 April, the inauguration of a Female School at Somerset House was agreed. Two candidates for the post of superintendent were considered, a Mrs Norman and a Mrs Mclan. The latter seemed the more suitable, but the Council "being desirous to have the fullest information in reference to the party to be selected for this important charge, requested the Chairman [Lord Colborne] and Mr [Shaw] Lefevre to procure testimony of the respectability of Mr Mclan, whose connexion with the Stage might cause objections, on the part of the public, to the appointment of Mrs Mclan". All must have been well, for Mrs Mclan was appointed, and served

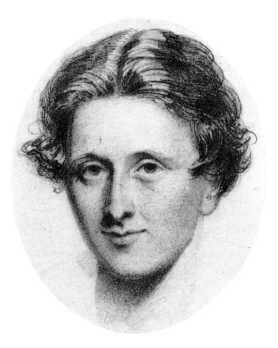

Above *John Partridge's portrait of 1825 of William Dyce, who in 1838 was made both Superintendent of the School and Professor.*

with distinction for very many years. The large room on the ground floor was allocated to the Female School, and the architect Edward Blore, a member of Council, was asked to see that the Office of Works fitted it out satisfactorily. The small portion of the Strand block of Somerset House which had been made over to the School was becoming crowded, not only for students, but for the growing collection of plaster casts, and this caused Dyce to ask for more accommodation, a request that was to be constantly repeated during the years ahead.

Dyce was, in fact, rather in trouble with the Council at this time, for the publishers of his *Drawing Book* had written to them as they were having difficulty in obtaining the text from Dyce, so that the agreed publication date could not be kept. The Council minuted:

*That Mr. Dyce be informed that the Council feel much regret and disappointment at the non-completion of the text for the elementary Drawing Book, which he had promised to prepare in sufficient time to enable the first number to be published on the 1st May; that it is absolutely necessary that measures be taken for completing the required portion by a fixed day, and that it should be ready not later than the 9th of May; and that Mr. Dyce be requested to inform the*

Council whether he can undertake to supply the text before that time; as, if he cannot, the Council will, at the next meeting, take into consideration the steps necessary for remedying the situation.

In a private letter to Mr Gladstone, Dyce told the other side of this story: the Council insisted on taking "microscopic views of my proceedings," he said, and it didn't seem to have much confidence "in the person who fills my office"; in addition, some of the manufacturers had difficulty in behaving like gentlemen.

But at long last, both the Council and the Schools were beginning to find their feet. John Rogers Herbert, ARA, had been appointed Master of Figure, student numbers were increasing, and more regional Schools of Design were being founded, so that Somerset House was coming to resemble a spider with its geometric web stretching across the country.

The Board of Trade, early in 1842, thought that the time had come to put the School on a more official basis.

## THE DRAWING BOOK

On behalf of the Board of Trade, J. G. Shaw Lefevre wrote to the Council on 4 May. He reminded them that they were only a provisional body, and told them that the Board of Trade had now decided to appoint the Council officially. All the newly-appointed members, Edward Blore, the architect, Sir A. W. Callcott, RA, Lord Colborne, William Etty, RA, T. F. Gibson, Bejamin Hawes, H. T. Hope, H. Bellenden Ker, J. G. Shaw Lefevre, Philip Pusey, MP, J. Thomson, Thomas Wyse, MP, and Apsley Pellatt (who was the unfortunate "treasurer" referred to in Dyce's letter to Gladstone) were already members of the old Council. Hitherto, the President and Vice-President of the Board of Trade had been ex-officio members; they would not remain so in future, for, as they were responsible to Parliament "they may in many supposable cases be in the anomalous predicament of having been outvoted, and of afterwards feeling it to be their duty, as responsible servants of the Crown, to disallow and overturn the decision of that majority". The Board hoped to increase the membership to twenty-four, but in the meantime the Council was to draw up rules and regulations for the conduct of its own business and that of the School.

Dyce had hoped for a smaller Council, and a clearer division of responsibilities between Director and Council: what he got was a larger, still unpaid, Council, a ruling that the Director should be "subject to the control of the Council", and a letter from Mr Gladstone expressing the hope that this solution was "compatible with your honour and comfort". The only substantial change was that the Council itself was in future to be "subject to the control of the Board of Trade". The Council would also be required to draw up its own annual estimates of expenditure, and then be responsible for such money as was eventually voted to them by Parliament. The days of rather happy-go-lucky attitudes, with members calling each other ungentlemanly names, were disappearing fast. Dyce, who was still writing his text for part of the *Drawing Book* but who hoped to have it ready for yet another revised publication date of 1 June, was told that the publication would be supervised by a committee of the Council, and that this would meet in a few days' time for "the purpose of revising the letter-press". They kept Dyce to it, and announced that the second part of the Book would appear on 1 August. This section would deal with ornament and its application to industry; and the same outlines, coloured, would serve to illustrate the various arrangements of colour in pattern. The third number, to be published at the beginning of October, would begin the series of outlines of freehand ornament. Dyce then told the Council that if that was the way they felt about it he was quite unable to finish his report on the management of regional schools.

During the remainder of 1842, the main business of the Council, to which Ambrose Poynter, an architect and official of the Board of Trade, and Sir Richard Westmacott, RA, had been appointed, was taken up with regulations for the School. In the middle of June, they consulted Dyce about a job-description for the Director who was to "suggest" the courses of instruction, to teach the Normal Class, superintend the library, and to attend every day of the week, at least one evening, and from 11 am until 3 pm on Saturdays. Dyce agreed to all this, and was re-appointed Director at an annual salary of £400, with the use of "the best studio that could be arranged for him on the premises . . . consistent with the interests of the School".

The first Report of the Council in March 1843 was optimistic. Student numbers had risen since October 1842 from 160 to 296, mainly in the Evening School; those during the day had grown from 47 to 76. Lectures had been given in the neighbouring King's College (because the School had no lecture room of its own) on various subjects including calico and silk printing, weaving by hand and power, lace-making, type founding, engraving, and sculpture by machinery. It was hoped that more general lectures on the history and styles of ornament would be given by Dyce, "who should avail himself of the excellent collection of casts of ornament now in the possession of the School".

21

The Council had, nevertheless, one disappointment to report. Dyce's book, which the Council had confidently expected to sell well at 3s. 6d. for each part, had been a commercial disaster. The Council had agreed with the publishers, Chapman and Hall, to pay for the drawings, their engraving on wood and a proportion of the publishers' loss (if any). Because of the poor sales, the Board of Trade was warned that there was a heavy financial liability and that the Board could expect a considerable bill. In view of this, the Council would in future pay only for the drawings and their transfer to lithographic stones, in return for which the publishers would take the entire risk for an edition of 500 copies, giving the Council fifty of them free, with a further 100 at cost price. To meet these expected costs the Council had put the sum of £300 in the Estimates for 1843/4, since the £100 in the Estimates for the previous financial year had turned out to be "altogether unsufficient".

It was an inauspicious start to the debate about "science and ornament" which was to play a key role in the development of the School from the late 1840s onwards. Dyce's position was that "though it be admitted that artists work by impulse, does it follow that there is no law by which their impulses are in the main regulated?" The illustrations to his *Drawing Book* – sharp, linear outlines, followed by assorted lithographs of classical motifs – were intended to "educate young persons in the art of inventing and executing patterns and designs", by teaching them the grammar of design, step by step.

But in 1843 – before the "branch schools" were quite ready for compulsory textbooks – Dyce's *Drawing Book* simply caused the School Council considerable financial embarrassment.

## SCHOOL OR MUSEUM?

However, early in 1843, the Council made some crucial changes: they divided the duties of the Director between two officers, the Director and a new post, Inspector of Provincial Schools, suggesting £400 for the Director and £100 for the Inspector.

Dyce was not happy as Director of the School. For one thing, he wanted to get on with his own painting and, in addition, he had, he said, fallen foul of Bellenden Ker who had persuaded the Council to adopt a resolution that Dyce should give all his time unreservedly to the School. Dyce was unwilling to accept this without argument, but the Council took the easy way out and decided that he had resigned, and offered the position of Director and Headmaster to his former colleague in Scotland, the watercolourist

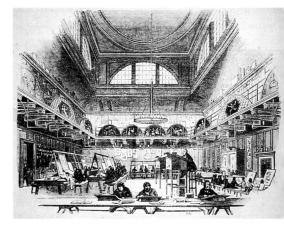

Above *Interior of the School of Design at Somerset House in 1843.*

Charles Heath Wilson who took over on 1 May 1843: Wilson was quite happy with the condition that he should work full-time "without any reservation whatever", even if it meant abandoning (what there was of) his career as an artist. As a sop, Dyce was appointed to the Council and made Inspector of the Provincial Schools the following day.

Wilson proposed, and the Council approved, a new course of instruction:

### THE NEW DISCIPLINE

Whatever had been the atmosphere in the School before, the temperature undoubtedly changed under Wilson as he attempted to make it much more regimented – by submitting new rules for students to be approved by the Council. If, as was said of him, "timidity was his guiding motive", Wilson certainly wasn't about to show it. Students had to be aged twelve years or over, they were "to sit down immediately in their proper places on coming into the School", talking was not to be permitted, nor were the students to be allowed to move about "unnecessarily". Moreover, no student was to be admitted if he wanted to be a painter or sculptor, and within three months of entry he must state in which of the departments of Ornamental Manufacture or Decorative Art he wished to study. In addition, due to what the Third Report described as the substantial increase in applications to the Evening School, it was ruled that any student absent for a week or irregular in attendance was to be struck off the register – and that no Evening School student could be younger than fifteen. However, if they were well-behaved, the twelve-year-olds from the morning class might be allowed to work in the evenings.

ach Student to commence with the class for
lementary Drawing in Outline, *which he is not to
eave until he can draw with correctness. . . The
outline examples must, if properly copied, cause
im to draw with accuracy, and by their graceful
orms, will improve his taste without giving him
ny bias in the formation of a peculiar style. . . He
will thus be taught to draw, but will not be made
mannerist.*

*When the Student can draw in outline correctly,
e will pass to the class for shading, at first from
he flat, when he will be taught how to use the
chalk. . . Of course, the Student will not draw for
uch a length of time from these examples as to
ncur any danger of his becoming too mechanic-
l; an evil which needs little to be apprehended.*

*The Student will next commence drawing from
he Cast, no bias yet having been given to his
mind; and having been taught to be correct, and
o observe accurately, the probability is, he will
orm a style of his own – an effect which has
een found to be verified by experience.*

*The Student will then proceed to the study of
olour. He will at first paint in chiaroscuro, until
e can master the materials. He will then paint in
water-colours, or in tempera, from proper exam-
les, and lastly from nature.*

*Those Students who require it will now com-
ence drawing the Figure. The class for the
igure to be divided into, first, an elementary
lass, and secondly, an advanced class; and as
his class is especially intended for persons to be
mployed in making ornamental designs, it is
equisite that casts from objects in which figures
re* combined with ornament *should be placed in
he figure room, as well as casts from ancient
atues. The practical application of all that is
aught in these classes should be shown, as
uch as possible, by the examples on the walls,
which should not present merely the appearance
f a classroom for the Figure attached to an
cademy of Fine Arts. The tendency to become
rtists, so observable in classes where the Figure
s taught, is partly to be attributed to example; for
his reason no persons studying to become
rtists, as distinguished from* ornamentists, *will
e admitted to the School of Design.*

*Those Students whose pursuits require a
nowledge of Perspective, will be taught at this
eriod of their studies. . .*

*From these classes the Student will proceed to
he highest class, in which he will study the
istory, principles, and practice of Ornamental
esign. By copying the best examples that can be
btained, he will be exercised in composition,
at is, in forming new combinations, and will be
arefully taught to apply the knowledge he has
cquired to various practical purposes.*

Wilson's own course of lectures was on "Historic
Principles and Styles of Ornamental Art" – in
which he set out to prove that total immersion in
elementary drawing, followed by a sound know-
ledge of all things Roman, was by far the most
effective training for a budding ornamentist. Dyce
had been too concerned about "trade" and too
little concerned about stock-piling exemplars for
the students to copy. After sending some copyists
to Pompeii, armed with reams of tracing-paper,
Wilson set about arranging copies of Raphael's
Vatican loggie decoration in Somerset House on
"quadrangular pillars" so that they could be seen
and copied: he also introduced glazed show-
cases for exhibits, and new frames for drawings
and prints. Desks were provided, and in the
Figure Room the casts from Antique statues were
lighted by a powerful Bude burner in the centre.
In all rooms, a total of more than 800 casts of
architectural ornament were "heaped together"
stylistically, and pedestals provided for busts,
vases and candelabra. The School was now being
conducted within a Museum which was expand-
ing almost by the day.

## THE STUDENTS REVOLT

During 1844, Wilson reported that the number of
male students was greater than in previous years
and that, as a result, receipts from fees had risen
by £88 to £326 9s. 6d. But forty of the students
were aged between 12 and 15 years, while a
further 189 were between 15 and 20. Their
occupations were very mixed. The largest groups
were classed as "Ornamental Painters", carvers,
architects and draughtsmen; then came 15 "De-

Below *Watercolour of the Museum of Ornamental Art,
in Marlborough House, which contained examples of
work for design students to copy.*

signers – Ornamental"; and, decreasing in number, modellers, "Arabesque Painters and Decorators", engravers, down to one silversmith, a Clock maker, a "Herald Chaser", a "Piano-forte Maker", an "Organist", a "Shawl and Silk Manufacturer", an "Embroiderer", a "Picture Cleaner", a "Coach Joiner", and finally a "Schoolmaster". A year later those under 20 years old in both the Morning and Evening classes totalled 200, and of the remaining 130 on the books, just over 100 were aged between 20 and 25. The largest trade represented was still that of the "Ornamental Painters". Of these, the Council said that they attended the School solely for improvement in drawing, and that usually they had to start off with "mere elementary exercises".

The most successful class was the Figure Class run by John Rogers Herbert, ARA, who, by this time, was the only teacher left from Dyce's day, all the others having decided to move on. Dyce himself had resigned as Inspector of the Provincial Schools, and Ambrose Poynter had been appointed in his place.

Herbert soon found himself at odds with Wilson. Apart from more mundane disagreements, Herbert went on record as saying that a young student who studied things Roman "may get honey from the flowers, but is more likely to get poison than honey".

Wilson thought Herbert was something of a *poseur*, since he had developed the irritating habit of speaking to the students in a French accent, even though he couldn't speak a word of French. Charles Landseer was later to suggest that Herbert must have "tumbled down whilst at Boulogne and broken his English".

Matters came to a head in the early months of 1845, when Wilson first ordered the removal of plaster casts while the students were working from them, then sent in a draped life model – whom most of the class refused to draw – and finally ordered the lighting and the heating for Herbert's evening class to be turned off. At this stage, according to the report in *Hansard*, there followed "an unseemly altercation . . . in the class room, Mr Herbert appealing to the students against the character of Mr Wilson. It was then found necessary, in order to preserve discipline, to suspend the class". The Director put up a notice explaining how the students had seriously infringed the new School regulations, and thirty-three of the most senior of them immediately wrote to the Council and the Board of Trade, as from "Cast Room, School of Design":

*My Lords, We, the undersigned students of the School of Design, are at length compelled to perform a painful duty to ourselves and the*

*School by laying before your Honourable Board complaints relative to the Director of the School, Mr Wilson. . . Without wishing to make any personal reflections on Mr Wilson we must submit that he is utterly incompetent as an Artist and Teacher of* Ornamental Design *to fill the station he holds . . .*

An emergency meeting of the Council was called for Tuesday 8 April, and under the chairmanship of Lord Colborne it was attended by twelve members in all. They listened to Wilson's version of the disagreement (which implied that Herbert had deliberately set out to "prejudice the Director"), and then heard read a statement by Herbert, as well as the letter written by the students. The Council promptly suspended all those who had signed the letter, and ruled that the Figure Class was not to meet again until sanctioned by them. In addition, a copy of Wilson's statement was to be sent to Herbert, who would be given a chance to reply to it in person at another meeting of the Council on the following Saturday. This he did, but the Council reserved its judgement until later in the month (they were still unclear about the general "misunderstanding which appears to have existed on this occasion"): at the later special meeting Council members unanimously resolved to express their satisfaction with the "honourable and disinterested manner" in which Wilson had tried to meet the situation; "fully sensible of Mr Wilson's talents and zeal, and of the essential service which he has rendered to this Institution [the Council] are satisfied of the importance of supporting his authority over the Masters and the Students". The students were to remain suspended until they had each seen Wilson personally, admitted the impropriety of their conduct, agreed to conform to any rules laid down by Wilson and affirmed their "*bona fide* intentions of seeking instruction exclusively as designers for manufactures".

Wilson was instructed to reorganize the Figure Class, based on the firm principle that any student in it must either attend the Ornament Class and be known to Wilson, or certified by him, as either a "decorator or industrial designer". The new class had to be under Wilson's inspection and subject to his authority.

By now everything about the unsavoury affair had become public knowledge. Old Benjamin Haydon had seen to that by writing a letter to *The Times* under the *nom-de-plume* of "Alpha": according to Haydon's account, the "unseemly altercation" took the form of the Figure-Master calling the Director "a snob", with the Director replying that the Figure-Master was "a liar and a scoundrel"; "luckily," added Haydon, "neither

master having the organ of combativeness very largely developed, they separated, bowing, and swearing vengeance before the Council – a very pretty way of occupying precious time, spending public money, and advancing the refinement of the mechanic".

A correspondent to *The Builder* added that since all the promising students had been expelled, what was left was "nothing more than a cheap school".

These and other comments prompted twelve loyal students to protest and defend the School against the "calumnies so plentifully heaped" upon it, which in its turn spurred the ringleader of the rebellion, the student Richard Burchett, to reply. It was a fact, he wrote, that there was general discontent in the School, though it should not come as a surprise that twelve students could be found who were "willing to purchase the goodwill of the Director", but almost without exception all the senior students had complained and been suspended, and *these* were the only pupils that the School could claim had been educated. Augustus Pugin was drawn in, for he had "almost given up my hopes of seeing any real good effected by the Schools of Design". Herbert was a friend of the family, and besides, Pugin felt strongly that the basis of an education for the ornamentist should be study of the "principles of nature", combined with workshop practice, rather than the copying of "obsolete symbols and designs".

During May, Wilson presented his proposals for the reform of the Figure Class, which were intended to end the practice which had become established (by Herbert) of students being given a course of anatomical and figure drawing "such as is supposed to be given at the Royal Academy". The result of this "dangerous and injurious" instruction had been that the students, instead of considering the study of the figure as supplementary to that of ornament, had been led to look upon it, and up to it, as a more *elevated* branch of study. The Council gave its approval, with only Dyce dissenting.

That was the end of Herbert, for two weeks later, the Council at a meeting attended by none of the artist members, unanimously declared:

*That, having regard to the very important duties confided to the Director, in the general management of the School, and to the very satisfactory manner in which he has executed them, and also to the contemplated change in the instruction of the students in the Figure, which will render Mr. Herbert's peculiar talents less necessary and available to the School, the Council arrive at the conclusion that the welfare of the School will be best consulted by terminating Mr. Herbert's engagement.*

The Council then went on to act in an extraordinary way. It heard a letter from Herbert, stated in the Minutes as having been handed in during the meeting (which by then had barely begun). In this he stated that as he did not think he was in any way in the wrong, he was determined not to resign. The Council brushed this to one side:

*The receipt of the communication was ordered to be acknowledged, stating that on its delivery to the Council, which was not until some time after the foregoing Resolution had been passed, it was read from the Chair, and that under the circumstances, no further notice could be taken of it.*

So the knives came out; Herbert had to go. And in his place came John Calcott Horsley, known in the trade as "Old Clothes Horsley" for his strong views about the hanging of nude paintings at the Royal Academy. At his interview with the Permanent Under-Secretary at the Board of Trade, Horsley was emphatically told: "My dear young friend, bear in mind one thing – that the real object of the Government is not to educate picture Painters and Sculptors but *Designers for Manufactures*".

An attempt was made a little later to get the House of Commons to appoint a Select Committee to investigate both the complaints of the students and the general management of the School. Although one of the original supporters of the foundation of the School, William Ewart, was in favour because it was obvious that the institution was in a state of disorganization, the motion was defeated. One of the last parting shots of *The Builder* was to ask if it were true that at least 5,000 copies of the *Drawing Book* had been consigned to the cellars of Somerset House.

Wilson and the Council turned now to consider a pressing matter which had been held up by the student revolt. Because of increasing numbers of young students in elementary drawing, accommodation was continuing to be a worrying problem, which was also hindering the "original object" of the School, and it was proposed that all these boys should be removed into another building. At last the Council was admitting that nearly all those seeking admission to the School were unable to draw. Suitable additional premises had been found in Blackfriars Road, and the Board of Trade was asked for extra funds for it. Shortsightedly, the Board refused.

A report made by Wilson following the Board's rejection gives an impression of the congestion to which both staff and students were subject in the three classrooms at Somerset House. There were:

*An Elementary School which holds, as at present arranged, about 150. In the same room, drawing from the round is carried on, and modelling, as also painting, under the most disadvantageous circumstances as to space.*

*A Colouring Room, which accommodates, at most, ten pupils* [it was in a passage], *whilst the class consists of a much larger number.*

Above *Cast-iron stove lid designed by Alfred Stevens about 1851 and manufactured by Hoole of Sheffield.* Below *The Wellington Monument in the North Aisle of the Nave of St Paul's Cathedral, by Stevens, who taught, among other subjects, architectural drawing and perspective at the School of Design.*

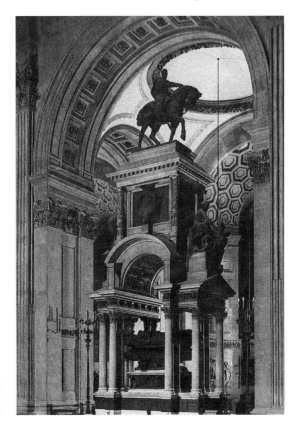

*A Figure Room, in which a number of the pupils in the class of Colour are obliged to work.*

At the same time, the Council's attention was drawn to the "very serious" situation of the regional schools. Several of them were being attended by a "very different class of individuals from those at first contemplated". If the Council were not careful, the schools of design which had been founded for the manufacturing community would become no more than "cheap drawing schools for the benefit of the middle and even upper classes". This trend, the report added, had become even more evident where classes for females had been established.

## THE STAFF REVOLT

During 1845, not surprisingly, most of Wilson's staff had left or were planning to do so; to add to his troubles, therefore, he was faced with finding an almost total replacement of teachers. By the beginning of the following year, the masters of the Morning Classes were Henry Le Jeune (drawing and painting the figure), Alfred Stevens ("Architectural drawing, Perspective and Modelling, also Ornamental Painting if required"), and of the Evening Classes, Henry James Townsend (drawing and painting ornament, and modelling), Charles James Richardson (ornamental and geometrical drawing) and Herbert's replacement John Calcott Horsley (drawing and painting the draped figure). An assistant master, John Murdoch, took both morning and evening schools.

Of these new men, Richardson was an architect who had been assistant to Sir John Soane, but by far the most significant of them was Alfred Stevens, then only about 28 years old, a relative unknown, some of whose early designs must have made an impact on Wilson. He had trained in Florence for some years, as well as in the Rome studio of the Danish neoclassicist sculptor Bertel Thorwaldson. If he had stayed at the School of Design for more than eighteen months, he might have been able to influence much of its future course. As it was, he was invited back several times, but always declined. He had no patience with slavish copying, nor with the distinction between so-called inferior and superior forms of art: his own work and his teaching were intended as a challenge to these artificial barriers. In fact, the motto under which he successfully applied for the national monument to Wellington in St Paul's Cathedral – "I know of but one Art" – says it all. While he was working part-time at the School, Stevens designed bronze doors for the newly-built Geology Museum in Jermyn Street, and planned the interior of Deysbrook Hall near Liverpool.

A young artist, Richard Redgrave, ARA, who was to have a major influence on the School for decades, joined the staff temporarily to cover a month's absence by Horsley, during the summer of 1846, the year in which there was yet another revolt against Wilson – not by the students, but this time by the masters, who resented the high-handed way the School was run.

---

### "WE DON'T SKETCH HERE"

On one occasion, one of Stevens's students, Richard Beavis, eagerly announced "I've sketched in the ornament, Sir", to be met by the reply "Sir, we don't sketch here: we *draw*". On another, he told the Morning Class "make as many interesting details as you please, but the map must be good". When the students asked him for his views on William Mulready's pretty (and popular) red-chalk drawings, he observed "Well, the paper was worth about three-halfpence, I suppose, and now it is spoiled".

---

Above *Self-portrait of around 1835-40 by Alfred Stevens, who taught at the School of Design for eighteen months.*

Left *Enamelled vase and dish designed about 1864 by Alfred Stevens and manufactured by Minton.*

The revolt seems to have been sparked off by Richard Redgrave who, in September, wrote a long letter of complaint to the Prime Minister, Lord John Russell, which was to be the signal for the end of the beginning of the School of Design and its regional satellites; during the next three years, no fewer than three committees of investigation were appointed to investigate the School.

Redgrave's very long letter, given wide publicity, put forward five proposals for the more efficient running of the School. Firstly, the masters should have more independence. Up until that time they, who had been chosen for their "talents and acquirements", were "controlled in the use of them by a *director*, who however generally competent, must be far less acquainted than they are with that peculiar knowledge which they are required to impart – and whose object it must be, by occasional interference, to assert his primary authority to which they are bound to submit. This causes the masters either gradually to remit their exertions, *which, even if successful, rebound to the credit of the director*, and to content themselves with merely routine instruction; or leads to dissensions. . ." Men of great talent had already been lost, asserted Redgrave, and there would be no improvement unless the office were abolished, and the routine business devolved upon a secretary. Redgrave's other proposals were that masters should be encouraged to lecture on the science and the *principles* of design, they should be paid more, and as professors, rank "scarcely inferior" to those of the Royal Academy. Finally, he suggested that there should be periodical exhibitions of students' work, with prizes for original designs.

Redgrave's bold action spurred both Richardson and Townsend to write to the School's Council, making more or less the same points. As a result, in November the Council was forced to appoint a Special Committee, under the chairmanship of J. G. Shaw Lefevre, which sat until the summer of 1847.

Each of the masters was interviewed, and naturally each came armed with his favourite horror stories. Richardson, for instance, told the committee of a young iron-worker who had asked for help with a drawing of an ornamental stove. Hardly had he been set to work, when Wilson interfered and "placed before him an elevation of the Temple of Theseus by Stuart, and directed him to copy it. . . In a few evenings the young man left the school. By the same system, my three classes of ornamental drawing, architecture and perspective, lost, in the middle of the season, from ten to fifteen of the senior pupils, who would willingly have remained, had they been allowed such a course as could have been

practically applied to their several businesses".

Eventually, the Committee produced a report containing several recommendations together with alternatives, so the Council set up another committee to report on the report. The major recommendation was that a Committee of Instruction or Management should be appointed from the Council, to consist of five members, three of whom, at least, should be practising artists. This Committee's decisions would not require confirmation from the Council. In addition, at the head of each class would be a Professor who would be responsible only to the Committee of Management, and who would lecture regularly each week: one of these Professors could be styled Director, attending to general administration.

Following this report, the old Council was dissolved in April 1848; the new Committee consisted of Stafford Northcote of the Board of Trade, Ambrose Poynter, Shaw Lefevre, George Richmond, and Sir Richard Westmacott – and within a short time there was an almost complete about-face at the School.

Back came William Dyce as the Master of the class of Ornament; Redgrave was appointed Master of Flower-drawing and Botany; Townsend was to teach Form; Horsley was to be Master of Colour, while Richardson remained as teacher of Geometrical, Architectural and Perspective Drawing. William Danby, and, to complete the triumph, Richard Burchett, chief rebel student in 1845, were made assistant masters. Charles Heath Wilson was edged out, not very happily, to look after the regional schools of design, and shortly afterwards he gave that up to become Master of the School of Design at Glasgow: the official version of why he left the School of Design was that "he has had too much to do".

Then Alfred Stevens resigned – "not before I was heartily sick of it". Stevens had hoped that he would "gain much credit" during his time as "Professor of everything", and he had, in fact, made the contacts which led to his appointment as chief designer to Hoole, the ironfounders of Sheffield: there, he designed a series of stoves and grates which attracted much attention at the Exhibitions of 1851 and 1862.

## "DO IT WITH ALL THY MIGHT"

A mighty man at cutting and drying, he was; a government officer; in his way (and in most other people's too), a professed pugilist; always in training, always with a system to force down the general throat like a bolus, always to be heard of at the bar of his little Public Office, ready to fight all England. . . And he had it in charge from high

authority to bring about the great public-office Millenium, when Commissioners should reign upon earth.

"The Government Officer", from Chapter Two of *Hard Times* by Charles Dickens (1854).

The departure of Alfred Stevens – the only practising ornamentist, up until then, on the staff – was followed by the resignation of Dyce in autumn 1848 and, almost incredibly, the return of J. R. Herbert to take his place. The continuing confusion and argument gave a chance to a civil servant in the Record Commission who had been watching the affairs of the School for some while with growing impatience, and he now decided that the time had come for him to strike.

Henry Cole (motto: "Whatsoever thy hand findeth to do, do it with all thy might") was a reformer and had, during the 1830s, pursued a campaign to sweep away the inefficiency he saw at the Records, and to improve the conditions under which public records themselves were stored. To do this he organized a stream of pamphlets and letters to such good effect that the House of Commons eventually appointed a Select Committee. He thus discovered the power of publicity in its various forms, and so he did the same to help Rowland Hill in his campaign for the Penny Post. In the mid-1840s Cole joined the Society of Arts, of which Prince Albert had just become President, and began to organize small exhibitions. At one of these, in 1846, he won a prize (as Felix Summerly), for the design of a tea service, which was taken up by Herbert Minton and produced for the remainder of the century: he claimed that it was produced "in prodigious quantities", but, since so few examples have survived, this is difficult to establish. Cole then set up a company, "Summerly's Art Manufactures", with a shop in Bond Street, and encour-

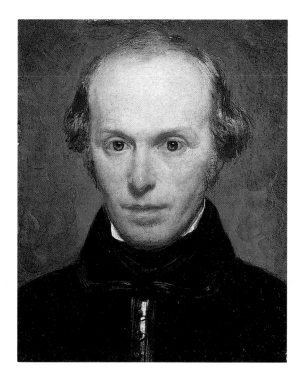

Above *Self-portrait by Richard Redgrave.*
Below *Vase designed by Redgrave in 1847 for Summerly's Art Manufactures.*

Above *Wallpaper designed by Richard Redgrave around 1849. At that time he was Master of Flower Drawing and Botany at the School of Design. He had joined the staff in 1846 and was to exert an important influence in the School for several decades.*

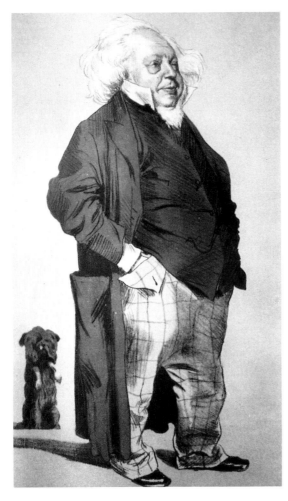

Above *Cartoon of Henry "Old King" Cole with his inseparable terrier Jim, published in* Vanity Fair *in 1871. Among the greatest of reformers of the College, Cole was a skilled administrator who had also acquired practical experience of art and design.*
Below *Teapot designed by Cole for Felix Summerly's Art Manufactures. Cole himself briefed the workmen on the manufacturing techniques.*

aged his friends to design for him. Among these were Richard Redgrave and J. C. Horsley. No doubt, what Cole heard from them stimulated his interest in the School of Design, and he determined on its reform, by the same methods that he had so successfully employed before – public print and a Select Committee of the House of Commons.

In his youth, Cole had taken a short course in watercolour painting under David Cox; in 1839 he had commissioned William Mulready to design the "highly poetic" cover for the prepaid penny post; in 1843 he asked John Horsley to draw the first Christmas card ever to be published; and in 1846, while preparing the Felix Summerly tea service, he spent three days at Minton's in Stoke-on-Trent, advising the workmen on how to manufacture the pot, jug, cup, and saucer.

So, in addition to being a spectacular lobbyist, Henry Cole was one of the the very few civil servants in the history of British art and design education who actually had experience of the practice of art and design, who knew what it was like to participate in a drawing class, and who sympathized with other practitioners. He had also been a member of John Stuart Mill's circle of friends and kindred spirits, in the 1830s, so he knew a great deal about what the idea of "utility" (a key concept in the discussions of the 1830s and 1840s) really meant.

In the library of the Victoria and Albert Museum is Henry Cole's personal copy of the Report of the Second Special Committee of 1847, on which he has marked those points he wanted to single out for attack. By the beginning of 1849 he had negotiated with the publishers of Dyce's unfortunate *Drawing Book*, Chapman and Hall, and convinced them to undertake an expensively produced periodical to which he, at first, would be the principal contributor, and which he would co-edit with Richard Redgrave. It would contain information for manufacturers (with samples of wallpapers and fabrics, in full colour, stuck to some of the pages), and it would also include comments (in the form of lectures, articles, and reprinted extracts) from design theorists such as Owen Jones and William Dyce. But, most of all, it would be full of news from Somerset House. The first number of the *Journal of Design and Manufactures* appeared in March 1849, and in it Cole, making use of his annotated 1847 report, went straight onto the offensive. He stated his aims unambiguously: "The *Journal of Design* will best prove itself to be the friend of the School of Design by helping to accomplish a complete reformation of it". He continued:

*It has been the reiterated declaration of the*

1837-1852

Right *"The Government Officer" himself: Samuel Laurence's 1865 portrait of Sir Henry Cole.*

Right *The first-ever Christmas card, commissioned in 1843 by Henry Cole and drawn by John Horsley.*

*managers of the School, that its object was "the promotion of improvement in the ornamental and decorative manufactures of this country". Looking to the results and taking the testimony of the various officers of the School, we are compelled to admit the unanimous verdict that the School has been a "complete failure" . . . after an expediture of tens of thousands of pounds of public money (published accounts are not precise enough to say how much exactly!).*

Cole proceeded to give a summary of the School's history, adding that the Board of Trade failed to appreciate that all past errors were due to the School's defective constitution. The latest Council was a new committee of nine, which "meets *once-a-month* or so! and no-one is paid for his service, or bound to attend":

*It would be a cruelty to place these* [men] *in the midst of Alderman Copeland's Pottery at Stoke, or Messrs. Thomsons' Printing-works at Clitheroe, or the Coalbrookdale Iron-works, and desire them, not indeed to produce, but merely to lecture on the improvement of any ornamental design. We should almost expect they . . . would hardly know whether metals were to be* carved *or* chased.

---

### A FORCE FOR CHANGE

The first issue of the *Journal of Design* sold 1,600 copies (as Cole duly noted in his diary), and, throughout 1849 and 1850, it became a powerful weapon in the battle against the administrators of the School of Design. The tone of its criticisms (often Cole's own contribution) was robust, to say the least: the School, said one editorial, had merely produced unemployable artists who "normally cover dog kennels with crochets and finials . . . and fall back on the dreary expedient of copying scroll and shell work or gothic panelling"; since these students had been taught by a bunch of "dilettanti half-informed bunglers", said another, the indifferent results were hardly surprising. But beneath all the bombast, and the in-jokes (on one occasion, it featured a bad review of Felix Summerly's new range) the *Journal* was making some very serious points: about the social status of the ornamentist (Dyce's contribution); about the *principles* of design, in relation to the principles of nature (Owen Jones's contribution); about archaeological discoveries and their contribution to colour theory (Gottfried Semper's contribution); and about the problems which are bound to arise, if "the designer and the engineer do not know each other's business" (Cole's contribution).

---

This last was a dig at a nonsensical reference to "carving metal" in the report of the Second Special Committee.

At last, Cole was successful. The House of Commons decided on a Select Committee, its chairman being Thomas Milner Gibson, a friend of Cole's. This Committee examined members of the School's Committee, most of its masters, some eighteen manufacturers, and several others who had opinions to express, including Cole himself.

All the well-worn arguments against the School were once again aired, but on this occasion there was a new dimension, in that the opinions of industrialists were sought. These were rather mixed, but as was stated in the eventual Report, almost all the witnesses were prepared to admit the value of the various Schools of Design. So far as the governance of the School at Somerset House was concerned, the Select Committee made no definite recommendation, except that it was "generally of the opinion" that the supreme executive authority should be vested in the Board of Trade, which should appoint all the masters. This final report of the Select Committee was a well watered-down version of an earlier draft which was much more critical. It was generally rumoured that this had been written for Milner Gibson by Cole. It could well be true for, in the Victoria and Albert Museum is a collection of draft reports, amended by various members of the Select Committee. Cole was obviously well-enough in on their deliberations for him to have gathered up their papers for his own use. The rejected draft was no secret, however, for it was printed together with the Committee's final report – and there was always the *Journal of Design* to provide extra ammunition. In these ways, it became very widely circulated, and people began to notice that one of the conclusions was that the management of the School should be delegated by the Board of Trade to one full-time official who would have sole responsibility.

Ralph Wornum, who was by then lecturer in the History of Ornamental Art to the Schools of Design, and who did not like Cole at all, stood up for Somerset House in the columns of the *Art Journal*. As one of the "dilettanti half-informed bunglers" mentioned by the *Journal*, he was also angry about a reference to his lecture course in Cole's draft report: the report had considered that his twelve lectures were almost unbelievably esoteric, and had gone on, "your committee have great doubts of the propriety of their continuance". Wornum's *Lectures on the History of Ornamental Art* were, in fact, subsequently published for circulation around "the provincial masters", with an Analytical Index of four double-column pages specially prepared by the editor

"finding the Lecturer had slightly deviated from the syllabus issued". Even *with* the Index, the lectures (which finish on MODERN ART – the rococo) are very heavy-going indeed – and a student recalled the "slightly irritable manner" with which they were delivered.

No wonder a member of Wornum's audience in Stoke-on-Trent complained that his lectures were "much above the heads of the people" who thought they had come along to hear about design for ceramics: no wonder, too, that Henry Cole published this complaint with some relish in the *Journal of Design*. When Wornum defended the School in the *Art Journal*, he did so "in the absence of a more able defender, since we are convinced that the School has been most gratuitously traduced, and, as it would appear, not with the best of motives". The Final Report, he added, had been received "with anything but courtesy; it is, in fact, too impartial for a mere partisan, and perhaps too general for the genuine advocate of the schools". He then weighed into the "Cole" Report, which had, it seemed, been well-sifted; not one sentence favourable to the School had been left in and:

*the upshot of this appeared to be that the Schools of Design would never be of any use until a well-paid Deputy-President [of the Board of Trade?] be appointed to control the whole working machinery... This is the scheme of Mr*

Above and below *The immense Crystal Palace for the Great Exhibition of 1851, by Joseph Paxton.*

*Henry Cole; and the chief feature of the rejected report is its constant bearing on the evidence of this witness...*

During and after this verbal duel between himself and Cole, Wornum found time to write some interesting things about the direction he thought the School might be going in. Cole's plans, he warned, would result in too much *training* and not enough *education*: he was also convinced that it was wrong to base the School's curriculum exclusively on industrial and commercial applications. "There is a distinct study of Design or Ornamental Art wholly independent of its application," and the School's proper purpose was "to offer instruction of the highest description to all who desire to obtain a knowledge of Ornamental Art, and to supply a complete and systematic course of education in relation to *every kind* of decorative work".

Up until the autumn of 1851, Cole was far too busy organizing the Great Exhibition to become too deeply involved with the School. In the meantime, it carried on under a new committee, perhaps with a sense of foreboding. The problem of accommodation in Somerset House had become so acute as to create enormous difficulties for both teachers and students. In the Public Record Office is a note from Redgrave to Horsley which gives an idea of the problem:

*Will you in your next report to the Committee of Management say a few words as to the Flower Class. For the last week I have been absolutely unable to get at my pupils ... without passing over the desks from the crowded state of the school. Free hand & geometrical draughtsmen being mixed up with those who are studying from the living plant... I need say nothing about your own class ... since you are yourself but too well aware of the disadvantages under which we labour from want of light – being in the corners of the room – & from want of space being confined in the great room by the tables – & in the figure room behind the Casts...*

In an attempt to improve things, the Female School was ejected from Somerset House into a nearby tallow-chandler's in the Strand. During all the arguments about the School of Design, the girls ("from the better and educated class"), under Mrs McIan, had quietly carried on doing the sort of thing considered by the early Victorians to be suitable for them – such as wood-engraving, and drawing and painting flowers, instruction "calculated to be of especial service to females, by furnishing them with at least some portion of the means of obtaining a livelihood". For years, the work of these students – when it went on show at Somerset House – had attracted better reviews than the work of the male classes.

In the light of this track-record, the young ladies must have felt somewhat aggrieved by the move – even if it did mean moving further away from the volatile regimes of Somerset House. For, apart from being ejected, their fees were doubled and their staff numbers were cut by half. The guardian of one of the students complained that it was scandalous that "some fifty or sixty young women should be subject to innumerable petty annoyances ... located in premises where the light is bad and unsufficient, and even where there is not a single advantage for study; to say nothing of the lodging provided for them in one of the least reputable of London thoroughfares..." The move had been arranged without anyone bothering to ask Mrs McIan about it, and she was concerned that her young charges (some of them only thirteen years old) might be taken for streetwalkers in the vicinity of Drury Lane. Also, she didn't like the idea of a *separate* Female School. "When the school was at Somerset House," she wrote, without a trace of irony, "there was a respectability about it..." One consolation, perhaps, was that Laura Herford, the first woman ever to be permitted to study at the Royal Academy Schools, was an early student of the independent Female School.

# MARLBOROUGH HOUSE

## "WE MUST HAVE STEAM, GET COLE!"

At the end of 1851, Henry Cole, a newly-appointed Commander of the Order of the Bath, triumphant following the success of the Great Exhibition, on amiable terms with Earl Granville, ministers and ex-ministers, and politicians, and regarded with favour by Prince Albert, was definitely a man to be reckoned with. It was at this time that Lord Granville first sounded him out about going to the School of Design. During January 1852 Cole had an interview with the President of the Board of Trade, Henry Labouchere, and afterwards wrote to him putting forward his suggestions for the reform of the School. To achieve this, a special department of the Board of Trade should be created, with a Secretary responsible only to the President or Vice-President, and called, perhaps, the Department of Practical Art. This Department should direct: (a) elementary instruction in drawing and modelling; (b) the practice of art connected with processes; and (c) the cultivation of the power of designing. He got his way just in time, for the government changed in February, and when the incoming President, Robert Henley, arrived at the Board of Trade, he found that the new Department had been formed with Cole named the General Superintendent, and Richard Redgrave the Superintendent for Art. These two men thus became the virtual dictators of art education for the next quarter of a century.

Cole immediately set about inaugurating a paternalistic and extremely bureaucratic regime, although at first he had to sort out various problems at Somerset House. The most pressing of these was to deal with overcrowding, as he had found everything in confusion, with the casts and examples of ornamental art relegated to the cellars. Therefore, he at once saw Prince Albert who promised help with obtaining Marlborough House in St James's for Cole's use: Cole was later (on various occasions) to express his gratitude to: "His Royal Highness Prince Albert, the foremost, uniform and consistent, though oftentimes unknown, advocate of the better education of all classes of the people." At the time, Albert was buying land at Brompton from the profits of the Great Exhibition, and the Prince hoped that Cole would eventually link the School of Design with his great scheme for Science and Art – the dream of "Albertopolis". He persuaded Queen Victoria to consent to the temporary occupation of about forty rooms in Marlborough House. The Office of Works raised no objection and Cole moved in with all speed, without waiting for the necessary formalities to be completed. There was a slight rumpus, and it was only some time after the event that the Board of Trade received official approval. It may, perhaps, have been this incident which the Queen had in mind when she later recalled how Albert used to say: "We must have steam, get Cole".

*Above Portrait of Prince Albert by students of the "Ladies' porcelain class" of 1870. Henry Cole praised on several occasions Albert's advocacy of "better education of all classes of the people".*

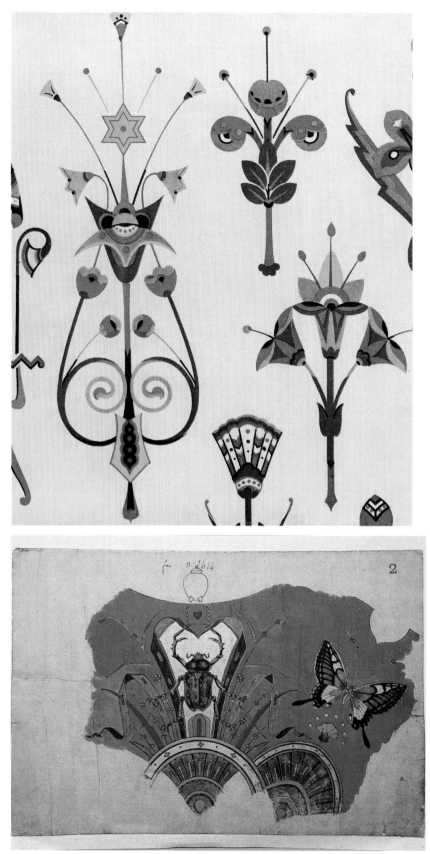

Left *Illustrations from* The Principles of Decorative Design *by Christopher Dresser, published in 1873.*

Left *Design for a vase by Christopher Dresser, who enrolled at the School of Design in 1847, at the age of fifteen.*

Richard Burchett was appointed Headmaster at Somerset House, and his school was renamed the Metropolitan School of Ornamental Art, where the young Christopher Dresser was one of its star students.

Dresser had entered the School of Design in 1847, when he was fifteen. Five years later he was awarded a "£15 scholarship at Metropolitan School of Art", to which he was reappointed in 1853 (£20) and 1854 (£25). During his final two years at the School he won a number of prizes, including £6 for "four designs for printed fabrics", £2 for "applying the principles taught by the Department to a chintz", and £4 for a design for "printed garment fabrics". In 1853, he also produced a "block printing, designed by C. Dresser, pupil of O. Hudson, and made by Liddiard and Co., London, for Hargreaves and Co. of Accrington".

In 1849, Richard Redgrave, too, had (twice) lectured on the importance of the study of botany to the ornamentist, both of which were published in the *Journal of Design* (Redgrave had become

Above *Wallpaper design of 1860 by Owen Jones, whose work had a powerful influence on the School.* Below *Example from Jones's* The Grammar of Ornament, *published in 1856.*

Below *Botanical drawings by Dresser which he used as visual aids when he was a student teacher at the School of Design in 1852-4.*

---

### THE BOTANICAL MODEL

Dresser started giving lectures while still a student. What are undoubtedly visual aids from his classes, dated 1852, still survive. They consist of a series of careful botanical drawings (mainly of the structure of leaves) mounted on canvas for lecture room purposes. From his later published works, it is clear that the two lecturers who made the deepest impression on him while he was at the School were the scientific botanist John Lindley, who gave a course on *The Symmetry of Vegetation* (1852, published 1854), and the design theorist Owen Jones who, according to Dresser, gave a course of lectures at Somerset House in 1849. One of Dresser's earliest published drawings (entitled "The geometrical arrangement of flowers") was for Plate XCVII of Jones's *The Grammar of Ornament*, with a note beside it which read: "the basis of all form is geometry, the impulse which forms the surface, starting at the centre with equal force, necessarily stops at equal distances: the result is symmetry and regularity".

---

botany master in 1847). This, to our eyes strange, mixture of botany, "art botany", science, pseudo-science and the latest design thinking, which made such an impact on Dresser, represents the first flowering of a systematic design theory at Somerset House and Marlborough House, although the particular tradition goes back as far as Dyce's *Drawing Book*. "The ornamentist has not had the time to study botany", Dresser was to write in 1857, "and the botanist has not had time to study the requirements of the ornamentist." The most effective means of getting away from the "style wars" which plagued design criticism (mainly the Gothic versus the Classical Revival) was for botanist and ornamentist to get together. The study of botany was not important to the ornamentist only because it provided decorative exemplars (the Dyce approach), it was also important because the "fitness of purpose" of plants – as they adapted to the circumstances which surrounded them – could teach the ornamentist a great deal.

John Lindley left the School in 1855 (the year after he had given a course of lectures with T. H. Huxley), as did Christopher Dresser, armed with his "accreditation to provincial schools as a competent person for botanical lectures, schools to have use of his diagrams, he is to have the usual payments for certificates when he takes them". But the tradition lived on, in the person of Richard Redgrave and through the influence of Owen Jones: Moncure Daniel Conway was to

note in his *Travels in South Kensington* (1882) that a version of Jones's basic principles as applied to "Metal-work, Pottery and Plastic Forms generally, Carpets, Printed Garment Fabrics, Muslins, Calicoes, etc." was to be seen on "placards hung up in the schools of South Kensington" over twenty-five years after they were first delivered in lecture form. Dresser's metalwork, his glass and the better examples of his ceramic design (dating from the 1870s onwards) may seem surprisingly modern – perhaps because they are not over-decorated with "ornament" – but Dresser insisted that they should be interpreted in the light of the thoughts on botany which he developed under the influence of Marlborough House.

In the year when Dresser won his first scholarship, discipline was tightened at the School, for Cole had discovered that students had been coming and going at will, without the masters' control or knowledge, that there were no inventories of any of the property, and that records were so fragmentary, that only by asking students could it be established when they had entered the School, or even which classes they were supposed to be attending. Somerset House became exclusively concerned with training teachers; the Female School was moved from the tallow-chandler's house in the Strand to Gower Street, from which time it operated independently.

Cole transferred the more advanced and specialized teaching to Marlborough House, where it tended to take second place to his Museum of Manufactures, which formed a very important element in Cole's ambition to display approved objects to industrialists, designers and workmen, but equally with the intention to educate and improve the taste of the public. Here were displayed many of the old School of Design's examples, together with exhibits bought from the Great Exhibition with a special government grant of £5,000, and selected by Herbert, Redgrave, Owen Jones, Pugin and Cole. A feature of the new museum was the "Chamber of Horrors" in which were recently-made artefacts designed, according to the Department, on "false principles".

This concept of a "Chamber of Horrors" was immediately satirized by Henry Morley in Charles Dickens' magazine *Household Words*, through the medium of one Mr. Crumpet, a clerk from the suburbs, who came home from the exhibition in a fit of despair:

*I returned from seeing those exhibits haunted by the most horrid shapes. I could have cried, sir. I was ashamed of the pattern of my own trousers, for I saw a piece of them hung there as a horror...*

Since the producers of these "horrors" were mentioned by name, the enraged manufacturers

soon forced Cole to bring that particular experiment to a close. He had, in fact, planned to set up other "Chambers of Horrors" on prominent sites in London and the manufacturing towns: but he was misunderstood by the Chairman of the Sydenham Crystal Palace Company who thought he meant Madame Tussaud's wax museum and tactfully enquired whether Cole had at last taken leave of his senses. In any event, the idea of a circulating horror show came to nothing.

Of far more important and lasting value was the foundation of what has now become the National Art Library by Ralph Wornum, Cole's new Professor of Ornamental Art. When offered a post largely based in the Library, Wornum had rather lamely forgotten all about his principles (which were a matter of public record) and accepted it.

In the upper bedrooms ("too small and not well lighted"), eight technical classes were established, most of which could be attended by students of both sexes. Octavius Hudson (the O. Hudson who supervised Dresser) taught woven fabrics, lace, embroidery and "paper staining"; John Simpson taught painting porcelain; H. J. Townsend taught artistic anatomy; C. J. Richardson continued with his class on architectural details; and D. Brucciani taught casting and moulding. Female students also had special classes on wood-engraving, superintended by John Thompson, and on chromolithography superintended by Vincent Brookes: the wood-engraving class had been poached wholesale from the Female School as a going concern. Owen Jones was offered a full-time appointment to teach the theory and practice of ornament, but he declined.

The great architect and design theorist, Gottfried Semper, at the time a political refugee from Dresden after the abortive revolution of 1849, was appointed the Professor in charge of a class dealing with "the principles and practice of Ornamental Art applied to Metal Manufactures". Later, the post was enlarged to include "Practical Construction and Architecture".

Henry Cole had helped to publicise Semper's name in England, by printing a short article of his in the *Journal of Design* in December 1851, and appending to it the comment: "Mr Semper it was who so skillfully arranged the Canadian Court in the Great Exhibition. His knowledge both of architecture, and generally of decoration, is profound and his taste excellent".

On hearing (incorrectly as it turned out) that Cole was intending to devote the profits of the Great Exhibition to "the Establishment of a School for art and industry", Semper had immediately offered his services, in broken English, on 29 January 1852. Eventually Cole set him a test

which, if successfully completed, would assure Semper a Professorship at the Department of Practical Art. This test was the compilation of a "catalogue raisonée of the whole field of metallurgy from the oldest to our own times," to be ready in four months flat. Semper worked on this mammoth catalogue (and on the drawings for it) over the summer of 1852, and when he had completed it, with help from his contacts in Paris, Rome, Hamburg and Dresden, Cole handed it on to a Mr Robinson for advice and textual criticism. The manuscript copy of Semper's "illustrated catalogue for a projected collection of metalworks", in the library of the Victoria and Albert Museum, contains marginal comments by an unknown hand – presumably Mr Robinson's. On the first page, Semper had written the following cryptic comments:

*1. The high Development of modern practical Science, is not equalled by proportionate progress in Art, general artistic feeling and taste.*
*2. National Education will be perfect, when Science shall be pervaded by Art, and Art by Science, and all human relations by both. It was so at the time when Grecian Culture had reached its point of Culmination.*
*3. This happy result can only be attained, when Society is based upon sound principles, and not in Decline. The most careful and intelligent protection of Art will be without result, where these premises are wanting.*
*4. Supposing that such a sound basis were given, it would be possible to remedy the Imperfections and irregularities of national education, by Instruction, and to bring about an harmonious, intellectual, moral and practical Development of a Nation.*

To which Mr Robinson added, in pencil: "Seems to involve politics. Wants more explanation".

The catalogue – part system of classification, part treatise on design theory, part social tract – was certainly a great deal more radical than Cole had expected, and there is evidence that he also may have been concerned about Semper's political opinions: when Cole asked the Minister whether there were any objections to "an alien and refugee" being offered a Professorship, the Minister replied that "he did not care at all to which faith and to which political party he belonged", so long as he knew his job.

In the event, Semper started work at the School at the beginning of the autumn term of 1852. Three months later, he submitted to Cole a characteristically thorough "System of Instruction", which offered advice on how to restructure his teaching. Apparently, only Semper's classes in metalwork, and Octavius Hudson's in woven

fabrics, were at that stage conforming to the guideline of "constant reference to industrial production". The solution, according to Semper, was to base all instruction on practice in the workshop; to use the students as "assistants" to the Professor in his commissioned work; and above all to reduce the amount of time spent on copying: "many a talent has been spoiled by having been too long a time engaged with copying and studying from models and even from nature". When Cole published Semper's recommendations in the first Annual Report of the Department of Practical Art, he personally amended this sentence to read "those copies would have much more interest for the student, if done in connexion with some idea which the student had in his mind" – which doesn't quite have the force of the original, to put it charitably.

Semper's inaugural lecture, on 20 May 1853, was about "the relationship of the various branches of industrial art to each other and to architecture", and he began it by quoting the first of Owen Jones's *Propositions*: "The decorative arts arise from and should properly be attendant upon architecture." This proposition "headed the few rules which the Department has drawn up as a teaching norm", and besides it was "the first of those which are fixed on the walls of Marlborough House". So it had to be taken seriously even if, Semper went on, it had been formulated completely the wrong way round: the truth of the matter was that architecture arose from the decorative arts. Owen Jones's comments on this lecture do not appear to have survived, but Cole's have: he found it "thoughtful and suggestive".

By the time Semper left the School in spring 1855 to take up a Professorship of Architecture in Zurich – with a note to Cole about how he had not really been "in my element" at Marlborough House – his three main classes were attended by thirteen day students, twenty-two evening students, and fifty teacher training students. A particularly popular feature of his day-time metalwork classes had been the involvement of students in "real-life" commissions. There were four of these: the commission from Sir James Emerson Tennant to design a large-scale sideboard (with a prize of £25 for the best entry); the commission from the Electric Telegraph Company to design a telegraph kiosk for the middle of Oxford Circus (which was never built, although Semper's drawings have survived); a cabinet for Holland and Sons, in an all-purpose Renaissance style, which was subsequently displayed at the 1855 Paris Exhibition; and the Duke of Wellington's funeral car.

Cole had hoped to encourage industrialists and designers (for a small fee) to consult *all* the professors who taught the technical classes upon the "execution of any works or designs originated by them", but according to Semper's "system", this only had a significant effect in Metalwork and Woven Fabrics. Cole's response was to consult various manufacturers about what was going wrong: Garrard's thought that, apart from public ignorance, the greatest obstacle was the demand for low prices; Wheeler's, the silversmiths of Clerkenwell, considered that though their workmen were not able to draw, they would not be willing to learn, so Cole should concentrate on apprentices, if employers could be persuaded to give them time off. J. Gray was of the opinion that the public would not accept higher prices for better design, while Hunt & Rockell felt that their silversmiths and chasers would certainly benefit from instruction in design, but feared that not many would attend Marlborough House – "A workman, after the fatigue of 12 or 16 hours in a day, is not in a fit state to acquire art", but they, too, had apprentices who would profit, and thus benefit the firm. Even among students Cole found "very little willingness" for training: one from Spitalfields who had been given a scholarship for training in design for silk weaving had soon abandoned it and gone off to take up portrait painting. Therefore, concluded Cole, at least two years must pass before a "more correct" feeling towards the decorative arts could be expected.

As a result, Cole sped on towards his next goal, public education. The museum had proved popular, and in the three or four months during which it had been open in 1852, had been visited by more than 40,000 people. So he and Redgrave now turned to elementary art education, and their hefty 390-page first report devotes much space to the bureaucratic procedure required to establish elementary art classes in towns and cities throughout the British Isles.

The towns were expected to find a lot of the money themselves, but the Department of Practical Art would encourage and assist them by guaranteeing the salary of a teacher, providing books and materials at half their cost, and offering help with samples of drawing materials. The government would not direct, and the initiative had to come from the towns themselves. Marlborough House devised a welter of questionnaires and forms to be completed, standard letters of application, specimens of approved furniture and so on. That there was not only a need, but enthusiasm as well, is perhaps demonstrated by the fact that as 1852 came to a close more than 350 towns had applied.

Another part of Cole's scheme was to encourage manufacturing towns to form their own miniature museums of manufacture. From the

Marlborough House collections he formed a "Travelling Museum" which trundled round the country forming a temporary nucleus for which the town paid the expenses. After a short stay, the "Travelling Museum" would move on, leaving behind, Cole hoped, enough interest for the town to form a collection of its own.

In all of this Cole was not to have everything his own way, and he certainly had his critics. Among them was one of his own professors, Ralph Wornum, who, having accepted his appointment, continued to write critical articles in the *Art Journal* during 1852. Cole retaliated by suspending him, but "protests and explanations compelled his restoration". A continuing source of irritation to Cole was Wornum's friendship with John Ruskin, who most certainly did not approve of the new direction which the School was taking and who wrote, some years later, that "the Professorship of Henry Cole . . . has corrupted the system of art-teaching all over England into a state of abortion and falsehood from which it will take twenty years to recover".

## THE GOVERNMENT OFFICER

Undeterred, Cole brushed aside all criticism and doubt, and as was his wont, continued to do it "with all (his) might." His Art Superintendent, Richard Redgrave, drew up a formidable scheme for art education, which could be adapted to different types of schools and requirements. This Redgrave scheme remained in favour until at least the end of the century, and probably older art masters were still using it, and their pupils condemned by its rigidity, until well between the two world wars.

Redgrave's course was divided into 23 stages, most of which were subdivided into sections. It began with Stage 1 (Linear drawing by aid of instruments) and ended with Stage 23 (Technical studies). Once Redgrave had established the complete range of the course, it was then a simple matter to extract from it those stages and sections required to suit particular interests, as he had done for the primary schools. The Department of Practical Art laid down, for example, that machinists, engineers, and foremen of works should be taught Stages 1-5, then Stage 23; designers and ornamentalists had to undertake the full course, omitting only Stage 19 and section (a) of Stages 2, 3, 4 and 23.

To the bureaucratic and orderly mind of Henry Cole, Redgrave's system possessed the admirable characteristic of standardization; everyone was to be taught the same thing, in the same way, by teachers who had been taught by the same method. Universal examinations and competition

for scholarships and prizes could be worked round it, and another stream of regulations and lists of examples emerged from Marlborough House for this purpose. In 1853, for instance, they announced that for two years, competing students in Stage 5a would use ornament from the architrave of the Ghiberti Gates, or for Stage 6, an outline of the Laocoön. Approved reproductions could be supplied from Marlborough House on application (on the approved form).

The teaching at the School itself was to be a microcosm of the national system, for working students (in the evening), national scholars training to be designers, general fee-paying students (in the daytime), and art teachers in training who intended to make a career in the branch schools. All of these had to prove their competence in geometrical principles (Stage 1)

Below *Cabinet and stand for the Paris Exhibition of 1870 by the design theorist Gottfried Semper.*

and in drawing from flat examples (Stages 2, 4, 6 and 13), before proceeding to drawing from shapes (Stages 7 to 12), modelling (Stages 18 to 21), and, finally, to "composition in design" (Stage 22, supported by technical classes, such as painting on porcelain, metalwork and woven fabrics). If they could prove their competence in these areas, there would be a corresponding reduction in fees.

The basic principle underlying the scheme was that "design" could be taught as a language (or as Redgrave put it, as "an aid to perception and a language of explanation"). First you had to learn the grammar, then the syntax, and finally you were ready to explore usage (in Stage 22). Indeed, in announcing the scheme, as part of a lecture he gave on the 27 November 1852, Redgrave used precisely this analogy:

*In this way, drawing becomes, so to speak, a* language *of accurate description, a* universal *medium of explanation, and moreover may be, to men of other professions as well as to the artist, a means of treasuring* facts *and collecting stores of* truths.

Having learned the grammar and the syntax of this new language, Redgrave went on,

*the student is prepared to enter upon Elementary Design – the twenty-second stage of progress. Hitherto, the study of the pupil has been strictly imitative; that is to say, he has obtained technical skill in the use of his tools and materials by means of exact imitation, and in this respect the route of the artist and the ornamentist has been so far the same. But in this stage the special direction of the latter, which had as yet only been suggested by the examples used for the purposes of study, becomes real; and the ornamentist enters upon the consideration of the fundamental principles wherein his Art differs from Fine Art.*

These fundamental principles – a mixture of the grammar of ornament, linear geometry, botany, chemistry, and the history of design – would be taught alongside the class in Artistic Anatomy and the class in Architectural Details. At this stage, and only at this stage, could students proceed to the technical classes. It was, as Redgrave concluded, a case of training the mind first, the eyes second, and the hands third.

Where the technical classes were concerned, there was little point in trying to keep up with the latest developments in manufacturing industry: since the days when "the designer and the artificer were united in the same person" had long since passed away, it was unlikely that the designer would ever be expected in later life also

to be a producer. So the role of technical classes was to help ornamentists to *communicate* both with the manufacturer and the public, at a technical level. As Ralph Wornum (who helped to teach the history courses) said, the purpose of the Marlborough House system was "not *how* to apply a design, but *what* to design. While the accomplished practice of an Art may be a matter of five years, the mere mechanical process of application is, in comparison, a mere matter of five hours."

When Redgrave had been offered the part-time post of Art Superintendent, in effect under the supervision of Henry Cole, in 1852, he had been nervous; Cole, too, had "rather objected" to what he called "shared responsibility". In his private journal, Redgrave expressed concern that he would never be given the full credit he deserved for the Marlborough House doctrine. He needn't have worried. Nearly every writer on the history of art education has noted Redgrave's contribution – and singled him out for special attack.

The most famous satire on the system came eighteen months later from Charles Dickens in *Hard Times*, where the man from the Ministry tells a class of Coketown schoolchildren, "you don't walk upon flowers in *fact*", and proceeds to outline "the new discovery" with all stops out. "You are to be in all things regulated and governed by fact. We hope to have, before long, a board of fact composed of commissioners of fact, who will force the people to be a people of fact, and of nothing but fact. You must discard the word fancy altogether." His speech may have been based on Redgrave's published lecture of November 1852, which includes the passage:

*We shall endeavour to point out the* principles *which are to regulate and guide us. . . The fact is that the ignorance of the public in such matters is most melancholy, their want of guidance like that of a child.*

Equally, the speech could have been based on lectures by William Dyce or Owen Jones, both of whom were fond of saying "we walk on flowers and tropical plants, crushing them beneath our feet" – as part of their polemic in favour of conventional (meaning linear and geometrical) patterns on carpets. But by far the most likely prototype for "the Government Officer" is Henry Cole himself – who actually said in a published lecture of 24 November 1852: "If the individual be ignorant, self-willed, prejudiced, and therefore will not seek our instruction, then I still feel it is our duty, if we would succeed, never to relax any efforts to remove his ignorance, to direct his wilfulness in a right course, and to smooth away his prejudices." The fact that Charles Dickens *did*

have Henry Cole in mind is revealed by the notes he took when preparing the novel (notes which are bound up with his manuscript draft of *Hard Times*, now in the Forster Collection, Victoria and Albert Museum) and by a letter he wrote to Henry Cole Esquire shortly after the novel's publication. In Dickens's notes for the second chapter, he lists "Cole" among the cast of characters in Mr Gradgrind's classroom, and in his letter (dated 17 June 1854) he tells Cole that he is passing the summer "in the society of your friend Mr Grad-grind". Dickens continued:

*I often say to Mr. Gradgrind, that there is reason and good intention in much that he does – in fact, in all that he does – but that he overdoes it. Perhaps by dint of his going his way and my going mine, we shall meet at last at some halfway house where there are flowers on the carpets, and a little standing-room for Queen Mab's chariot among the Steam Engines.*

# SOUTH KENSINGTON

**1857-1896**

## A MOVING SITE

An administrative change which had little effect on the art schools was the renaming of the Department of Practical Art in 1853, when it became the Department of Science and Art. Henry Cole became, for a few years, Joint Secretary with Lyon Playfair, who acted for science. At the same time the museum became the Museum of Ornamental Art.

As the goverment required the rooms occupied in Somerset House for the Registrar-General of Births, Deaths and Marriages, Richard Burchett's school there was transferred to Marlborough House and reorganized as a Normal Training School. During the first seven months of 1853, student enrolments rose to 422, bringing in £291 in fees; even Marlborough House was proving too limited to house both students and museum, so extra classrooms had to be provided in wooden huts erected in the garden. Cole, who had condemned the way casts had been stored in Somerset House, had now to admit to himself that at least fifteen hundred casts were now lying buried in the cellars of Marlborough House.

The first major public commission, given to students in the autumn of 1852, was the Duke of Wellington's funeral car. There had been earlier design commissions with a high public profile – such as that in 1843 "for the Honiton lace which decorated Her Majesty's bridal dress, made by Mr Hudson, then a pupil of Mr Dyce's, and now our Professor of Woven Fabrics", as Henry Cole recalled – but this was the grandest of them all. The day of the funeral had been proclaimed a bank holiday, and it was expected that at least one-and-a-half million people would be watching the spectacle.

The car was to be an extraordinary construc-tion, 27 feet long, 10 feet wide and 17 feet high, and the Department had only three weeks in which to have it ready. Since the arch of Temple Bar was barely 17 feet, the car was "so arranged that, by application of some ingenious machin-ery, the whole could be lowered a couple of feet

while passing under the Bar, and raised again after entering the City". The six bronze wheels were cast by firms in London, Sheffield and Birmingham – "an instance of the remarkable rapidity with which the most elaborate works can be manufactured" (although some mistakes were made). Above the frame, there was a pediment 7 feet wide "presenting a mass of gilt carving, enriched with circular panels, within which the names of the Duke's principal victories were

Below *The School of Design's huts, painted by A. Stannus when he was a student in 1863.*

### COLE AS PUBLICIST

Although the Board of Trade considered that "the Department has not yet adequately organized" to undertake the commission for the funeral car *officially*, it permitted "assistance to be given. . . as a private transaction". Cole immediately saw this as a unique opportunity to publicize the school. He went straight out to measure the arch of Temple Bar, and decided, with Redgrave, that the carriage should be made of solid bronze – as befitted the Iron Duke: "a real substantial work . . . thoroughly simple, as was the character of the Duke, the only decorations being the pall, the armorial bearings and the names of his great battles". Redgrave made a series of drawings of "the general design of the car", Gottfried Semper drew "the structure, with its ornamental details", and Cole noted in his *Diary*: "sketching car". These drawings were all displayed before Prince Albert two days after the Lord Chamberlain agreed to the "private transaction", and following his audience Cole told Semper: "the Prince liked many parts of your design". He then wrote in his *Diary* "settled and approved". Apparently, Prince Albert had exclaimed: "This is the thing!" Under guidance from Redgrave, Semper and Octavius Hill (for the "Woven Fabric Decorations"), the senior students of the metal-working, porcelain painting, and textile classes got to work on executing the details: some "figures of Victory", part of the bronze ornaments, were modelled by Mr Whittaker, a Scholar, and Mr Willes, a day student, while the embroidery of the heraldic devices was done by "some fifty female students", working round the clock.

Above *The Duke of Wellington's funeral car, designed in 1852 by staff and students of Marlborough House.*

*London News*, two days after the State Funeral, on 20 November 1852. The funeral car was "the object of universal admiration, even as it was drawn along with sufficient rapidity to prevent a scrutiny of its design". It just showed "how fine was the contrast between the style of decorative art, and that adopted at the tawdry fittings-up of the Invalides for the reception of Napoleon's ashes in 1840".

However, a week later, on 27 November, after all the ferment had died down, the *News* added quietly that "a great deal remains to be told". The twelve dray horses had done magnificent service, but "the ponderous weight of the car can be seen in the traces left by the wheels". And on the Mall there had been a disaster:

*When the funeral car had reached the Mall, its ponderous weight caused the wheels to sink in a small gutter intersecting the Mall. The wheels sank several inches, and the twelve horses could not for some time be brought to pull together, notwithstanding the zealous efforts of the sergeants of the Royal Artillery who accompanied them. Aides-de-camp galloped to and fro – advice was tendered, and orders were given on all sides – the Duke of Cambridge furiously galloped up Constitution Hill and down Piccadilly to tell all the Commanding Officers that the car had broken down, and directing a halt – and Her Majesty, alarmed at the delay, sent to inquire into the cause. After a pause of a quarter of an hour, by the assistance of a body of police, of some private soldiers, and militiamen, and of a few bystanders who lent their aid by means of ropes attached to the car, the horses were got to pull together, and the car was extricated . . .*

Temple Bar was successfully negotiated, and the

emblazoned". Above the pediment rested the bier, 6 feet high and 4 feet wide, covered "in a gorgeous canopy of rich Indian kinkhol", designed by Hill and manufactured in Spitalfields. The bier was arranged on a turntable, so that "upon arrival at the West front of St Paul's Cathedral, it can be readily moved round". As the *Illustrated London News* pointed out, "the mere manufacture of this car has been wonderful proof of the English capacity, such as the deceased himself was always one of the first to honour".

The final assembly took place in a huge ordnance tent, erected on Horse Guards Parade. After a last-minute decision to cover the top storey of the car with a canopy, the Duke of Wellington's last journey commenced on time. As twelve black dray horses (courtesy of Booth's gin distillery) heaved the funeral car from under the tent, Cole and Redgrave both heaved a long sigh of relief. "London never yet was in such a state of ferment and excitement", wrote the *Illustrated*

arrival at St Paul's went quite smoothly, but the sheer weight of the funeral car had let Cole and Redgrave down. It must have been a bitter blow to Cole, who had written two years earlier that no successful results can be ever be attained, until the designer and the engineer know each other's business. To make matters worse, the quarter-hour delay had enabled at least one eye-witness to have a good long "scrutiny of its design". "It was a moving sight", he later wrote in his *Recollections* of the funeral, "which even the horrible South Kensington catafalque with all its tawdry vulgarities, could not altogether deprive of its solemnity."

In retrospect, Cole brushed the whole incident off by concluding that the School had done remarkably well, considering they had "just three weeks to produce a work which would reasonably occupy a whole year".

For a while, the School settled down in Marlborough House. Cole, Redgrave and the administration doggedly continued with the work of reorganizing the old regional schools of design, and establishing new art schools, until the next upheaval came in the mid-1850s. This was the result of an offer made to Cole by Prince Albert and the Royal Commissioners for the Exhibition of 1851, of about 12 acres of land adjoining Brompton Oratory, on which to transfer the school and museum. Cole and the Department of Science and Art accepted, and by the middle of 1856 work was well advanced on a temporary iron building for the museum, given by the Royal Commission, while plans were drawn up for the school to move once again into makeshift accommodation in an early 18th-century house on the site, Brompton Park House, which was in a rather decayed condition. The government architect, James Pennethorne, built a special lecture theatre, a luxury that the school had not previously enjoyed, and the move was made from St James's during 1857. But as space still proved inadequate, the wooden huts had to be taken as well. At the time of the move the Department of Science and Art had been removed from the authority of the Board of Trade and had become the responsibility of the Privy Council Committee on Education, the political head of which was the Lord President of the Council, with a Vice-President in the House of Commons. It can, perhaps, be argued that this shift in emphasis from Trade to Education had a dramatic effect on the fortunes of the School for decades to come, and that its original aims would have been better served if the Board of Trade had remained its sponsoring government department.

However, as a result of this and the aims of Cole, the School gradually became almost exclu-

Below *The pillar-box commissioned in 1856 by the Department of Science and Art for the Post Office and designed by Richard Redgrave. Students of the School of Design were also involved in the project, notably in its construction. The commission for the pillar-box represents a rare example of a government department entrusting important work to the School.*

## A SCIENTIFIC PILLAR-BOX

The hexagonal cast-iron pillar-box designed by Richard Redgrave, "ornamented with national emblems and classical leaves" by Mr Willes, the assistant modelling master (probably the same man who as a day student had contributed to the funeral car four years before), and constructed, with help from the students, by A. E. Cowper (the Post Office's consulting engineer) was commissioned in 1856, following widespread complaints about the very first batch of roadside pillar-boxes which had been introduced in London in 1855. A total of fifty boxes were produced (by a Birmingham firm): thirty-two for London, eleven for Edinburgh, and seven for Dublin. They were the earliest pillar-boxes to bear the initials "VR" – although, as critics were not slow to point out, there was nothing else written on them to indicate their purpose. As a result, they could easily be mistaken for patriotic street decorations. Nevertheless, they got a much better press (in *The Builder*, for example) than the funeral car, and they did conform to one of Christopher Dresser's precepts – that cast-iron looked "appropriate" in green.

sively devoted to teacher-training, although in 1863 the Department of Science and Art instituted a system of National Scholarships to be awarded yearly to "advanced students who might give evidence of a special aptitude in design, and who were intended to become designers for industry". Other categories of students were Students in Training (prospective art teachers), who were the main body of grant-aided people, and a very large number of fee-paying young men and women who wished to take up "art", and on whom the School depended for most of its income. Projects on which students were employed included a series of "portraits" of members of the House of Tudor, as part of the decoration of the new Prince's Chamber in the House of Lords, and a new pillar-box, commissioned by the Department of Science and Art, for the Post Office.

## THE NATIONAL SCHOLARS

When the School, in 1864, at long last transferred into a permanent building expressly designed for

Below *The gardens of Marsh Court, Stockbridge, Hampshire, designed by Gertrude Jekyll.*

it, it had been renamed the National Art Training School. Among the first National Scholars was the artist Luke Fildes, who most certainly did *not* go into the career of an ornamentist for industry. In fact, in the biography of his father, Luke Fildes's son relates that Burchett was slightly put out to be told that young Luke wished to become a book-illustrator, because Burchett had him earmarked as a designer of ecclesiastical mosaics!

Another student at this time, who had entered the School in 1861 when she was eighteen, was Gertrude Jekyll. Miss Jekyll grew up in a house full of "Etruscan vases and life-size casts of the Milo Venus, the Venus of the Capitol and other fine examples", and in her mid-teens was encouraged to draw them, so she was well prepared for Stages 3 (Free-hand outline drawing and details of architecture from copies), 5 (Shading from round or solid forms) and 12 (Painting ornament from the cast, etc.) of Redgrave's system. Redgrave had used the example of the garden-designer to help illustrate his new scheme in 1852:

*How many are there to whom a power of geometrical imitation is far more valuable than that of perspective imitation! For instance, in all drawing as explanatory between employer and employed, in working drawings, and patterns, from the plans used by the carpenter and gardener to the patterns for the sempstress and the embroiderer, a power of delineating exact superficial forms is needed...*

But Gertrude Jekyll's interest in the plans used by the gardener was not fully aroused until a decade after she registered at the School: at the time, the main influences on her were the lectures of Professor John Marshall on Comparative Anatomy, and the colour theories of Michel Chevreul which were, much later, indirectly to inspire her flower borders. She later recalled that, at the end of Professor Marshall's first lecture, he collected his students' notebooks and selected one of her drawings for use when adapting the anatomy lectures for publication.

The illustrator Kate Greenaway enrolled at the National Art Training School in 1865, aged nineteen. She had been working her way through the National Course ever since she was twelve, a day student at the Canonbury House branch school in Islington. In 1858, she won a local medal for a shaded chalk drawing of a plaster-cast column (Stage 4b); three years later, she was awarded a local bronze medal for an outline flower-drawing (Stage 10a). In 1864, she received a "National Medallion", judged at South Kensington, for a set of six tile designs in tempera, with "conventional" floral patterns (Stage 22c) – which were bought by the National School as teaching aids; and in 1869, she was to win a silver "South Kensington" medal for a watercolour study of a young boy's head "from the life". Out of a total number of 767 students she was one of only two "female students" to be awarded a silver.

At the National School, Kate took some of the Stages she had missed out at Canonbury under Miss Sarah Doidge, and repeated others such as drawing shaded studies of plaster-casts in the "South Kensington manner" – in pencil or chalk, with "plenty of stump-work" and heightening of the lights with thick white chalk. Eventually, she joined the School's Sketching Club (with its inevitable motto "Thorough") – where she won a copy of Tennyson's *Idylls of the King* – and was permitted into the Life Room, where drawings were made of a man dressed in a suit of armour. Since she had hoped that Life Drawing implied studies of the human form rather than of bolted metal, Kate Greenaway joined Thomas Heatherly's private School of Art (where nude models were allowed) for evening classes, and in 1871 enrolled at the Slade – a new and lively alternative to the Redgrave system.

While she was a student at the National School (and still enjoying its restrictions, in her timid way), Kate Greenaway published her earliest book illustrations – for *Infant Amusements*, *Diamonds and Toads* and *Topo* – as well as some drawings in *People's Magazine*, and assorted Christmas and Valentine Cards – collected under the title *The Quiver of Love*; she also exhibited drawings and paintings (usually whim-

---

"THAT EYE"

During her otherwise rather uneventful time at South Kensington, Kate Greenaway shared a studio with fellow-student Elizabeth Thompson, later the Lady Butler who specialized in large-scale military paintings. Elizabeth Thompson was to recall the entrance examination which both she and Kate endured: the terrified candidate had to approach the "the bearded, velvet-skull-capped and cold-searching-eyed" Richard Burchett, as he sat behind a gigantic desk in his office, and to wait for "the Presence" to start the interview in his own good time; he would then stare closely at the candidate's portfolio of work with "that Eye", and declare that several of the Stages had to be done all over again. Kate Greenaway was a "very quiet student", wrote Lady Butler, "so that it is difficult to find anything striking to say of her ... she never, to my knowledge, gave any trouble or offence to any one in the schools"; but she did find that interview extremely nerve-racking.

Above and top *The gardens of Folly Farm, laid out by Gertrude Jekyll. The house itself was designed by Edwin Lutyens. This partnership created many fine houses across southern England.*

Right The Little Red Girl – *a greetings card of 1878 by Kate Greenaway, who benefited from the art teaching of several institutions; among them, from 1865, the National Art Training School.*

49

1857-1896

sical variations on the fairies and gnomes theme) at the Dudley Gallery, Egyptian Hall, Piccadilly.

The building for the new National Art Training School – in which Kate Greenaway studied – formed part of a plan drawn up for Cole by a Royal Engineer, Captain Francis Fowke who, at first an Inspector for Science, had been appointed architect to the Department of Science and Art. Cole seems to have been suspicious of members of the British architectural profession, and much preferred working with soldiers. Fowke's reputation as an inventor may have been part of the attraction: he had designed a draw-bridge, some floating pontoons, a portable milit-ary fire-engine, a collapsing camera, a portable bath to pack up like a book, and an "improved umbrella" – none of which were necessarily the best qualifications for an architect.

The School's accommodation was in an L-shaped block to the north of the site, and was on two floors, above museum galleries and a bar-racks for the detachment of sappers employed as photographers, firemen and in other useful activi-ties for the museum. (The sappers were given tuition in the art school, as part of a deal Cole had made with the War Office for their services). The School had fireproof floors, the girders of which, being hollow, contained heating pipes, and also acted as ventilation shafts. Fowke designed exceptionally large windows, so that as much daylight as possible was available and, as he subsequently wrote in a departmental report, there were no interior walls, "so as to allow the interior to be divided by screens at pleasure, and thus give the greatest freedom to the changing wants of the school". Less than twenty years later the building was greatly criticized as being totally unsuitable.

Drawing and painting from the nude figure, especially if paid for from government funds, continued to cause argument. Not for the reasons so often put forward earlier in the School's history, but this time on moral grounds. The move seems to have originated in Glasgow where, in May 1859, the Lord Provost of Glasgow denounced the use of models. A few weeks later, Lord Elcho, MP, speaking at a meeting of the Friends of the London Female Penitentiary, gave as his opinion that drawing the living naked female was disgraceful, "but such was the secrecy with which it was carried on, that it was not generally known, and the money of the country was given annually to carry on these proceedings – proceedings which I would blush to describe." He. raised the matter of these "vicious practices" in the House of Commons, but was rebuked by Palmerston for trying to interfere by legislation in matters which were not

the House's concern. Of course, the journals took the matter up, but the *Saturday Review* felt it was far better for the models to be nude because if they were partially clothed they were much more suggestive of all sorts of evils, as could be seen in the "offensive photographs" of women "exhibit-ing their legs and manipulating their garters, which we see in every shop window".

By 1864 – when yet another Select Committee was appointed to look into the affairs of the School of Art – the Department of Science and Art may have been surprised to read that French educationalists (of all people) were beginning to rate the national system as a great success. A *Report* by the French Minister of Public Instruc-tion concluded that:

*The Department of Science and Art has sown with a liberal hand the seeds of artistic instruc-tion among the working population and has alarmed France in her possession, up to the present time, of taste and delicacy of feeling in industrial art... If our superiority in point of style remained undisputed, if no rivalry arose to disquiet our supremacy, we might remain such as we now are and slumber in the triumph which we might flatter ourselves we should enjoy forever; but ... rivals are springing up, and the pre-eminence of France in the domain of taste may ere long receive a shock, if we do not take care... While we are stationary others are raising themselves; the upward movement is visible, above all, among the English.*

With the new system of gold, silver, and bronze "South Kensington" medals – for work displayed and judged in the Museum's Competition Gallery (now rooms 100, 101) – the Department began to publish the names of successful medallists in successive annual reports, and sometimes a well-known name appears as a student of the National Art Training School. In 1868, for exam-ple, George Clausen won a gold medal for a tapestry design (Stage 23c of the Redgrave system) and a year later, as we have seen, Kate Greenaway was awarded a silver medal for a watercolour study (Stage 17b).

The newly-formed body of National Scholars was put to good practical use in decorating the Museum's growing permanent buildings, and their work includes the Ceramic Staircase, win-dow blinds (really cartoons for stained glass) for the Cast Courts, panels of mosaic decoration, as well as the classical frieze around the Royal Albert Hall and various architectural details in the Entrance Halls. Under the eyes of their Instructor in Decorative Art, Francis Moody, the scholars were sent scrabbling up the looming east wall of the Science School (now the Henry Cole Wing),

to engrave layers of coloured cement. Moody was to have a public row with Christopher Dresser about whether or not these decorations were ideologically sound. A class in painting on porcelain was begun for women students, and this produced the painted tile decoration of the Grill Room in the museum's refreshment rooms, designed by Edward Poynter, ARA. For the insertion of black and white chips in the floors of the cloisters and corridors, Cole authorized the use of prison labour – which he called, rather coyly, his "opus criminale" – but National Scholars painted the ceilings.

One of these was the young Hubert von Herkomer. In a privately-printed autobiography he described how, when short of money, he

*heard of some stencilling to be done . . . at ninepence an hour. I obtained this, and worked at it with a fellow-student. We worked many hours, but produced little. Then they made it "piecework", under which we produced too much in the time. But I could not stand the slavery of this mean work. . . My companion thought it best to keep on, but I felt it derogatory to my condition (poor as I was) and struck.*

Herkomer does not seem to have enjoyed his time at what he described as "that stupid school". On his arrival in 1866 he showed his life-studies from Munich to one of the teachers

*who pooh-poohed them in right English fashion. He did not believe in these foreign schools; but what he did believe in were the outlines from the antique which were distributed. . . He was the draughtsman of those outlines. I might go into the antique room I was told, but the life class was out of the question. . . In the antique room I started a figure, but during the hours of rest I wandered into the life class where Luke Fildes, RA, Henry Woods, ARA, John Parker, RWS, and others were working. This was too much for me to see and to be debarred from. I brought my easel over and straight away began a life drawing in chalk. As luck would have it a master came. A Mr. Herman came first and fumed. The master, Mr. Collinson, followed and uttered some surprise at my audacity. Then finally came the headmaster, Mr. Burchett, and looked carefully at the drawing, and then at me. He said I had infringed a rule, but as the drawing was good, I might stay in the life class!*

Incidentally, Mr Herman – by now the Deputy Head – was the same man who had been Burchett's second-in-command during the student rebellion of 1845, and who today is mainly remembered (if at all) as a member of the Cyclographic Society with Millais and Rossetti.

The teachers themselves were becoming somewhat restive, and in 1873, they all wrote to Burchett asking for more money. "We need scarcely draw your attention to the fact that our salaries (share of fees inclusive) have for a long time remained stationary, while the Schools have been progressing both in numbers of Students, and amount of Fees received." They thought that as they had been teaching for a long while, most of the masters in the Department's regional art schools had been trained by them and therefore their services to the state deserved recognition. Burchett referred the matter to the Board who directed Redgrave to devise a scheme that might be acceptable. Redgrave took a year, and finally came up with a proposal which involved payment by results. He calculated that there ought to be

Below *Memorial to Richard Burchett, designed by George Clausen and Henrietta Montalba.*

51

**1857-1896**

about £250 available to be divided among the teachers proportionately, based on the hours they worked and the success of their students. Under the scheme Herman would receive 10 per cent, while other teachers received a smaller share.

For some while, also, Burchett himself had been in trouble with Cole and the administration for absenteeism. Cole eventually demanded a record of Burchett's attendance, and was annoyed to discover that, during 1872, Burchett had arrived at the School punctually on only seven days, and had been late on another 126 days. Cole retired in 1873, but his successor, Philip Cunliffe Owen, was still raising the matter in both 1874 and 1875. It was obvious that Burchett was a sick man, although he tried to convince the Board that the question of his absences had been exaggerated.

Six months later, in the middle of 1875, Burchett was dead, thirty years after his revolt against the system at Somerset House. To art historians, he is chiefly remembered as a minor painter in the Pre-Raphaelite manner, who was responsible for *Edward IV withheld by Ecclesiastics from pursuing Lancastrian Fugitives into a Church*. His memorial in the Exhibition Road premises of the College was designed by Henrietta Montalba, with the surround designed by George Clausen, when both of them were students. Mrs Burchett applied for a pension, but thirteen years later, General Donnelly (one of the three Royal Engineers who had arrived at South Kensington in the 1850s and had risen to the rank of General in the service of Science and Art), Secretary to the Department, looking through a file, discovered Mrs Burchett's letter. What had been done, he asked. No one had any idea, but the assumption was that the matter had probably been overlooked.

John Sparkes of Lambeth was appointed Burchett's successor as the headmaster of the National Art Training School. He had trained as an art teacher at the National School from 1855-9, and had subsequently become Head of the Lambeth School of Art – where he had established strong links with Doulton's pottery works, and had introduced a very successful "clay modelling class" for sculptors and "future workmen". Between 1868 and 1877, more than half the "South Kensington" medals for modelling had been awarded to students from Lambeth: during the same period, only one of the South Kensington sculpture students, Henrietta Montalba, had been a winner.

## THE MODELLING CLASS

Redgrave, the Inspector General for Art and Surveyor of the Queen's Pictures (to which he had been appointed after Cole had written on his behalf to Prince Albert), decided to retire in 1875. Tragically, his sight was failing. There can be no doubt, however, that he shared Cole's satisfaction in their achievement that since 1852 they had witnessed "the conversion of twenty limp Schools of Design into 120 flourishing Schools of Art in all parts of the United Kingdom, and other schools like them, in the Colonies and the United States. Five hundred night classes for drawing have been established for artisans. One hundred and eighty thousand boys and girls are now learning elementary drawing." Edward Poynter was recommended to the Treasury in his place, and was appointed both Director of Art and Principal of the National Art Training School in August 1875.

Poynter was thirty-nine years old, and was well known for the strong views he held about the central importance of life drawing classes – views which had originated with experience of how they did such things in the *Ecole des Beaux Arts*, in 1856. "The students of eight or ten years' standing", he recalled, "work in the same room and from the same model as the newcomer; if he has never had any instruction, he is set at first to make a few drawings from casts, to give him some idea of the use of his pencil, after which he begins *at once* his studies from the living model." As the very first Slade Professor of Fine Art in 1871, Poynter had already had a good opportunity to put these ideas to the test – even if he had turned out to be a stricter disciplinarian than his views, today, would imply. "In the Slade Schools", affirm the earliest prospectuses, throwing down the gauntlet to South Kensington, "the study of the living model is considered of the first and paramount importance, the study of the antique being put in the second place and used from time to time as a means of improving the style of the students."

It is one of the stranger paradoxes of art and design education at this time that as French educators came to admire the British system of design education more and more – because it was grounded in principles – British educators were turning, once again, to the French system of fine art education – because it wasn't. Hence Poynter's appointment at South Kensington. With his arrival, there was a noticeable shift towards a more creative approach (though still within the Redgrave system), and, in addition, a reemergence of the distinction between something called "precepts" (today we would call it "theory") and something called "practice". Poynter remarked of his lectures at the Slade that "in spite of the difficulties attending the subject I have come to the conclusion that it is much easier to write about art than to practise it, and

Above *Characteristic painting by Edward Poynter, from 1875 Principal of the National School.*

am led to the further conclusion that as example is always better than precept, the more time I devote to painting in future and the less to public lecturing the better it will be for my art and those interested in it." Since Poynter's art consisted of large-scale scenes from Ancient Greece and Rome (such as the lachrymose *Faithful unto Death*), to which history has not been kind, the question must remain an open one.

Poynter, holding both senior positions at the National School, was consequently very strongly placed to bring about changes and reform to the School. There seems to have been an immediate move away from industrial design, and a strengthening of an academic training in the fine arts, but it should not be forgotten that it was Poynter who had designed the iron grill in the museum's refreshment rooms in 1866 – the only recorded occasion when a Royal Academician has admitted to designing an oven! An increasing number of the fee-paying students were hoping to become artists. This trend had become apparent during the later years of the Redgrave-Burchett regime, and the latter's summaries of the activities of the training school, and its successes, published in the annual reports of the Science and Art Department, gave fair prominence to the number of students who had applied for and been accepted by the Royal Academy Schools.

Shortly after his appointment as Headmaster, Sparkes went off to the continent to inspect art

53

schools in Germany and Belgium. What he saw made him thoroughly dissatisfied with conditions at Kensington. He had particularly noted that students worked to strict deadlines at continental art schools (in contrast to the open-ended South Kensington approach, where it could take up to six months to draw an apple), and that they often took a great interest in the latest architectural sculpture (a subject in which he was particularly interested). In Berlin, the art school was linked to the *Gewerbemuseum*, after the South Kensington original, but the students seemed to have made much more impact on "the arts of the town":

*The modelling section is excellent and has a large and beautiful influence on the arts of the town. Berlin, like London, is a town of brick construction, the bricks either covered with stucco or relieved with stone carving or decorated with terracotta. The excellence of the ornamental designs is remarkable all over the town and its suburbs... The character of fitness is found everywhere in these applications of the decorating materials, and gives evidence of sound principles in teaching... A considerable amount of credit is due to the modellers and carvers who carry out the architect's design.*

Clearly, there were lessons in this for the National School, and implications where both staffing and resources were concerned. Money was hardly expected to be forthcoming from the Treasury, particularly as the museum library block was just nearing completion after a struggle for funds. But in 1881, Sparkes decided that the situation was so bad that it had to be drawn to the attention of the Department officially. The building was not only ill-planned, badly-lighted and ventilated, it was also too small. In addition, it was time to replace several members of the staff, and there were currently not enough teachers to cope with the demand.

So far as the L-shaped building was concerned, Sparkes wrote that in 1864 it had consisted of simply two floors of covered space, lighted on both sides. Burchett had done what he could with it by dividing it up to produce "what would nearly resemble studios and working rooms", but these were simply not good enough. The space was wholly insufficient, resulting in the students being crammed into it, and the place was packed with plaster casts in various states of decay, because there was nowhere to put them. The Female School was particularly badly off:

*The advanced rooms are placed over the Barracks of the Engineers, whence comes the noise and crying of children, and the smell of cooking food. On the same side is the road round the*

*Museum; over this road the traffic is considerable of cabs, vans, empty or loaded with empty packing cases or similar resonant materials. Coals are delivered under the windows, during which operation the idiomatic English of the men who deliver them, among themselves and to their horses, is not instructive to anyone and particularly offensive to the ladies in the schools. Immediately opposite the windows of the large classroom is a steam engine, and close at hand the machinery it moves, also a blacksmith's forge with anvil complete and a chimney or even two so arranged that dense smoke drives on to the windows with westerly winds and deposits of blacks are the inevitable consequence. These inconveniences are on the outside; on the court-yard face, the odours from the Refreshment room, kitchen and scullery arise so abundantly as to make it impossible to open the windows...*

Nothing was, nor could be, done; the refreshment rooms were in operation until 1939, and the blacksmith's forge is still there.

Sparkes also wanted to get rid of two members of the staff, Miss Channon and Felix Miller, both elderly, and whose powers of teaching were not up to the expectations he had developed at Lambeth. Miller had taught modelling for decades, but was gently eased away from teaching, and for a while took over the duties of the Registrar, but as late as 1888 both he and Miss Channon were still a worry to Sparkes – who was concerned that they might not get pensions, and so if he retired them "it would be to turn them out to starve".

However, Poynter and Sparkes by this time had been able to strengthen the teaching staff by the appointment of Alphonse Legros to take charge of the etching class, and Jules Dalou for the modelling class. For a long time the etching class had been very sparsely attended, and unfortunately it did little better under Legros. He had only four students in 1881, who produced seven plates for museum catalogues at a cost of £115, of which £84 had been paid to Legros and £31 to the printer, F. Goulding. Sparkes therefore recommended that the class be discontinued, for the money saved could be better used in providing a new structure of Assistant Teachers, selected from the more promising members of the Training Class. These could be engaged yearly to take charge of the evening and other special classes. One of Poynter's last acts before he retired in 1881 was to agree with Sparkes: the original purpose of the etching class was to provide illustrations of museum objects, and this project, he thought, had now been abandoned.

Of much greater and more lasting significance

was the arrival of Dalou who entirely rejuvenated the modelling class. From the early 1860s onwards, although Alfred Stevens had no direct contact with the School, his influence had been all-pervading: most of the decoration of the buildings then in South Kensington – the Museum, the Science School, the Royal Albert Hall – had been in the hands of his pupils and disciples: Godfrey Sykes, James Gamble, Reuben Townroe and Frank Moody. The arrival of Dalou saw the birth of the "New Sculpture" in Britain, heralded by Stevens.

Edward Lantéri, who had been one of Dalou's pupils in France, reminisced about him in the first issue of the *RCA Students' Magazine* – an article illustrated with a bust of Dalou by Auguste Rodin:

*What he did for the National Art Training School (now the Royal College of Art) is well known to all artists. He gave an extraordinary impetus to sculpture during the two years he was there. By his sound method, his marvellous technique, and his lucid demonstrations he completely carried his students along with him. He knew how to inspire them with the* desire *to work as well as the* love *of work, and succeeded in awaking an extraordinary enthusiasm where all before seemed dormant. It is no wonder that he gained the admiration of his students – an admiration which extended to sculptors at large, and many, as I have reason to know, gladly acknowledge their indebtedness to him. In the meantime an amnesty for all political offenders was proclaimed by the French Government, and Dalou was therefore free to return to his native land.*

When Dalou left South Kensington early in 1880, he asked that his work be carried on at the National School by Lantéri himself. Lantéri had come to England in 1872, and worked in the studio of the sculptor Joseph Edgar Boehm as an assistant, where his path crossed that of the young Alfred Gilbert. Lantéri was to become the most respected teacher of sculpture and modelling of his generation – and, of the list of sculptors who made a significant contribution to the "New Sculpture" movement from 1880 onwards (in Susan Beattie's book *The New Sculpture*), no less than ten emerged from his class, including a number of extremely accomplished sculptresses.

Poynter's resignation led the Board of the Department of Science and Art to reconsider the administrative arrangements at Kensington. They decided that it was unrealistic to search for someone to assume all the duties that had been undertaken by Poynter for no one was likely to "sacrifice his Professional Career by devoting himself entirely to the Public Service". Therefore,

---

SCULPTURE FROM WITHIN

Aimé-Jules Dalou had landed in England as a refugee from the Paris Commune of 1871, and had lodged with Legros in London. Although, according to Edward Lantéri "he was cordially welcomed by the artists of London and received a warm hospitality . . . he was practically without means", so Legros suggested that he should give paid demonstrations of modelling to the National Students: "If I, who have never learned English, can teach drawing . . . why couldn't Dalou, who can't be worse than I at English, teach sculpture . . . at South Kensington, for example?". Poynter was impressed by the idea, which, he hoped, would ultimately give a much-needed shot in the arm to the teaching of modelling and sculpture in the whole of England, and so on 11 May 1877, the Department "approved the employment of Monsieur Dalou as teacher of modelling". His teaching methods were, by all accounts, bizarre: much waving of the arms and shouting of "you do *so!*", as he attacked the clay and tried to explain that sculpture came from *within* the material, not from the surface. But they were effective.

---

it was decided to split the appointments and salaries of the Director of Art and the Principal of the School, Poynter agreed to become the Visitor, and Sparkes was appointed Principal, with an additional £100 a year, for which he "will be required to give his full time to the Department". This condition must have given Sparkes food for thought because he had just agreed to accept the additional post of Superintendent of Studies at the City and Guilds School.

The new Director of Art, Thomas Armstrong, invited Walter Crane in the mid-1880s to lecture and give demonstrations of crafts allied to decorative design, among them gesso and plaster reliefs, stencilling, embroidery, and repoussé metalwork. Armstrong also asked L. Dalpeyrat in 1886 to demonstrate the art of enamelling to the National Scholars.

Another of the students at this time was the sixteen-year-old Edwin Lutyens (known to everyone as "Ned") who entered the South Kensington School in 1885 with encouragement from the illustrator Ralph Caldecott. He was already steeped in the writings of the Arts and Crafts Movement, and had a boyish interest in the vernacular architecture of Surrey. From his home base at 16 Onslow Square, shortly after starting the course, he wrote to his mother of:

*. . . how necessary it is for me to concentrate my whole attention, energy and time on possessing*

**1857–1896**

*that confidence and also to obtain that great amount of knowledge required to help make a "successful architect", and an architect without that success (not financial necessarily) is well I can't describe it... So be ready for a blow when my failure is announced. I heard today that a fellow called Mayhew who had been working at S.K. Museum has gone violently mad it took six men to take him to an asylum he was nineteen years they say it was from overwork but that's all bosh, I expect he had something else the matter with him some home troubles or something and then perhaps worked hard to drown them. But he was a curious sort of chap, used to come in and argue for hours on something he overheard he was supposed to be very clever I never saw it never seeing the point of his arguments perhaps that was my stupidity ...*

Another unpunctuated letter, this time to his sister Molly, and probably dating from early 1886, informed her that: "I have to pass examination in Perspective in about fortnight's time ought to pass easily does not matter if I don't".

Many of the young Lutyens's drawings from his time at South Kensington have survived – and they include a study of a Boat Club (in a mixed style of old English and Norman Shaw), a Public Library (in the English Renaissance style of Wren) and a Second Empire style Town Hall. These were probably drawings of set exercises as part of a course in architectural styles. Lutyens was also awarded a Certificate of Merit from *Boy's Own Paper* for his design of a Boy's Home of Rest, in 1886. It was probably during this period that he first met the young Detmar Blow who was a fellow student at the National School.

In 1887, before he had completed all the required drawing exercises, Lutyens decided that he had learned all he was going to learn from them – and became a paying pupil with the architectural firm of Ernest George and Peto. He had won a National bronze medal for a set of seven drawings for "A Country House", and was presented with a copy of Richard Redgrave's *Manual of Design* (South Kensington Museum Art Handbook number 6) inscribed "Queen's Prize, South Kensington School of Art, presented to Edwin L. Lutyens, 1887".

One thing Lutyens *does* appear to have gained from the experience is "that confidence". Shortly after leaving, he amused the great architect Norman Shaw by laying down the law about "my fixed principles" – in particular the principle that "anything that was put up by man should harmonize with what Nature, who had been there first, should dictate!"

But despite the inspiration and confidence it

provided for individual students, the School was entering into another period of self-doubt, one which lasted for more than a decade. During Poynter's early years as Principal, student numbers had risen to a total of 878, of whom no fewer than 780 paid fees, upon which the salaries of the teachers depended for topping-up. But by 1885, the number of these fee-paying students, a large proportion of them girls, had fallen by more than 250, thus reducing payments to the teachers by about one-third. As a result there was a great deal of grumbling and discontent. The School set up a board of enquiry under Frederic Leighton, in 1888, with Poynter and H. A. Bowler, Assistant Director of Art, as the other members, to see if the exact cause of the decline could be established. Alan Cole, Sir Henry's son, an Assistant Secretary in the Department, acted as the board's secretary. Three main reasons emerged; competition from private schools, the poor accommodation, and the inefficiency of the teachers.

Sparkes told the board that at least twenty or

Below *Plumpton Place, Sussex, by Edwin Lutyens.* Bottom *Lutyens's model of 1933 for the projected Metropolitan Cathedral in Liverpool. It was first exhibited at the Royal Academy in 1934.*

thirty artists had set up teaching studios nearby, some of them being former students of the School. "In fact," he said, "a great number of ladies leave us, take studios, and teach to make ends meet." There was general agreement that many potential fee-payers were attracted to these studios because they were "tempted by promises to paint from the model at once, without the bother of passing any entrance examination or taking the National Art Training School's preliminary and dryer course, which is necessary for serious study". This, Sparkes considered, attracted the amateurs, though he believed the teaching they received was "very imperfect".

The teaching staff of the School came in for much adverse comment from everybody. Sparkes, himself, was criticized by the committee for not turning up at Kensington on Saturdays "although we understand that his whole time is due to the Department", and they wished also to call attention to his appointments at other schools, "which must have some effect in reducing his attendance and influence at this School which evidently suffers from his pre-occupation

elsewhere". In spite of this stricture, only Sparkes and Lantéri were treated in any way favourably by the committee. All the other teachers had faults: "Mr. Morton who takes charge of the painting class seems to be an able teacher, but somewhat lacking in energy . . . Mr. Hagreen . . . is a good master, but somewhat out of date . . . and Mr. Clack, though much liked by the students, does not appear to have a grasp of any particular subject."

General Donnelly, the almost all-powerful Secretary to the Department, and, incidentally, said to be the original "model of a modern Major-General", stated to the astounded committee that if the Art School were in decline, "it must be because it is not wanted, or because it is not doing its job properly. If it is not wanted, it had better be shut up, and if it is inefficient, then I think you can only deal with that school as you would with any other public school; improve it by modifying its staff. . ." The committee rejected Donnelly's first hypothesis as "an idea that can hardly be entertained", but made three recommendations – more accommodation [hardly likely, with the museum pressing for the completion of its building], an eminent artist as Visitor "more closely connected with the schools than the

*Below The Durbar Hall in the Viceroy's House in New Delhi, built by Lutyens in 1931.*

57

present Visitor [Poynter]", and as of paramount importance, a re-organization of the teaching staff:

*With the declining condition of the School, it would be hopeless to expect an increase of the salary fund from the Treasury, and there is but little superfluous money available from the fee-fund under the present conditions. The enforced retirement of the inefficient members of the teaching staff ... thus becomes a demonstrable necessity, as it is only thus that even an initial step can be taken towards its proper organisation.*

Another advantage would be that the Students in Training, who had to take over classes because the real teachers were not up to it, would be able to get on with their own studies.

Even Edward Lantéri was a casualty of the School's declining fortunes. When he had been invited by Poynter to join the staff in 1880, the School was riding high, so that Lantéri agreed to teach for only a proportion of the fees. He now estimated that he was losing £40 a year, a loss which was "out of proportion to my circumstances", and asked for a fixed salary. Alan Cole told Armstrong that Lantéri received 14/240ths (1s. 2d from every pound) of fees, and thought that the Treasury would not agree to a fixed salary, unless another teacher went and so created a vacancy.

The Treasury, however, was about to approve new arrangements for payments beginning in the financial year 1894/5. All fees were to be paid directly into the Exchequer, and teachers were to receive fixed salaries based on a new scale. During discussions, it was suggested that if Lantéri attended for fifteen hours a week (instead of ten) his salary might become £247. A few days later, Donnelly made a spirited appeal to the Treasury: "Although he has frequently expressed great disappointment ... his zeal and industry have not by any means abated, and the great success of his teaching has been the most satisfactory feature of the work of the . . . School." Donnelly feared that Lantéri might be induced to teach elsewhere (Kennington, perhaps?), in which case as "his qualities as a teacher are so exceptional . . . it would, so far as I know, be impossible to replace him. Not only does he know all that can be taught in the art he professes, but he has the kind of enthusiasm which stimulates students to do their best." The Treasury, surprisingly, agreed to an increase of £110, to take effect the following year.

## FANTASY IN AN OLD ENGLISH GARDEN

Whatever urgency there was for reform, it was not until November 1894 that Donnelly issued a "Future Organisation" for the School. Sparkes remained the full-time Principal, with two assistants, H. B. Hagreen (twenty-one hours per week), and T. Black (twenty-four hours). Lantéri was to continue teaching Modelling, but for fifteen hours a week, with Hugh Stannus (for the same number of hours) instructing in Decorative Art. There were to be six assistants, Mrs Casabianca, E. S. Burchett, H. C. Innes-Tripp, G. Cartlidge, G. Morton and W. P. Watson, working from six to thirty-six hours weekly, together with two pupil teachers engaged for thirty-two and a half hours each. Frank Short had been appointed to teach etching for three hours, succeeding Frederick Goulding, and Lt. General S. W. Lennox remained the full-time Registrar.

Donnelly recorded that the Board of the Science and Art Department wanted the School to be open every Saturday until 2 o'clock in the afternoon. Full-time members of the staff appointed before 15 August 1890 were to work a six-hour day for six days a week, and anyone appointed, or promoted, later than that date had to work a seven-hour day, for six days weekly, with a half-holiday on every alternate Saturday.

Early in 1895, the Board appointed William Blake Richmond, ARA, and ex-student Frederic Shields as Visitors to the School, though with unusual inefficiency, no one ever remembered to send them a formal letter of appointment. The two Visitors took their duties seriously, and as might now be expected, produced *their* report on what they thought was wrong with what had just become the Royal College of Art. According to the Calendar the purpose of the College was "the training of art teachers of both sexes, of designers, and of Art workmen, to whom facilities and assistance are afforded in the shape of Studentships in Training, Royal Exhibitions [established in 1891] and National Scholarships with complete or partial remittance of fees are also granted. A school for the instruction of general

---

RENAMING THE SCHOOL

A suggestion made by one or two of the witnesses was that, as Princess Louise, Queen Victoria's sculptress daughter, had been a student for a short while in 1875, and had given the prizes in 1888, the School might be renamed the Royal and National Art Training School, or something similar. This, some felt, would attract the daughters of the neighbouring rich, and thus bring in additional fees; but the committee brushed the idea aside as "trivial".

students is attached and serves as a Practising School for the Training Class." In view of its enhanced status, the College would award an Associateship.

The Visitors' preamble to their Report stated that the Royal College of Art was not founded to train painters of easel pictures, but was intended to train designers and craftsmen, rather than artists. Therefore, the aim of the Report was to show (a) what the weak points in the present system were; (b) what had to be done to "remedy such evils"; (c) to urge teachers to pay more attention to their original instructions; and (d) to suggest severer tests for the students. Discipline had to be tightened, so they suggested that in every class there should be someone to enforce silence and with authority to report any students who interrupted the concentration of other students. No student ought to be allowed to talk during working hours. These measures, they felt, would soon establish the respect for authority which they had found to be lacking.

As Visitors, they had been unable to find any evidence of a regular course of study laid down for the students who seemed to enter any class at will: "instead of organized discipline there obtains disordered, empirical, and desultory practice". They ordained that every student had to take a course of geometrical drawing and "his knowledge gauged by severe tests to discover if [he] has not only grasped the superficial features of the science, but has understood its principles".

Spread through all the classrooms in future should be carefully selected works of decorative art – a Morris wallpaper, some Venetian lace, an enamel, a tapestry, a panel of fine English stained glass, and so on. The students in training should practice teaching and give lectures to their class-mates. This was an innovation, perhaps, for no other report seems to have stressed the importance of students being trained to stand in front of a class and transmit their knowledge by "word of mouth". It was also stressed that, now that the teachers were paid a fixed salary, and thus students were no longer their paymasters, entrance examinations to the College should be made much stricter, and there should be very much more rigorous examinations for them during their period in the College.

The Visitors pointed out the importance of practical classes, and urged the College to provide a loom for tapestry weaving, a forge, and a kiln for firing ceramics. They had been astounded to find that there were no classes in stone, marble or wood carving. "How in the name of common sense", they declaimed, "can students be taught what is required for a special craft without the materials for that craft?"

Above *Portrait of Walter Crane by G. F. Watts, 1891. Crane was Principal of the School in 1898-9.*

Before the College was able to undertake many of these recommendations, both Sparkes and Thomas Armstrong retired in 1898, and everything was thrown back into the melting-pot once again, until Walter Crane, one of the leading figures of the Arts and Crafts Movement, was appointed Principal in August. Crane wanted at once to set in motion a drastic reform of the College, moving away from so much teacher-training, and reverting to the original intention of the study of design. "The school", he wrote, "was in rather a chaotic state. It had been chiefly run as a sort of mill in which to prepare art teachers and masters. . . The curriculum seemed . . . terribly mechanical and lifeless. . ."

Shortly after his appointment, Crane (no doubt to his displeasure) was told that, as Armstrong was to retire in October 1898, he would have to assume some additional duties hitherto undertaken by the Director of Art, but it was not made clear to him that among these would be the organization of the summer courses for teachers. Disillusioned by the lack of enthusiasm for his reforms shown by Donnelly, and the about-to-disappear Department of Science and Art, Crane resigned after only eight months in post as Principal, in March 1899. He wrote to Donnelly:

*The endeavour to carry on the official work, together with my private professional work is too much of a strain, & my doctor is of opinion that I*

*am undertaking too much at present, & that my health must suffer... Looking to the future of the art department, with all its uncertainties, I do not feel that any sacrifices I might have been able to make for the sake of helping to bring about the reorganization of the College (upon what appears to me to be a more useful & efficient plan for a school the main purpose of which is the study of design) would be any security for the attainment of that end. The understanding upon which I accepted the office that it would afford the proper time for private work has proved illusory.*

Crane offered his willingness to help the College in the future with occasional professional advice. It was just that, with his mind on *A Floral Fantasy in an old English Garden*, and on *Beauty's Awakening: A Masque of Winter and Spring* (in which the beautiful Fayremonde puts to shame the demons Philistinus, Bogus and Ignoramus, words courtesy of Mr C. R. Ashbee), Walter Crane could not take the departmental in-fighting any more.

One of the last straws, where he was concerned, appears to have been the vexed question of accommodation. Even though an expansion of the College into the top floor of the western range of the (newly-named) Victoria and Albert Museum's quadrangle had been promised to him, other rooms which the College would have to give up near the lecture theatre would mean a net gain of only 3,650 square feet, which was not adequate for "the development of the College" along the lines Crane considered essential; the only alternative was an entirely new building.

The Board of Education, however, had another idea, which at first looked promising. Aston Webb's extension to the Museum flanking Exhibition and Cromwell Roads was then being built. Why should the College not take over the entire top floor all the way round, as far as the Brompton Oratory? This would provide a lot of additional space. Webb was therefore asked to modify his plans of the building. In the revised version, the College's library was placed immediately over the main entrance to the Museum, and the tower above was adapted to house its book-stacks. On either side were to be studios, classrooms, rooms for professors and teachers, extra staircases, and so on. The scheme came to nothing, but by then it was too late for Aston Webb to make further major revisions to the building and so the main tower has remained only an empty shell to this day. It is ironic that this much-photographed symbol of the Victoria and Albert Museum was never in fact intended for the use of the Museum itself.

## DESTINATIONS

Owing to the lack of adequate records of the students who attended the School of Design at Somerset House, few of them are known, except men like George Wallis and Richard Burchett

Above *Book illustration by Walter Crane, 1873.*
Below *Dado design entitled* Swan, rush and iris *by Crane for Jeffrey & Co., 1877.*

1857-1896

who were prominent for one reason or another. But among these early students was H. H. Armstead, RA, who became chief designer for the gold- and silversmiths Hunt and Roskell, but later turned to sculpture. Armstead won a £2 2s. prize in 1843 for the second best chalk drawing from the cast of a Fighting Gladiator, and, according to the Department of Science and Art, Edward Poynter attended the School in 1849 or 1850. He must have been one of the under-fifteen year olds who were almost the main body of students at that time. There is no reason to doubt his attendance, for not only was he the son of Ambrose Poynter, a member of the early Council, but the Department with which he was later so intimate would not have stated this unless they were sure, or had the fact from Poynter himself. Octavius Hudson, later a Professor at Marlborough House, designed the Honiton lace for Queen Victoria's wedding dress in 1840. And, of course, there was Christopher Dresser.

There is also the probability that F. W. Moody, later the instructor in Decorative Arts at South Kensington, was a pupil at Somerset House, for he was awarded a first prize for a design for glass by Apsley Pellatt, another member of the Council. The date of this award has not been established, but as Moody was born in 1824, it could have been in the early or mid-1840s. If he did attend the Somerset House School, he was not a pupil of Alfred Stevens (he insisted on that later in the century). However, it is not always clear which school a student might have attended as each of the regional schools founded under the auspices of Somerset House was known as a Government School of Design until 1852, when Henry Cole assumed control and changed the system.

Was the "G. Duncumb" mentioned in the Council minutes of 2 July 1838 as having been the runner-up in a competition for a chintz design, the G. F. Duncombe who helped Cole (as did George Wallis) with the organization of the Great Exhibition of 1851, and who later became a member of the administration of the Department of Science and Art at South Kensington? The occasional early lists of prize-winners do give names, but nearly all of them do not appear to have become known designers in subsequent years – who were Silas Rice, Adam Findon, or Clarissa Jennings, for instance? Perhaps "J. Hennell", awarded £1 10s. in 1845, for a shaded drawing from the flat, was a member of the well-known Hennell family of silversmiths. Frederic Shields, a student in the mid-1840s who became well known as an illustrator and architectural ornamentist, is an exception. Two of the students who worked on the Wellington funeral car – Mr Whittaker, a Scholar, and Mr

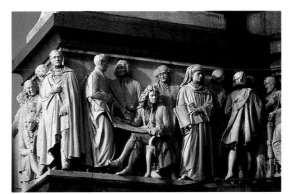

Above *Detail of frieze on the Albert Memorial by H. H. Armstead, an early student of the School of Design.*

Below *Honiton lace designed by Octavius Hudson in 1840 for Queen Victoria's wedding dress.*

Willes, a day student – have been recorded, but none of the students who worked, a little later, on the Department of Science and Art pillar-box, or the "portraits" in the Prince's chamber of the House of Lords, have left their names behind.

In 1858, George Wallis commented, even then, on how difficult it was to trace works by former students. There were, he thought, at least three reasons for this. Manufacturers were reluctant to acknowledge the part played by their employees; "nor have some of the more successful designers themselves been more candid as to their early obligations to the School of Design"; and Wallis had also found that the problem was "much greater in London than in the provinces, except in cases where those who have obtained employment as designers or Art workmen have continued to keep up a desultory connexion with the Department through attending Lectures, availing themselves of the Library, and visiting the Museum of Works of Ornamental Art". Nevertheless, Wallis managed to stage an exhibition in the South Kensington Museum of student work that included quite a number of items by past

students and masters of the London school.

C. H. Wilson exhibited a dinner and breakfast service and other designs for all the decoration and furnishing of the steamship *Admiral*, built at Glasgow. Gottfried Semper designed an ebony cabinet made by Holland & Son, and there was also an ebony sideboard by him, the drawings for which had been enlarged by John S. Cuthbert and Z. King of Marlborough House, and then these had been sent to Ceylon, where the sideboard had been made and carved by local workmen for Sir Emerson Tennant. George Trollope & Sons of London made a satinwood "Garde Robe" and a walnut wine-cooler from designs by Richard Beavis.

For the centre of the quadrangle of Buckingham Palace, C. P. Slocombe, student, and then master, designed a gas-lamp in cast iron and brass, which was made by Barrow & Turner of Paddington. Slocombe also designed lace for Treadwin of Exeter, paper-lace and the 1858 decorated calendar for Thomas de la Rue & Co., and he was responsible for an illuminated Address presented by the Lord Mayor and Corporation of London to the Prefect of the Seine.

Frederick Andrew, a long-term student who kept going back for more – Somerset House (1845-8), Marlborough House (1852-5) and South Kensington (1857-8), designed the backs of playing cards for Goodall & Sons. Joseph Ash, another Somerset House student, had found employment with the metalwork firm of Hart & Son, in Wych Street, off the Strand, and for them was the designer of a wide range of artefacts from gas-lamps, pavement gratings, lecterns, pulpit lights, bell-levers, finger-plates, door-knobs, and hat-pins to coffin furniture. Robert Jefferson, also one of the earliest students, working for William Potts at the Art Works in Handsworth, Birmingham, designed and modelled sepulchral monuments and "art mantelpieces" with relief decoration of such subjects as The Chase, Apollo and the Muses, or Shakespeare. Of these, the manufacturer stated that they were specimens of a new combination of materials for which he had obtained the patent – the metallic portions were "Electro-deposited" and then chased. Potts was "aiming at a higher class of art work than is usually found in such objects as mantelpieces &c., except in very special cases and at great cost" and, as he wished to support local talent, nearly all his designers and workmen had been to the Schools of Design in Birmingham or London.

Designing for textiles was taken up by a number of students. William Vickers produced patterns for lace for his father's firm in Nottingham, who also employed Adam Town. Montague Wigzell, who had become Master of the Exeter School of Art, was a designer of lace. Louisa Gann designed damask for John Wilson & Sons of New Bond Street, while patterns for carpets were made by J. K. Harvey (for Charles Harrison of Stourport), and Frederick Andrew (for Graham & Jackson of Oxford Street). William Woollams & Co. was another firm to employ Andrew, as well as James Aumonier, to design wallpapers.

It seems that the earlier students in London were not sought after by the manufacturers of ceramics, who preferred to take on modellers, painters and other staff from their local Schools of Design, among them Burslem, Stoke-on-Trent, and Worcester.

Once the Department of Science and Art had been created, annual accounts of the School's activities and successes began to be published, particularly after its move to Kensington, and when it had become the National Art Training School. Each year there were lists of those students from the art schools all around the country who had won gold, silver, or bronze medals, books and other prizes. So far as the Kensington school was concerned, many of these were teachers in training, or fee-paying students, most of whom did *not* become well-known after they left, although there were exceptions like Kate Greenaway or Gertrude Jekyll or Rosa, the daughter of George Wallis.

Several of the teachers at the National Art Training School had been students there themselves, and included among them were some of those criticized later in the century – Mary E. Channon (she was awarded prizes of three and two guineas in 1845 for a copy in tempera of an arabesque, and a chalk drawing of a head), Henry Hagreen, Thomas Clack and George Morton. John Sparkes was at the Training School between 1855 and 1859, and August Spencer, appointed as Walter Crane's successor in 1899, had entered in 1881. Students in training who in the end did not take up teaching included A. L. Baldry, who became an art critic and writer, and Maria Edwards who was employed by Owen Jones as an assistant.

The first National Scholar, Sir Luke Fildes, RA, did not, later, interest himself in industrial design, any more than did Sir Hubert von Herkomer, RA, Henry Woods, RA, Elizabeth Thompson (later Lady Butler) or Sir George Clausen, RA. The latter's elder brother William was also a National Scholar, and George Clausen himself won several prizes at the School for design projects, including one for the decoration of a horse-tramcar.

Rowland Morris, who as a Scholar between 1865 and 1871 had modelled the terracotta decoration for the Wedgwood Institute at Burslem, and the Dog and Hare frieze for William

Above *Tile painted by William Coleman around 1870.*
*Coleman ran Minton's Kensington Art Pottery Studio.*

Morris in the museum's refreshment rooms, went to Wedgwood's as a modeller, where another student, Thomas Allen, was a decorative painter. William Mackarness, Thomas Sharpe and John Eyre all joined William Morris's firm in Queen's Square in 1869 and 1870. Mr Harbutt of "Plasticine" fame left the School in the early 1870s.

The decoration and design of ceramics attracted a number of Scholars, who took positions, or gave occasional assistance, as designers and modellers in the Potteries; among them were William Wise, Herbert Wilson Foster, George Rhead, John Moyr Smith, Leon Solon and Christopher Dresser for Minton; Robert Abraham, for Copeland; and Charles Hindley became the art director of a pottery, probably at Coalbrookdale. Several National Scholars were employed on the ceramic decoration of the Museum, for which Minton's established the Kensington Art Pottery Studio, with a kiln to cope with the flood of work from students, near the Royal Albert Hall, almost on the present site of the Royal College of Art. In charge of this establishment was William Stephen Coleman, with whom many of the students, together with the instructor, Francis

Moody, must have been associated. Coleman is well-known in another sphere of activity, the illustration of greetings cards, in which he did a nice line in coy, naked little girls, sitting beside the sea, listening to assorted sea-shells. A student who became established as a greetings card illustrator was William Jabez Muckley, who also designed wallpapers for Jeffrey & Co. Frederick Marriott, a Scholar until 1882, became a designer for the publisher Marcus Ward, and Alfred J. Morrow a year later became a "wood draughtsman" for the Fine Art Society.

Stained glass and church decoration were an attraction to several students, who entered firms catering for the then fashionable demand for memorial windows, or mural painting, but as nothing was signed their work is not identifiable. William Montgomery joined Clayton & Bell; Thomas Golding went to Heaton, Butler & Bayne; Henry Rossiter to O'Connor's; and Charles Hardgrave to the Whitefriars Glass Company. Others, who perhaps were freelance designers, were Walter Jenks Morgan, Henry Reynolds, and in Birmingham, Charles Bardell might have been employed by Hardman.

Two brothers, Walter H. and Edgar R. Singer, both National Scholars, went back to their family firm in Frome as designers of ecclesiastical and domestic metalwork. Thomas Cox joined the firm of Hart, and Charles Collins set up in Birmingham, both as designers of metalwork.

Various textile manufacturers took on National Scholars and other students as designers – Ackroyd & Son of Halifax engaged George Payne, and Crossley's of the same town employed George Rushworth and John Bates Smith; George Kingman went to Kidderminster to design carpets for Dixon & Sons, and George Drummond joined Heyman's of Nottingham as a designer of lace. Furniture did not seem to be so attractive to the London students, though John Turner was taken on by Walker's as a designer.

Although William Wright settled in Stamford as a modeller in terracotta for Blashford's, and Alfred W. Bowcher was employed for the same purpose by the Terra Cotta Works at Canstock in Cornwall, except for William Randall who went to the Westminster Marble Company in 1869 (and no doubt designed some of their notably undistinguished church tablets), and Henrietta Montalba, sculpture did not figure in the achievements of students until the arrival of Dalou and Lantéri. After that, there was a notable surge of activity, and among students at the time were Alfred Drury, RA, Conrad Dressler, Frederick Schenck, James Havard Thomas, Albert Toft, Reginald Fairfax Wells, Francis Derwent Wood, RA, Florence Steele and Esther Moore.

Alfred Drury sculpted several of the figures on the main entrance to the Victoria and Albert Museum, including those of Queen Victoria, Prince Albert, St Michael and St George, while Professor Lantéri, together with four students, Vincent Hill, Reginald Goulden, Sidney Boyes and J. A. Stevenson, carved the figure of Fame at the summit of the Museum's main tower, as well as those of Sculpture and Architecture, somewhat lower down.

National Scholars who were involved in the earlier decoration of the Museum were Albert Gibbons, Edward Wormleighton (later designer for Trollope's), Richard Lunn and Amy Black (who had started her school life as a student in training). Gibbons was drowned in the Serpentine in 1868; in the same year Lunn became a master at the School of Art in Sheffield. While there, he designed a porcelain dessert service, made by the Derby Crown Porcelain Company, which was presented in 1883 to Gladstone by the Liberal working men of Derby. Lunn also designed an earthenware and porcelain mantelpiece set consisting of a clock, vases and candlesticks illustrating "Early to bed, early to rise . . .", "Jack and Jill", "Four Stages of Life" and "Four varieties of illuminators, Sun, Moon, Stars and Lightning". The set was made by McIntyre of Burslem and the Derby Crown Porcelain Company, for Sir Philip Cunliffe Owen, Director of the Museum after Cole.

G. M. Kirtland designed and worked on a silver inkstand for Lord Wolseley, which was made by J. & H. Garrard; Rosa Wallis decorated enamel plaques for a silver vase with cover and handles (in the Italian Renaissance style) made by Elkington's of Birmingham. Other metal artefacts with which students became involved include the Magdala Trophy by C. P. Slocombe (a former Somerset House student), made by Elkington's for the King's Own Royal Regiment. T. Walter Wilson designed a gold casket which Garrards' made for the Prince of Wales (Edward VII), and a gold and jewelled casket, for the Czar of Russia, made by Benson & Son, of Ludgate Hill.

John Watkins, who drew a series of views in the Museum in the 1870s, designed a silver shield, with panels showing such scenes as Romulus and Remus, the Rape of the Sabines and the Triumph of Caesar, which was also made by Elkington's; on the recommendation of Poynter, Watkins's design was bought by the Museum.

George Morgan, who became the Chief Medallist of the United States Mint at Philadelphia, after a period with Wyon's and the firm of Pinches, was a National Scholar from 1866 to 1868. Among medals he produced in this country was a prize medal for the Royal Engineers (1872), with a portrait profile of Captain Francis Fowke. A student who was a pupil of Lantéri and became a medallist, was Frank Bowcher, among whose work is the medal commemorating the opening of the Tower Bridge; in 1903 he became Engraver to the Royal Mint.

In 1873, John J. Shaw, a Scholar from 1871, joined George Aitchison, the architect of Leighton House, as draughtsman, and Herbert Gribble, a student between 1866 and 1869, designed Brompton Oratory; Edwin Lutyens, a student between 1885 and 1887 (at roughly the same time as Detmar Blow) had set up a practice of his own by the time he was twenty, and first met Gertrude Jekyll, another ex-student, two years after he left the College, but otherwise excursions by students into architecture seem few. Girl students often found themselves fully employed in meticulously painting over photographs of museum objects which were to be sent to the various art schools. At one time there must have been hundreds, but now, unfortunately, every example seems to have been destroyed. Other students were expected to draw for illustrations in museum publications.

The Arts and Crafts Movement made little impact on the School (College) until the end of the century. Then Alexander Fisher took up the Arts and Crafts with enthusiasm, after winning a travelling scholarship to France and Italy to study enamelling, later teaching at the Central School of Arts and Crafts. Another student at Kensington, a year or two after Fisher, was Nelson Dawson (later one of the founders of the Artificers' Guild), who became one of Fisher's students. While Fisher was a National Scholar, he was commissioned to paint a duplicate set of the *Months* by Poynter, from the Museum's grill room.

As so many manufacturers during the nineteenth century were reluctant to credit their designers, much of their work has been forced to remain anonymous, and the designers themselves unrecognized. Richard Burchett recorded in 1869 that the Parisian firm of Corbière had bought many student designs from the school for silks and wallpapers, all of which were to be produced in France, and George Wallis stated in 1884 that at an exhibition of works by students, several designs for textiles were displayed. It so happened that these textiles were at the time being sold in London shops as "French" so that "attempts have been made to obtain the withdrawal of [the designs] exhibited because the seller objected to the real origin of the design and fabric being made known to the public". To admit that the designs originated in South Kensington was, it seems, bad for sales. Such an attitude was fast disappearing by the 1890s, with the arrival of the illustrated design journals.

# PART TWO

## "IT WOULD, I FEAR, BE OUT OF THE QUESTION TO APPOINT DR GROPIUS . . ."

Top *Publicity poster for Shell by Paul Nash, 1930s.*
Above *Henry Moore's* Head of the Virgin, *1922-3, a copy in marble after the work by Domenico Rosselli in the Victoria and Albert Museum.*

Top *Mural by Edward Bawden.* Centre *Jug and beaker by Eric Ravilious, about 1938.* Bottom *Radio cabinet, 1932, by R. D. Russell.* Right *"Atalanta": memorial to Derwent Wood.*

# SOUTH KENSINGTON

1896-1940

## THE ART WORKERS' GUILD TAKES OVER

*There is of course no absolute determination of rules for all cases. There is nothing absolute in art. Art is not science.*

From *The Claims of Decorative Art*, based on a course of illustrated lectures about "the cast-iron system of education", by Walter Crane (1892).

When *The Studio* first heard, in autumn 1896, that the National Art Training School had been granted permission by Her Majesty the Queen to change its name to "The Royal College of Art", and that in future the School would be able to grant its own diplomas, the influential magazine expressed some surprise:

*Why the right to assume this dignified title should have been given to the South Kensington institution at the moment when its methods and practices are being called into question with more than ordinary persistence and vehemence it would be a little difficult to explain. The Training School has of late given evidence of no very conspicuous improvement in its educational manners and customs, and has just now no results to show that are in any sense different from those with which in past years it has had to be credited. We may therefore be forgiven for expressing the hope that this change in style is an augury of radical changes within the School. A Royal College of Art may fairly be presumed to be a place with a mission to set the standard of aesthetic practice throughout the country, and if this duty is for the future to be imposed upon South Kensington, some very considerable revision of its principles, and some marked alteration in its internal arrangements, must be made without loss of time. It will have to live up to its new title . . .*

Walter Crane, also, had been confused about why the name of the National Art Training School had been changed, "except that it was in contemplation to reorganise the school more or less on the lines of a college". The introduction of the new

diploma implied that RCA students would no longer be entering for the National Competitions; and the deletion of "training" from the name implied a recognition of the fact that art masters for the flourishing provincial schools could just as well be educated elsewhere. But, beyond these, it seemed a most unfortunate time to upgrade the College's status. Perhaps the change to "Royal College" was simply a matter of status: this seemed to be confirmed by a Board of Education Report of a few years later, which stated as a matter of fact that:

*In 1897, a desire amongst the masters of schools of art for a more obvious recognition of their qualities was met by the adoption of the name Royal College of Art in place of that of the National Art Training School, and the establishment of a Diploma of Associateship.*

During his brief term of office as Principal, in 1898-9, Crane had "endeavoured to expand the range of studies, especially in the direction of Design and Handicraft . . . to give the students some insight into the relation between design and material", and had recruited several lecturers from the Art Workers' Guild for those students who specialized in design, but his plan for the re-structuring of the College (prepared with Alan Cole) had been promptly shelved by the Department of Science and Art. In particular, he had asked for extra workshop facilities, for an exhibition area in which teams of design students could create complete interiors, and, where the curriculum was concerned, for a mandatory first year course in architecture for all students in the "fine" and "applied" arts (a distinction he did not accept). He had also suggested that the appointment of honorary visitors to the College be discontinued, to be replaced by a Council of Advice for Art made up entirely of "experts engaged in the actual practice of their respective branches of Art", who could "advise on the syllabuses of instruction and examination".

The transfer of responsibility for the Royal College of Art from the Department to the Board

66

of Education, in 1899, provided the opportunity for at least some of Crane's recommendations to be implemented. A Committee of the new Board, chaired by Sir Horace Walpole, supported the idea of a Council of Art, ("composed of four experts"), and urged this Council, as a priority, to give some thought to "the primary object" at the RCA. Surprisingly, the Committee added, on 20 November, that in their view "the primary object . . . is the training of students to act as teachers in Art Schools and the arrangements of the College should be subordinated to this end".

The members of the first Council, all from the Art Workers' Guild, were announced on 7 March 1900. They were to consider painting and drawing, sculpture and modelling, architecture and design, and their specific brief was to advise on the "College curriculum and the principles that should govern its teaching". The appointments were for three years in the first instance, and came with a retaining fee of 100 guineas.

The Council of Art acted very quickly. Almost at once, it recommended that the College should be divided into four main schools, each with its own Instructor (re-titled "Professor" in 1901). These schools would match the expertise of the four Council members: Mural and Decorative Painting (under Professor Gerald Moira), Sculpture and Modelling (under Professor E. Lantéri, the existing head of the area), Architecture (under Professor Beresford Pite) and Design (under Professor William Richard Lethaby). Lethaby's appointment, in particular, seemed to confirm the view of the Art Workers' Guild, expressed in 1894, that "if you want a good man for a public post connected with the Arts, the Guild is the place to come". For Lethaby brought with him Christopher Whall to teach stained glass, Grace Christie to teach embroidery and tapestry weaving, George Jack to teach wood-carving and gesso, Henry Wilson to teach silverwork and

jewellery, and Edward Johnston to teach writing and illumination: in addition, there were to be special lectures by the industrial designer (and Guildsman) W. A. S. Benson, on *Metalwork* and by the architect (and one-time Master of the Guild) Halsey Ricardo on *Types of Construction*. The Council of Artworkers, it seemed, was transforming South Kensington into the Royal College of Artworkers, and *The Studio* was well pleased.

Augustus Spencer, who had been a National Scholar in 1881, and head of the Leicester School since 1888 (where he had supervised its transformation into a fully-fledged municipal School of Art) became the first Headmaster of the Royal College of Art – a post he was to hold for the next twenty years (although his title reverted to "Principal" in 1902).

With his track-record at Leicester (which suggested that he had not mellowed *that* much) Spencer must have seemed exactly the sort of person who could handle the transformation of National School into Royal College. His papers of appointment, issued by the Board through the Council of Art, stated that:

*The special object of the College is to train Art Teachers of both sexes, designers and Art Work-*

---

TEACHING FAILURE

In 1884, shortly after leaving the National School, Augustus Spencer was interviewed by the Royal Commissioners on Technical Education, and was very outspoken about the training he had just completed:

*South Kensington teaching is slow, vicious, feeble and antiquated. What takes place . . . is that students are set to copy an apple or a sphere, or a cone, on which they spend a year, a second year is spent on copying a bad torso and thus the student reaches 30 and knows nothing . . .*

67

1896-1940

*men to whom facilities and assistance are afforded in the shape of studentships in training, Royal Exhibitions and National Scholarships with maintenance allowances. Free studentships with complete or partial remission of fees are also granted. A limited number of General Students are also admitted to the College on payment of fees. The subjects of instruction include Drawing, Painting, Modelling and Designing for Architecture, Manufactures and Decoration.*

The Headmaster had to supervise the instruction of the students (in day classes from 9.30 am to 3.30 pm, with an hour's interval for lunch, in evening classes from 4.00 pm to 6.00 pm, and in short courses for teachers over the summer vacation); he had to administer the complex scholarships system within the College; and "generally to control the professional work of the Instructors". Each annual session consisted of two terms: the first began early in October and ended in February; after a fortnight's break, the second began in February and ended at the beginning of July. Throughout the entire session, the Principal was expected to teach a course on *The Methods of Teaching* – which consisted of "a history of drawing as a means of education"; a survey of British theories of art education, supplemented by discussion of Rousseau, Pestalozzi and Froebel; and an analysis of art teaching in schools. He also had to ensure that teachers in training "gave instructions to others" in the Lower School at the RCA "under the direction of the Principal". Augustus Spencer was answerable for the good performance of all these duties to the Board of Education, and was expected to act as a channel of communication from the Council of Art (the policy-makers) to the Instructors.

This job description suggests that although the Arts and Crafts philosophy, carried by distinguished Guildsmen, was to become part of the "mission" of the RCA – replacing the formal knowledge of the "South Kensington" system with the informal knowledge of the craftsman – the development was not quite as dramatic as it might have been: the student body was still a mixture of "Art Teachers of both sexes", "designers" and "Art workmen" (a new post-William Morris concept). The upper school consisted of "Art Masters and Decorative Artists", the lower school of "less qualified students"; and the role of the College, now that it was no longer a training school, was ambiguous.

But Spencer was already far too busy to ask the big questions about his institution. Apart from confirming the appointments of the four new Professors (who, because of bureaucratic delays,

were not in post until November 1900, with their contracts confirmed a year later), Spencer had to appoint a Deputy Headmaster (G. Morton), a Registrar (Mr Grant) and to revise the terms of reference of the College Matron, Miss Simpson: there had been a Lady Superintendent at the school since 1863, as well as a Matron, but in 1894 the posts had been amalgamated; the Walpole Committee of 1899 was insistent that "as upon Mrs Casabianca's retirement there will be no Woman Teacher, the Matron should be entrusted with those disciplinary duties among the Women Students which ordinarily devolve on the Women Teachers".

Augustus Spencer also managed to negotiate a pay-rise for Instructors, from £300 to £500 a year, and an increase in student fees from £5 to £12.10s a term (or £6.5s "for students joining us at half-term"). And he was requested by the Council to impose a more demanding entrance examination, as well as to reduce the overall number of students over the next few years (in fact, from 400 in 1900 to 200 in 1910). But, above all, there was the question of space. As was by now traditional, the Principal asked the Office of Works for extra room, to house the "craft" workshops – but all he was given, some time later, was a few temporary huts made of wood and tin, situated between Exhibition Road and Queen's Gate, to accommodate the students working in Sculpture and Modelling, Stained Glass, Pottery and Metalwork, and to provide a students' "refreshment club". The staff, he was informed, were expected to eat in the Victoria and Albert Museum or in their own clubs.

An early *Memorandum upon the Royal College of Art*, submitted to the Board of Education by the

---

FRATERNAL GESTURE

As Principal, Spencer appointed his brother Beckwith to teach courses on the history of literature and the history of art: all students were expected to attend the weekly art-history lectures, which cantered from ancient Greece right through to "the industrial revolution in the nineteenth century and its effects", and to take part in seminars the following morning, where the hapless students had the opportunity to "revise their notes". In fact, Beckwith Spencer appears to have given the same course to the same students twice over – the first time in darkness, the second time in daylight – since he found it difficult to generate much discussion about what must have been a very general history. Quite apart from the suspicion of nepotism, Beckwith Spencer's appointment was to become the cause of much controversy.

Council, gives a detailed account of the work of the college at this time.

Shortlisted candidates who had applied to either the Upper or Lower School had to sit a six-day examination in the College on four set subjects: architecture ("a drawing of a small architectural object in the Victoria and Albert Museum selected for the purpose – time allowed 12 hours"); sculpture ("a model in clay of the mouth of Michael Angelo's David – time allowed 6 hours"); painting ("a drawing in charcoal from life of the head, hand and foot – time allowed 9 hours"); ornament and design ("a drawing from memory of a piece of foliage, such as that of the oak, ash or lime" and "lettering by hand of a given sentence" – time allowed for both, 9 hours). In addition, those few students who had applied directly to the "craft" schools had to bring examples of finished work with them.

All successful applicants entering the College had to take a preliminary one-term course in architecture, unless already qualified, so that they would fully understand "the unity of the arts in their decorative aspect". Taught by Arthur Beresford Pite, this preliminary course involved drawing geometric elevations (of real and imaginary buildings), making freehand drawings from life and then memory, attending lectures on building construction and visiting building sites in the near vicinity. If they intended to become art teachers, the students would then spend a quarter of their time in each of the four main Schools; if they intended to specialize, the students would spend all their time in one of the Schools. Walter Crane was keen to point out that if the chosen School was Painting and Drawing, it should be noted that the work was *exclusively* concerned with the "mural and decorative" aspects of painting.

Where the Design School was concerned, the authors of the *Memorandum* felt strongly that "no student is capable of designing for any material with whose limitations and nature he is not personally acquainted". So the "craft classes" were, as one might expect, an essential part of the curriculum.

By 1905, the College was in a position to offer demonstrations and facilities for students in stained glass, embroidery and tapestry weaving, wood-carving and gesso, calligraphy and illuminating, and pottery (which appears, in most cases, to have been a synonym for blank-painting and tile-painting): since these courses did not involve costly equipment, they had gone ahead as planned. All the other crafts mentioned in the Council's *Memorandum* (such as metalwork and enamelling, stone and marble carving, textile weave and print, furniture construction and mosaic work) were still awaiting resources from the Board: they could only be taught in general classes, because the College lacked the necessary equipment for fully-fledged workshops.

Another activity listed as a "craft" (although today we would probably consider it as a "fine art", partly as a result of this epoch at the RCA), was etching and engraving. Under Frank Short, the "etching class" (as everyone called it) stood for "the thorough teaching of pure craftsmanship in every phase and stage of all the methods of the copperplate, together with the inspiration of the true artistic tradition of the masters". Short had succeeded Frederick Goulding as director of the class in 1891 (before that, he had been its assistant teacher), and had re-oriented the work from the copying of old masters (which had gone on since 1865), to the creation of original work (mainly in the form of landscapes). As *The Studio* rather gushingly commented:

*Under the aegis of Frank Short, a freer artistic principle prevailed from the first. The students were encouraged to utter their own pictorial conceptions on the copper, while learning all that the master could teach them of craftsmanship, so that they might become freely articulate as artists. In that spirit, therefore, the Etching Class of 1891, with its five or six students, gradually developed into the School of Engraving ... with its diplomas and the students numbering between sixty and seventy.*

Frank Short was to direct the influential "etching class" for thirty-three years, until 1926, when he was succeeded by Malcolm Osborne, ARA, a former student of his. Osborne himself brought in two other ex-RCA students as assistants: Job

---

"THE ETCHER'S EYE"

Frank Short liked to present himself as a craftsman (wearing the blue overalls of a railway engineer, as he distributed the tools he had made to all his students) and much of his curriculum was concerned with the etching and the mezzotint as "reproductive media", or with "the mastery of technique": he had originally trained as an engineer. But he had equally strong views on what he called "the etcher's eye":

*I do not think a man can be a good interpretative engineer unless he has a pretty strong imagination; indeed, unless he can paint fairly well himself he will never make a fine interpretative engraver.*

Which was just as well, since most of his students *had* to do their time in the "decorative painting" class before joining him.

Nixon (for etching) and Robert Wright Stewart (for lithography).

*The Studio*, reviewing all the developments which had taken place at the College between 1900 and 1905, noted with some satisfaction that "the prevailing spirit is one of sincerity and courage" and "achievements of real interest and merit" should in time emerge from it: above all, at last there was evidence of "a generally *practical* outlook". Since 1901, the magazine had been championing the partnership of Ramsden and Carr, in the craft of silversmithing, as an isolated example of what the College *could* be achieving: Omar (perhaps after the Yorkshire pronunciation of Homer) Ramsden had studied at Sheffield as a silversmith, before attending the RCA at the turn of the century. Having designed and made a mace at the College (and having joined the Artworkers' Guild), he had joined forces with fellow student Alwyn Carr – who started out as a sleeping partner, then became a collaborator. Together, they had registered a mark at Goldsmiths' Hall: Ramsden designed silverware, Carr was responsible for enamelling, and William Maggs, a cretonne designer, was brought in as draughtsman, to tidy up Ramsden's very rough sketches. Later on, Ramsden was to be responsible for the wrought-iron gates of the Old Bailey, for an astounding number of ceremonial presentation pieces, and for crosses and chalices in cathedrals and churches all over the country. The arrival of William Richard Lethaby, as the first Professor of Design, seemed to *The Studio* to be a sign that many more students of that calibre would soon be appearing.

Lethaby had spent his entire professional career up to that time – following his conversion to the gospel according to William Morris in the 1890s – battling with a succession of bureaucracies: first, with his status-conscious colleagues in the "just and noble profession" of architects; then with the RIBA; then with the people he called "Mr Inkpots" at the Technical Educational Board of the London County Council over the exact aims of the new Central School of Arts and Crafts.

Lethaby had turned the Central into the first school ever to be based entirely on the principles of craft training: South Kensington had been far too obsessed with draughtsmanship and the copying of ornament from the antique, for examination purposes, fully to appreciate the value of workshop teaching. Now that the National School had become the Royal College, perhaps some really substantial changes could be made at South Kensington as well. However, Noel Rooke (who was one of Lethaby's first Central students) recounted that Lethaby had his doubts about the company he was to keep:

*In 1901 he was asked to become Professor of Design at the RCA. He explained to Douglas Cockerell and to me at lunch one day: "At the moment it is the worst school in England, probably the worst in Europe. So I'm going to it. I feel a call, like Livingstone to the heart of darkest Africa. They'll probably try to eat me. I'm going to accept, on condition that I am allowed to stay on here as well." For having got the Central on its feet, he was then able to run it on two or three evening attendances a week. Lethaby was appointed to the RCA as a result of a reorganisation inspired by Walter Crane, whose work was based on the usual assumption that a designer should be prepared to design for all processes and materials, and should proceed from generalities to the particular. Lethaby's working principle was the opposite, that design is best performed by those familiar with the material and process, and that movement should be from the particular to the general.*

Actually, to judge by Lethaby's syllabus for "Elementary Ornament and Design" – which most of the students would have taken – his teaching did not, in fact, proceed "from the particular to the general". It consisted of:

(a) *plant studies from the structural point of view, with brush and pen in outline or in flat tints, or monochrome water colour only*
(b) *memory drawing of plant form*
(c) *line drawing from common objects with pencil, charcoal or chalk, or brush work in water colour*
(d) *exercises in adapting forms ornamentally to simple geometric spaces such as circles, squares, triangles or lunettes*
(e) *design in lettering and its adaption to given spaces.*

Only when students had completed this course – with its emphasis on outline, colour, simple shapes, and "games" with forms, rather like an Art Worker's version of basic design – were they considered ready to become producers of artworks, "competent in a certain small group of subjects and an artist in at least one branch."

Arthur Beresford Pite was later to recall the effect which the "Elementary Ornament" course had on the RCA students:

*One watched [Lethaby's] influence in disintegrating the creepers and parasites of form, weeds which had planted themselves at South Kensington and taken root, and his influence in gradually disintegrating and destroying them, supplanting them with the healthy seed of truth and directness of expression, and his ultimate success in winning the affection of the students. I remember,*

*on his first advent, a lady student came, with tears, to the Principal, and said the new Professor wanted her to draw watercress! But that atmosphere soon changed...*

In the context of the old "South Kensington" system, the drawing of a piece of watercress (or, as the syllabus put it, "plant studies from a structural point of view") may even have seemed something of a breakthrough: up until then students would have been expected to copy a drawing of a piece of watercress and to attend lectures on its botanical significance. Indeed, Lethaby's personal design philosophy during his period at the RCA *seems* to have involved a fairly comprehensive rejection of all the grammars and rules which had sustained the National Art Training School. "What we have to aim at", he wrote, "is not the rigid application of any rule, nor even the training of model prize-earning students, but rather the forming of competent and re-sourceful men". Since his students at the RCA (most of whom aimed to become teachers) had very different expectations from those of the craft apprentices he had been teaching at the Central, it was important that they had a general grasp of "Elementary Ornament": after that, the purpose of the course was firmly to establish in their minds that "art is thoughtful workmanship". And the most effective means of establishing *that* was to base most of the teaching in the workshop:

*By this* direct access *to the material conditions the meaning and purpose of design as an arrangement for real work is brought home to the students, it corrects the erroneous idea that design is an abstract theory, and convinces them that suitability and pleasant fitness are the main consideration.*

In short, the concept of "design" was to be brought down to earth. Not, as we might expect today, in order to encourage originality or novelty for its own sake: Lethaby never tired of pointing out that no art that is only one-man deep is very much good, and he would only allow students to build up a tradition of their own *out of critical use of past traditions*. If "South Kensington" had encouraged the copying of past traditions, Lethaby would encourage standing on the shoulders of what had been done before. "Everybody must be interested", he said, "and it must be half drill and half game." In the bad old days, by contrast, it had been all drill and no game at all: Lethaby (who, according to one of his students, looked like "a white-moustached rabbit, with a quick, dark eye"), would spend eighteen years burrowing away, to bring the "game" back into design. Ever since its foundation, the South

Above *Silver sauceboat designed and made by ex-students Omar Ramsden and Alwyn Carr in 1909.*

Kensington School had been criticized for departing from its original intentions – by subtly (and ineffectively) directing students towards "fine art" rather than "ornamental design". From now on, there was to be a new kind of criticism. Lethaby was trying to turn the place into the Royal Cottage of Art.

Although William Morris had, through his practice and his socialism, laid the foundations for many of Lethaby's educational ideas, Morris himself had not said or written much of consequence about art education. He could not have predicted that the socialism, the "river of fire" of the Arts and Crafts Movement would be tamed – to become an established part of British art education at all levels, as a substitute for what he called "the sham science of design". So the question of how to institutionalize the arts and crafts philosophy was not, for him, very high on the agenda. It was Lethaby who filled the gap.

He did this not only through his teaching at the Central and the RCA but also through a series of illustrated books – the *Artistic Crafts Series of Technical Handbooks*. Most of these influential handbooks were written by members of the RCA design staff: George Jack on *Woodcarving* (1902); Henry Wilson on *Silverwork and Jewellery* (1903); Lethaby himself with a folder of *School Copies and Examples* (1904); Christopher Whall on *Stained Glasswork* (1905); Grace Christie on *Embroidery and Tapestry Weaving* (1906); and Edward Johnston on *Writing and Illuminating and Lettering* (1906). Together they represent the most sustained attempt to articulate the "Arts and Crafts" philosophy of education – firmly rooted in workshop practice, and derived from the experience of teaching in the design school at the Royal

71

College, as well as in the craft departments of the Central School. Lethaby's introductions made clear that the purpose of the series was to "treat design itself as an essential part of good workmanship"; to demonstrate that design and workmanship were so closely allied that "one may hardly know where one ends and the other begins"; and to convince teachers that "the true method of design is always growth, not rootless egoism".

George Jack's contribution begins with a dramatic contrast between "the ancient carver at his bench, cheerfully blocking out images of leaves and animals and his busy workshop, surrounded with the sights and sounds of country life" and "the modern craftsman . . . left totally free to choose style, period or nationality, from examples of every conceivable kind of carving in museums, photographs and buildings".

The *Artistic Crafts* handbooks – some of which were to remain in print for over fifty years, and the concept of which was to be copied by several other publishers – provide a unique insight into the *atmosphere* of the RCA design school during the Lethaby era. When Walter Crane produced his collection of essays *Ideals in Art*, in 1905, he could think of no better way of illustrating the points he wished to make, than by selecting examples of work produced by students attending the design school as well as Professor Lantéri's modelling school. Recalling his time at the College in the mid-1920s, Douglas Percy Bliss

---

### THE ROLE OF DESIGN

A consistent theme of the *Artistic Crafts* series of handbooks planned and edited by Lethaby from 1901 onwards is that an education in design can take the place of the old workshop tradition – by providing "masters", by monitoring standards, and by offering a guide through the wonderful but frightening "fairyland of design". Another theme is that the latest "styles" – and in particular Art Nouveau (the style of the recent and highly controversial Donaldson Gift to the Victoria and Albert Museum) – should be treated with the utmost suspicion: as Christopher Whall put it, "shall we work in the style of the "New Art", then . . . the style of the last new poster? The art-tree, the art-bird, the art-squirm . . . Heaven in mercy defend us and forbid it". The "New Art" encouraged the heresy that design was "put on" and was not "a true and natural thing – part of good workmanship". Another concern was that too many students drifted into "the over-crowded ranks of picture-making": the *Handbooks* could help them choose "other weapons in the armoury of the arts".

---

was to stress the direct connections which still existed between the school and the life and work of William Morris, as mediated by Lethaby:

*There were tutors at the Royal College of Art to whom Morris had been as a god. I remember how impressed we were to think that George Jack, who came to teach wood-carving, had been a Morris worker and was the craftsman who carved Morris's tomb in Kelmscott Churchyard. Edward Johnston too was teaching lettering at the RCA . . .*

---

## THE LETTERING CLASS

It had been Lethaby who, in 1897, first encouraged Edward Johnston to focus his ambition of "going in for Art" onto research and teaching in the craft of lettering. At the Central School, Johnston had taught a whole new generation of calligraphers, and, in parallel with his own researches into the techniques and origins of the craft, had stimulated a revival of interest in handwriting and type-design through his successful students. When in 1901 Lethaby invited him to teach lettering, part-time, at the RCA, the nature and purpose of his course was rather different. As Rooke recalled:

*At the College all the students had to spend their time preparing for a diploma. They had willy-nilly to attend Johnston's class in batches of 50 or 60 for two hours once a week for about nine months. At the end of their nine months they were switched off to something else. So small a number as to be negligible stayed on with Johnston, to be attended to by him in the very few minutes out of the two hours he could spare from the next batch of 60. The teaching became more and more collective teaching, by lecture and blackboard.*

In a letter of 23 May 1901, Johnston described how "at S. Kensington I have a v. big Room with a gt. black-board worked by pulleys, and a platform, with a railing, where I stand and sit and look down on the . . . embryo scribes below". Among these "embryo scribes" in the early years was Anna Simons, who had registered at the RCA (at first to study metalwork) because the Prussian design schools back home would not at that time admit women. She was to translate Johnston's *Writing and Illuminating* (in 1910) and *Manuscript and Inscription Letters* (in 1912), and was to play a significant part in the revival of calligraphic skills in Germany. Others who were to "stay on with Johnston" included E W Tristram (eventually to become Professor of Design at the RCA), Dorothy Mahoney, Violet

---

**JOHNSTON'S BLACKBOARD**

Dorothy Mahoney and Violet Hawkes were both to publish their reminiscences of Johnston's teaching in the mid-1920s:

*During his lectures, Johnston made use of the great blackboard and wrote with broad chalks which were specially made for him. They were 4½ inches long, 1 inch wide and ½ inch thick. Johnston sharpened the chalks to a chisel edge, just like a pen. When teaching he used the blackboard as a notebook – perhaps one week illustrating on it the characteristics of Roman capitals; the following week adding variations of serifs, heads and feet; the next week adding more varieties of shape, such as rounded capitals; and so on until the whole board was covered and he had to turn to a new page (clean the board). Fortunately some of those blackboard demonstrations were photographed by Miss Violet Hawkes ... To students who ruled double lines, he would say, "writing between ruled lines is like trying to dance in a room your own height".*

One of Violet Hawkes's photographs of "E. J.'s" blackboard – taken in 1926, and showing a range of specimen alphabets – clearly shows the classical Roman capitals from which, in 1916, he had derived the famous Johnston sanserif type for use on the London Underground and its associated companies. These block-letters were to influence all subsequent sanserif types, particularly the Gill-sans series, both in Britain and Europe: but, typically, Johnston regarded his work for London Transport (from which much of his income was derived) as a distraction from his *real* work and "a concession to Mammon".

---

Above *Uncial alphabet by Edward Johnston. In 1901 William Lethaby invited Johnston to join the College as a part-time teacher of lettering, impressed by his success at the Central School of Art, where his students included Eric Gill and Noel Rooke. Johnston's appointment was to turn into a career at the College of nearly forty years.*
Below *Manuscript by Edward Johnston to commemorate the retirement of Lethaby.*

Hawkes, Thomas Swindlehurst, and Irene Wellington.

Not surprisingly, given Johnston's somewhat monkish presentation of the subject-matter, of the 2-3,000 students who were forced to attend his lectures between 1901 and 1939, only a mere handful were to become professional calligraphers. Of the rest, as Noel Rooke was to recall, a great many were to spread

*some knowledge of calligraphy ... into the provincial schools of art and into secondary schools. The knowledge might be thinner but it was wider spread. It resulted in affecting the ordinary handwriting of many people; and this could not so easily have been attained in any other way.*

Johnston and disciples taught calligraphy and lettering at the RCA from 1901 to 1953, when Robin Darwin introduced typography and closed down the calligraphy course: most other art

73

schools were not slow in following his example.

In a sense, Johnston's teaching at the College (under Lethaby's guidance) – combined with his craft and design practice outside – epitomizes the design philosophy of the RCA in the early years of this century: his lectures were based on his original research into medieval manuscripts at the British Museum, and, after 1916, they were presented to students who knew that he had designed the sanserif lettering used by London's Underground Railway. This was what "thoughtful workmanship" could eventually achieve in modern society.

## "MEN ARE DECEIVERS EVER . . ."

In another sense, Johnston's course was uncharacteristic: a relatively large number of Johnson's students who made a name for themselves after leaving, were women. Lantéri's modelling class of the mid-1890s had also produced a significant number of women artists – such as the sculptors Margaret Giles, Ruby Levick, Esther Moore, Florence Steele, and Gwendolen Williams – who made a living as decorative artists or designers (in ceramics and metalwork) after leaving the College. But, on the whole, the number of female students who managed to sustain a career in the subject or subjects they had studied at the RCA was very small indeed. A detailed survey of student destinations – covering those who had graduated between February 1901 and July 1909 – was appended to the published *Report of the Departmental Committee on the Royal College of Art* (1911), and it revealed that out of the total of 140 female graduates (30.4 per cent of the student body between these years), only seventeen went on to teach at art schools, secondary schools or private academies, while one remained at the College (Constance Pott, who became "Assistant Instructor, Etching Class" in May 1902). And yet a substantial proportion of those who had stayed the course were fully *qualified* as art teachers. It would seem that, for one reason or another, the teaching posts were simply not open to them: for the *total* number of graduates who went into full- or part-time teaching between 1901 and 1909 was one hundred and thirty-three (126 full-time) – so the number of female teachers represents only 12.8 per cent of those employed in the profession.

Of equal interest is the number of female graduates recorded "as having exhibited work at one or more of 24 representative exhibitions in 1909" – a total of eleven (as compared with fifty-three male graduates).

During 1911, *Every Woman's Encyclopedia* published a series of articles on the Royal College of Art, under the general heading "where to study Art". In the light of the official statistics which were released in precisely the same year, these articles were optimistic, to say the least:

*While the primary object of the Royal College of Art is to train teachers, many students afterwards take up the practice of one or other of the fine arts as a profession, and the list of past students who have risen to fame is a fine one. Among present-day women artists who owe at least a part, if not all, of their training to the Royal College of Art may be mentioned H.R.H. Princess Louise, Duchess of Argyll, Clara Montalba, Mrs Stanhope Forbes and Miss Lucy Kemp Welch, R.B.A., who for a time attended the Etching School.*

Turning (rather reluctantly, it would appear) to design, the *Encyclopedia* goes on to provide a brief shopping list of all the activities which happen in "the spacious class-room of the Design School, under Professor W. R. Lethaby, which seems always crowded to overflowing": overflowing it may well have been, but no female students "who have risen to fame" as a result of the experience are even mentioned.

One design activity which was not, apparently "too hazardous for the ordinary woman" was:

*The Embroidery Class, which takes place on Thursday afternoons, under the direction of Mrs Archibald H. Christie [Grace Christie], and which is attended by almost every woman student in the school, for the demands for design and embroidery go together in almost every woman teacher's post, and girls double their chances of success if they are skilled in the intricacies of embroidery. There is a constant demand for teachers of embroidery and design from the training schools, for which the salaries offered range from £130 to £150 a year. The Embroidery Class in full swing is specially interesting to the visitor . . .*

Drawing to a happy conclusion, the *Every Woman's Encyclopedia* series made the most of the success stories the editors had managed to track down. Thus, for example:

*The College has from the first been open to women of whom there are now between forty and fifty, forming about one-fourth of the entire number of students in the College. A very large proportion enter the Design School, owing to the wider opening which it affords those without private means to gain a livelihood on completing their course, though the majority of women students have no difficulty in getting good appointments . . . one, Fraulein Anna Simons, a fee-paying student, took the Design School diplo-*

*ma, and went to Germany, where she was offered and accepted a post at the first Hamburg State School of Art at a salary of £300 a year with full pension... The feminine members of the College are very proud that, since 1894, three of their number should have taken travelling scholarships – the most coveted of all awards – in open competition with the men.*

The claim that the College had from the first been open to women was, of course, accurate – at least, since October 1842 when the Female School of Design was established. But, as we have seen, the attitude of successive administrations *since* that time had not always been quite as positive as the *Encyclopedia* implies: in the summer vacation of 1848, the School had been moved to ill-ventilated premises above a tallow-chandler's shop in the Strand; in 1852, the female wood-engraving class had been taken over by Cole's training school, and in the same year, the Female School – with half the number of staff and double the fees – had been moved yet again, to Gower Street; because Cole's South Kensington School existed to train both "Art masters and mistresses", the government had finally withdrawn all financial support from the "Metropolitan School of Ornament for Females" in 1859. Since then, it had moved to Queen Square in Bloomsbury, had been allowed to add the word "Royal" to its title "The Royal Female School of Art" (in recognition of the patronage of the Queen and the Prince of Wales, some thirty-five years before the RCA was permitted to do so), and had been amalgamated, rather traumatically at first, with the Central School in 1908. In South Kensington, at the same time, women had been accepted alongside men as potential (if not always as actual) art teachers, as craftworkers (who could hope to earn a living in the "feminine" crafts, at least) and as fine artists (provided they attended separate life classes, complete with fully-clad models).

*Every Woman's Encyclopedia* was, as one might expect, painting altogether too rosy a picture, although observant readers may have spotted a small touch of realism in the enormous difference between the £150 a year earned by women teachers of design in England and the £300 earned by their counterparts in Germany.

One female student who had recently "risen to fame", but over whom the *Encyclopedia* drew a well-embroidered veil, was Sylvia Pankhurst – who was listed in the 1911 *Report* as "Estelle S. Pankhurst, National Scholar, 1904-6". Sylvia Pankhurst had applied to the RCA from Manchester School of Art, where she had been awarded the "Best Woman Student Prize" of 1901, a National Silver Medal for mosaic designs, and a

Travelling Scholarship to Venice. She arrived in London, having survived the arduous National Scholarship examinations, in September 1904 – shortly after completing her first public commission, a series of allegorical murals for the newly-built hall of the Independent Labour Party in Manchester (which she later discovered, to her horror and that of her mother Emmeline and sister Christabel, would be open to men only). Sylvia Pankhurst expected a great deal from her course: it would, she hoped, teach her how to "decorate Halls where people would foregather in the movement to run the new world and make banners for meetings and processions".

Sylvia Pankhurst's work between October 1904 and October 1905 included a watercolour portrait of her good Labour Party friend Keir Hardie (which now belongs to the National Portrait Gallery), a brightly coloured poster showing a group of working people clutching a placard saying "Workless and Hungry. Vote for the Bill" (which was intended by Hardie to support his bill for the unemployed, and which was later to become a propaganda postcard), and a pen and ink drawing, in Walter Crane style, of a woman offering a bowl of milk to two children, with the bold caption "Feed my Lambs" (which was also to be turned into a postcard). At this stage in her career, she was unsure about whether she wanted to become a professional artist or a full-time political activist on behalf of The Women's Social and Political Union – the most outspoken of suffragette organizations, run by her mother with help from her elder sister. She could

---

**COMMUNICATION PROBLEM**

Sylvia Pankhurst's first few months at South Kensington came as something of a shock.

She had failed to notice that section of the College *Prospectus* which stated that all first-term students had to take Beresford Pite's preliminary architecture course in the day-time, leaving only the evenings for life drawing. According to her memoirs, she immediately went to see Augustus Spencer and asked him if she (and other students who had approached her) could do figure drawing in the day-time, leaving their evenings for architectural history: instead of taking the trouble to explain the Walter Crane line on "the unity of the arts in their decorative aspect", Spencer immediately asked her to get out of his office. From then on, whenever she encountered the Principal, they would snarl at each other "like savage dogs" – a breakdown in communication which was to come to the government's attention, in no uncertain terms, several years later.

not make up her mind "whether it was worth-while to fight one's individual struggles, as fight one must, and that strenuously, to make one's way as an artist, to bring out of oneself the best possible, and to induce the world to accept one's creations, and give one in return one's daily bread, when all the time the great struggles to better the world for humanity demanded other service". On balance, she felt, "the idea of giving up the artist's life, surrendering the study of colour and form . . . to wear out one's life on the platform and the chair at the street corner was a prospect too tragically grey and barren to en-dure". Many of her fellow students – such as Austin Osman Spare, who was in his final year in 1904-5 – found it difficult even to understand her dilemma: the life of the *aesthete* was for them, the *only* way to travel.

During her second year, Sylvia Pankhurst became more deeply involved in the women's movement: instead of holding self-help life classes (as she had done in her first year), she used her digs in Park Walk, Chelsea, as the West London base for the WSPU, and spent as much time as possible designing posters and banners for meetings at the Albert Hall or Caxton Hall ("Will the Liberal Government give Justice to Working Women?"), organizing demonstrations, and appearing "on the platform". When the time came, in July 1906, for her to decide whether or not to apply for a Free Studentship to complete her five-year diploma course, Professor Moira advised her to apply – but she preferred to leave the College, to become, in effect, the official artist and designer of the WSPU.

Shortly after her National Scholarship ran out, she prepared an extensive visual survey of women's work in Britain – and returned from her fact-finding mission with a series of gouaches and watercolours of labourers in the chain and nail trade of the Black Country, workers in a Leicester boot factory, "pit brow" women in Wigan, women "on a pot bank" in Staffordshire, fisherwomen in Scarborough, potato-pickers in Berwickshire, and textile factory-workers in Glas-gow. Back in Chelsea, she worked full-time designing membership cards, Christmas cards, heraldic emblems, posters, badges, banners, even a suffragette tea set – when she was not arranging meetings, or going on hunger-strikes in Holloway jail – so it is remarkable that she still found time to take an active interest in the RCA.

Her experiences at the College must have made a profound impression on her, for when she heard that a Departmental Committee was taking evidence in preparation for an important *Report* of 1910-11, she immediately joined a deputation of seven recent graduates (five men and two women, all of whom had been on the course at the same time as her, most of whom had completed their diplomas) on a visit to Mr S. J. Cartlidge, Chief Inspector of Schools of Art. Cartlidge had himself been a student at the College in the late 1890s, as well as an assistant in the modelling school. The discussion, which was incorporated – in a suitably watered-down form – into the final *Report*, covered the compul-sory course in Architecture (which the students thought was unsuitable for Fine Artists), the distribution of internal scholarships (which bore "no relation to the artistic capacity of the students" and which favoured male students to a ridiculous degree), and the way in which the Principal made recommendations for and against the employment of students leaving the College (which was thought to be "inequitable"). But, most of all, the deputation had a lot to say about Augustus Spencer himself:

*That seeing it is generally felt that the organisa-tion of the Royal College is unsatisfactory and that we, the students, found the Principal to be neither an artist nor a sympathetic organiser, we respectfully wish to ask, since we have suffered the system, in what way does he merit the position he now holds as Head of the Nation's School of Design.*

Spencer, they added, had made his brother's repetitive courses on the history of literature and the history of art compulsory for all students (a decision which was "strongly resented").

After the Departmental Committee had had a further meeting with "Mr John Currie, Mr Austin Spare and Miss Estelle Pankhurst":

*They recognised the weight of some of the criticisms made which were supported by other evidence received by them and by their own investigations: and to these due consideration has been given in the Report. At the same time they felt that many of the criticisms, especially those of a more personal kind, were such that it was impossible for the Committee either to investigate them satisfactorily or to arrive at any conclusion about them. They desired, therefore, to be absolved from pursuing these matters any further.*

On one issue, however, the Committee did take immediate action. They had heard "from a number of distinguished students of Art" that no-one on the College staff seemed to have "special responsibility for the women students". "There is at present a Matron", they had dis-covered, "but we have been unable to ascertain that she comes into any contact with the stu-dents, or that some of them at least have any

knowledge of what her function may be". Miss Simpson had been College Matron since 1890 – and in the absence of any "women teachers" at the RCA, had been given extra disciplinary duties as part of the reorganization of 1900. When she retired from the College in July 1911, Augustus Spencer had immediately decided "to see how we can manage without a Matron". In the political climate of the day, this could have been a disastrous decision. It could even have led to suffragette-style demonstrations. Sir Robert Morant of the Board of Education immediately wrote to the Treasury, requesting the establishment of a new post of Lady Warden, and to the Principal, informing him that Walter Runciman, MP, the President of the Board of Education no less, "strongly disagrees with your suggestion that the Royal College of Art might conceivably manage without a Matron altogether".

Because of this swift action, a Lady Superintendent (Miss L. Preece), together with a Woman Attendant, were appointed. But just before she arrived, Miss Preece made it clear – in a letter to Constance Pott, the assistant in the Etching Class – that the root of the problem lay elsewhere:

*I have long had the idea that all large art schools suffer because as a rule women teachers are not found in any position of influence – let us say that of vice-principal, or director of women's studies. If the RCA could lead the way by establishing a post for a woman whose duty would be to advise on the direction of women's study as well as to influence the general conduct and welfare of the students it is possible that some such course may be followed by the large schools in the country and that the general tone of the schools be thereby raised. I believe this to be all the more important since there is a tendency (unconsciously sometimes) at the present time to sacrifice the real ethical principles of art teaching to the utilitarian needs of the day ...*

The RCA only employed two women teachers – Constance Pott and Grace Christie – and that, surely, wasn't good enough. Then, as indeed now, Miss Preece's points were well made.

But by 1912, Augustus Spencer had a lot of other weighty problems to occupy his mind . . .

## ANOTHER DECLARATION OF WAR

*The impact of Art with modern industrial conditions, as illustrated by the English Art schools, of which the Royal College is the chief, has resulted, so far, in the creation of a certain type of official who may or may not be an artist, and in the production of certain types of commodities, many of them good in their way, but having little or no bearing upon the general taste of the people or upon the output of Industry . . . The figures of the Royal College of Art always come back to one as a sort of refrain: You have taught 459 of us this thing, but only 32 of us have taken it on as a livelihood and 126 of us are going on teaching it. The eternal serpent is devouring its tail . . .*

From *Should We Stop Teaching Art?* by C R Ashbee (published in November 1911, as a commentary on the recent *Report* of the Board of Education on the Royal College of Art).

In July 1909 the Board of Education decided to ask one of the College Visitors to prepare a confidential report on the working of the RCA and in particular on the effectiveness of the new Design School. The Council of Advice for Art had been disbanded in 1907, to be replaced by four Visitors (the old 1890s system) who were expected to report to the Board at the end of each term: but the confidential report of 1909-10 was expected to be a much more substantial and hard-hitting document. The designer and design reformer Lewis Foreman Day was appointed as

Below *Women's Social and Political Union membership card, with poster by Sylvia Pankhurst.*

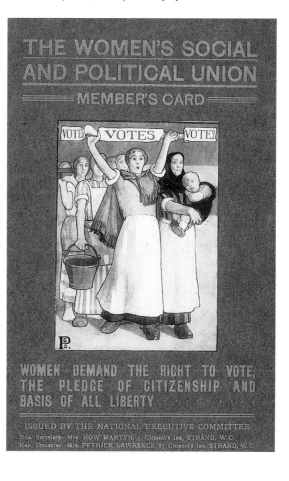

the Visitor to the Design School in autumn 1909 with the specific brief to "set out in the fullest, clearest and most outspoken terms" his views on the regime of W. R. Lethaby. Day had been a very conscientious examiner in the National Competitions since 1890: Walter Crane's *Moot Points* (1903) contains a cartoon of "the decorative artist Lewis Day" slaving away at some labelled piles of examination scripts, and looking enviously at a fine artist who is doing some drawings for an audience of admiring ladies.

Day was also "occasional lecturer in surface design" at the RCA, from 1895 to 1900, and in 1899 gave twenty lectures on the history of decorative art, illustrated by lantern slides of objects from the Victoria and Albert Museum. In his own design practice, he had supported some outstanding students who had recently left the College: Lyndsay P. Butterfield, a designer of flower patterns – whose work was to be printed by the textile firm of Turnbull and Stockdale – supplied several designs for Day's book *Nature in Ornament* (1909 edition); and Omar Ramsden, who had first been encouraged by his examiner Lewis Day, made at least three pieces of silverware to Day's designs (with Alwyn Carr) between 1904 and 1909.

So, Lewis Day knew a great deal about design work at the RCA both before and after the arrival of Professor Lethaby – and as an "insider" might be expected to be sympathetic to the College. But he was also known to have strong views on the "craft" orientation of the course since 1901 – he felt that the Arts and Crafts movement ought by the 1900s to be having a more appreciable effect on industrial design, particularly at the level of design teaching – and he had gone on record as saying that RCA students' work was not measurably better than that of its London and regional rivals. In August 1908 Day had presented a paper on *Art Teaching in relation to Industrial Design* at an international conference on Art Teaching held in South Kensington, in which he had criticized Design Schools in general for stressing the *pictorial* rather than the *industrial* bases of design, for giving more prestige to fine art than to design (which made him personally "rather sore" and which, he added, merely produced generation after generation of out-of-work painters), and for training design students in single craft skills rather than transferable design skills. "Every handicraftsman is to design what he does. That implies the reduction of design to what every workman or workwoman can do. This is the minimum. I want the maximum."

Industry, Day concluded, required people who were experienced in design and its adaptations – rather than people who were experienced in all

Above *Roller-printed cotton by Lyndsay P. Butterfield, who studied at the College in the 1890s.*

aspects of making. It was a surprising position for Day to adopt, since he had been one of the founders of the Art Workers' Guild and the writer of the first-ever monograph on his friend and colleague William Morris. But he felt that the take-over of design work at the College by the Guild had gone too far.

By separating "design" or "ornament" from process, he was at one level harking back to the old South Kensington ways of thinking – against which the Arts and Crafts people had consistently argued; but at another level, he was laying the foundation for a substantial new critique of design teaching which has survived to the present day.

On 12 February 1910, Lewis Day wrote to the Board of Education:

*I should be glad to know whether this is to be regarded as a Confidential Report or whether it will in any way be made public. The difference would not affect what I said, but it would very greatly affect the way I said it.*

This led to much consternation at the Board – internal comments included "As you know, it is possible that Mr Day's report may be strongly condemnatory of Professor Lethaby's work" – and to the rather panic-stricken advice to Day that the report *might well* be published. In the event, the lack of confidentiality did not seem to inhibit Lewis Day.

After several visits to the College, he wrote of the Lower School: "It seems to consist of only two students, one of them quite hopeless". And of the Upper Design School: "They indulge in renderings often too pictorial for practical purposes . . . I want to urge upon the Board the necessity of doing something also for Ornament and Design in relation to Industry . . .'

In a letter to Sir Robert Morant which accompanied his report, Day added a more personal note:

*Design and Ornament, so far as they are taught at all, are taught in relation to Architectural decoration, so that in reality Ornament is very little considered and its practical application to Industry is entirely neglected. It could not be otherwise with Professor Lethaby and his staff . . . The very fact that Ornament and Design are connected with Trade, and that the Royal Academy ignores them, makes it, I know, difficult to do anything for the subject. And the Arts and Crafts Movement, instead of helping it, has drawn what artistic sympathy there may be for it away from Industry and towards the more or less amateurish pursuit of Little Handicrafts – which to my mind matter much less.*

By the time the Board of Education had set up a fully-fledged Departmental Committee in April 1910, to examine these and other criticisms of the RCA, Lewis Day was dead at the age of 65. But the basic questions he had raised (echoing comments in the Art Press) served to frame the agenda for the Committee.

The College no longer took part in the National Competitions, and, since the Education Acts in 1902-3, it had relinquished its authority over London and regional colleges to the local authorities: so, what exactly *was* its role in the national system of art education? The College was perceived to be "a training ground whence a supply of teachers is regularly drawn for the local Schools of Art", and it was also expected to train "the pick of the industrial students of Art from the local schools". So, which of these roles should predominate, and was there to be any relationship between the two? Within the Design School, the Lethaby philosophy (derived from the Arts and Crafts Movement and particularly from the Art Workers' Guild) and the Day philosophy (also derived from the Arts and Crafts Movement, but with an emphasis on its implications rather than its contemporary practice) represented two models for design education at the College: which of the two should become official RCA policy? Since the reforms of Henry Cole, a lot of fee-paying students (some of whom had little previous training, and many of whom "desired to proceed in due course to the Schools of the Royal Academy") had been working side-by-side with National Scholars (who were supposed to specialize in "the industrial Arts"): given that the College was never "intended to compete with the Schools of Art as a training ground for painters of portraits and other such pictures", what *was* Fine Art's role in the College, and should it go on recruiting fee-payers to pay bills?

In attempting to answer these questions, the Departmental Committee took evidence from, among many others, the architect Halsey Ricardo and the designers W. A. S. Benson, T. Erat Harrison, and Charles Voysey. Its final report "on the functions and contribution of the Royal College of Art, and its relations to the Schools of Art through the country", dated 3 July 1911, caused a sensation.

Examining the reasons for the College's "difficulty", the *Report* began by looking at the effectiveness of the staff. "The Principal", it said, "was largely occupied in the administrative business of the College and was not in close touch with the students". This wasn't entirely his fault: as the main bridge between the Board of Education and the day-to-day management of the College, he had a lot of "administrative business" to get through – and, when questioned about this, Augustus Spencer expressed resentment that his main contact at the Board was "a scientific man", which didn't help matters. And the complaint about the amount of paperwork involved in the job was not a new one: it went back at least as far as William Dyce, who had brought up the matter in 1846.

But Spencer was supposed to be in charge of all the teacher-training classes at the RCA and the *Report* concluded that if, instead of giving a few lectures on how to use the blackboard, he spent

---

IMPERFECT RELATIONS

The Departmental Committee's report "on the functions and contribution of the Royal College of Art, and its relations to the Schools of Art through the country", dated 3 July 1911, caused a sensation. The statistics appended to the document gave rise to the most concern: they showed that 33 per cent of the fee-paying students stayed at the College for only one term, a further 25 per cent stayed for only one year, and not more than 25 per cent of all students stayed long enough to complete their courses; they revealed that only 8 per cent of art teachers employed in the London Schools had been trained at the RCA (and only 5 per cent of teachers employed in Elementary Schools); and, most damaging of all, they suggested that of all the students who had graduated between 1901 and 1910, a mere 26 had become professional "designers and craftspeople". Clearly it was the understatement of the decade to conclude that "the College now suffers from being in imperfect touch with the local Schools of Art, and consequently finds some difficulty in fulfilling the exact place planned for it in the national system of education".

his time bringing in specialized lecturers on educational psychology and arranging for secondments to London Schools, the quality of the training would be greatly professionalized and greatly improved. One suspects from the tone of this that Ms Pankhurst and her delegation must have put over their point of view very forcefully indeed.

Turning to the School of Mural and Decorative Painting, the Committee noted that Professor Moira's "method is one of criticism rather than demonstration":

*He also exercises considerable freedom in allowing departures from the normal line of study laid down in the Prospectus, and does not regard it as inconsistent with the object of the school to permit students, of whom there are now not many, who desire to proceed to the Academy Schools, to increase the amount of time devoted to the study of the life at the expense of that devoted to decorative composition.*

But, that said, far too much had been made in the past of "the distinction beween fine and applied art" at the College:

*At bottom, the human instinct which leads to those diverse forms of expression which are comprehended under the notion of "Art" is the same instinct, however diverse the forms of expression may be; although it is true that the workings of this instinct are complicated in a so-called civilized community with many matters which are social and economic rather than artistic, so that in the end the approach to Art of a young lady who desires to paint impressionist landscapes is sufficiently far apart from that of a brass-worker who desires to model electric light fittings to constitute a difference which is almost one of kind rather than of degree.*

The College existed to educate fine artists, applied artists *and* designers – and the three had much more in common than critics often supposed: the key thing was to accustom young fine artists to working "under conditions".

But by far "the greatest divergence of opinion" had been expressed by witnesses to the Committee about the School of Design:

*The Professor's method is an individual one, and does not appear to lend itself to the formulation of a very definite course of study . . . The detailed criticisms which have reached us are numerous. It is argued that the students get an imperfect training in the historic styles of design. Again, it is maintained that they spend too much time in making imitative studies in the Museum and then acquiring a "stock-in-trade" of motives for future*

*use; and, as a corollary, that their exercises in inventive design lack originality and are pieced together from the models they have reproduced. In so far as they receive a definite artistic bent, it is described as "medieval" . . . The most serious criticism however, is no doubt that, in spite of the experience in "arranging for real work" which the Craft Classes afford, much of the inventive design remains impractical . . . It must be pointed out that it is on the side of designing for manufacture rather than for handicrafts that the School is criticised.*

The evidence before the Committee was certainly conflicting. The designers might complain that the emphasis of the course was too historical, that it could lead to "archaeology" rather than to "the formation of a personal style", but most manufacturers thought the opposite: "the public which they serve will have 'styles' and the Royal College of Art students have a wholly negligible knowledge of the history of design". The Committee itself thought that the College should take more account of the fact that "the methods of handicrafts have long been replaced by those of the factory": but the head of a major design studio (who "has been himself exceptionally successful in the training of designers") preferred to think that "design for handicraft just as much as design for manufacture, has to accommodate itself in a greater or less degree to the limitations and conditions imposed by the appliance used". But whoever was to blame for the mismatch, there was no getting away from the declaration of young Mr William Rothenstein, that "Art schools have been occupied in one direction and the trades in another". Or, to put it another way (as did the Calico Printers' Association in its submission to the Committee), "designs prepared in England supply the Indian market; those from Paris the markets of England, Europe and America".

The solution was *not* to turn the College into a facsimile of manufacturing industry: that would be far too expensive, and in any case, direct contact with "the industries most dependent on Art" (industries which could, perhaps, share the expense) was more appropriate for local schools of art which were near manufacturing centres; "each industry must be studied as a separate problem". South Kensington, for geographical if for no other reason, must have a different role. The solution was to increase the workshop element in all design courses, to encourage the student as part of his programme to "take part as an apprentice, so to speak, in work carried on under professional conditions as distinct from those of the studio" and, above all, generally to

work towards making the RCA "a place of research, providing opportunity for the highest specialisation in art and craft, and conducted to meet the fullest educational requirements of both the artist and craftsman".

Where these "fullest educational require-ments" were concerned, there was no divergence of opinion at all: the Committee had been convinced by all the Professors *and* the witnesses that at present "in far too many cases the students reach the College lamentably deficient in general education". Because the art education system ran in parallel with the general education system, a very large number of the students – even those who intended to become teachers – had left Elementary School at the age of 13, in order to "devote themselves solely to drawing". Add to this the widening gap between what was by now called "theory" and "practice" in courses taught at the College, and the result was, in the immortal words of the *Report*, that the RCA student's 'comparative illiteracy is too frequently a real bar to the efficiency of his teaching". The courses in the History of Art, Literature and Modern Lan-guages – all taught by one person, the Principal's brother Beckwith Spencer – had, not surprisingly "been attended with indifferent success" and were "quite inadequate to afford the literary discipline which ought to have been gone through at an earlier age". The answer was to impose "a test of literary as well as of artistic attainments upon students entering the Col-lege . . . for which a Secondary School education would prove the obvious means of preparation", and in future to teach courses which took these attainments into account.

By way of conclusion, the *Report* stated that:

*The Royal College of Art has done and is doing useful and important work, and although the development of the greater Provincial Art Schools now makes it possible to relieve the College of some portion of its present duties, we anticipate that the changes we recommend will rather add to, than detract from, its importance. As a Post Graduate College in close touch with Art Schools throughout the country, it will have for the first time a well-defined position as the culminatory point of the whole system of industrial Art training in England.*

Other art schools should, in future, train art teachers for their own localities – 40 per cent of all post-school art teachers were already trained in this way; the RCA should continue to train teachers, but in a more "professional" way than heretofore. Provincial art schools which were sited near manufacturing industries should be-come "monotechnics", a development which

would help to answer "the plea put forward by Mr William Rothenstein for some attempt to breath a new inspiration through the medium of Art into provincial life and to diminish the constant drain of talent to London". And, to accompany this policy of decentralization, the RCA should aim to offer "a higher and wider type of artistic culture than anything to which these schools can them-selves aspire". The 1911 *Report* was "presented to both Houses of Parliament by Command of His Majesty". But various members of the Committee and of the Board were unsure about its status and nervous about its contents. Sir Richard Morant, for example, had written that: "it would be hardly decent, would it, to refer to a Committee the fundamental question of what the Government ought to have in view as to the purpose of the Royal College of Art?" Was the *Report* expected to speak for the Committee, the Board or the Government itself? As it turned out, they were right to be nervous. The *Report* was greeted with a torrent of criticism.

## SHOULD WE STOP TEACHING ART?

Well-known painters who had been connected with South Kensington – including Hubert von Herkomer, Edward Poynter, Luke Fildes and George Clausen – sent a memorial to the Prime Minister, Asquith, stating that:

*The whole question of art education has now reached a stage at which it is imperative, in the interests of the nation that it should be dealt with by a* comprehensive inquiry conducted by Royal Commission.

Walter Crane complained to *The Times* that:

*The recent Departmental Committee on the Art Schools was mainly composed of men more or less hostile to the Government Art Schools and the Royal College of Art . . .*

Augustus Spencer, in a letter to the Board, called the *Report* "to my mind one of the most wrongly framed and delusive documents ever published under the imprimatur of a Government office". He went on, rather lamely, to question the statistics about the destinations of teacher-training students:

*Since its reorganisation in 1900, 50 students of the College have been appointed Head Masters of Art Schools in the United Kingdom, the Colonies and Egypt . . . Four students have re-ceived appointments as Art Inspectors, three ex-students as Art Masters at Public Schools and the London County Council Schools are largely staffed by students of the College.*

And yet, on the basis of misleading information, "it is proposed to remove one of the fundamental reasons for the existence of the College".

Spencer did not mention, for fairly obvious reasons, the other "fundamental reason" for the College's existence, the training of designers for industry. Apart from a few well-known names such as Ramsden, Carr, and Lyndsay P. Butterfield, the Royal College had not produced very many professional designers of note since the days of Walter Crane: Léon Solon had become a designer for Minton's (specializing in slip-trailed *art nouveau* decoration), and Gordon Forsyth had become an art director of Minton's (1901-5) before moving on to the Pilkington tile and pottery company (1906-15); Margaret Chilton had become a senior partner in Chilton and Kemp Stained Glass Works, Edinburgh; John Dearle had become an art director for Morris and Company; E. B. Wilson was to become a distinguished silversmith, making an alms dish from a design by Eric Gill for the Goldsmith's Company; Frank Dodd had become an illustrator for the *Graphic* and Harry Oakley was beginning to design posters and advertisements for LNER, HMV and Bird's Custard, before becoming a well-known illustrator; Charles Sykes was to design the Rolls-Royce bonnet mascot and, later, the Gold and Silver Cups for Royal Ascot; and George Wolliscroft Rhead, a member of the Art Workers' Guild who designed, among many other things, Queen Mary's Coronation Fan, was in the process of publishing a series of design guides, popular in Schools, including *Elementary Drawing and Design* (1902), *Studies in Plant Form* (1903), *The Principles of Design* (1905), *Chats on Costume* (1906) and *Modern Practical Design* (1912). But, even taking these twelve successful careers into account, Augustus Spencer was not in a strong position to make much noise about the *Report*'s extraordinary statistic – that only 26 College alumni had become "designers and craftsmen" in the first decade of this century.

C. R. Ashbee, who wrote *Should We Stop Teaching Art?* as a contribution to this debate, also noted that the students listed as "unknown" in the *Report*'s survey "may for aught we know be practising Art", and in any case "it has been argued that much general education in Art has been given irrespective of livelihood, which we need not deny". But he reckoned that the *Report* was correct when it noted "how many good craftsmen are turned into Art Schoolmasters and give up their craft as a consequence. They jump at the chance because it gives them a better livelihood"; and the allied point, that art teachers had never really adjusted to the implications of industrialization was, he added, well made.

Ashbee's main interest in the matter was that the stir created by the *Report* could well provide an excellent opportunity to consider *his* proposal that: "much of the public money now spent in futile teaching might be better spent in the endowment of artistic workshops, where this teaching would be more efficient than it is at present . . ."

The Arts and Crafts Movement, he went on, had been "the first consistent attempt to give expression to the Arts under the conditions which machinery imposes": but the development of the Arts and Crafts "has been arrested, during the last ten years, in the country of its birth. The principles of the movement are now more consistently and logically studied in Germany and America". Maybe his plans for state subsidised "artistic workshops" could do something about that. Incidentally, Ashbee's more down-to-earth colleagues at the Art Workers' Guild were to satirize his attempts to get involved in abstruse discussions about educational policy at their annual revels, the craftsmen walked on carrying a huge book with the title *Should Ashbee Stop Teaching Us?*

As his contribution, F. P. Brown put together the first full-length history of the College, *South Kensington and its Art Training* (1912), complete with a preface by Walter Crane: actually, it was more of a polemic than a history since its main purpose seems to have been to show that the Departmental Committee meddled with such a distinguished institution at its peril. The low number of College-trained designers could be explained away by the old-fashioned attitude of the industries who should have been employing them: "Industry will not adequately pay Art; as a matter of fact she looks down upon her as a flighty, impractical creature . . . In the majority of firms in the Potteries, they do without designers rather than pay them properly".

This was an argument which appealed greatly to those contributors to the *The RCA Students' Magazine* who commented on the *Report*. Their view, expressed in characteristically camp fashion, was that the findings in the Departmental Committee had merely "opened our eyes to the abyss of official jobbery and chaos, on the verge of which we dwell, placidly engaged upon our 'poker-work'". They went on:

*To change the present state of things, to decentralize South Kensington and condemn you artistic suckling to work out his salvation in Glasgow or Liverpool in an atmosphere of cotton and machinery, with only* The Studio *to help point the way to Heaven? What does it all mean? What is at the back of the official mind?*

*Above Louis Solon, the famous Minton designer who encouraged his son Léon, a ceramicist at the RCA.*

The references to Glasgow and *The Studio* were parochial even by the standards of a *Students' Magazine* which seems to have specialized in ignoring any developments which happened beyond the confines of Exhibition Road: for Glasgow School or Art, as *The Studio* never tired of pointing out, was going through its golden age in precisely the years covered by the *Report*. But one student fulminated against the suggestion that centres such as Glasgow might be best placed to train local teachers and, more to the point, designers for local industries:

*Though artistically London is purgatory, for some the provinces are hell, from which nothing can escape . . . Have we no word in all this? Must we remain passive, and wait for the upheaval that may or may not come? It is chiefly with those who are in search of life that I am in sympathy; and in London there is a certain amount of articulate life – sufficient to wake very light sleepers, at any rate. There is only the sound of snoring in the provinces.*

The plain fact was that the Royal College of Art had undergone a *social* change since the days of Henry Cole and the Victorian reformers. There was no point in pretending that its primary function, in the early part of the twentieth century, was to provide artisans with an understanding of the principles of design, for that was no longer the case. According to the *Students' Magazine*, "the provinces" could deal quite adequately with that side of things. The College's primary function was to provide "your artistic suckling" with a stimulating environment – made up of museums, galleries, and lively teachers – which would also allow him to have a good time.

In many ways, the response of the *Students' Magazine* to the report was the most revealing of all. And at least it made a change from the old arguments which had been clanking around since 1837.

But as it transpired, *all* these various reactions turned out to be premature. The *Report* may have been radical in implication but very few of its proposals were to be implemented in the foreseeable future – indeed, according to Walter Crane, "the new syllabus was more academic than ever", and according to W. R. Lethaby, there was soon to be "a re-emergence of the catalogued styles". The main historical significance of the *Report* is that for the very first time it provided the Royal College of Art with a "well-defined position as the culminatory point of the whole system" or, in other words with the position as a "Postgraduate College" which it occupies today – even though the concept of "postgraduate" has changed beyond all recognition in the meantime. The

specific recommendations on design teaching of a specialized kind, on the role of the workshop and the studio, and on "the fullest educational requirements" were not to become real until the late 1940s: and it also took nearly forty years for the College to shed its "duties" as an establishment for the training of art teachers.

One of the *Report*'s recommendations – that the College was seriously in need of "new buildings" – was *very nearly* acted upon by the Board of Education. Since 1910, when the complex of buildings which are the Victoria and Albert Museum had been completed, the College had been formally separated from the Museum for the first time since the invention of "South Kensington". A minor effect of this was that, instead of getting clerical support from the Museum, the College had to send the bulk of its typing to Whitehall – which caused considerable delays: also, the separation of the two institutions revealed the existence, to everyone's surprise, of an attendant who for years had been paid by the College but worked in the Museum! A major effect was that if the College at any time wanted to expand, it would require accommodation away from the Museum's South Kensington site.

In January 1912, the Departmental Committee urged the Office of Works to purchase the piece

**1896-1940**

of land opposite the Victoria and Albert known as the "island site". "The College of Art", it stated, "is now too overcrowded and its accommodation quite insufficient and steps should at once be taken to provide more suitable premises . . . The existing conditions materially increase the difficulty of warding the Museum against burglary." The Design room was so cramped that the students *had* to be sent to work in the galleries of the Museum, in shifts. It was difficult to think of the existing accommodation as "a College" at all: it consisted of some rooms at the back of the Victoria and Albert Museum, a Lecture Theatre in the Natural History Museum and a few sheds "or iron and wood construction" between Exhibition Road and Queensgate, which were liable to be demolished when the new Science Museum building went up. These sheds, it was said, had been originally built for Crimean War casualties.

On 5 November 1912 the Department formally proposed to re-locate the College in its entirety – as well as a gallery for "the King's Indian presents" – on the triangular island site which by then belonged to the Office of Works. The cost of the new building was estimated to be £65,000, with a further £7,500 to adapt the buildings behind the Victoria and Albert for the future development of the Museum. These figures were thought by a Cabinet Committee to be "rather excessive". Nevertheless, in January 1913, Beresford Pite was asked to produce preliminary plans which would also permit the students to carry out some of "the decorative work". He would, of course, not receive a fee for the plans. Later in the same year, £65,000 was allocated to the Royal College of Art, under the terms of the Public Buildings Bill, and Pite's designs were approved by the Board of Education. For the first time ever, it looked as though the entire College would be moving into a set of specially designed buildings.

But with the outbreak of the First World War all progress was halted – and the island site was used by the military authorities until 1919. The proposal to move the College into its own new buildings was postponed for over forty years – and those sheds are still "liable to be demolished" at six months' notice.

## SCULPTURE IN WAR AND PEACE

Only one area of College activity – the School of Sculpture and Modelling – had been exempt from all criticism in the 1911 *Report*, which simply stated:

*Professor Lantéri continues the tradition established by his predecessor Jules Dalou, and the reputation of the School and of the teachers whom it sends into the country has for a long time past received the general recognition of artists.*

In 1913, the School received a great accolade when Auguste Rodin dropped in for a much-publicized visit, and professed to be "delighted with all the students' work I have seen". After spending a day in South Kensington, Rodin was taken out to dinner at the Holborn Restaurant by the Modelling students – with Alfred Gilbert, their local hero, in the Chair.

One of the ex-students present may well have been Charles Sargeant Jagger, who in 1907 had been awarded a Scholarship by West Riding County Council to study at the RCA, and who had completed his course in 1911: since then he had worked as Lantéri's Studio Assistant at the College and taught modelling part-time at Lambeth School of Art.

Jagger, the son of a Sheffield Colliery Manager, was apprenticed to Mappin and Webb as a metal

---

THE INFLUENCE OF LANTÉRI

The School had been steadily transformed by Lantéri from being, in the words of one student, "made up chiefly of plaster casts, young gentlemen from the provinces, and retired military officers" into becoming the cradle of the "new sculpture" (through Alfred Drury and disciples) and the best place to train as a teacher of modelling: ex-student James Thomas, for example was to become the first Professor of Sculpture at the Slade in 1915. Above all, the students from Lantéri's school had, through their work and their teaching, established for all to see that sculpture could be treated as three-dimensional decorative design. Even the Royal Academy eventually accepted that this important development had taken place, from 1901 onwards.

It wasn't that Lantéri had particularly advanced views: "The student", he said in an interview with *The Art Journal* "needs only to study three heads for his busts – 'The Head of Lucius Verus', a Graeco-Roman antique; Donatello's 'Lawyer'; and the bust and features of Michelangelo's 'David'. These three possess all the qualities desirable for the study of form." And he didn't believe in the use of elaborate modelling tools: two turn-tables, two wooden boards for transferring, three spatulas, a pair of callipers and a piece of sponge were the most that was required: "The human finger is more firm, and at the same time more sensitive than any mechanical instrument. It is nature's spatula, and should be used in preference to anything else." His simple method, he concluded, was like a mariner's compass which "gives my pupils confidence in themselves".

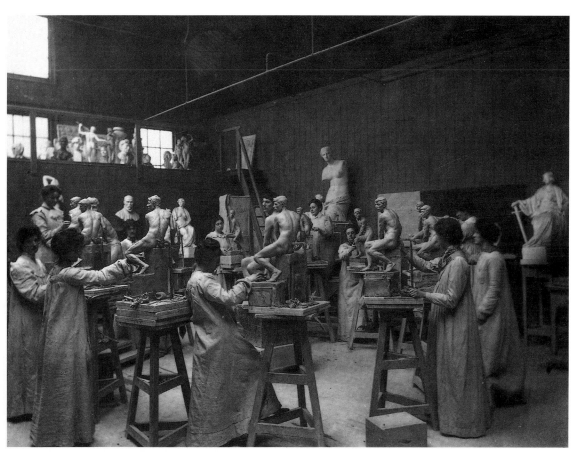

Above *Classroom in the School of Sculpture and Modelling, around 1905. The School was at that time in the charge of Professor Lantéri.*

engraver when he was 14, and taught his craft at Sheffield School of Art during 1905-7. His Scholarship at the Royal College of Art brought him into contact with bright young sculptors for the first time – including his fellow student Gilbert Ledward – most of whom came from a very different social background to his own: *they* were "RCA men". Jagger's only contact with the place before autumn 1907, was a copy of volume one of Lantéri's book *Modelling*, which he read after long days teaching apprentice metalworkers.

He was later to write, from personal experience, that:

*A student sculptor has chosen the most exacting, the most arduous and the least appreciated of all the arts. Financially the future will be a gamble, with the odds against him. . . . In return for the misery, fatigue and despair, of which he may have more than his fair share, (sculpture) will fill his whole life with an absorbing passion to which all other worldly joys will minister as a foil.*

If these seem to be the sentiments of a down-to-earth Yorkshireman with a strong streak of romanticism, Jagger's work at the RCA dramatically confirms them. When he was photographed as a student, he adopted a soulful, *aesthetic* look – complete with centre parting, floppy bow tie and huge white collar. He was a regular contributor, with a group of friends, to *The RCA Students' Magazine*: pencil drawings, flamboyantly signed C. S. Jagger, of Professor Lantéri, of Mr Francis "the modelling toolmaker at the RCA for over forty years" and of other South Kensington characters appeared full-page in successive issues. His projects for the "literature" course – including an illustration to the *Rubaiyat* of Omar Khayam in the style of Rackham – were madly *fin de siècle*.

In 1913 he was among the four sculptors shortlisted for the very first *Prix de Rome* in Sculpture: two of the others on the shortlist – Gilbert Ledward and Harold Brownsword – were also from the RCA. Ledward won the Scholarship to the British School at Rome that year but in 1914 Jagger tried again with a bronze relief of a *Bacchanalian Scene*, and this time was unanimously selected. Almost exactly two months later, Jagger gave up his Scholarship – which meant a very great deal to him – to enlist in the

85

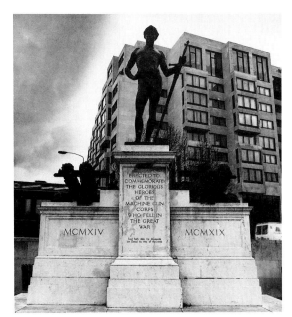

Above *Derwent Wood's monument to the fallen of the Machine Gun Corps, unveiled in 1925.*

Artists' Rifles. He did so at the same time as twenty-one current students and eighteen students from the recent past "laid aside the brush for a while to wield the sword" (as the *Magazine* characteristically put it). It must have seemed at the time a very romantic thing to do.

As it transpired, active service at Gallipoli and the trenches of the Western Front changed the whole direction of his life and his work. A legend, much circulated at the time, had it that when he was shot through the left shoulder in November 1915, only the girl who was nursing him – who happened to be George Clausen's daughter, a friend of his from College days – prevented his arm from being amputated. Actually they met again *after* he had recovered.

At the end of the war, and after he had been awarded the Military Cross, Charles Sargeant Jagger managed to persuade the assessors at the British School at Rome to give him a year's grant for work on an "approved subject" (as a substitute for his 1914 Scholarship). His chosen subject was *No Man's Land*, an ambitious bronze relief, and it turned out to be the first of many war sculptures – reliefs, statues, and memorials – which he produced between 1919 and his tragically early death in 1934. The best-known, and they are among the finest examples of public sculpture in the realist tradition this century, are his *War Memorial* at Hoylake, Lancashire (1919-22), his *Tommy Reading a Letter* (1922), located on Platform One of Paddington Station, and, above all, his monument to the fallen of the *Royal Artillery* (1925), at Hyde Park Corner. Only Gilbert

Ledward, with his Guard's Memorial on Horse Guards Parade, could even claim to be in the same class.

"South Kensington" had, in fact, educated two Victorian artists who produced the most popular military paintings of the nineteenth century: Hubert von Herkomer, whose *Last Muster* (1875) showed a congregation of Chelsea Pensioners, many of them on their last legs; and Elizabeth Thompson (Lady Butler) whose *Roll Call* (1874) showed a dark battalion of wounded Grenadier Guardsmen after an engagement in the Crimea, and whose *Scotland For Ever!* (1881) showed the

Below The Sentry *by Charles Sargeant Jagger, a prize RCA student just before World War I.*

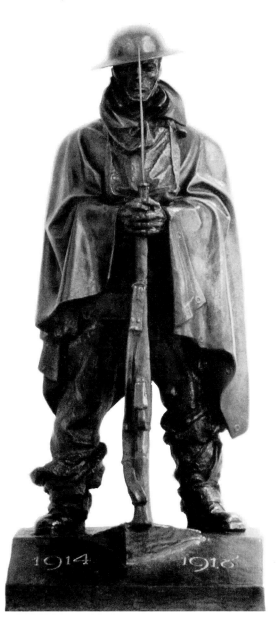

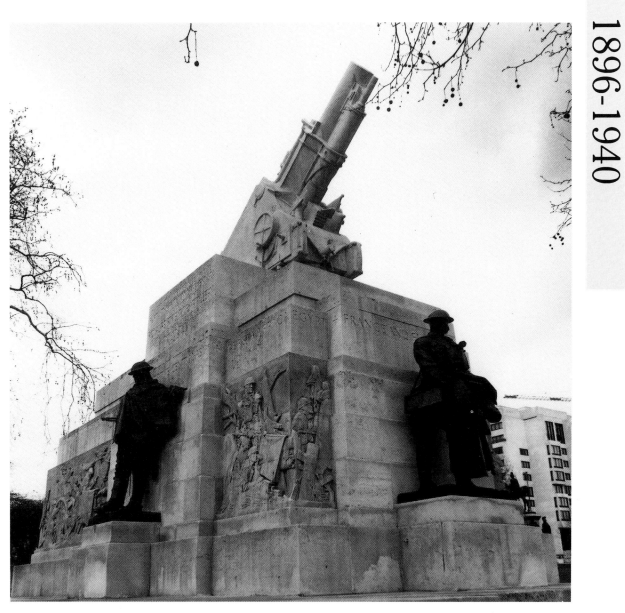

*Above Charles Sargeant Jagger's Royal Artillery Memorial (1925) situated at Hyde Park Corner.*

Royal Scots Greys at Waterloo charging towards the viewer. These were among the now legendary paintings which had to be cordoned off, when first exhibited, to keep the crowds at bay. But Jagger's sculpture in stone of a 9.2 inch howitzer, guarded by four bronze figures, on a pedestal covered with elaborate reliefs, was something else again. It was more than just an example of uncompromising realism (which proved very controversial at the time), the product of Jagger's own experience of the horror of war; it was, in the words of a recent critic, "a violent gesture of rebellion against the aesthetic cliché embodied by its neighbour, the langorous nude *David* by

Derwent Wood, which commemorates, with sickening irrelevance, the dead of the Machine Gun Corps". Francis Derwent Wood had also attended South Kensington, as a National Scholar, and assisted Legros at the Slade. He had produced several decorative sculptures of some distinction, school of Alfred Gilbert, such as the work of 1899 that had been commissioned by the Glasgow School of Art. He was to take over from Lantéri as Professor of Sculpture at the Royal College of Art between the years 1918 and 1923. However, Derwent Wood's memorial to the Machine Gunners (1925) was merely an example of how to convert "the new sculpture" into a formula that was ultimately empty.

When the *Students' Magazine* resumed publication in 1924, after a gap of several years, it

---

### THE CLIMATE OF WAR

The dramatic change which Charles Sargeant Jagger experienced as a result of the First World War – from romantic to realist – was also experienced by many of the students back home, to judge by the *RCA Students' Magazine*. In Autumn 1914, the *Magazine* tended to treat the whole affair as something of a joke:

*Last Friday a wild rumour spread among the men and naturally caused some bitter feeling. The ladies, we were given to understand, had organized a meeting to practise barricade and entanglement construction. The men felt it was hardly fair, when the Red Cross afforded plenty of amusement, with the immediate prospect of Zeppelin bombs. We have great pleasure in being able to state that Friday was merely the ladies' knitting meeting, and the easily mistaken scene was the winding of wool.*

But by spring 1915, the atmosphere of the *Magazine* had changed. There were references to "the termination of Beethoven recitals at lunch time", and to a lecture on German design having "met with a mixed reception". A letter from a fellow student who, like over fifty others, had by then joined up – with the promise that they would not lose their Scholarships – was printed in its entirety, from the Western Front. The student, Corporal T. H. Jenkins, was trying hard to be cheerful:

*Somewhere in the small hours of the morning the sides of our trench began to fall in, a steady rain falling meanwhile, and two of my section temporarily disappeared. Under cover of darkness we smuggled in some planks and poles and propped things up again.... One of our chaps slipped off the bridge the other night, and it was a two hours' job to get him out of the mud, and in the dark too.*

---

featured on the first page a drawing of the bronze memorial plaque by Percy Metcalfe which had recently been unveiled on the main staircase of the Exhibition Road building. It showed five soldiers bearing a dead comrade on a stretcher, and beneath this image, the names of twenty-six students ("and all others") who never did return from the Dardanelles and Flanders to take up their Scholarships. The figure who is lying on the stretcher under a groundsheet, was posed by George Stephenson – a modelling student who had served during the latter part of the war in the Royal Flying Corps: the same George Stephenson who was assistant to Charles Sargeant Jagger, when they worked together on the modelling that went into the Royal Artillery Memorial at Hyde Park Corner.

## A BOLT FROM THE BLUE

*The new spirit was sometimes trying. There stood the model, one of a succession of marvellous figures, each a miracle of form and colour. But God's work was no miracle to some students, who looked rather at Cézanne's and Picasso's. Cézanne's French progeny might legitimately be called, after their father, ces ânes; but these later ones I named, ces mulets, for they, I knew, would have no progeny, and, my goodness, they were obstinate! Yet from teaching, whether helpful or not to my students, I learnt many things.*

From *Men and Memories*, the memoirs of William Rothenstein

By the time William Rothenstein was appointed Principal of the Royal College of Art, in 1920, Max Beerbohm had known him well for over twenty-five years. They had first met when 'Will' returned from *fin-de-siècle* Paris, and a course at the Académie Julian, to visit Oxford – where he began a series of lithograph portraits which were later to be published as *Oxford Characters*. Max was to describe, in characteristic style, what Rothenstein was like at this time:

*In the Summer Term of 1893, a bolt from the blue flashed down on Oxford. It drove deep, it hurtlingly embedded itself in the soil. Dons and undergraduates stood around, rather pale, discussing nothing but it. Whence came it, this meteorite? From Paris. Its name? Will Rothenstein. Its aim? To do a series of twenty-four portraits in lithograph ... dignified and doddering old men, who had never consented to sit for anyone, could not withstand this dynamic little stranger – he could not sue, he invited; he did not invite, he commanded. He was twenty-one years old. He wore spectacles that flashed more than any pair ever seen. He was a wit. He was brimful of ideas. He knew Whistler. He knew Edmond de Goncourt. He knew everyone in Paris. He knew them all by heart. He was Paris in Oxford.*

One of those who "consented to sit" was a young Fellow of New College, the historian Herbert Fisher, who had first met Rothenstein in Paris. As President of the Board of Education, that same Herbert Fisher was the Minister (recently appointed by Lloyd George) who wrote to William Rothenstein in May 1920, offering him the post. A great deal had happened, in the intervening years, to the young Bradford-born artist who drew all those "dignified and doddering old men": more collections of portraits, of the great and the good; a series of magisterial paintings of life in the Whitechapel synagogues; a spell with Sickert's Fitzroy Street Group; regular exhibitions at the New English Art Club; rows with Roger Fry

over the Post-Impressionist exhibition; drawings and paintings of war-torn France and Flanders; and, in 1917, the first Professorship of Civic Arts at the University of Sheffield (where Fisher, his patron in such matters, was Vice-Chancellor).

William Rothenstein had, by 1920, thoroughly distanced himself from the "art for art's sake" of the 1890s: he had strong views on what today we would call community arts, he had become the champion of regional art colleges, and if his own taste in art tended towards the conservative (to put it charitably) he had done a great deal to help the rising generation of painters and sculptors – including, most notably, Paul Nash, Eric Gill and Jacob Epstein.

But for Max Beerbohm, who had successfully got away from it all by settling in the Villino Chiaro, at Rapallo, the distance between the 1890s and the 1920s was not quite so evident. He had heard the news of Rothenstein's appointment from the stage designer Edward Gordon Craig, in July 1920, and immediately sent "dearest Will" an imaginary reconstruction of the conversation:

M.B. *Oh really? South Kensington... the Museum?*

E.G.C. *No – not the Museum so much – you know (with a sweep of the arm). The place. Whole thing. School. Telling them what to do.*

M.B. *I see, yes, but – telling whom?*

E.G.C. *Everybody. What to do and what not to do. Great fun. Students.*

M.B. *Ah – yes. What's the post* called?

E.G.C. *Professor – King – Director – Governor – something of that sort.*

M.B. *Director, I should think, perhaps?*

E.G.C. *And I suppose it isn't honorary? I mean, is there a salary attached?*

E.G.C. *Oh yes – surely. All the jollier! etc. etc. etc.*

*I was glad, but bewildered, until a day or two later I saw the announcement (evidently not written by Craig) in the weekly edition of* The Times... *I hope the Moiras and Derwent Woods and others already on the premises won't be a bother. They are very good fellows, of course. But then, very good fellows are sometimes the hardest of all to deal with: they are so apt to suspect that one isn't a good fellow oneself. However, I'm sure all will be well.*

Rothenstein's reply to Max was:

*Yes, I am to have a salary and Poynter's old studio at South Kensington to work in, and the welfare of a large number of men and women to look after, and various Professors, mostly*

Above *Self-portrait by William Rothenstein, who was Principal of the College from 1920 to 1935.*

*academicians, among whom to take my exercise delicately. The art-masters are crying "Bolshevism" and questions have been asked in the House of Commons. If anything could convince me that the spectre of Revolution need never trouble the dreams of Englishmen, it would be the fact that this baldheaded, elderly middle class and almost academical painter, who is myself, should be hailed as a dangerous young féroce by the teachers of our artistic provincial youth.*

If Rothenstein's letter was a lot less "jolly" than Max's imaginary conversation, this may have been because the whole question of his appointment as Principal was, at the time, no laughing matter. Rothenstein knew the College well: he had given evidence to the 1911 Committee (which was quoted verbatim in their *Report*), and in January 1919 had been made, by Fisher, the official Visitor with special responsibility for Painting. As Visitor, Rothenstein had made it very clear to the Board that, in his view, the main weakness of the College was that it was expected to produce art teachers rather than artists: "only where the art school is training for a *specific purpose* can it be useful". But, as things stood, the post of Principal was usually expected to be offered to a qualified teacher (preferably a Headmaster from one of the provincial schools, as the final rung in the career ladder), and

certainly expected to be offered to someone who knew a great deal about design. Rothenstein was lacking in both departments.

Augustus Spencer reached the retirement age of 60 in April 1920, and the Board of Education started looking for his successor from early 1919 onwards. Their first choice was Mr S. J. Cartlidge, who had been a modelling instructor at South Kensington, had subsequently been a Headmaster, and was currently Chief Inspector of art education: since Cartlidge was near retirement age himself, it was suggested by some civil servants that he be appointed for one year only, 1920-21. In March 1919, W. R. Davies (the College's "immediate chief" at the Board) wrote to William Rothenstein, in his capacity as Visitor, to ask what *he* thought about the succession. Rothenstein replied that Arthur Gaskin, of Birmingham School of Arts and Crafts, seemed to be the best qualified candidate, but might not be able to cope with the administration of the RCA. A figure like Legros (in the past) or "like Professors Lethaby or Tonks" were what the College really required. Rothenstein went on:

*Such teachers are rare. I have been thinking over all the men I know and there are two who have the necessary power, but who would not I fear either accept or be acceptable. Augustus John would make an admirable teacher; he has great knowledge and sense of leadership. But there are difficulties in the way of his fitness for the post. Wilson [Steer] has wide vision and fine ideals, but I cannot help feeling him to be less reliable when organisation and precise work are needed. Tonks would not leave the Slade, nor would Harvard Thomas. Clausen and Lethaby are neither of them likely to take on so large a task...*

Clearly, Rothenstein did not consider that the conventional approach to the appointment was necessarily in the best interests of the College, and Davies, like the cautious civil servant he was, still wanted to play it by the book. So when Davies received the inevitable memorandum from Fisher, his response was cool:

*The President has asked me to submit my views upon the question of appointing Professor Rothenstein for at least a limited period as Principal of the Royal College of Art. I know nothing of Professor Rothenstein's work as a teacher or of his capacity for such business as would fall to the Principal if the present system continues.*

Furthermore, he went on, there was the question of how the candidate might fit in with existing members of staff: "[Professor Derwent Wood] is

the most vigorous member of the staff and I am sure he would chafe at any change in his present relation to the Principal."

Would Rothenstein have the experience to teach the courses on "how to teach art" which Augustus Spencer had always undertaken? "It is this complication about pedagogy that makes me doubtful about the wisdom of appointing Professor Rothenstein."

At the end of April, Rothenstein had an informal interview with Herbert Fisher and Sir Amherst Selby-Bigge, the Permanent Under-Secretary, during which he reiterated the points he had made to the 1911 Committee, discussed the issue of "public work of use to the community", and he added some more detailed thoughts on the RCA's role: he summarized these in a letter to Fisher on 18 June. The College was, he believed, "established to foster and strengthen the arts of design in this country". But there had been a tendency of late "to regard the College first and foremost as a training school for future teachers of art . . . It is unfortunate that it has not always attracted the best type of student".

The solution to the College's dilemma was emphatically *not*

*to limit itself to the education of designers and teachers and industrial craftsmen, while schools elsewhere would provide training for students of fine art... The separation between craftsmen and artists is already too wide. Each has lessons of value to learn from the other. The craftsman's education has tended towards a somewhat doctrinaire pedantry of a pseudo-medieval character, while the painter's training has been based too exclusively on the study of the single human model... Nor is it desirable to define and to limit, early in a young aspirant's career, his future activities. From the practice of the arts of design a fine artist may develop naturally; while too many men and women become indifferent painters whose gifts are better fitted for more modest and useful work.*

If Fisher and Selby-Bigge were surprised to hear industrial design categorized as "more modest and useful work", they were not about to show it. On 13 May, they offered Rothenstein the post. "I shall feel it a privilege to serve in the capacity you propose", he immediately wrote to Fisher. "I am well aware of the greatness of the task and of the limitations of my equipment, but I hope I shall not be wanting in drive or zeal."

At Rothenstein's request, the post was offered on a part-time basis (three days a week) – he would not be expected to teach Method, as Spencer had done, and he would be relieved as far as possible of heavy administrative duties – in

the first instance for a period of three years. The salary would be £900.00 a year, with no pension, and he would continue, for the time being, as Professor of Civic Arts at Sheffield.

Selby-Bigge lost no time in offering a word of advice (with a copy to the Treasury, who would be expected to foot the bill): "it is extremely desirable that new blood and new ideas should at once be infused into the staff of the College . . .". Easier said than done. In his first few years as Principal, Rothenstein was to offer "new blood" appointments to both Eric Gill and Jacob Epstein. Gill turned the offer down, on the bizarre grounds that "I am not of one mind with you and the aims you are furthering at the College, and, may I whisper it, I think there áre far too many women about"; besides, he was very much afraid that he would be unable "to keep God out of it".

Where Epstein was concerned, Selby-Bigge himself would not hear of it: it would be

*a very perilous experiment and might cause us considerable embarrassment. For a Professor we*

*would want not only a genius (as to which I am no authority) but also* character; *and I am not sure that character in a place of this kind is not of greater importance.*

At a time when the Royal Academy itself wasn't exactly rushing to Epstein's defence, Rothenstein's suggestion had been a brave one. In fact, it was not until spring 1955 that the College had any formal relationship with Jacob Epstein, when it lent him a huge studio to work on the sculptures *Social Consciousness* and *Christ in Majesty*: Epstein was to note that "there is quite some talent here, and they seem to like my being here", and the staff and students returned the compliment by publishing a small book on his work in progress. But in the early 1920s, the Board of Education was, quite simply, terrified at the prospect.

Rothenstein did, however have better luck with his new appointments to the Schools of Painting (which had, by now, dropped the adjective "Decorative") and Design. He personally took over the running of the Painting School in 1922, when Gerald Moira left to become Principal of

Below *Poster designed in 1936 for London Transport by Barnett Freedman.*

**1896-1940**

Edinburgh College of Art, and again in 1930: both of Rothenstein's periods as acting Professor were accompanied by generous (and much-needed) infusions of "new blood". In his early years, Allan Gwynne-Jones (of the New English Art Club), Leon Underwood (ex-RCA), William Simmonds, Edward Allston (ex-RCA), Walter Monnington, Randolph Schwabe (ex-RCA) and Cyril Mahoney (ex-RCA) were all brought in as part-time Instructors; from 1930 onwards (after Gwynne-Jones had been Professor for one year, and had moved on to the Slade to give support to his friend Randolph Schwabe), Barnett Freedman, Alan Sorrell, Percy Horton and Gilbert Spencer – all ex-RCA students – were to become the new generation of painting Instructors.

If during Rothenstein's first period, the School was seen to rival, and even to improve upon, the Henry Tonks and Wilson Steer regime at the Slade, in the second period it settled down to a new identity of its own – Fine Art in a context of Design. In the Design School itself, the key tutorial appointments of the early and mid-1920s – all of which were to prove very influential indeed, in the long term – were William Staite Murray (pottery), Reco Capey (textiles), Martin Travers (stained glass), Paul and John Nash (general design).

## "QUITE A DIFFERENT PLACE"

Rothenstein was keen to develop within the College the concept of the part-time tutor who was also a practising artist or designer – and most of these appointments were made on that basis. The "pseudo-medieval" character of the Design School was partly to do with the fact that some of the teachers had, over the years, transformed themselves from active members of the Art Workers' Guild into career academics: given the shortage of space and equipment in South Kensington, there was a great temptation to devote all one's energies to the question of how many craftspeople could stand on the head of a pin. But the part-time concept, when introduced throughout the College, brought with it a new kind of tension. Paul Nash, for example, resigned what he called "my usher's job" at the College in 1925 because:

*When I was a painter I had the evenings for amusing myself, now I'm a bit of a painter and a pedagogue and a lecturer and a designer for the theatre and for textiles and a plugging engraver to boot. But it won't do.*

Actually, Nash was to return to the College in 1938 (again to teach design), after his first stint during the academic years 1922-5 – but he always had the feeling that "pedagogy" wasn't quite like the real thing. In his outline for an autobiography, this aspect of Nash's life merits just ten words: "I became an instructor in design, Royal College of Art."

It was a feeling that even Rothenstein, in moments of doubt, tended to share. He wrote on 25 October 1922 that:

*The disloyalties and smallnesses and stupidities of older men are shut out when one closes the door on oneself, but at times they leap unpleasantly on to us when we emerge into the corridors.*

Not just "older men" – he also tended to "close the studio door" on the more avant-garde students who dared to smile at his endless reminiscences of 1890s Paris.

But Max Beerbohm's famous caricature of Will's "old self" being told to take off his top hat by his "new self" did express a tension which runs through the Rothenstein autobiographies: he clearly saw himself as a painter first, a Professor second, and was always concerned that his duties at the College would marginalize him from the art world. On 25 August 1931, Paul Nash (who understood the dilemma well) tried to reassure Rothenstein about this – by making use of a symbol that was destined to play an important part in College history from the post-war period onwards. This was probably its first appearance in the context:

*As for being left out and forgotten, my deal Will, it comes to us all in time. Then when we are dead we rise like the Phoenix from the bitter ashes. Perhaps we shall be able to see ourselves taking that triumphant flight – who knows?*

By this time, Rothenstein had firmly established himself as Principal, and his dual policy – "training for a specific purpose" combined with "the best possible general education through the arts" – had already taken effect. But when he was first appointed, this new definition of the College's role vis-à-vis the art education sector as a whole was the cause of much controversy. Art Teachers' organizations from all over the country wrote in to complain and some threatened to demonstrate. There was even a question in the House by the Member for Aberdare. Fisher contented himself with writing "What impudence!" in the files and left it at that.

By 1925 even those Civil Servants who had reservations about Rothenstein's appointment were *beginning* to accept that he had "made the College into quite a different place". But in what sense? Well, the students' perception of it – particularly in the Fine Art Schools – had certainly

altered. John Rothenstein, the Principal's eldest son, was to write his impression of what the atmosphere was like at the time his father took over:

*... the place had the look – and even the smell – not of an art school but of an inferior elementary school: the members of staff whom I happened to see resembled clerks, the retiring Principal wore a morning coat, and the students seemed to have sunk into apathy ... My father's dynamism ... had a most fruitful theatre of action in the College. In no time at all artists were appointed in place of pedagogues to teaching posts (then a startling innovation resented by the art teachers' organisations), and a generation rich in talent was gathering in the classroom.*

Even allowing for the time-honoured tradition in the College (which has survived from 1837 right up to the present day) for every single new Principal to announce his presence by launching all-stops-out attack on the achievements of the previous regime, there is no doubt that the atmosphere did change – in a fairly dramatic way.

Rothenstein tended to look upon the College

*as a centre which serves, not so much to give vocational training, as to give each student, whether he intends to be a simple designer of cotton fabrics or an ambitious painter or sculptor, the best possible general education through the arts ... I believe we should concentrate on work which can be done more efficiently at the Royal College of Art than elsewhere.*

One of his first reforms, in September 1920, was to upgrade Sir Frank Short's engraving course to become "a whole time school of the College" (supplementing the other four), and to incorporate within it new classes in wood-engraving and lithography. Since the Board of Education agreed that "it is not possible for the intending students to get their further instruction in etching and engraving at other institutions in London already existing", the change was soon to be formalized. Early in 1924, the Principal was invited by Sir Charles Trevelyan to visit the equivalent institutions in Prague, Sweden, Berlin and Paris, and to write a report on *Continental Art Education*: he returned convinced that "wood-engraving and book illustration" should play a central part in the life of the College, that the more advanced students should be treated as young professionals – if possible, with studios of their own, so that the Painting School could approximate to "the fifteenth century bottega" as a member of staff put it – and that, instead of spending their final year preparing to become teachers, the students should be involved in real world projects for

---

A NEW ERA

Under the new management of Rothenstein, the rule-bound regime of old South Kensington, and indeed its purposes, must have seemed a whole world away. Rothenstein himself was to recall:

*At the Royal College of Art I tried, by demonstration before the students, to hint at a logical method both of drawing and painting, only to find it consistently disregarded; yet for tennis, billiards or cricket, the advice of professionals is carefully followed ... why should painters alone disdain discipline? It was useless to tell the students of the severe practice which Degas, whose name was constantly on their lips, had to endure: further, that Matisse and others of his generation went through strict academic training.*

---

public places.

A series of these projects were mooted during his Principalship – including murals for St Stephen's Hall, Morley College, India House, the Council Chamber in County Hall, employment bureaux in dockland and Leeds Town Hall – and many of them came to fruition. For King George's Jubilee, at the end of Rothenstein's reign at the College, the students were commissioned to make the railway bridge over Ludgate Hill look something like a triumphal arch in the baroque style – with the aid of plywood and *trompe l'oeil*: meanwhile, a sculpture student made the model for a lion with a crown, to surmount the masts in the Mall, which was cast and re-used for the coronation of King George VI.

So in future, the word "professional" was to take over from the word "vocational" in discussions with the Board on the subject of the College. But, on the vexed issue of the most effective way of teaching industrial design (and other such "humble" pursuits), Rothenstein's fact-finding mission did not seem to result in any concrete suggestions – even though, following discussions with Dr Muthesius in Berlin, he had his views on the common objectives of artist and craftsman confirmed.

Rothenstein's aim to provide students of all Schools with "the best possible general education through the arts" was helped along, considerably, by all the famous politicians, academics, poets and novelists who went into the Principal's studio to sit for their portraits: no less than 167 portrait drawings were produced in these circumstances between 1920 and 1922 alone. One imagines the Fine Art students ticking off the names, one by one, from *Who's Who* as they waited for an appointment. A useful side

effect of this was that the sitters often agreed to give an informal talk, or reading, to the students in their Queensgate Common Room: the pantheon included T. E. Lawrence, Rabindranath Tagore, John Drinkwater, G. K. Chesterton, Edward Gordon Craig, and Walter De la Mare, who "read an enchanting paper on Edgar Allan Poe". Some of the fine art students thought Lawrence of Arabia "very quiet", and G. K. Chesterton "very grubby in a large black hat and cape"; but they seem to have been suitably impressed.

One evening a week, throughout most of his Principalship, a group of students would be invited to the Rothenstein home in Airlie Gardens, to be initiated into an ever-widening social circle: speakers on these occasions included Ralph Hodgson, James Stephens, Arnold Bennett and, of course, Max Beerbohm. Arnold Bennett couldn't have liked it more:

*Last night we had supper at Professor William Rothenstein's (head of the Royal College of Art). It is a very interesting house, where the only tobacco offered is Gold Flake in the form of cigarettes, and where thousands of young girl art students appear after the meal. Also poets.*

If the aim was "to provide truly educated men" – whatever the discipline they were studying – and to "raise the prestige of the College", then at least the talks in the Common Room, the *soirées* and the portrait sessions were a start. Memos about the "disgraceful" educational standard of many of the "qualified Art Masters" leaving the College had been passing around the in-trays of the Board of Education, with monotonous regularity, ever since the revelations of 1911: the most recent of them suggested that the RCA should aim to become a place "where discussion and criticism and the free play of ideas are as much at home as clay or columns or drawing boards".

For Rothenstein, the question of the overall educational standard of the institution in the end boiled down to one simple fact: "the College has not always attracted the best type of student . . . the presence of half a dozen gifted students will raise the standard of a whole school". To put it another way, half a dozen gifted students with an interest in fine art could help to provide what he called "true education" for everyone else.

It wasn't very long before the half dozen were to come along.

## "TRAVELLING IN HEAVEN"

Henry Moore, a twenty-three year old veteran of the First World War, arrived at the College in autumn 1921 with an ex-serviceman's exhibition worth ninety pounds a year. He had spent two years at Leeds School of Art – during the second of which he was tutored in Sculpture by Reginald Cotterill (another veteran of the war, and a recent RCA student). Since the Department of Sculpture at Leeds appears to have consisted of just two people – Cotterill and Moore – the tutor had had plenty of opportunity, according to Moore, "to concentrate entirely on teaching me all the tricks he knew"; the trouble was that "he would never leave me alone". Despite this thorough grounding, Moore's arrival in South Kensington came as a complete revelation to him. He was later to recall, in a characteristically unselfconscious way, that:

*when I rode on the open top of a bus I felt that I was travelling in Heaven almost, and that the bus was floating in the air. And it was Heaven all over again in the evening, in the little room that I had in Sydney Street, Chelsea. It was a dreadful room, the most horrible little room you could imagine, and the landlady gave me the most awful finnan haddock for breakfast every morning, but at night I had my books, and the coffee stall on the Embankment if I wanted to go out to eat, and I knew that not far away I had the National Gallery and the British Museum and the Victoria and Albert with the reference library where I could get at any book I wanted. I could learn about all the sculptures that had ever been made in the world.*

At first, the day-to-day work of the Sculpture School, under the most scholarly of the academic sculptors, Francis Derwent Wood, and the mandatory course in architecture, still taught by the ageing Beresford Pite, were a great deal less appealing to Henry Moore than the fact of living in London. Particularly since he thought that "the College was pretty much in the doldrums; it had become a place to train teachers, to train teachers, to train teachers, and so on – something eating its own tail":

*One room after another in the British Museum took my enthusiasm. The Royal College of Art meant nothing in comparison. But not till after three months did things begin to settle into any pattern of reality for me. Till then everything was wonderful – a new world at every turn.*

A visit to Stonehenge, by himself, in early October 1921 was also to make a powerful and lasting impression: "that first moonlight visit remained for years my idea of Stonehenge".

The disjunction between "the new thoughts I was getting from the British Museum" and "the teaching in the school" almost proved too much; there were times, in his early months at the College, when Moore even considered striking

out on his own. "Walking on air" or "travelling in Heaven" seemed so much more rewarding to him than the preparation of architectural drawings of imaginary places – locations such as "Minster Hill" (an English village) and "Thetis" (a Mediterranean port).

*My aims as a student were directly at odds with my taste in sculpture . . . for a considerable while after my discovery of the archaic sculpture in the British Museum there was a bitter struggle within me, on the one hand between the need to follow my course at College in order to get a teacher's diploma, and on the other, the desire to work freely at what appealed most to me in sculpture. At one point I was seriously considering giving up college and working only in the direction that attracted me. But, thank goodness, I came to the realisation that academic discipline is valuable. And my need to have a diploma, in order to earn a living, helped.*

What helped almost as much, it seems, was the company of his fellow students from Leeds School of Art, Raymond Coxon and Barbara Hepworth. Coxon arrived at the College at the same time as Moore – in the Painting School – and from early 1922 onwards they shared a series of bedsitters together, eventually moving to a studio in Adie Road, Hammersmith. Barbara Hepworth had entered the Sculpture School in autumn 1920, with a major scholarship from Leeds. She was only seventeen and a half at the time, and, in her own succinct words, "when I arrived at the Royal College of Art they said I was too young and set me to do a test and I was allowed to stay":

*It was at Leeds that I first met Henry Moore, his friend Raymond Coxon (both on ex-army grants) and Henry was five years older than I. I felt very young and brash; but Edna Ginesi, later married*

Above *Edna Ginesi, Henry Moore, and Barbara Hepworth, about 1924. With Raymond Coxon they formed "the Leeds group" at the RCA.*

*to Raymond Coxon, was there too and became my friend, and all four of us set off from Leeds for our three years at the Royal College of Art, got our Diplomas and then travelling scholarships. We were in touch . . .*

Barbara Hepworth, for her part, felt a sense of "united purpose" with Henry Moore, in their enthusiasm for what was then known as "direct carving" – "a personal harmony with the material", which was not, at that time, part of the modelling syllabus – and for pre-Renaissance art, which was generally considered "primitive". Like Moore, she learned as much from discussions with her fellow students – and, in her case, from leafing through copies of *Cahiers d'Art* in the Common Room – as from the Sculpture staff. The impulse to move towards stone and wood carving came "from within" rather than from the College – although there is evidence that the young Barbara Hepworth occasionally experimented with "direct carving" in 1921. But her early life-drawings show that, like Moore, she was keen to master all the conventional techniques, and saw the value of "academic discipline" during her

---

THE LEEDS TABLE

Henry Moore's recollection of his friendship with Barbara Hepworth in the early years was that at Leeds "I became a bit sweet on her, and we went out together", and at the College "I looked upon her as a kind of young sister". They stuck together in the Queen's Gate Common Room – there was a "Leeds table" where they regularly ate their lunch while talking in a "lively and confident way" – and, according to Edward Bawden, the other students (who had the disadvantage of *not* coming from Leeds) could always tell when Moore and Coxon were arriving for a tutorial, because they had not lost the habit of marching in step.

time at the RCA. Apart from any other consideration, she could not afford to lose her scholarship.

Following his decision to knuckle down to the course in architecture, modelling, and drawing from the life model – a decision which was beginning to teach him "the value of an academic grounding" – Henry Moore had settled into the College by spring 1922. He was fortunate that his drawing tutor, Leon Underwood, was also a sculptor: "he set out to teach the science of drawing, of expressing solid form on a flat surface – not . . . the art-school imitation of styles in drawing".

He was also fortunate with "no more than six or seven students in the Sculpture School at that time", to have a large studio in the sheds, and a model, almost entirely to himself for the whole of his first year: when the time came, he knew the technical assistant Barry Hart well enough to persuade him to allow "direct carving" in the studio (rather than the then standard practice of preparing a model, and then using a pointing machine – or, for the lucky ones, a technician – to transfer and enlarge it). Barry Hart was a trained stonemason, rather than a sculptor,

which also helped. But the difficulties Moore encountered in this area would seem to show that the philosophy of the Arts and Crafts movement, which had become dogma in the Design School since the turn of the century, had yet to take root in the Sculpture School.

At last Moore had managed to get rid of "the romantic idea that art schools are of no value", and, as proof of his new resolve he seldom missed the Wednesday afternoon life class – unlike a lot of his fellow-students who "avoided drawing like poison. It showed them up, showed how bad they were. They would spend months modelling, afraid to do drawing". He was even getting reasonable reports from Derwent Wood: in the first year, "his life work shows improvement. Design not to my liking. Is much interested in carvings"; in the third year, "this student shows great improvement in his life work. His drawings are excellent, but his design might show improvement. He appears to be somewhat limited

Below Reclining Figure, *1929, by Henry Moore. Having received his diploma in 1924, Moore had by this time gained several years' experience of teaching sculpture.*

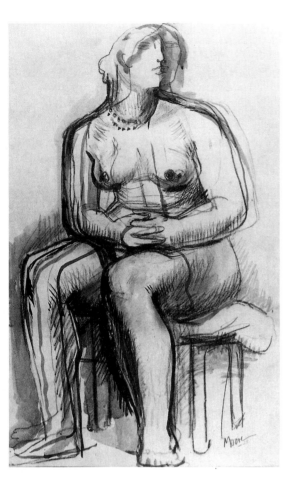

Above Seated Woman, *1928, a drawing from life in chalk and wash by Henry Moore.*
Right *Moore's* Standing Woman, *1923, walnut. As a student, Moore was fascinated by the non-European art he saw in London's museums and galleries.*

in his interest of tradition in Sculpture". And his notebooks, which were full of drawings of "the ecstatically fine Negro sculptures", "the Japanese things", and especially the Mexican sculptures which "seemed to me true and right" in the British Museum, were also beginning to contain plans for future projects:

*Half figure of woman with clasped hands*
*Reclining couples*
*The Stone carrier*
*Woman kneeling*
*Horse with turned head*
*Speed-deer-legs doubled beneath it*

But there were still to be collisions between his "new thoughts" and the College's "hand to mouth timetable existence", which on one occasion only some words of reassurance from the Principal could sort out.

In autumn 1924, shortly after receiving his diploma, Henry Moore was offered by the Princip-

A LESSON IN LIFE

At a "monthly comp" in his first year, which took place in the crowded lecture hall on Friday mornings, Henry Moore pinned his drawing on the set subject of *Night* to the traditional green-felt board:

*My composition showed the influence of some Etruscan sculpture I had admired in the British Museum. It was criticized very adversely by the Professor of the Architecture department, Beresford Pite. Eventually he arrived in front of my drawing and for several minutes spotlighted his violent dislike of it. "This student", he said, "has been feeding on garbage." That Friday afternoon I could not work, but wandered around Hyde Park to work off my hurt feelings. I almost decided I would leave the College and study on my own. But on the Monday morning, Rothenstein sent for me and said: "Moore, do not take what happened on Friday too much to heart, you will often meet this kind of criticism throughout life." He talked to me like a father.*

al the post of part-time instructor in the Sculpture School, to replace a Mr Wilcoxon. Even allowing for the hindsight of Moore's reminiscences, it is clear that he had made the fullest use of his time as a "mature student" in London (despite the fact that "there was much about the teaching that I didn't like"). His stone carving of the Virgin's head (from a marble relief by Domenico Rosselli, presently in the Victoria and Albert Museum), dating from his second year, is by any standards a remarkable piece of student work; and in his first public show of April 1924 – at the Redfern Gallery, with RCA contemporaries Vivian Pitchforth, Percy Horton, Edward Burra, Charles Tunnicliffe and Barbara Hepworth – he was already beginning to attract attention.

So when Derwent Wood resigned over the question of whether the Principal was doing enough to challenge the "Philistinism" of the Board of Education, with its incessant references to industrial design, Rothenstein turned to "the ablest student in the Sculpture School". Derwent Wood was, according to Rothenstein's memoirs, "subject at times to violent moods", and his unexpected decision left the Principal with a serious problem – just as the students were returning from the summer vacation. There was, of course, no question of the twenty-six-year-old Moore taking over as Professor or Head of Department, but there was the urgent need for someone temporarily "to take over the School until a new professor was appointed".

While the Board argued about Epstein, while

Gill turned down the offer and while Ernest A. Cole (who had been "hailed as a youthful genius", but who had since become the safest and most academic candidate imaginable) prepared to take over, for a term and a half Henry Moore was in sole charge. The moment Cole arrived, it seemed politic for Moore to take up the travelling scholarship to Italy which he had been awarded six months before. He preferred to spend the money in Paris, but the College insisted on Florence and Rome because (apart from anything else) the cheque had to be collected there. In the event, the trip brought the Leeds alumni together again, it helped Moore to get his ideas about Italian sculpture into focus (he remained convinced at this time that Donatello was "the beginning of the end") and it also, crucially, encouraged him "to get England into perspective":

*If this scholarship does nothing else for me it will have made me realise what treasures we have in England – what a paradise the British Museum is, and how high in quality, representative, how choice is our National Collection – and how inspiring is our English landscape. I do not wonder that the Italians have no landscape school. I have a great desire – almost an ache – for the sight of a tree than can be called a tree – for a tree with a trunk.*

The Italian experience was giving him aesthetic indigestion: it would take him, he said, at least four months to find his own feet again.

On his return, he took up his two-day-a-week appointment – which had been confirmed as on a seven year contract. Cole resigned in 1927, Gilbert Ledward – his successor – left two years later, and Richard Garbe became Professor of Sculpture from 1929 right through to 1946. Under these three regimes, Henry Moore, with the encouragement of William Rothenstein, "got strength from fighting the academic restrictions and prejudices: it was a preparation for meeting the widespread philistine atmosphere which prevailed in England up to 1940 towards the so-called Modern Art".

Clearly, the years 1925-31 were not easy, either for Henry Moore or his Principal. The main problem took the form of a particularly vitriolic campaign against Moore's work by the *Morning Post* – whenever he put together a one-man show in London – spilled over into the working atmosphere of the Sculpture School. With one or two notable exceptions, the British press reaction as a whole, in the late 1920s, wasn't exactly ecstatic, but it was the *Morning Post* alone which insisted on abusing the sculpture, the man, and even the way he earned his living. On 28 January

Left *Dancing figure by Barbara Hepworth, probably from 1924, her final year as a student of sculpture at the College.*

1928, for example, the *Post*'s critic wrote:

*There is on view ... an exhibition of statuary and drawings which must raise furious thoughts in the minds of those responsible for the teaching at the Royal College of Art ... One does not expect every art master to be a genius ... but a master in a national school of art should be ... a man of taste with a keen sense of form.*

And in an article of December 1930, the *Post*'s critic gleefully quoted the reaction of Charles Sargeant Jagger to a photograph of one of Moore's carved Reclining Woman sculptures: "the sort of people who do it merely seek an early road to notoriety . . . like every other epidemic, it will die a natural death".

By the time the *Post* had concluded "frankly, we think that Mr Moore's work is a menace from which students at the Royal College of Art should be protected", Sir William Rothenstein found himself pressured – both from inside and outside the College – to fire his Instructor in Sculpture. He was not prepared to do this, but a little while before the contract came up for renewal, both parties seem to have agreed that it was time for Henry Moore to move on. Moore resigned early in 1931 (giving a term's notice), and his resignation was very reluctantly accepted:

*My dear Moore,*
*It is with particular regret that I accept your decision to give up your work at the College. Under the circumstances, however, I feel this to be inevitable ... I hope and believe you will make the best possible use of the fuller working hours freedom from teaching will bring you. I am sending your letter to the Board with my own personal expressions of regret.*
*Believe me, my dear Moore,*
*Ever yours sincerely,*
*W. Rothenstein*

When he forwarded Henry Moore's letter of resignation to the Board of Education, he added (presumably for the benefit of those civil servants who were so concerned about "character"):

*In sympathising with Mr. Moore's wish to devote himself entirely to his own work, I should at the same time like to draw the attention of the Board to the high estimate I have formed of Mr Moore's character and of his teaching ability.*

On receipt of the letter, and appended note, the Board had to decide whether or not it was correct to send Moore "a complimentary letter", and if so, who exactly should send it. In the end, it was agreed that the letter should not go out over the President's signature – someone more junior would be far more appropriate.

**1896-1940**

## "AN OUTBREAK OF TALENT"

During his visit to Florence, early in 1925, Henry Moore had told his friends the Coxons that he had got to know a design student called Ravilious, whose company he much enjoyed. This was, according to fellow-student Helen Binyon who recorded the incident, "a surprising statement, for the Painting and Sculpture students felt themselves to be pursuing aims so much more serious and elevated than those of the design students that there was little contact between them at the College". Another fellow-student of the same generation, Douglas Percy Bliss, confirms the impression:

*I remember how we of the Painting School put the situation. We used to say . . . "Designers do bad drawings and mount them beautifully. We do good drawings and don't bother about mounts".*

This was, it seems, part of the "quite different" atmosphere of the Royal College of Art during the Rothenstein era. An early exception to the rule was the tight-knit group of friends who arrived in the Design School and the Painting School in autumn 1922, and who were to stay together for many years after graduation – a group which, in retrospect, could say "one and all we loved the College": Douglas Percy Bliss (Painting, an ex-"Eng Lit" student from Edinburgh University); Eric Ravilious (Design, ex-Eastbourne School of Art); Edward Bawden (Design, ex-Cambridge School of Art) and Helen Binyon (Design, ex-St Paul's Girls School).

This group re-generated the student magazine together; they were the life and soul of the Common Room (apart, that is, from the "Leeds table", and apart from Edward Bawden who insisted on "seeing life like a foreigner at a cricket match"); they visited exhibitions together (and "discovered" Samuel Palmer, Frances Towne and William Blake); and, in the Design School, they all came under the influence of Paul Nash who encouraged them to practice watercolour painting, book illustration, wood-engraving, and lino-cutting (which tended to be associated by most artists at the time with the elementary school classroom); and to develop what he called "an obsession with design". Nash was only at the College for one and a half days a week, but he was to recall that period 1922-3 involved coping with "an outbreak of talent".

The Professor of Design in their first year was Robert Anning Bell, RA, who "did not see much of them", but who did take them to hear Arthur Rackham giving a lecture to the Art Workers' Guild on book illustration. Bell does not seem to

Top We are Making a New World – *Paul Nash's depiction of trench warfare, 1918.*
Above Barrage – *illustration by Paul Nash for* Images of War, *published in 1919.*

have been overly concerned with the commercial application of design, although he did become an early member of the Design and Industries Association. He was succeeded by Professor Ernest Tristram, or "Trissie", a distinguished medievalist who specialized in "reconstructing" Cathedral wall-paintings. An ex-RCA student himself (who had particularly enjoyed Edward Johnston's class), "Trissie" was not the type to "lay down the law", and he was far more interested in the Black Prince than in Le Corbusier, but that seems to have suited his students fine. According to Douglas Percy Bliss, "Professor Tristram disliked the very *thought* of Industrial Design". Where William Rothenstein was concerned, Professor Tristram's meticulous copies of "every fragment of mural painting throughout England, which retain all the energy and delicacy of the originals" made him an *ideal* candidate for the Professorship of Design.

Helen Binyon, in her memoir of *Eric Ravilious* (1983), has recalled the first day at the College of the 1922 arrivals:

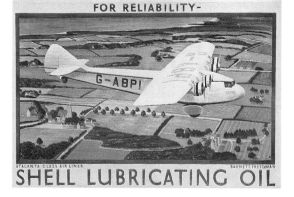

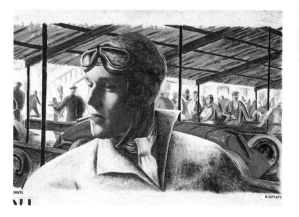

### PAUL NASH DAY

Bawden and Ravilious would sit next to each other in the right-hand corner of the design room "where they could be undisturbed by the sight of their fellow students". The highspot of their week was "Paul Nash day", when, one of those fellow-students remembered:

*He would wear a bow tie and a dark suit and look almost too smart for an artist. He would wander down the long room, looking carefully at what the students had to show him; he was witty and jokey and often encouraging, or he might say "This is just what we want to get away from". He was particularly helpful with watercolours, demonstrating ways of using the medium, trying out colours with a starved as well as a full brush, or washing one transparent colour over a ground of another.*

It was certainly imaginative of Rothenstein to appoint a well-known painter as a "consultant to designers" as Bliss noted, "the more so since Nash was not skilled in matters technical".

Above right, right, and below *Posters for Shell from the 1930s designed by, respectively, Barnett Freedman, Richard Guyatt, and Paul Nash. During this period Shell derived great benefit from the talents of several RCA-trained artists and designers.*

THE RYE MARSHES      PAUL NASH

Above *Professor Ernest ("Trissie") Tristram's depiction of the murder of Thomas à Becket.*

We were to be assigned to one of the four schools – Painting, Design, Sculpture or Architecture – whose professors were also present. The last student to appear was Edward Bawden who came from Braintree in Essex. At a rather confusing interview with Rothenstein, who mistook him for someone else, it was decided that Bawden would study book illustration in the School of Design. From Rothenstein's office he found his way to the students' common room and, going into the canteen, he noticed a group of new students sitting at a table and listening to one of their number, a good-looking young man, whose large dark eyes lit up with enthusiasm as he talked animatedly about Sussex. This was Eric Ravilious . . .

Douglas Percy Bliss, who was selected for the Painting School on the basis of *his* drawings, has described these interviews from a different point of view – in his memoir of *Edward Bawden* (1979):

*We painters who had passed the drawing exam were condemned to a course which consisted of little else but the representation of the naked human body in over-heated and under-ventilated rooms. Those who failed to draw up to the Professor's standards were "kicked into the Design School". Looking back I regret that I had not been banished from the Paradise of Painters (for we felt ourselves to be the Elect) into the Purgatory of the Design School. For my two best friends were in Design.*

The interviews followed a full day's test of life-drawing at the College – during which Ravilious had been rather unnerved to find himself sitting next to a young man "who spent the day making a very beautiful study, in the middle of his page, of one of the model's eyes". The young man's name, it transpired, was Edward Burra; and the eye study got him into the Painting School, from autumn 1923.

Although, as a result of the interview with the Principal, these students were "assigned" to a particular school, they worked together on the introductory class in architecture, and they sometimes met at drawing classes on Wednesdays: design students had to begin with plant drawing, were promoted to drawing plaster casts from the antique, and were eventually allowed to draw from a model; fine art students were admitted to life-classes from the beginning. Eric Ravilious (or Rav, as he was known) was lucky, in that he was authorized to enter the life-classes during his first term. These classes were taught, in isolation, by a group of teachers who, Helen Binyon recalls, offered "rather confusingly different advice":

*In the women's life-class, for instance, we would have started drawings when the door would open and in would come the Principal – a short, slight figure, wearing very emphatic horn-rimmed glasses. Those students who had taken his advice to buy plumb lines for themselves now held them out, and tried to use them to test the perpendiculars in their drawings. Rothenstein's ideal was the pencil drawing of Ingres. He would go round the class, criticizing, advising, and perhaps sharpening the blunt pencil a student was trying to draw with, and then would go out. A little later, the door would open again; heads would turn to see who it was this time. A larger, clumsier man would stand waiting in the doorway; a thick dark fringe of hair covered the top of*

his face, while the lower part was obscured by his hand, the fingernails of which he was biting. The weaker students felt a little shiver of fear. It was Leon Underwood, the exponent of "Form", of cylinder and section; drawings would darken, line was out, shading was all important.

Strangely enough, another member of the staff who proved particularly useful to them was the College Registrar – or to be precise two successive Registrars. The first was the painter Hubert Wellington (at the College from 1923 to 1932), whose son Robert managed the new Zwemmer Gallery in Litchfield Street (off Charing Cross Road) which was to host an exhibition in April 1932 called *Room and Book* (Nash designs, Bawden wallpapers, Ravilious interiors), and the first Bawden and Ravilious one-man show of paintings and drawings in the autumn of 1933. Hubert Wellington, who successfully protected the Principal from "all administrative detail" for nine years, had taken over from Beckwith Spencer – after Spencer had asked for a rise in his payment as lecturer in art history and literature: instead of giving him a rise, the Board had agreed to make him part-time Registrar, to supplement his earnings from 1921 up to retirement age.

Wellington was eventually succeeded by Athole Hay (appointed Registrar in 1932), who in the mid-1930s opened a shop at 15 Albemarle Street which specialized in "the sale of objects of applied art which in the ordinary way might be difficult to market". Hay went into partnership with Cecilia Dunbar Kilburn, an ex-student who had been a contemporary of Bawden and "Rav" (in the Sculpture School) and who had worked with the whole crowd on the student magazine *Gallimaufry* (1925) and edited its successor *Mandrake* (1926). When it was suggested by Rothenstein, in summer 1932, that Athole Hay be made Registrar, members of the Board of Education had been less than enthusiastic. After the interview in June 1932 they wrote:

*He seems to have reached his present age, which we imagine to be something over 30, without having done anything in particular except study Art to a certain extent in Italy. There is the fact, also, that he has not had any previous administrative experience.*

But Rothenstein knew Athole Hay socially (Hay had been to Oxford with his son, although he left without a degree) and so went ahead with the appointment: like Wellington's, it proved to be a great success. In addition to his administrative duties, Hay sent student works to the Dunbar-Hay shop, and Cecilia Dunbar Kilburn used her connections in the design world to encourage a range of firms (including Wedgwood) to produce them: designs for ceramics, glass, textiles, furniture and carpets; one-off pieces as well as machine-made goods. The stock was to include a Ravilious suite of Regency-style furniture; printed linens, organdies and velvets designed by Enid Marx; the famous Wedgwood pots decorated by Ravilious, and numerous one-off pieces produced by other RCA people.

While they were still students, Bliss, Bawden and Ravilious were already beginning to attract professional commissions: Bliss was the first to publish a book (*Border Ballads*, illustrated with wood engravings); Bawden did "odd jobs at the Curwen Press", trade cards and even a poster for London Underground; and Ravilious worked on wood-engraved illustrations for Jonathan Cape and assorted "little design jobs". They were all introduced, by Paul Nash, to the Society of Wood-Engravers, and they made contact with the private presses which were just beginning to take on a new lease of life.

But their outstanding collective achievement at the College was the production of *Gallimaufry*, edited by Bliss, with woodcuts by Ravilious, caricatures by Bawden, and hand-colouring throughout by all three of them. Bliss had revived *The RCA Students' Magazine*, with its austere school-mag cover and "its old stale air of

Below *The Painting School of the Royal College of Art in the 1930s.*

**1896-1940**

Left *Wood engraving for Marlowe's* Jew of Malta, *by Eric Ravilious, one of the "Class of '22".*
Above *Wood engraving by Ravilious from the '20s.*

Rav), and of Bawden's book illustrations. The College agreed that both should be granted Travelling Scholarships – Ravilious in summer 1924, Bawden in summer 1925. In neither case does the Scholarship appear to have been particularly successful: Ravilious went in the hope that "perchance the painters of the Renaissance might be touched on the sleeve, reverently of course", but returned after three long months of "walking about in the fresh air" with just one Italian phrase: *dov'è il gabinetto.* Bawden was impressed by Rome – "after all, the whole place *is* a museum" – and bowled over by the Piero della Francesca frescoes in San Francesco – as Bliss was to say, "Piero was at the very top of the old Master Popularity League" among art students at the time – but still couldn't wait to get home.

However, shortly after the two friends reluctantly left the College ("the place itself was delightful") they were given the opportunity, by William Rothenstein, to produce mural decorations for two large rooms at Morley College, Lambeth – and this turned out to be both a major and a successful commission. It was sponsored by the art dealer Sir Joseph Duveen, in the wake of Rex Whistler's murals for the Tate Gallery Restaurant: Whistler had been to the Slade, and now it was the RCA's turn – with Cyril Mahoney (ex-Painting School) and the two young designers being paid by the day to cheer up the Concert Hall and the Refreshment Room on the basement floor of Morley College. The murals, which took Bawden and Ravilious almost two years to complete, were thought to be among the finest of the inter-war years, and were officially "opened" by the Prime Minister Stanley Baldwin on 6 February 1930. They led to several further commissions, but were tragically destroyed during the Blitz in 1940 – together with fifty-seven local residents who were sheltering in the Morley basement. A final opportunity for Eric Ravilious

officialdom", in his second year: it was entirely a student venture, financed from the profits (if any) from the Common Room canteen. But in his third year, he broke new ground by producing an ambitious "new magazine, which will appear for this once only": in the editorial, he wrote that "we have tried to give you something cheerier, with clearer type, more stimulating designs and a touch of colour, hand-applied by the Committee for the love of you all". A bold Ravilious cover, showing a bee alighting on the centre of a flower, was followed by a woodcut of a country chapel by the same artist – the largest he had ever done, up to then, and a clear precursor of his mature style. Various poems, reviews and examples of student gossip were illustrated by whimsical Bawden caricatures, and the traditional student Hall of Fame appeared on the same page as an Enid Marx woodcut.

At the end of their second year at the College, both Ravilious and Bawden were judged to be "top students in the Design School" – on the basis of "a big gay painting that really had some pretensions to being a mural" (as Bawden said of

¶ THE MANDRAKE: A MAGAZINE OF THE STUDENTS OF THE ROYAL COLLEGE OF ART. EDITED BY CECILIA A. DUNBAR KILBURN : OF WHICH TWO HUNDRED COPIES HAVE BEEN PRINTED, AND COLOURED BY HAND, AND THE WHOLE PUT TOGETHER IN MAY, MCMXXVI, THE MONTH AND YEAR OF THE GREAT GENERAL STRIKE

Above *Title page of the RCA students' magazine* Mandrake *for May 1926, by Ravilious.*

BARBETONIA sive TERRA LEONIS.

Above *"Big-game hunting" depicted by Edward Bawden in the students' magazine* Gallimaufry, *1925.*

to collaborate with the students of the RCA course came in the spring of 1935, by which time he was himself teaching one day a week in the Design School. The project, again set up by William Rothenstein, involved street decorations for King George V's Silver Jubilee, and in particular the transformation of Ludgate Hill bridge – under which the carriages in the royal procession would be passing. But Ravilious wasn't entirely convinced that the Principal's design ideas for this were the most appropriate:

*Rothenstein wants something baroque (pronounced by him,* barrock*) and mighty fanciful, so everyone is designing a bridge like a pantomime scene with Neptunes and mermaids and Britannias – I'm not sure that it really is a good idea when you have to compete with BOVRIL, ten foot high – John Nash (newly appointed to the College) wants to use sheets of tin, and I should like scaffolding with no paint and lots of flags – but the baroque idea will win probably.*

It did win, and, together with Barnett Freedman's special large-size 1½d postage stamp, drew

much public attention to the College: the Freedman stamp was the subject of a short documentary film, directed by William Coldstream for the GPO, which began in black and white but blossomed into stunning Dufaycolor as the stamp came off Freedman's drawing board. *The King's Stamp* (1935) is almost unwatchable today, but it was the first film to be devoted to an aspect of the College's work.

The "class of '22" was at its best when engaged in collective work, or what today we might call "team design projects" – and, indeed, it was part of the Rothenstein philosophy to get the College involved in as many prestige public works as possible. They painted as designers and (in Ravilious's case) designed as painters. But there were many other *individual* students in these years who may have helped, in unusual ways, to "raise the standard of the whole school".

Students such as Edward Burra, who arrived in 1923, after taking a course at Chelsea Polytechnic. Burra was considered by his contemporaries to be "a strange scholar", as he read all the latest novels from Paris, the goriest of

Elizabethan revenge tragedies, and as much Gothick fiction as he could lay his hands on; and as he haunted the two local cinemas – the Kings Picture Playhouse and the Chelsea House of Enchantment. He spent his year at the College, in John Rothenstein's words, charging "his imagination with precisely the ideas and the imagery that it most required", and he left with a highly developed technique for painting sharply defined, but distorted, pictures of neon-lit street life. The day-time life-class appears to have appealed to him a lot less than the night-time Kings Road. As he wrote, shortly after leaving:

*I am going to Manhandled tomorrow at the local cinema pathé gazette comedy and Episode 709000 of the Pink faced horror Black Duggan lures Lulu Platinum who has a clew to the treasure of the Idols Eye concealed in her false teeth to the disused cellars beneath the old corset factory . . . How I run on when the creative spirit is on me there's no holding me I declare also Forbidden Paradise is coming which I've been itching to see.*

Or Charles Tunnicliffe, "a sometime farmer's boy" from near Macclesfield who also arrived in 1921, and eventually moved into the new Etching and Engraving School: he spent as much time as he could, in the words of his biographer, "drawing the animals of the farm . . . making hundreds of pencil and ink drawings of . . . pigs, cows, horses, chickens as well as crows and magpies". Tunnicliffe shared digs for a time with Eric Ravilious and, after he'd been granted his diploma – he wrote home a very short letter "Passed with distinction. Charles" – was offered a further year's scholarship to specialize in Etching: following a short spell of teaching poster design, part-time, at Woolwich Polytechnic, he started his career by designing packages for manufacturers of cattle food, seed dressings and fertilizers.

And there was Percy Horton (known as "Perthy" to his fellow students, on account of his lisp – and, perhaps among the fee-payers, on account of his political views), who arrived in the Painting School in autumn 1922, with a Royal Exhibition. He had studied at Brighton School of Art from 1912-16, followed by eighteen months' hard labour in Calton Prison, Edinburgh, for being an "absolute" conscientious objector. After his release (on grounds of severe ill health), he had registered from 1919-20 at the Central School. At the RCA, he was awarded the College Drawing Prize for 1924 (his examiners were Charles Ricketts and Charles Shannon), and left with the ARCA Diploma with Distinction in Painting. His surviving student drawings – such as *Farm Labourer – study for a Nativity Composi-*

*tion* (1922) – already reveal the naturalism, and the social concern, which were to be even more evident in his mature work.

In 1930, Horton was invited by Rothenstein to become an Instructor in the Painting School, a post he was to hold for nineteen years, combining it with part-time work at the Working Men's College at St Pancras: there, he encouraged his student friends Barnett Freedman and Albert Houthuesen to teach with him. During the mid-1930s, he contributed regularly to *Left Review*, with articles on "painting for reality and with human concern" which exhorted artists to "throw away their blinkers and look around them a good bit more": at the same time, he told the students in his RCA life class that "it was a damned cheek of André Breton and Co to pose as Marxists".

An early member of the Artists' International, in its Marxist phase before it became an Association, with James Boswell (Painting School 1925-9) and Peggy Angus (Design School 1922-5), he organized touring exhibitions, painted portraits of hunger marchers and unemployed men, sold portrait drawings in aid of the anti-Fascist cause and attended committee meetings at Misha Black's design studio, first in Seven Dials and later in Charlotte Street: meanwhile, Boswell contributed Grosz-inspired caricatures to *Left Review* (of which he was art editor) and Angus drew political cartoons for the women's page of *The Daily Worker*. A second generation of politically progressive artists emerged from the Painting School of the RCA between the late 1920s and 1936 – all of them tutored by Percy Horton – including Reg Turner, Cecil Collins, Bateson Mason, Mervyn Levy and Ruskin Spear: by this time, the AIA had adopted the slogan "conservative in art and radical in politics", and, although as an Association it embraced a wide variety of styles (Henry Moore, Barbara Hepworth and Eric Gill showed work in AIA exhibitions), it provided a focus for a growing interest among young artists in what might loosely be called "social realism".

Another attraction was that the Association provided opportunities for these artists and designers to show work in conditions, and in a context, over which they had some control: in 1934, *The Studio* had published a report on the depressing prospects which faced graduates from the College; the examples cited in the report included a recent ex-student who worked nine hours a day, six days a week, making drawings of jewellery for thirty shillings a week, and another who spent his life painting lampshades for twenty-five shillings a week – was *this* where three to five years' education in the nation's premier art college would lead? Just after the

Second World War, James Boswell was to publish a full-length analysis of these and other issues facing young artists – including the "futile muddle" of most art teaching – called *The Artist's Dilemma* (1947): he concluded that teaching *was* a viable option for the committed artist, but that "to be stimulating it must be done in an atmosphere of seriousness and confidence in the value of art," and there wasn't much of that atmosphere around; in the mid-thirties, the "causes" had all seemed so clear-cut. For instance, in 1935 there was the Silver Jubilee; while Ravilious reluctantly helped the Design students to knock up baroque arches, the AIA put a giant banner "25 years of Hunger and War" across the Strand, just as the procession arrived, and Peggy Angus produced her *Poison Gas* drawing – a satire on the "poison gas" which hissed out of newspapers (notably the *Daily Express*) on Jubilee day, and which smothered the banner "Long Live the King" perched just above a London Underground sign.

## "MORE MODEST AND USEFUL WORK"

All this must have seemed a long way away from those merry japes in the Queen's Gate Common Room. As William Rothenstein was wistfully to observe of his students in general, "they adventure forth, free from the bondage they endured, leaving one far behind, in act and, frequently, in memory". By this time, his "half a dozen gifted students" had certainly helped to "raise the prestige of the Royal College of Art", as he had hoped. But a question which was asked, with increasing force, throughout Rothenstein's tenure as Principal, was whether "prestige" among gallery-owners, art critics and assorted arbiters of taste should really be the main objective of the College. In a BBC radio talk of January 1932, Rothenstein attempted to answer such criticisms – which came from, among others, the new profession of industrial designers, with a series of increasingly articulate manifestoes and reports – by stressing the central importance to young artists and designers of "creative activity" in a creative environment:

*Mechanization has touched education, and in a student who feels himself a part in a machine the missionary spirit is often steadily crushed ... My colleagues want to link education with industry: good. But there is a danger in the limited objective. If a man is to design cotton prints he has a right to a complete education in the arts first.*

In the years before Rothenstein's appointment, members of staff from the RCA had played a central role in the foundation and early activities

A LATE STARTER

John Piper arrived in the Painting School in 1926 – having abandoned a career in his father's firm of solicitors – and stayed for just under two years ("without a diploma, and without prizes or honours of any kind"). He was later to write:

*I was undoubtedly a flop at the Royal College of Art. When I arrived I was a bit sophisticated and arrogant, and not at all humble. I managed to scrape into the Painting School through the kindness of Hubert Wellington, the Registrar; but he said I must go to Richmond Art School for a year before I could be accepted, and I was lucky enough to be taught my first elements of drawing by Raymond Coxon ... It was by far the best teaching I ever had. I can remember some of the things he told me to this day, and if I ever feel like writing self-taught after my name I immediately correct myself with shame. I was a bit shocked when I got to college to find that life drawing – in which I believed profoundly, and wanted to do passionately – was made so boring. However, young, ex-student teachers again gave one hope – Tom Monnington and Morris Kestleman among them – and I survived to paint, do summer comps, make my first lithographs and copy a Cézanne in the Tate on Tuesdays. I did not see a great deal of the Principal, Sir William Rothenstein ... I do not think my departure was of any more interest than my arrival.*

Piper was not to "find his own voice", with the painting *Rose Cottage, Rye Harbour*, until several years after leaving the College: even at that time his work was still "undisciplined, dependent on various likes and supposed dislikes – admiration for Picasso, Braque, Léger and Matisse, and strong anti-Academic prejudices". After he had re-discovered his interest in the British landscape and church architecture, in the late 1930s, he returned briefly to the Royal College to take private lessons in the Etching and Engraving Department (at a cost of ten guineas).

of the Design and Industries Association. This had been established, in 1915, in order to promote "decent design for ordinary people" – on the model of the *Deutsche Werkbund* (which itself had been established seven years earlier, to promote and extend the achievements of the British Arts and Crafts people, in Germany). In the same year as he became "the elder statesman" of the DIA, Lethaby (with some of his colleagues) was suggesting in a memorandum to the Board of Education, that the College itself should, with the Victoria and Albert Museum, become "a propagandist centre for the improvement of British

goods . . . The Principal and Professors would be prepared to give free advice to Manufacturers in Design . . . The College should take the position of a research centre advising on matters of design". After all, "the Germans have made it their business to understand English experiments in Art training with a view to applying them directly to commerce", and it had become an urgent priority to find "some means to bring to the notice of our industrial employers the desirability of making more use of men trained in this College": a useful start would be to publish a series of tracts, under the RCA imprint, on subjects such as Design and Manufacture.

These suggestions from the Professor of Design would imply that early in 1915, it was envisaged that the RCA would take on some of the functions – and have an institutional relationship with – the Design and Industries Association. But, in the event, it was the DIA alone which took the initiative – with Harold Stabler (who taught metalwork at the College shortly after the reorganization of 1901) and Lethaby as its most imaginative contributors: although the Association did promote the work of several ex-students – notably the ceramic designer John Adams (who also taught at the RCA, 1912-14), the painter and ceramic designer Gordon Forsyth, the potter William Dalton and the lighting designer Alfred Read – and although the products with which it was primarily concerned at that time (furniture, pottery and glassware) were all covered in the Design School – the DIA began to move further and further away from the teaching atmosphere of the College.

In 1918, Lethaby was "retired" on the advice of the Board of Education, at the age of sixty-one: the Board had clearly been concerned about his performance, ever since the disparaging comments made by Lewis Day in 1910. The Report of the College Visitors for that year, which noted the "trivial and amateurish" character of much design work in South Kensington (owing to "the War and the depletion of the schools"), also complained that they had not even been consulted over Professor Lethaby's sudden retirement. The usual expressions of regret seem to be completely absent from the Board's files: but at least the students in the Design School clubbed together to buy him a farewell gift – a bicycle. He left behind him the wise thought that "the first thing in the arts which we should learn from Germany is how to appreciate English originality".

By the end of the First World War, the new Industrial Art Committee of the Federation of British Industries had begun to issue pamphlets on "the question of industrial art in this country" – notably, the question of whether the College

had done anything about the 1911 recommendations concerning design for industry: the Committee's conclusion was that if anything the College had taken several steps backwards. It should at least have instituted sandwich courses (as we would call them today), to give the students the opportunity to study industrial works and drawing offices at close quarters. By June 1924, the debate had even found its way into the columns of the *RCA Students' Magazine*. John Adams and his wife Truda (also ex-RCA Design School) had recently gone into partnership with Cyril Carter and Harold Stabler to form the very successful Poole pottery Carter Stabler and Adams Ltd. So when John Adams wrote a substantial article for the students called *The Art Student and Industrial Design*, he must have hoped it would make some impact – particularly since he had been the founder and first editor of the *RCA Students' Magazine*. Adams had recently given a presentation "with Mr Carter", and had been struck by the fact that "each generation of students holds fast to the illusion that College remains the same forever . . . I shall cherish that illusion no longer".

In spite of the Report of 1911 (of which "it is safe to assume the majority of the manufacturers and students were unaware"), most design students still seemed to think that it was far better to be a successful artist like Vermeer than a discontented and probably unrecognized painter of Delft ware:

*We cannot escape mass production. We are obliged to use the products of it every day of our lives. The London Underground Railways represent the principles of mass production applied to traffic, but humanised and made decent by the unusually able men who direct it. That humanising influence will work its way in time whenever the machine is used, but mass production will cease to be the squalid affair it sometimes is, only when the artist and the public consider the crafts as exciting as what are known as the "Fine Arts" . . . Instead of talking about the limitations of the machine, would it not be a better thing to investigate some of its possibilities?*

The tone of the article – "low standard of taste", "made decent", and the reference to Frank Pick's enlightened regime at London Transport – are pure DIA. In fact, several of the students who would have read Adams's article (including Edward Bawden, Barnett Freedman, Eric Ravilious, and Enid Marx) did go on to design posters, illustrations and fabrics for London Transport – but that wasn't really the point. The point was that the College as a whole *still* did not consider the crafts as exciting as what are known as the "Fine Arts". The new Principal, with his

hierarchy of "the fine arts" and "more modest and useful work" – which had been presented almost as an article of faith – was the person who needed convincing.

In fact, Rothenstein had already instituted one or two changes which would have met with the DIA's approval (although even these went too far for the likes of Derwent Wood). In April 1922, for example, he established short refresher courses for "designers in the service of manufacturers", at a cost of ten guineas per person: the pilot courses were taken by a designer from a bedstead factory (for three months), and two textile designers (for one month each). But, quite apart from the Principal's firm belief in "the human hand as something intuitive, obeying intuitively the laws of the universe", there were the more mundane matters of equipment and space. In a lecture at Stoke-on-Trent in 1922, Rothenstein complained that "the industries which need the services of artists and craftsmen and designers" had not extended help to schools and colleges of art and the Board of Education was unable to help either.

The Board had to admit, in a private memo, that "our administration has in the last few years been thrifty to a point" – and, on this occassion, "the industries" did respond to the call. A kiln was donated by the federation of Stoke potteries (including Wedgwood) in summer 1922, and another a year later. The Goldsmiths' Company, impressed perhaps by the outstanding work of ex-students such as Omar Ramsden and Henry Murphy and by the metalwork designs of one of Lethaby's Instructors, Henry Wilson, agreed to sponsor the appointment of a silversmith (William Stocker) as well as other "schemes for the improvement of plate". But, at a time when design students *still* had to be sent to work in the Victoria and Albert Museum in shifts because the College workshops were too overcrowded, the basic problem remained space. Since the island site (when it had been vacated by "the military authorities") had been leased to the *Institut Français*, on the vague understanding that it *might* one day be occupied by the College "as circumstances allowed", the only option had to be a new building that was specially designed to meet the needs of the College.

By the late 1920s, a Report by the Royal Commission on National Museums and Galleries had concluded that "increased space for the enlarged Circulation Department at the Victoria and Albert Museum should be found by the removal of the Royal College of Art . . . to a new building proposed by a Departmental Committee seventeen years ago". While the French kept renewing their five-year lease on the island, and the Museum pressured the College to get out of

Above Market Day, *1926, a watercolour by Edward Burra, who studied painting from 1923.*

their only building which wasn't a temporary shed, the number of students at the RCA went up from around two hundred at the beginning of the decade to three hundred and fifty-eight at the end: a high proportion of the increased number came in the "fee-payer" category, and they understandably wanted value for money. To make matters worse, the Royal Commission *Report* had concluded with the cryptic comment "there *is* a large provision of state-aided art education in London and the provinces." It was only a matter of time before the question of the College's new building became linked with the question of the College's attitude towards industrial design.

## CANVAS-FREE ARTISTS

Meanwhile, two senior members of staff in the Design School were beginning, in their very different ways, to attract a lot of attention in the press, among critics and beyond – both for their work, and for the effect of their teaching. One was the artist-potter William Staite Murray and the other was the industrial designer Reco Capey.

109

After studying drawing and painting in his teens, Murray had taken the pottery course at Camberwell School of Arts and Crafts from 1909: at that time, William Dalton (ex-RCA) was headmaster and Richard Lunn, who was instructor in pottery at the College, was also running the pottery workshop at Camberwell. Lunn had published the first substantial book in England ever to be devoted to the teaching of *Pottery* (1903), and in it, he had described his new course at South Kensington as "the first attempt to make pottery in a school, carrying out all the processes of making, drying, firing biscuit, decorating, glazing and firing glazed ware in the classrooms themselves". Significantly, "throwing" was only discussed towards the end of the book – for his students, at both the RCA and later Camberwell, spent most of their time painting on ready-made blanks and decorating tiles: throwing was done by a professional thrower, who worked from drawings prepared in advance (in imitation, perhaps, of the division of labour in the industry).

After he left Camberwell, Murray became deeply interested in "experiments of that time in abstract painting and abstract sculpture" – by which he meant the two Post-Impressionist exhibitions organized by Roger Fry. His close associates in the years just before the First World War included the Vorticist painters Cuthbert Fraser Hamilton and Frederick Etchells (who had been a local Exhibitioner at the College in 1905, which makes him the only avant-garde artist ever to emerge from the era of Augustus Spencer). In 1919, following military service, Murray set up his own pottery at his brother's engineering works in Rotherhithe, and before long his pots were being exhibited in the Paterson Gallery in Old Bond Street. He had learned a great deal of craft technique from Bernard Leach's associate Shoji Hamada, but the work, and indeed the philosophy, of Murray's pottery was developing in a very different way from the St Ives equivalent. To put it crudely, while Staite Murray marketed his pots in fine art galleries (under the label of "abstract art" and with titles to match) for anything up to 150 guineas each, you could buy a complete tiled fireplace by Leach for £27 10s. And Leach at that time was convinced that "the solution to the underlying problems of craftsmanship, or at any rate those which presented themselves most forcibly, were not likely to be discovered in the expensive precincts of Bond Street".

So when William Rothenstein offered them *both* the job of Instructor in ceramics at the RCA, in 1925, he must have thought that this neat arrangement would provide the students with the widest possible range of approaches, and attitudes, to studio pottery. Murray would bring with him his connections with the avant-garde world of fine artists, and his publicly-expressed view that "pottery is the connecting link between Sculpture and Painting, for it incorporates both"; Leach would bring with him his knowledge of Japanese technique and practical philosophy, and his moral position that "the craftsman . . . has been the chief means of defence against the materialism of industry". Neither of them, it need hardly be added, would bring the remotest interest in the ceramics industry. As it turned out, the concept of a joint appointment was a disaster. Murray told Rothenstein that he would not accept the post until he had Leach's clear refusal of it, because he "didn't wish to do anything unfriendly". However, Leach was interested – and offered to come to the College from St Ives for two periods of six weeks each year. At this point, Murray wrote to Leach:

*I am not justified in accepting the post and then to retire for periods of six weeks twice a year . . . My rate of pay would be rather less than the amount you mention . . . It seems to me absurd that I must ask Rothenstein for your post . . . it places me in a position I most heartily dislike.*

Eventually, Leach was persuaded that there simply wasn't enough money to pay for his six week teaching stints – in addition to a full-time Instructor – and so withdrew. The two men seldom spoke to each other again. When *A Potter's Book* by Bernard Leach was first published, Murray wrote that this "theorising on Pots and Art . . . I found a little tiresome"; and Murray used to warn his RCA students that "the man has a bank clerk's mind". This was unfortunate. The two greatest potters of the interwar years, whose pots are still a living inspiration to the two main traditions of artist-craftsmen working in clay, *could* have enriched the Design School immeasurably. But, in the craft world, two is often a crowd.

Herbert Read wrote enthusiastically of Staite Murray's teaching, in an article for *The Listener* (May 1929): "Some experiments recently conducted at the Royal College of Art School of Pottery under the direction of Mr W. Staite Murray are interesting as revelations of the possibilities that lie before *canvas-free artists*". These "experiments" did not exactly involve a teaching programme: Murray's philosophy, as a devotee of Oriental mysticism in its various forms, was that "A Zen Master teaches by not-teaching, at least verbally; he merely demonstrates the art of potting . . . calligraphy, painting with the brush and ink". Those students who were tuned into his wavelength – and the most distinguished of them were Heber Matthews (RCA 1927-1931), who was

himself to teach Hans Coper at Woolwich Polytechnic, Sam Haile (RCA 1931-1934), Robert Washington (RCA 1933-37) and Henry Hammond (RCA 1934-8) – found that his personal style made a profound impression on them. All four initially registered at the College to study Painting, and moved over to Staite Murray's class for artist-craftsmen (either mid-way, or in an extra year) during their course.

Henry Hammond started with Mural Painting. Halfway through his second year, he recalls, he "began feeling dissatisfied with my work": the last straw came when he was set a project to draw a bull, submitted a drawing in the style of Picasso, and was told by Professor Tristram to "go to a zoo and do it again".

## SO HAMMOND STARTED "MAKING POTS"

At the end of his first term amongst the potters, Henry Hammond successfully fired a bowl with a green celadon glaze – the recipe for which he was kindly given by fellow student Philip Wadsworth (the son of the Minton's designer): "there was little formalised instruction", he says, "you had to pick up what technical information you could from others".

*I put it on the table and the next time Murray came in and looked through the window he saw it. He entered and came over to my table, saying "Did you make it?" To my astonishment he asked me to bring the bowl to his room for discussion over a cup of coffee. After a long silence he said to me, "I think you are a natural potter". After this I joined the ranks of Staite Murray's disciples. He was a god to us ... I remember Sam Haile once importuning him to criticize his pots and Murray had twice flatly refused to look at them. Eventually, he agreed to look at them, refusing to speak but agreeing that he would point with a stick at those pots he thought should be broken up and put in the soak bin ...*

The basic premise of Staite Murray's teaching was, as he put it, that "you have to gather and store as soon as you can disperse": it was no use gathering information until you were ready to receive it; by the same token, "you have to know when to stop, at the right minute". And at 10 o'clock on a Tuesday morning, every week in term time, he would decide who among the students was ready to "gather and store". "What would you say God is?", he once asked Henry Hammond. "I've always been taught that God is love." "Nonsense," said Murray, "God is clay!"

On the days when Murray *wasn't* in the Department, this atmosphere was more difficult to sustain:

*The College would interfere – and in particular Reco Capey would interfere. He'd say that the work we were doing wasn't really design at all. And he'd have us all teed up to go to Stoke-on-Trent for a fortnight. Capey used to say that "Murray couldn't have anything to do with design, because he was anti-industry".*

Reco Capey had become Chief Instructor in Design at the RCA in 1924, a post he was to hold until 1935: after three further years as a visiting lecturer, he became, in 1938-9, the "Industrial Liaison Officer" for the College – the only years when such a post existed. Very little is known about him (even Rothenstein manages to misspell his name as Recco in the second volume of his memoirs) – which is surprising, since Capey was the only self-styled industrial designer regularly to work at the College before the Second World War. Born in Burslem, into a Czechoslovakian family, he studied in the Design School some time between 1921 and 1924: he also studied design "in France, in Italy and in Sweden".

Like so many of the first generation of industrial designers in Britain, he did not restrict himself to any single medium: he designed pottery (for Doultons, among others) glass, metalwork, fabrics, lacquer-work, and from 1928 to 1938 he was the art director for Yardley, producing for them a much-publicized range of packages (1936-8), for perfumes, toiletries and cosmetics, in Parisian "floral" style. These included designs in glass, pressed paper, moulded plastics and gilt metal, and were accompanied by matching sales brochures and a "Tint Guide".

In 1937, Capey was made a Royal Designer for Industry – an honour which had been instituted by the Royal Society of Arts the previous year, in the wake of the Burlington House exhibition "British Art in Industry", which Herbert Read called "modish and Mayfairish", and about which Nikolaus Pevsner lamented "it *might have* set up a milestone in the evolution of the Modern Movement in England". "Modish and Mayfairish" or not, Capey was the first industrial designer working at the College ever to be admitted to the Faculty (for his work in "General Design"), and his citation proudly announced the fact. This must have needled Staite Murray, and his students, a great deal. From 1930 to 1942, he was President of the Arts and Crafts Exhibition Society, and he published an important book on *The Printing of Textiles*.

Reco Capey's "modern printed textiles" (notably a scarf, and a length of fabric) had first come to the attention of *The Studio* in 1926, which reported:

**1896-1940**

*One of the ablest of the young men who have turned their attention to fabric designs is Mr Reco Capey... His influence at the Royal College of Art, South Kensington, where he is training students in this type of work, should produce results... In a somewhat different category are the beautiful fabrics designed and executed by Miss Phyllis Barron and Miss Dorothy Larcher at their workshops in Hampstead. These textiles possess a fascinating quality and texture obtainable only by hand block-printing, and are necessarily more costly to produce than machine printed goods. With these two artists is associated a designer of great promise, Miss Enid Marx...*

Enid Marx had joined the Barron and Larcher studio in 1925 as an apprentice. There she did all the essential chores by hand – including the vegetable dye-mixing, the steaming, the working, the ironing, the printing and "the hosing of velvet to get the chalk out" – as a way of mastering the craft. Marx was introduced to Barron and Larcher's hand block-printed work by the potter Norah Braden – who had been a contemporary of hers at the RCA before joining Bernard Leach in St Ives and Katharine Pleydell-Bouverie in Coleshill. Clearly, the young Enid Marx was drawn to "hand-made things of quality and individuality" at a time which was, she has recalled, "that halcyon period when all the arts flowered in such profusion". But she had not, in fact, studied in the Design School at the RCA. After leaving the Central School (where she was introduced to drawing, pottery, and design for printed textiles under Bernard Adeney who "said my work was like William Blake's, but I'd never heard of him"), "Marco" entered the College Painting School in autumn 1922:

*I went into the Painting School, it was really unacceptable to be in any other, and drawing was so important to me. Sir Frank Short wouldn't have me in his wood engraving class: he said I drew so badly and wasn't worth teaching. But Eric Ravilious sneaked me in after hours and taught me what he'd learned that day!*

Although she was "in" with the Queensgate Common Room set – and contributed wood-cuts to *Gallimaufry*, which must have irritated Sir Frank – her work was a reaction against "the washed out William Morris stuff", and at her final assessment in summer 1925 she was failed by Charles Ricketts. But her time at the College had not been wasted: she had developed an interest in fabric printing while still on her Painting course, and she may well have met Reco Capey (who was in post during her final year). Shortly

---

### ASTRID SAMPE

One of Reco Capey's students, during 1932-4, was Astrid Sampe – who was herself to be made an Honorary RDI in 1949, as Sweden's leading textile designer, at the height of the British design establishment's love affair with Scandinavia (the other Hon RDIs of the same period were Alvar Aaalto, Steen Rasmussen and Kaare Klint). She was sent to the RCA by her parents, who thought that under Capey's supervision she would receive a better professional training than was available at that time in Sweden. During the course, Capey "encouraged me to continue with textiles", taught her block-printing (which she hadn't tried before), and created such a supportive environment around his students that, on her return to Sweden in 1934, Astrid Sampe "introduced his methods of teaching" into the Stockholm National College of Art, Craft and Design.

---

after she left the RCA, the work of Barron and Larcher was being exhibited "in a remote corner of South Kensington Museum", as part of the British Institute of Industrial Art's permanent exhibition of "modern decorative art".

By 1927, she had set up her own studio "over a cowshed on Hampstead Hill", and was successfully to sell her fabrics through the Little Gallery (off Sloane Street) and Dunbar Hay. Her work throughout the 1930s was to display an extraordinary range of interests and skills, even by the standards of the time: it included wood-cut designs for book jackets, pvc and rayon linings for Whatajoy luggage ("much later, I had to take the propellers off the planes in the lining designs"), pattern papers and book jackets for Chatto and Windus, upholstery moquettes for the London Passenger Transport Board (commissioned by Frank Pick, following an introduction to him by Christian Barman) and woven materials for Alastair Morton of Edinburgh weavers Morton and Sundour.

In 1944, Enid Marx became a member of the Design Panel of the Utility Furniture Committee (at Gordon Russell's invitation), and produced most of the Utility cotton furnishing fabrics, for power-loom production, over the next four years – in the regulation four colours: the same year she became a Royal Designer for Industry. Since well before her college days, Enid Marx had been a keen collector of ephemera and examples of "English popular arts", and in the years before the Festival of Britain she co-authored two trail blazing books on the subject.

It was an interest she shared with Rothenstein, who said in his Sheffield lectures:

Go into any house in any of our towns and villages, the home of a working-man or of a wealthier householder, and compare the furniture, the crockery, the drapery, the needlework, the silver, the fire-irons, lamps and candlesticks, with similar things to be found in such houses a century ago. English furniture was then superior to any in Europe, and so was her silver; and no pottery had the charm and naiveté of our own homely Leeds and Staffordshire ware. It is less difficult, indeed, to pick out charming things from dealers' shops than to have the knowledge and taste to order from good living craftsmen what we need.

To compare the naiveté of Staffordshire figures on a cottage mantelpiece with the work of "good living craftsman" was, by the 1930s, to miss the point by a fairly wide margin: the plain fact was that, despite one or two honourable exceptions, most of the leading designers of the day were emerging from architectural schools rather than the Royal College of Art. And Rothenstein's ideal of good modern design – a new Oxford College with "its assembly hall decorated by Augustus John, it's chapel by Stanley Spencer . . . its common room made bright by Duncan Grant and Vanessa Bell, its refectory by Bawden, Ravilious

Below *A selection of packages designed for Yardley by Reco Capey in 1936-8. Capey was Chief Instructor in Design at the College from 1924 until 1935.*

Top *Design on velvet by Enid Marx, who joined the RCA Painting School in 1922.* Above *Marx's moquette design for London Underground seats, 1937.*

1896-1940

or Cyril Mahoney, the lecture-rooms enlivened by illustrations of Time and Space by Wyndham Lewis" – did not inspire much confidence either, in the age of the Modern Architectural Research Group, the Industrial Design Partnership and the new Council of Art and Industry.

## ART AND INDUSTRY

The Council, under the Chairmanship of Frank Pick, had been set up in 1934 as a direct result of the Gorell Report on "articles of good design and everyday use". The Gorell Committee – which included Roger Fry, C. H. St. John Hornby, Clough Williams Ellis and Professor Tristram (who, sadly as it turned out, "has not found it possible to attend any of our meetings and has accordingly not signed the Report") – had had some tough comments to make on the state of art education:

*We are of the opinion that art education is a subject which requires the constant attention of teachers and educational administrators ... they will have to review the form of art training which will best fit candidates for posts in industry, and the means of placing these young people in suitable employment. It is common knowledge, we believe, that co-operation between Industry and Art Schools is not always so close as it should be, and we feel that much remains to be done ...*

The Hambledon Committee on "advanced art education in London", which reported in 1936, was set up precisely to examine what "remains to be done": it was to consider and advise "how far the provision in London for the teaching of Fine and Applied Art on the highest plane would be advanced by a closer correlation of the work and organization of the Royal College of Art with that of other institutions of similar standing in London ... and as to the character of any new buildings which may be required".

The blunt conclusion of the Hambledon *Report* – that "it is impossible to feel that all is well with the Royal College" – was followed by some hard-hitting recommendations. While "the presence in the College of a body of persons studying Fine Art for its own sake and with the intention of becoming painters or sculptors cannot fail to exercise a broadening and educative influence upon the students of design, especially those who have spent some years in industry", it was nevertheless essential, in the future, that "the attractions of the Fine Arts should not again be allowed to divert the College from its primary function". The *Report* went on, in a rather less aggressive vein:

*The most glaring defect of the College on the Applied Art side is its lack of adequate equipment, which is largely due to want of space ... We have found, however, a remarkable divergence of opinion on this subject. On the one hand we are told that the designer ought to be trained under factory conditions with a full apparatus of machining to enable him to try out his designs, and we are referred to Continental schools equipped with machinery on the most lavish scale ... on the other hand the view is expressed that the only thing that matters is the student's artistic training, that the difficulty of learning industrial processes is a mere bogy and that the artist can pick up the technique of factory production in a very short time. As usual the truth doubtless lies somewhere between these two extremes.*

In the course of its deliberations, the Committee (under the chairmanship of Viscount Hambledon) had considered two very radical options: either that the RCA should be incorporated into the University of London, or that the Central School should be acknowledged as "the national institution for the advanced teaching of Applied Art, in conjunction with or in substitution for the Royal College". But these were both rejected – partly because they would have resulted in the complete and public humiliation of the College and all its staff, partly because London University wasn't willing to take the College on. Instead, the Committee insisted on the abandonment of teacher training at the RCA; the enhancement of teaching in the area of design for mass-production (and the "adjustment of numbers" of students in other areas); new courses in Weaving, Furniture Design, Commercial Art, and Dress Design; art history classes to be taught by members of the Courtauld Institute; and a new Board of Governors (still responsible to the Board of Education) which would make sure that these reforms were carried out.

Where "adequate accommodation and equipment" were concerned, the island site was at last ruled out as "unsuitable": a new site of at least one and a half acres – "not too far from its present situation" – would need to be found, as a matter of greatest possible urgency. A move to this new site would mean that "the featureless brick building at the back of the Victoria and Albert Museum" would be given over to the Museum, for the first time.

There weren't many new arguments in the Hambledon *Report*: most of them, depressingly, went back at least as far as the days of Henry Cole and Richard Redgrave, and in some cases even the phraseology resembled that of the *Journal of*

114

*Design and Manufactures*. But the question of a new building – and of what should go on in that building – had given the old arguments a new edge. And the government was at last putting funds into other means of promoting "good design" *apart from* the art education sector ("educating consumers in design appreciation", and "encouraging manufacturers", for example), so the *Report* was able to look at the Royal College in relation to other Government initiatives – for the first time.

There was no hope that this Committee's recommendations would go away, as the College authorities had hoped about similar recommendations ever since 1911. Apart from anything else, on this occasion the recommendations had an exceptionally high public profile – partly through the efforts of Herbert Read, who included both the Gorell Report and the Design and Industries Association memorandum on the reorganization of the RCA (1933) which had formed the basis of the Hambledon conclusions, as appendices to his seminal book *Art and Industry*. The DIA memorandum had proposed that the College be reorganized, to "serve as a university of design for industrial purposes":

*Art education is at present characterised by a bias towards the fine arts and a divorce from industry, which is equally a divorce from the needs of the time. There is only room for a limited number of specially gifted artists in the sphere of the fine arts. Their needs are adequately served in the London area by the Royal Academy Schools, the Slade School, and the Courtauld Institute (for the History of Art) ... All these institutions are of university standard. There is no provision of adequate instruction in Industrial Design (which has its own problems of technique and aesthetic) by any national institution of equal, that is of university, status. The Royal College of Art was founded for this purpose, but its teaching has been deflected towards the fine arts and the training of art teachers, and its staffing and equipment do not deal primarily or sufficiently with art industries.*

The rest of the DIA memorandum to the President of the Board of Education dealt in considerable detail with all the issues discussed by Hambledon three years later: the *Report* acknowledges the help of "the Council for Art and Industry" (as it had by then become) and especially "Mr Frank Pick for their invaluable assistance". To include such a document, unabridged, in the book which the industrial designer Milner Gray later reckoned was "in many ways the turning point for most of us", the only book from the art establishment which enthusiastically embraced Modernism in

design, was to launch its criticisms firmly into the public domain. It was time for William Rothenstein to do the decent thing. As he was to recall:

*The attack was pressed home by Frank Pick in a minute to the Board of Education, demanding a change of policy in the direction of the College. I had always held the view that the business of the College was to give the best possible training to the students, whether they aimed at being painters, independent artist-designers or humbler cotton-print or wallpaper designers for private firms, and believed further that well-trained students would quickly adapt themselves to the particular conditions they would meet with in industry ... It was now made clear to me that the Board was no longer satisfied with this position; the time had come for me to make way for a younger man, with a policy more in accord with industrial conditions.*

Even at the eleventh hour, he could not resist using the adjective "humbler".

Rothenstein had originally told the Board that he wished to retire in 1936, but following an interview with Sir Henry Pelham, the Permanent Secretary, in November 1934, he asked leave of the President, Lord Halifax, to go at the end of the session. The month before – or in other words, nearly two years in advance of the Hambledon *Report* – Rothenstein had been invited by the Board of Education to consider "an offer by the London County Council" to develop an Institute for Industrial Art at the Central School. This offer, said the Secretary of the Board, which would probably involve "protracted conversations with the LCC", must not be allowed to defer yet again the question of a new building at South Kensington. The Board's minutes went on:

*The secretary also adumbrated the possibility of the RCA being taken over by the University of London in much the same way as the Imperial College of Science and Technology had become part of the university ... The Principal saw no objection to the College being taken over by London University like the Imperial College, agreeing with the secretary that the College was likely to receive more support from business and commerce on such a basis than if it continued to be a Government institution.*

By mid-November, when members of the Board realized that they would soon have to appoint a new Principal, they had put everything back into the melting pot. According to a private memorandum of 19th November:

*It has been suggested that the best plan might be to get rid of the island site, and also the present*

*buildings of the LCC Central School of Arts and Crafts, and provide a single College on some entirely new site. Or, again, that the College might be placed in such a position that it could be co-ordinated or possibly amalgamated with the Slade School of Art ... There are substantial grounds for believing that the LCC are ready to consider a proposal for handing over the Central School of Arts and Crafts with a view to its incorporation in a unified institution under, perhaps, the aegis of the University of London. While the subject needs some further exploration I think that it may well become desirable before long to appoint a Departmental Committee to consider the whole problem.*

Hence the Hambledon Committee, which weighed up the pros and cons of all these arguments – and, in the end, lost its nerve. The Board's records show clearly that Frank Pick's recommendation of "a university of design" had rapidly turned into a game of pass the parcel among the civil servants – with arguments about industrial design becoming hopelessly confused with suggestions about new buildings – and that, had it not been for Hambledon, the College as an autonomous institution might well have been closed down. In these circumstances, the criticisms made in 1936 – "notwithstanding the success and prestige which it has achieved in various directions, it is impossible to feel that all is well with the Royal College" – suddenly seem very tame indeed.

For Nikolaus Pevsner, a recent refugee from Germany who was enthusiastically tracing the genealogy of the European modern movement in the design history of his adopted country, even if it meant going back to William Morris, the events of 1933-6 were a cause for rejoicing. In his book *Academies of Art Past and Present*, published a few years later, he expressed the devout wish that the Royal College of Art would at last be "organised on the same principles as the most advanced German establishments", and in particular the Bauhaus – which he styled "the most important experiment in art education so far ventured upon in our century":

*A University of Design is what the Design and Industries Association has advocated, and it should not be so extremely difficult to attain this change of aims. For some time the design department with its classes for metalwork, stained glass, lettering and book illustration, book-binding and embroidery, has been numerically the strongest in the College. The majority of the workshops are not so well equipped as in some other schools, but not worse off, as far as this goes, than some of the most influential*

*Continental Schools. In fact reforms seem to be on the way ...*

Pevsner could not have known, for the simple reason that it is here revealed publicly for the first time, that Walter Gropius was in fact considered by the Board for a senior position at the College – even, perhaps, *the* senior position. If Pevsner had been aware of this strange turn of events, he might well have been less optimistic.

## A BAUHAUS IN SOUTH KENSINGTON?

Walter and Ise Gropius had arrived in England, sponsored by Maxwell Fry and Jack Pritchard, first in May then in October 1934. Gropius took some time adjusting to the "remarkable quality of understatement" among the British architects and designers he met, and, as he wrote shortly after settling down, "despite my 850 'Basic English' words, I still have trouble converting meters and kilograms into feet and pounds". A car journey to Stonehenge, during the first month of his stay, has shown him that "one cannot get accustomed to a completely changed working life too quickly" – as Jack Pritchard was later to recall:

*Ise Gropius had almost believed the Nazi propaganda that we were down and out and that we had no courage left. She thought the roadside propaganda, prominent in that part of the country, was designed to give us more courage. As a matter of fact, she was quite right. It was provided by that great institution of public welfare, the Brewery, whose posters read: "Take Courage".*

Other brewery posters – which read "You are now entering the Strong Country" – didn't help either.

By Christmas 1934, however, Walter Gropius had been in London long enough to form some interim conclusions of his own:

*Nobody in Germany has a notion*
*– how rich this place is*
*– how good, willing people are*
*– how incapable in terms of art the average man is*
*– how little people know about the arts.*

It was inevitable that the first Director of the Bauhaus would be drawn into the debate about the education of industrial designers, which was gathering fire just as he arrived in England. In December 1934, Gropius was guest of honour at a dinner organized by the DIA, and Frank Pick immediately wrote to the Board of Education, suggesting that "we ought to make some use of him in connection with the problems of the Royal College of Art". A few days later, members of the Council for Art and Industry wrote officially to

116

Gropius, explaining that they were "collecting evidence from experts in the Art Education world with a view to discussing our shortcomings". Gropius replied on 24 December:

*I am extremely interested in art education, but I'm afraid my poor knowledge of the English language and of the English art schools might at present be a handicap in giving the Council a clear view of my experience in art teaching.*

Nevertheless, he did contribute to the Council's discussion, and when the Hambledon Committee was collecting evidence, it, too, consulted "Dr Gropius, formerly of the Bauhaus, Dessau, Germany". The Committee's published *Report* refers to the views of "our most distinguished and authoritative witness" on two occasions. First, on the question of equipment:

*To attempt to reproduce factory conditions, even if it were desirable, would be impracticable on the score both of the expense and the rapid obsolescence of specialised machinery. This view was fully confirmed by ... Dr Gropius, the founder of the famous Bauhaus, a combination on a large scale of Art school and workshop, which won the high regard of the industrialists of Germany.*

Later, on the value of paper qualifications:

*Dr Gropius told us that, when the Bauhaus became known, its Diploma was highly esteemed by German industrialists and was of considerable value to the student who desired to enter industry. We see no reason why the College Diploma should not in the course of time come to be similarly regarded ...*

Early in 1935, following a series of meetings with senior officials at the Board of Education (during which he talked about the concept of craft as research for industry), Walter Gropius was commissioned to write an article on "the uniting of art and technology at the Bauhaus" for the Board's *Education Year Book*; and in February met E. M. O'R. Dickey, the staff Inspector of Art at the Board, to examine any parallels which existed between the Royal College of Art and the Bauhaus. Dickey immediately wrote to the Principal Assistant Secretary, Cecil Eaton, suggesting that Dr Gropius would be:

*of the greatest possible assistance in an advisory capacity in connection with any new schemes which may be planned for a "Bauhaus" which might rise up in place of the present RCA ... I did not, of course, suggest to Dr Gropius that we might wish to employ him in any way. He hopes to be in England a little longer but this may*

Above *Ise and Walter Gropius with, left, Marcel Breuer, in 1936. Opinion was divided on Gropius's suitability for an RCA teaching post.*

depend on whether a project for building some flats in Manchester in partnership with Maxwell Fry will materialise or not.

It was difficult to make Gropius a formal offer of any kind, Dickey added, because of the nationality bar which operated for all types of teacher, because Gropius did not speak English very well and was getting on in years, and because the Treasury would need a lot of persuading before they would agree to pay him.

Frank Pick was at this time corresponding with Gropius about the forthcoming book *The New Architecture and the Bauhaus* (for which he was writing the introduction). Pick's introduction originally contained the words:

*This country may count itself fortunate in being able to entertain him in this period of crisis and to secure his guidance. It might even seek to utilize his knowledge and ability in accelerating the changes that must come, not only in architecture itself, but even more in the teaching of architecture and of art in its widest acceptation.*

But Gropius asked Pick to delete "crisis" and substitute "transition" – because the original wording might have caused him problems back home in Germany – and Pick agreed. So by the time Frank Pick received a copy of Dickey's letter, he had got to know Walter and Ise Gropius quite well. He wrote to Dickey:

*Could we not appoint him to a post at the Royal College of Art, to take charge of design in some*

117

*direction, give him the necessary equipment and see what he could do for us?*

On 20th February 1935, Dickey replied:

*I need not say that what was uppermost in my mind when talking to Gropius was the thought that we should avail ourselves of his services, and I have, like you, been wondering how this could best be done ... It would, I fear, for many reasons, be out of the question to appoint Dr Gropius successor to Rothenstein at the Royal College of Art, even if this were likely to be the best thing to do, but failing his appointment as Principal, I am not personally inclined to feel that the best use would be made of his wide knowledge and experience by putting him in charge of a section of work only. I think that he should be of the greatest possible assistance if we could employ him in an advisory capacity in connection with the scope and organisation of the work at the RCA as a whole.*

There was, he added, no nationality bar for visiting lecturers at the College.

Two days later, Frank Pick wrote to Dickey:

*I did not contemplate appointing Gropius to succeed Rothenstein at the Royal College of Art. I think it might be open to serious criticism, but I did think that we might try him out by inviting him to give a course of lectures upon design, followed by certain demonstration classes.*

In fact, of course, Pick *had* suggested that Gropius should "take charge of design". The change of tone from this suggestion to a mere "course of lectures" would imply that Pick was concerned about being misunderstood by the Board. On 14 March, he wrote again to Dickey, offering the thought that the LCC might well be willing to let Gropius lecture at the Central School:

*As to the Royal College of Art lectures, I agree that it may be necessary to wait until the new Principal has considered his organisation and what he is to do, but might we not approach Gropius, suggesting to him that he might give a course of lectures, and what his views are?*

By April 1935, Percy Jowett had been promoted from his post as Principal of the Central School to the Principalship of the Royal College of Art. He felt that asking Gropius "to give lectures at the RCA next term would be an excellent thing to do" and, after putting the suggestion to Gropius in person, wrote to the Board:

*Dr Gropius came to see me this morning and we had an informal discussion about the question of his giving lectures ... the idea attracts him and I*

*am of the opinion that his English will be by that time quite adequate for this purpose. In fact I was very surprised to find how well he speaks English at the present time. He was rather anxious to know what scheme the Board had in mind in reorganising the Royal College of Art, but of course this I could not tell him.*

And there the matter closed. Gropius never did lecture at the College, and when the Central offered him a course of six lectures on architecture and design in autumn 1935, he politely declined.

However, Gropius did achieve a few architectural commissions in England, with Maxwell Fry – including a village college at Impington, and a house in Church Street, Chelsea – and a few design commissions, with Isokon – including an electric fire, a chair and an aluminium waste-bin – but, on the whole, as Ise Gropius was to recall: "The people we felt close to in spirit were usually out of favour with the influential circles".

Maxwell Fry was rather less charitable about it:

*There is in the English character a vein of anarchism, amounting at times to pig-headedness, that rejects the logical approach and the commonly shared view in favour of going through the independent experience come what may.*

Perhaps *this* explains why the Board of Education picked its way so cautiously through the whole gamut of suggestions about how "we should avail ourselves of his services" – from Principal (maybe) to head of design to consultant to lecturer to visiting lecturer – in the space of three months flat.

---

THE NEW ARCHITECTURE

Ever since he arrived in England, Gropius had been successfully delivering slide lectures on "the development of the new architecture" – to the Design and Industries Association; at Liverpool's School of Architecture; in Manchester and Dublin; and to the Education officers of the LCC – but he had come to England in the hope that he would be able to practice design, not to preach about it, and by his second Christmas that "remarkable quality of understatement", initially so attractive, was beginning to get on his nerves. The design establishment which welcomed Berthold Lubetkin (arrived 1933) and Laszlo Moholy-Nagy (arrived 1935) – then helped them to get commissions to design, respectively, the Penguin Pond at London Zoo, and window displays at Simpson's of Piccadilly – evidently suffered in translation.

By March 1937, Walter and Ise Gropius had left for "the inevitable America" (as Herbert Read called it). Several months before, Gropius had decided to "draw a line under my English balance" and accept the post of Professor of Architecture at Harvard. At a farewell dinner at the Trocadero, he expressed his sincere appreciation for:

*the patient attitude towards shy and awkward people which has been specially developed by the English and which has turned this country into a place where one needn't shout to be heard.*

Returning the compliment, Herbert Read wrote to *The Times*:

*It was the confident hope of many people that we were to have the benefit of his outstanding talents for many years to come. In this we have been disappointed.*

During the first six months of Gropius's stay, the search had been on for William Rothenstein's replacement as Principal. The front-runners among those trawled by the Board were Herbert Read, Staff Inspector E. M. O'R. Dickey, H. H. Holden, Principal of Birmingham College of Arts and Crafts and Percy Jowett of the Central. So while Dickey was pondering how the Board could avail itself of Gropius's services, and while Read was becoming progressively more "disappointed" about the attitudes of the design establishment (outside Hampstead), both were being considered as possible Principals of the College. Frank Pick, and Cecil Eaton, the other characters in this sad story were on the interviewing panel which selected Jowett on 15 March 1935.

Percy Jowett had won a Royal Exhibition to the RCA from Leeds School of Art in 1904-7, after which he eventually became Head of Chelsea, and, from 1929 to 1935, of the Central. In 1912 he had married Enid Ledward (the sister of Gilbert). He had held four one-man shows at the St George's Gallery, London, in the 1920s, exhibited at the Venice International Exhibition in 1934, and was a member of the New English Art Club: contemporary critics treated him as one of the most distinguished English Post-Impressionists of his generation. William Rothenstein was absolutely delighted with the panel's decision to go for another appointment from the world of Fine Art:

*No better choice could have been made. He started with the confidence of the Board; under his able guidance the College was unlikely to become industrialised. I bade farewell to staff and students, not displeased to be freed from official duties.*

Within the year, two members of the interviewing panel and at least one of the unsuccessful candidates (Dickey) were putting their signatures to the Hambledon *Report*. Clearly, the Board of Education was moving in a mysterious way its wonders to perform . . .

Meanwhile, William Rothenstein moved from his large house at Airlie Gardens to a brand-new flat at High Point, Highgate. It was designed by Berthold Lubetkin and Tecton – a pioneering example, in England, of the kind of "new architecture" for which Gropius himself had become world-famous.

119

# PART THREE

## THE DODO
## AND THE PHOENIX

Top *Pots by Elizabeth Fritsch, who studied ceramics and glass 1968-70. Field telephone by Seymour-Powell. Evening dress by David and Elizabeth Emanuel.*

Top Cast Aside *from* A Rake's Progress, *a series of etchings from the early '60s by David Hockney.* Above *Tallboy in English sycamore, designed by Ron Carter, who studied at the RCA 1950-3.*

# AMBLESIDE

## PAINTING FOR VICTORY

When the students arrived back in South Kensington for the autumn term of 1940, they found that the College premises had been shut down. A note on the door of the Exhibition Road building informed them that the RCA would re-open "in the near future, somewhere in the country".

The Board of Education had, in fact, already decided that the College should be evacuated, during the long summer vacation of 1940, the summer of the Battle of Britain. It was not before time. The bombing of London had shattered most of the windows in the College buildings, and by October 1940 practically every institution of university status in London had already been evacuated. The office of works had suggested two possible locations – Penrhyn Castle, near Bangor, and the two best hotels in Ambleside in the Lake District – but, even as late as the first day of term, the Treasury was still raising objections about both: there was the difficulty of obtaining possession of Penrhyn Castle, and, where Ambleside was concerned, there was likely to be considerable expense involved – to say nothing of political objections "to the removal to a place of safety of the College, when there were still numbers of mothers and children in danger areas who had not been, and could not be moved".

Eventually, the hotels in Ambleside were selected: the Queens Hotel would house the male students and some of the staff, and provide "classrooms", while the Salutation Hotel across the road would house the female students and also accommodate "the teaching of engraving and dress design". Many members of the College staff were already on active service: Barnett Freedman, Edward Bawden, John and Paul Nash, Eric Ravilious, Alan Sorrell and Vivian Pitchforth had all become official war artists. The remainder – most of whom were part-time – including Gilbert Spencer (younger brother of Stanley Spencer, and Professor of Painting since 1932), Richard Garbe (Professor of Sculpture since 1930), Ernest Tristram (Professor of Design since 1924), Malcolm Osborne (Professor of Engraving since 1924), Robert Austin, Cyril Mahoney and Percy Horton went up to Ambleside from October onwards to prepare the buildings for the delayed arrival of the students. These members of staff had been deemed unfit for military service, for one reason or another (mostly age – the *average* age of the Professors was fifty-eight), and the transfer of the College and its movable equipment into makeshift accommodation at Ambleside must have been a major undertaking for them, in the absence of most of the manual attendants: presses, potters' wheels, furnaces and looms had all to be manhandled. Unfortunately, as Percy Jowett was wistfully to note, "we could not bring much of our heavy equipment with us".

On 2 December 1940, nearly one hundred and fifty students checked into the Queens Hotel and the Salutation Hotel – at a charge of five shillings a week for billeting, since they were not to be regarded as official evacuees – and the auumn term at last began. The College was to be based in Ambleside for the next five years.

The immobility of "our heavy equipment" was, as it turned out, most unfortunate, for the years since the publication of the *Hambledon Report* had seen various attempts to implement at least some of its findings, under Jowett's guidance: in 1937, the Industrial Art Committee of the Federation of British Industries had offered substantial prizes for the best work in "the various departments of industrial art", and this had inevitably affected the orientation of the work exhibited at the summer show by the Design School. In the same academic year, over thirty students spent periods of between two and six weeks in factories and distributing houses, observing "methods of production and display". In 1938-9, a course had been launched for all Design students on "how to present their work to employers, with reference to the special needs of the particular industry". Reco Capey had been appointed industrial liaison officer, and from 1936-8 the new Department of Weaving and a "large class in Dress

**1940-1945**

Design" had begun to attract students. Where public commissions were concerned, a group of senior students had prepared some large heraldic devices for one of the pavilions in the 1939 New York World's Fair, and another group had been engaged by the Department of Overseas Trade to copy two of the murals in the House of Lords for the same Fair, while Professor Tristram had supervised four Design students as they painstakingly prepared an armorial record of the cloisters of Canterbury Cathedral, known as the "Canterbury Book", which in 1939 was bound by Douglas Cockerell (head of College bookbinding during 1936-9) and presented to the Dean and Chapter at a special service. Also, in a competition organized by the Goldsmiths' Company in response to the suggestion of King George VI, J. L. Auld produced a winning design for the Royal Hunt Cup.

Of course, much of this was a world away from the "completely new orientation . . . towards the advanced study of all forms of Applied Art" which the Report had asked for, but it was a start. The outbreak of the Second World War meant that, for the time being at least, it would remain no more than that. Richard Seddon was a painting student at the College in the months leading up to the declaration of war and he was to recall how "the tension in the atmosphere of the times" made itself felt:

*The yellow spoil heaps from the trenches in Kensington Gardens grew bigger – barrage balloons hung pearly in the summer sky and the night was criss-crossed with searchlight beams.*

*With Paul Nash's brother, John Nash, who, like Paul, taught at the Royal College, I walked across Kensington Gardens one day for luncheon at the open-air restaurant. On the way back we paused and gloomily regarded the spoil heaps and the air-raid trenches. "If you knocked the trees about a bit it would look like the landscapes we painted on the Western Front", he remarked.*

*On our return we skirted the Albert Memorial. He stared at one of the groups of statuary.*

*"I was always told", he reflected, "that sculpture should be valid from any viewpoint but all I can see from here is an elephant's behind."*

*We walked on, across Kensington High Street and down Princes Gate.*

*"Not that it matters," he added, "they'll be bombing this soon enough."*

At the summer graduation ceremony of 1939 – the end of the last full year before call-up of staff and students began – the "diplomates" included John Ward (now RA), Harry Thubron, John Newton (the painter) and Frank Roper (the sculptor). The autumn term was supposed to commence at the

A "POTATO-LOFT UNIVERSITY"

The most delicate problem about the move to Ambleside appears to have been relations between the College and local residents. Reports in the local newspapers describe the students as being "somewhat strangely garbed", with young men sporting "wild and woolly beards", and the arrival of a group of students in the local tea-rooms tended to reduce everyone to silence. Who *were* the students attending this "potato-loft university" (as it was dubbed)? Was there something wrong with them? Were they perhaps conscientious objectors? Anything seemed possible with such "arty"-looking people. Three students, all from Sheffield, had in fact registered as conscientious objectors in 1940, and one of them had attracted a great deal of publicity for his remarks on the connections between sculpting and the creative acts of God.

beginning of October 1939, but as late as 28 November it had still not been decided whether or not the College was in a position to re-open. Holders of State scholarships had duly arrived on the first day of term, only to find that their awards had been withheld. By Christmas, the Board of Education had agreed that the College could open its doors on 9 January 1940 – with about 150 students – and that the minimum age of entrants could be reduced to 18, so that students could complete at least one year of their course before being called up for military service: the shortened academic year would count as a full one for the purposes of the Diploma. The potter and ceramic sculptor Arnold Machin graduated at the end of this first year of the war.

*Picture Post* had run a photo feature on the work of the College in the year 1938-9 – with pictures of pensive-looking students queueing up for lunch in the Common Room ("conversation over lunch is almost always on art – sometimes feelings run high"), and of anxious-looking students "hurrying for criticism" along one of the corridors of the Exhibition Road building – and the *Post* was to visit the College again, in wartime, no longer housed "behind the great buildings of the Victoria and Albert Museum", but evacuated to "the beauty of the Ambleside hills". The "great buildings" were by then occupied by the RAF and used for stores. Under the headline *Art School Carries On In Lakeland*, the article explored the differences between the College in peacetime and in war:

*The main body of the school is now housed in two fashionable hotels. A throne, a model and a*

*clutter of easels, paints and canvasses litter a peacetime ballroom. Students design, weave and dye fabrics from experimental formulas in a converted cowshed ... Some have converted old pigeon lofts and garage attics into patched-up, whitewashed studios, isolated above rickety ladders. Others may go off into the mountains sketching for several days at a time ...*

The atmosphere of "lovely tranquil things and beautiful surroundings" may have been idyliic – in fact, just what readers of *Picture Post* probably imagined painting was like in peacetime – but the first year in Ambleside had not been particularly easy for staff or students. Heating and lighting were far from adequate, the pottery students had to travel to Lancaster to fire their work, and several individuals were reported as suffering from malnutrition. One of the female students died, while digging in the hotel vegetable patch. By the first summer a brick kiln had been built in a roofless lean-to behind the Salutation Hotel, some Design students had converted a large barn into a weaving shed, and the billeting charge had gone up to £1 a week (21s. for staff – a low differential which was thought to be "unfair" by the Common Room Committee).

Leslie Duxbury, printmaker, who arrived in 1941 and after two years in the army returned to become Secretary of the Common Room Committee, recalls:

*It was like a frontier town – a haven for all sorts of people who had fled the cities. And we were staying in the two best country hotels in Ambleside ... It seemed very strange at first. I can remember one of the College retainers, name of Frank, who continued to be an odd-job man. Robert Austin, ARA, of the Engraving School did a design for a ram's-horn walking-stick which Frank made for the tourists. The sticks were all supposed to have been cut from a tree over Wordsworth's grave! ... I started at Ambleside in September 1941, and the first student I met, a painting student, was Roger Nicholson who much later was to become Professor of Textiles at the RCA. He stood at the entrance to the Queens Hotel and said to me "it gets bloody cold in winter" ... We complained like mad that we hadn't got this, that and the other. And everyone thought we were a bunch of cripples. But 1941 was a crucial year, as we settled and got down to work, because the result of it was that the College stayed open. And the great thing was that the students could move from department to department – calligraphy, engraving, life-drawing, textiles – without any barriers: everyone did everything, before Robin Darwin came along and pulled it all asunder.*

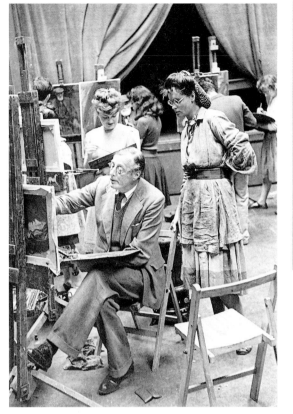

Above *Painting class at Ambleside in the Lake District, where the RCA was relocated 1940-45.*

From summer 1941 onwards, Percy Jowett – as a matter of policy – tried as far as possible to integrate the life of the College with that of the local community: this must have been a very novel experience for both staff and students, who customarily regarded themselves as well above such considerations. For Ambleside War Weapons Week, the Design students produced window displays in local shops, which were later transferred to Carlisle at the request of the Mayor: the week was inaugurated with a street tableau representing the Allies carrying a caged dictator. This was followed by Warship Week, organized by the students who had joined the 9th Westmoreland Battalion of the Home Guard, and by the College's contribution to the local "Dig for Victory" campaign, which made full use of the garden surrounding the Salutation Hotel.

But the activities which most endeared the students to Ambleside residents were the annual shows, and the murals. The College Exhibition of July 1941 attracted over 1,000 visitors ("more", as a member of staff said, "than had ever visited the show in London"), a figure which was doubled in July 1942. As Mr G. A. Varty, a local bookseller, recalled in February 1944:

123

*Through the presence of the College, and under the inspiration of the Professors, quite a few local people have found a desire to express themselves in watercolours for their own amusement: recently, we had an exhibition of 400 pictures and sketches. When someone gave three guineas for my second watercolour it gave me a tremendous thrill.*

Following the various "War weeks", with their attendant publicity, demand for College expertise began to rise. A mural showing coal-miners at work, based on drawings done in Monckton Main Colliery by students Bill Kempster and Barrymore Evans, was painted in the village school; another mural, decorating the ATS Recruiting Office at Kendal, was done by students Doreen Page and Barbara Harris and unveiled by the Mayor of Kendal; and Gordon Ransome painted a large mural *Rush-Bearing* (1944) in Ambleside Parish Church – using drawings by fellow-students and local residents: this was dedicated by the Bishop of Carlisle and featured in *The Times*, and is still in good condition.

Add to these the charity performances of College plays – such as *A Midsummer Night's Dream* with Percy Horton as Bottom the Weaver, Leslie Duxbury as Flute the Bellows-Mender and directed by Peter Bucknell (later to become a well-known theatre designer and, for the single year of its existence (1948) the Head of the Department of Theatre Design at the RCA) – and the lectures which were open to the public – by visiting speakers such as Nikolaus Pevsner, Francis Klingender (on "art and industry") and John Farleigh – and it is clear that Jowett was making every effort to present the Royal as a community-minded College. The *Westmoreland Gazette* was impressed:

*When you see evacuated people taking an interest in local events such as fox-hunting, mountaineering, shepherd's meets, etc., instead of devoting all their spare time to going to the pictures and dancing, you feel a kindred link . . .*

But for Gilbert Spencer, the whole interlude in the Lake District ran the risk of becoming too "idyllic" by half:

*Nearby Liverpool was in flames, but we were to know Grasmere as Wordsworth had known it, and to hear that strange note ringing round the frozen lake as its waters lowered – rather than the wail of sirens. Spurred on by a talk at the College by an air raid precautions officer from Liverpool I duly reported to the Home Guard at Ambleside . . . No words can describe my own pride at being able to crawl a hundred yards without my behind showing above the skyline.*

In addition to his paintings *Grasmere Home Guard* and *Troops in the Countryside*, Gilbert Spencer produced at this time a series of twelve comic drawings of the life and times of the Home Guard: although some critics didn't think they were very funny, they were eventually shown in London at the Artists International Association, with David Low opening the exhibition. Frederick Brill, a Painting student from 1941 to 1944, who played Theseus in *A Midsummer Night's Dream* and was later to become Principal of Chelsea School of Art, also drew and painted local members of the Westmoreland Battalion – in which he was a sergeant, as was Percy Horton who painted a series of local portraits: Horton had joined the Home Guard because, like many committed socialists at the time, his intense hatred of Fascism overrode his reasons for becoming a conscientious objector during the First World War.

Another evacuee to Ambleside, during the last year of the war, was the internationally recognized German abstract artist, of *Merz* and Dada fame, the self-styled "member of the *avant-garde* in art", Kurt Schwitters. He was living at 2 Gale Crescent, on the hillside above the town, about half a mile away from the Queens Hotel, while he worked on his third *Merzbau* "combining art and non-art" at a stone-walled barn in Cylinders Farm, Langdale – the home farm of Mr Harry Pierce. This *Merz* construction in plaster and wood, funded by a small grant from the Museum of Modern Art in New York, was to be "his last monument".

When Schwitters was no longer strong enough to climb up to Gale Crescent he moved to 4 Millans Park, next-door to a friendly young schoolteacher named Harry Bickerstaff, where he was even closer to the Royal College of Art. The extraordinary thing is that no contact seems to have been made between Kurt Schwitters and members of the "potato-loft university" during the months when they were all in Ambleside. According to Leslie Duxbury, "he'd scarcely been heard of by the RCA residents, and certainly not by the majority of students":

*We didn't know who the hell he was. We sometimes saw him collecting a pension or something from the Post Office, but he was never pointed out . . . There were an awful lot of old characters about, so he didn't stand out.*

Other students of the time do recall having tea with Schwitters, one day, but cannot remember whether the College staff took any interest in their account of the experience. Their feeling is "probably not".

Probably unaware of the irony of the German

artist's going unnoticed, Percy Jowett felt able to state in his Convocation Day Speech of July 1945, that the Lakeland episode had been a terrific success:

*After their training at Ambleside, and with a more mature outlook, the students will approach the Old Masters with far greater eagerness and reverence. When, for instance, they visit the National Gallery and the Tate Gallery, they might think they do not want to paint like Turner, or even to see as Turner saw, but they will not say – as I once heard a student of the College say – that "Turner was tripe"... The students may not have had at Ambleside the perfect and ideal accommodation of studio and workshop. If they feel that, they should remember that after all it is not ... the studio or workshop that makes the work of art, but the blouse-clad men and women at the easel, desk or bench, or potter's wheel, just getting on with the job whatever the surroundings might be.*

In fact, the previous October the Design students *had* managed to hold a major exhibition of 750 textile designs at the Cotton Board's Style Centre in Manchester, which was opened by Sir Thomas Barlow (a member of the College Council). It had attracted a lot of press coverage – as an example of "the closer links between College and industry" – although the Director, Cleveland Bolle, reckoned that "the exhibits were very good artistically, but apart from the furnishing fabrics, the work was out of touch with contemporary requirements – especially in dress design".

At an earlier Convocation, held in the "Pavilion" of the Queens Hotel, Mr J. Trevelyan, the Director of Education for Westmoreland, had expressed the hope that graduating students – and in particular the Design students – would be able to play their part in building the brave new world of post-war Britain:

*He touched on the general cheapening of interests and values which they saw all around them – on the films, even in the BBC programmes, and in the field of arts and lectures. There was an ever-increasing commercialization of things... They could not expect people living among squalour and ugliness to grow up and appreciate things of beauty. But out of the midst of the present catastrophe some good might come, and it presented them with a magnificent opportunity. There was a new spirit about...*

## THE DOVECOTS ARE FLUTTERED

But amidst all this dewy-eyed optimism – and after a period of several contented years when the

---

### THE PAVEMENT ARTIST

Schwitters spent most of his time while he was in Ambleside earning a few pounds by doing "naturalistic" drawings and paintings which he sold to passers-by from the steps of a tourist attraction in the town-centre. Indeed, for many years after his death on 8 January 1948, he was remembered by most of the inhabitants as "a penniless, eccentric foreigner who eked a living out of the tourist trade". But he did get to know Dr George Ainslie Johnston, the senior practitioner in Ambleside, who was one of the GPs looking after the students – and there is still a portrait of Dr Johnston by Schwitters hanging in the Armitt Trust Library, Ambleside. Like Gropius, this venerated figure from the European avant-garde almost crossed the path of the Royal College of Art – but not quite. Many of the students must have walked straight past him every day of the week.

---

College had been relieved of its usual obligation to be too sophisticated about the art and design it produced – the traditional problems of the College buildings in London, and the most appropriate training for industrial designers that was to happen in them, were not about to disappear into the mists of Lake Grasmere. As early as October 1940, the existence of a new London site for the RCA – a three-, or possibly four-, storey building next to the Royal Albert Hall – had at last been publicly announced by the Ministry of Works.

However, with all the post-war domestic rebuilding to be done in London, this new construction would probably take "from four to five years" to be completed. In the meantime, the Exhibition Road premises had been hit by a Flying Bomb on the night of 28 May 1944, and the Queen's Gate sheds had been turned into builders' huts for the duration. Clearly, the move back to South Kensington would disrupt the College's work for an indefinite period of time: as Jowett reported to the students in Ambleside, their "old building was a very sad place, with few windows in it, one or two walls down and part of the roof open to the sky, and that was where they would have to start their education after the war". This was likely to prove a particularly difficult time for the College, since returning servicemen (staff and students) would considerably swell its numbers at a time when workspace was even more limited than pre-war. And, by now inevitably, the Board of Education was making noises again – from early 1943 onwards – about "making use of the Central School instead of trying to turn the RCA into a rival show", in the words of E. M.

O'R. Dickey (who had been promoted to HMI). As Rab Butler, President of the Board of Education, wrote to Dickey on 4 December 1944:

*I see the great advantage in this idea, but it must be most carefully handled. The Royal College of Art is far superior to this LCC school in dignity. Even on questions of efficiency we do not always think of the LCC. The idea might enable us to shift the RCA Governing Body around a bit, and make a break in the life of the RCA, but we must be careful not to swamp its identity . . . It is easier to merge staffs than Governing Bodies.*

The direction in which the College was expected to "shift" had been laid down by the Weir Committee on industrial design, a committee of the Department of Overseas Trade chaired by Sir Cecil Weir in September 1943. Members included Kenneth Clark, Francis Meynell and Josiah Wedgwood and recommendations included the setting up of the Design Council. Weir had concluded:

*We are doubtful whether the Royal College of Art, reorganised on the lines proposed in the* Hambledon Report, *would gain the confidence and co-operation of Industry. On the other hand . . . we are averse to multiplying bodies or institutions if existing institutions, suitably modified, appear likely, given the chance, to meet the purpose we have in view. In our view there has been too much emphasis on the words "art" and "artists". Manufacturers, particularly in the more technical industries, are suspicious of the artist and the Art School, and it is a cardinal point in our recommendations that a status and prestige should be built up around the words "design" and "designer". We therefore recommend that the Royal College of Art be retained as the centre of training for individual design, but that it be renamed "The Royal College of Art and Design" and reorganised in such a way as to allow a greater specialisation in all branches of industrial design.*

A small interdepartmental committee, of the Board of Education and the Board of Trade, had immediately reacted to this by going even further. After noting that the pre-war changes in the College, 1936-9, were never more than tentative steps in the right direction, the Committee added (on Weir's recommendations)

*Their realisation will supply a means for providing designers, few, but of the finest, for industrial requirements. We suggest a change of name: "The Royal College of Design" is more precise than "The Royal College of Art and Design" and avoids raised eyebrows at the otherwise implied distinction between art and design. We think also that the Royal College could, when equipped to do so, accept practising painters and sculptors for courses in industrial techniques.*

A confidential discussion paper from Dickey, on the "reorganisation of art education after the war" – compiled from the results of a questionnaire put out by the Board in 1942-3 – had been far more specific:

*I do not think that the College should continue to cater for the easel painter as is done at present. He should go to the Slade and the Royal Academy . . . I think that the work of the College might reasonably be organised in the following departments, which I shall call "Main Crafts":*
*Mural Decoration (including house painting)*
*Sculpture (including modelling and carving)*
*Dress (including Hosiery and Millinery)*
*Woven Textiles (hand and machine weaving)*
*Printed Textiles and Wallpaper . . .*
*Precious Metals (Silversmithing, Enamelling and Jewellery)*
*Light Metalwork, wrought iron, etc.*
*Pottery*
*Stained Glass*
*Engraving and Etching*
*Lithography*
*Typography*
*Photographic Processes of Reproduction*
*Bookbinding*
*Furniture . . .*
*Before the College returned to London, I should give notice to the whole of the existing staff, if an entirely new organization was to be set up, making it clear that there would be no guarantee that any of them would be re-appointed . . . The justification for this drastic action would be that we must be sure of making a fresh start with the best available staff and we must not mind making ourselves unpopular if that can't be avoided . . . No teacher of a main craft would be appointed for more than, say, five years at a time, and we should declare that it would be our policy to make changes from time to time.*

This discussion paper is extremely interesting, for it introduces – in great detail – precisely the reforms which Robin Darwin was to implement from 1948 onwards: his Departmental structure, based on studio specialisms; his treatment of the existing tutorial staff; even his new contract structure – of five-year contracts. There is some evidence that the ideas contained in it were put to him, by the Ministry, six months before he was appointed, and that he agreed with them. But after Darwin took office, two basic changes of direction were to emerge: first, there *would* continue to be "easel painters" at the Royal

College of Art, and second, the Ministry of Education would have no direct say in how any of these reforms were implemented.

The College Council met on 12 April 1944, to consider the Weir Report (though not the ensuing memoranda) and replied to the Ministry that when more ex-students secured jobs in industry, then industrialists might begin to give more help to the Design School in order to keep students in touch with their requirements. Jowett added, with some justification, that "confidence must be of slow growth", and emphasized the fact that for five years out of the eight years since the *Hambledon Report* appeared, the country had been at war, but that the College had already incorporated Technical Instructors from Industry on the staff, and three more would have joined the staff if war had not broken out. Besides, he noted, some of the signatories of the Report had never even visited the College, let alone consulted the senior staff.

Dickey, for his part, did not find these arguments at all convincing:

*I should have thought that the RCA Council would have made a clear statement showing that they intend to adopt the Hambledon recommendations, and that, by so doing, the RCA will, in fact, fill the bill so far as is humanly possible, bearing in mind the well-known difficulties in securing satisfactory employment for ex-students as designers for manufacturing industry ... I have the general impression that as at present staffed, the RCA will not go all out to meet the industrialists ... I think the truth is that provincial art schools don't all regard the RCA as the place to which a student hoping to make a living as a designer for manufacturing industry ought to go, but let us hope that after the war improved conditions at the College will establish it as the Mecca of the aspiring designer!*

In the same month, June 1944, H. B. Wallis of the Ministry of Education wrote that:

*The deeper difficulty, as I see it, is that of finding the staff who have the gifts and the outlook necessary for this rather specialized work, and there have been times when rather in despair I have wondered whether it would not be better to abandon the RCA altogether and to build up training in industrial design at a number of centres on specialist lines ... Apart from this, which looks like acceptance of defeat, such a line*

*of development would, I understand, be subject to considerable criticism; that design of different kinds ought to be got together into one institution on the ground that you cannot properly deal with furniture in one place and fabrics in another, pottery in another and so on.*

He concluded:

*Nothing short of an almost clean sweep, as I see things, is likely to secure a breakaway from the old traditions and enable us to make a really new start with a new outlook.*

Just before Christmas 1944, Wallis added (in response to the Minister's letter of 4 December), on the question of the proposed amalgamation with the Central School "for a period after the war on the return of the RCA from Ambleside":

*Sir Harold Webbe, as Leader of the Opposition, has indicated that in his view the Minister might find considerable opposition in the House of Commons to any such proposal, and that this Ministry would be criticised as weakly throwing in its hand and abandoning this institution, which should be functioning as the apex of the Art School system. This is, of course, just the sort of quite unreal criticism which we know may take place, and what has to be weighed against this is the prospect of otherwise going on with the Royal College in the somewhat dismal condition in which it has subsisted for so many years, with little prospect of being able to make a clean new start in appropriate premises for a number of years.*

It was expected that these arguments and other "considered opinions" for and against, would be finally resolved by the President himself, after "testing the RCA reactions".

On this occasion, as on so many others in the period 1936-45, no resolution was forthcoming.

But it was clear that the "idyllic" episode in the Lake District was well and truly over, and "the lost generation" of students who had lived so happily in the Queens Hotel and the Salutation Hotel from 1940 to 1945 were about to be written out of the College's history altogether. During the months leading up to the Education Act of 1944, Rab Butler had observed that "the dovecots at Ambleside may well be fluttered". There was, in fact, to be a five-year wait before the doves, re-settled in London, were preyed upon by quite a different species of bird . . .

## 1945-1987

# SOUTH KENSINGTON AND KENSINGTON GORE

### THE SURVIVAL OF THE FITTEST

As part of a lecture at the Royal Society of Arts, on 20 January 1954, Robin Darwin described his arrival at the Royal College of Art in characteristically flamboyant style:

*January the 1st, 1948, broke wet and cold, and as I walked up Exhibition Road the rain came sluicing down from the Park into my face. All the "Happy New Years" and good wishes of the night before were forgotten, and I was filled with a feeling almost akin to panic, for I did not know the College and the College did not know me. I pushed open the door and entered the hall of the main building. It is by any account a depressing place, though I have since come to love it, but it was more depressing then than it is now, for it was painted – as I was soon to find every wall of the College was painted – with the deadliest and most institutional grey paint that the Ministry of Works could devise. It was as dismal as it was deserted. On the second floor, however, I found a sign of life, for in the room which is now my secretary's there were two aged stewards playing a game of shove ha'penny ... I went into my room which was, of course, coloured the same cold grey, and there on my desk I saw an oblong green book. Taking it up with interest I found it was called an Attendance Book, and when I enquired its purpose from the senior steward he told me respectfully but sorrowfully that I was expected to enter daily my times of arrival and departure in it. I threw it into the waste paper basket.*

This story, as the rest of the lecture revealed, was intended to be symbolic of the general state of the College in 1948 – and of the reforms which Darwin had implemented in his first six years as Principal. The dead hand of the Ministry had been amputated to allow the College to grow up as a National College with its own Council of Management and its own administration. No longer were members of HM Inspectorate permitted to take part in entrance examinations and

final assessments, which now rested "upon the sole decision of the teaching members of the College". The Attendance Book had been torn up (for staff, anyway) so that all Professors and Tutors could in future be "free to come and go as they chose" – and they would never again be insulted with the Ministry's references to a "leave allowance": it was essential, in an institution such as the RCA, that freedom from bureaucratic constraint be given in those places where it would release the most energy, activity and fresh ideas. And the depressing atmosphere of a down-at-heel ivory tower had given way to the livelier atmosphere of an establishment which had the fullest possible contact with the post-war world which surrounded it.

Partly, this transformation had been a question of marketing: Darwin had, with help from the new design establishment, "sold" the idea of the College to the captains of industry and commerce. Partly, it had been a question of the institution's morale; in December 1947, Darwin had been invited by Percy Jowett to meet all the members of his staff, at a tea party, and had been appalled to discover that most of them had never been introduced to each other before, while "two of the five professors were alleged not to have exchanged a word for fifteen years". Above all, it had been a question of turning the RCA into a "magnet for talent".

Neither the story of Darwin's arrival – nor indeed the ensuing lecture – made the slightest reference to any other institutions in the art education sector. The only reference to another "educational establishment" outside the College was to Cambridge University:

*When I was a small boy I had, as I think, the good fortune to be brought up at Cambridge ... As I came back on a winter's evening from children's parties through the great court of Trinity or through Kings, the windows of the chapel would still be glowing from the candles lit for Evensong, with lights twinkling in the Fellows' rooms upon all sides. The power that has kept them shining*

Above *Robin Darwin, Principal of the RCA 1948-67 and Rector from 1967 until 1971.*

*day in, day out, for six centuries and more, depends on the deep impulse which makes mature men come together in one place and associate with one another in learning and research, and in the common pursuit of ideas more important than themselves ... This is the spirit which hallows all universities and gives to them their timeless traditions, and I believe something of this spirit has begun to move within the Royal College of Art.*

*This* was Robin Darwin's ideal, and if it was more than a little sentimental – harking back to the idyll evoked in Gwen Raverat's *Period Piece*, and a time when the latest escapades of the Darwin clan were the subject of after-dinner conversations in Senior Common Rooms all along Kings Parade – it was certainly new to a small South Kensington College which had no timeless traditions and little influence in the "twin and equal" areas of teaching and research.

The College before 1948, when it was dependent for its every move on a group of civil servants who were responsible for "looking after women, Agriculture and the Royal College of Art", he likened to the Dodo. The "attitude of mind, the sphere of influence which *is* the Royal College of Art", he likened to the Phoenix:

*It will not escape the attention of keen ornithologists, and quite ordinary persons besides, that the Dodo is, or at any rate was, a real bird,*

*whereas the Phoenix was never more than a fantasy of the imagination. It may well be that in my enthusiasm for the College as it has risen from the ashes I ascribe an equally mythical importance to it. If so, I hope I may be forgiven.*

The "Phoenix" – which was to become part of the corporate image of the College from the mid-1950s onwards, when it appeared on countless letterheads, invitations, menus and dinner services – was, Darwin conceded, a highly ambiguous symbol. In choosing it, he could be accused of "inflicting unfair criticism or showing undue complacency", and the bird itself could be interpreted either as rising from the ashes or as having its tail-feathers singed. Previous generations of students – from both the Rothenstein and Jowett eras, or in other words, the era of the Dodo – were to be extremely offended by it.

Robin Vere Darwin was born in 1910, the great-grandson of Charles Darwin and the great-great-grandson of Josiah Wedgwood. His father Bernard was a "gentleman journalist", writing regularly for *Country Life* on many matters but especially golf, his passion. Bernard Darwin was reputed to be a very erudite man who affected a bluff, sporty philistinism as a protective armour around a vulnerable, sensitive personality. To those who had complaint to utter at the sometimes spectacular rudeness of his son, old acquaintances would say that it was nothing, you should have heard his father. Robin Darwin was educated at Eton (where his childhood enthusiasm for painting was encouraged), briefly at Cambridge, and, slightly less briefly at the Slade,

---

### A KEY DECISION

As can be seen from the affair of the Phoenix, Darwin seems greatly to have enjoyed symbolic gestures: in addition to tearing up the Attendance Book, introducing the staff to one another, and declaring war on the Ministry of Education, he issued each member of staff in the Exhibition Road building with a Yale key to the lavatory – to celebrate their new-found independence. As Gilbert Spencer was to recall:

*Hitherto there had been only one key available to us, and this always hung in the porter's lodge. The head janitor, George Pascoe, who mixed a permanent smile with a dry humour to ease any embarrassment, had attached the key to a block of wood, painting its face with gloss white, and adding in large black letters "King George V". Perhaps our Yale keys were an indication of the expected effect on our digestive organs of the changes at the College.*

where he "had a great bust-up with old Tonks, who I had known from childhood years, and left the place in a fury". The bust-up appears to have been "about Tonk's hatred for El Greco and also about his basic contempt for Cézanne . . . and to a lesser extent for Sickert also". As a friend was later to observe, "irresistible force meets immovable mass: hard to say who was which".

An early self-portrait shows Darwin at this time to have adopted a Bohemian image, with a thin moustache, hair brushed forward over one eye, and smoking a large Sherlock Holmes pipe – a revelation to those who later knew him to be intolerant of pipe-smokers. After working as a journalist, and having a series of successful one-man shows in London from 1933 onwards – his watercolours, slightly Victorian in atmosphere, were singled out for praise – he became art master at Watford Grammar School, and then at Eton from 1933-8. There, he drove around the town in a vintage open-top yellow Rolls-Royce, designed and built a delightful baroque puppet theatre, and gained a reputation for his innovative teaching methods: one of his pupils from those days was Patrick MacNee, later to become John Steed in *The Avengers* on television, and the actor still remembers very clearly how Darwin's method was based on encouragement of individual talents rathern than the usual "rules". He was succeeded in the post by Wilfrid Blunt, an ex-student from the RCA.

From 1939-45, Darwin served in the camouflage directorate, where he first met several of the artists and designers who were later to join him in senior positions at the College, including the architect-designer Robert Goodden, the furniture and industrial designer R. D. Russell, the fashion designer Janey Ironside (whose husband Christopher was a camouflage officer), the architect Hugh Casson and the young commercial artist (as it was then called) Richard Guyatt. Hugh Casson wrote of the experience in 1944: apparently, some of the designers in camouflage (and there were many of them) evolved a style which was so distinctive that connoisseurs could instantly recognize it; "this may", he added, "have been aesthetically amusing, but it was probably poor camouflage". Richard Guyatt, who was Regional Camouflage Officer for Scotland, has described flying up and down in the hull of a Sunderland flying boat, sketching possible targets in pastel and wondering how on earth he had got into that bizarre position. Many years later, when the College's Senior Common Room had become part of the Kensington Gore building, it was still not unusual to hear talk of "the camouflage people" and "the barrage balloon people" – and a fair measure of the *camaraderie*

which Darwin was to prize so much, went right back to the years during which Enid Marx (just before she became an RDI) wrote and illustrated *Bulgy the Barrage Balloon*. A famous College story, dating from Darwin's final years, had it that a Guards' Officer stumbled into the Senior Common Room, thinking it was Knightsbridge Barracks, and only discovered his mistake when he tried to pay for his lunch.

## "A CASE OF INSPIRED SIMONY"

In 1945-6, Robin Darwin was Training Officer at the newly-formed Council of Industrial Design, and his main task there was to act as Secretary to a post-war Training Committee which was commissioned to look at the Council's role in the education of young designers. The Committee's starting-point was that:

*the training of the designer is one of the most vexed, as it is one of the most important of the questions falling within the Council's terms of reference. There have been innumerable reports upon it within the last few years, but no finality of opinion and little development in practice.*

This *Report on the Training of the Industrial Designer* – which was written by "R. V. Darwin, Training Officer" – stated that:

*Many of the art schools, without the interest in their work and the demands upon their contributions which they have a right to expect from industry, have become somewhat remote from reality and, with the initial impetus given by the Morris movement, have tended to concentrate too exclusively upon handcraft subjects and upon the fine arts. In these circumstances a number of industrialists tend to look askance at them . . .*

All this had been said (and ignored) many times before, by assorted government agencies for at least one hundred years. And since it was the Board of Trade, rather than the Ministry of Education, which was repeating itself this time, it must have looked as though the clock had been turned right back to the mid-nineteenth century; indeed, yet another government report of the day on how Britain could design her way out of her economic difficulties made explicit the parallel:

*It happens to be the English method to break the hearts and empty the purses of the pioneers, by way of testing the validity of their ideas. It was not always so. "Back to Prince Albert" in spirit though not in detail would make a suitable slogan for our times.*

When it became public knowledge that the South

Kensington Phoenix was about to rise from the ashes, Noel Rooke immediately wrote to *The Times*:

*The new constitution of the Royal College of Art appears likely to bring into force several of Lethaby's ideas of 1901 ... the authorities are to be congratulated on this very short time lag of only fifty-seven years behind their best teacher ...*

But in the Council's 1946 Report, probably as a result of Darwin's drafting, a new theme was introduced (new, that is, to official publications – Lethaby had written an essay on it in *Form of Civilization*, 1922): the theme of the division in British education between "thinkers" and "doers", "science" and "art", and "art colleges" and "technical colleges". The Report concluded that, not only did young designers require "experience of business methods and modern production processes", they were also required to be thoroughly educated people – combining the sensitivity of artists, the technical know-how of production engineers, and the "amused and well-tempered" minds of sophisticated graduates. Just what Robin Darwin meant in this context by "amused and well-tempered" minds, was made clear when he subsequently wrote of industrial designers:

*You won't get good designs from the sort of person who is content to occupy a small back room: a man who won't mix because his interests are too narrow to allow him to, a man who is prepared and, by the same token, only desires to eat, as it were, in the servants' hall.*

In other words, unless designers were able to hold their own in the sort of Club where members of the Council of Industrial Design sat opposite Cambridge dons at lunch-time, they were unlikely to impinge on the modern world. Given the way the design establishment operated in the post-war period, this was probably correct.

Where the Royal College of Art was concerned, it was argued that when you raise the summit of the art education system, you raise the system with it: and, since the local schools were expected to provide a "broad training", the Royal College should specialize much more effectively than it had ever been able to do before – with the buildings and equipment to make this possible. In an essay for *Design '46*, the publication which accompanied the CoID's *Britain Can Make It* exhibition at the Victoria and Albert Museum, Robin Darwin was to add in September 1946 that "the man who designs a refrigerator or a sewing machine may be quite a different sort of person from the designer of, say, a wallpaper, and he will need a different training".

In the time-honoured tradition established by the Victorian reformers Dyce and Cole, Darwin concluded thus the section of the Report which concerned the RCA: "Much will, of course, depend upon the Principal, and the initial appointment will be a factor of pivotal importance for the ultimate development of the school".

The *Report on the Training of the Industrial Designer* was never published – although a summary of it appeared in the Council of Industrial Design's Annual Report for 1946-7. And it might well have gone the way of all the others, had it not been for the fact (which *did* turn out to be "of pivotal importance") that within two years the man who drafted it had become Principal of the Royal College of Art.

From 1946-8, Robin Darwin was Professor of Fine Art at Durham University, where he experienced at first hand the standardizing effects of the Ministry of Education's examination system on the work of painting students: "much of the work", he later wrote, "is well presented, some of it is suspiciously clever; technically it is mostly of a high standard. And yet, on the whole, it is curiously depressing. So much of it is tired and dull and nearly all seems insubstantial and lacking in personal conviction".

Meanwhile, at the Ministry itself, the Council of Industrial Design's Report – as well as various internal memoranda, written by members of the Art Inspectorate – had been the subject of a discussion in February 1947, between three representatives of the Inspectorate (including Mr Dickey), the first Director of the CoID, F. C. Leslie, Professor Darwin and a number of others. This discussion had been given an added urgency by the publication of *The Visual Arts: an enquiry*, sponsored by the Trustees of Dartington Hall, which had referred to "a sense of amateurishness" in the dealings of the Design School at the RCA and the Ministry which was responsible for it, and to the need for students "to acquire a humane education . . . as an important aspect of vocational training", before concluding that:

*The administration of the Royal College has been a longstanding reproach to the Ministry of Education. In the last six or seven years there have been signs of improvement ... But if in the years immediately after the war the College is to fulfil its function properly and to train designers for industry, it must have a greater degree of support from the Ministry ...*

The discussion at the Ministry began with the announcement that a new Principal and a new governing body for the College would be appointed later that year. According to the written summary, it went on:

131

*It was agreed that the College ought not to attempt to provide a training for the professional easel-painter, and that the right place for the man or woman who wanted to study for professional easel-painting was the Slade School or the Royal Academy. It was agreed that the annual output of students from the College was more than enough for the needs of industry and commerce and that the surplus was going into the art-teaching profession. In the Ministry's view there was no . . . need for the College to make any special provision for intending teachers. It was agreed that the College ought to provide facilities for the study of the fine arts, not as an end in themselves, but as a means of enlarging and enriching the background of design students, who would normally benefit from devoting some part of their time to drawing, painting and sculpture. The present practice under which all design students spend a portion of their time in the department of architecture was also considered sound. The meeting considered the Departmental organisation into a) pictorial design, b) domestic interior design, c) dress design and d) engineering design. Professor Darwin felt this could be one of the largest Departments: it was to consist of light metal, light engineering and the plastics industries.*

This summary would suggest that the basis for the re-structuring of the RCA came from two sources: Dickey's war-time memorandum and Darwin's Report (itself based on the findings of the Hambledon and Weir Committees).

When these ideas were at long last put before the College Council, and the retiring Principal, eight months later, the response was that they could only work through "closer contact between the Council and the Ministry": Percy Jowett added that he doubted whether the "light engineering and plastics industries" themselves knew yet what sort of training they wanted for their designers, so it would be premature for the College to embark on a fully-fledged course of training, but there *was* a case for the College undertaking "research in the teaching of design for them", perhaps by developing "a small research unit". In the event, Robin Darwin was emphatically to reject the first point – he was convinced that the plan could only work if the College cut loose from the Ministry as far as was humanly possible – but the concept of a "small research unit" was to develop under his guidance into one of the College's most substantial contributions to the profession of industrial design.

On 1 January, 1948, Darwin arrived in Exhibition Road:

*It was a shock to find stamped on the drawing desks the date 1870, to find Morrison Shelters doing duty for printing tables in the Textile Department, to find only one sewing machine in the Dress Section, and much of the weaving equipment dating from the early nineteenth century and useful only to the Geffrye Museum, to which, as far as I remember, it was subsequently offered. There were no drawing offices anywhere in the College, and only two studios for the whole School of Design; nor was there a lecture theatre. There were virtually no records of any sort, no paintings or other works by former students, and barely any of those memorial accretions which dignify a college, even though they sometimes embarrass it, and which one would certainly look to find in one over a hundred years old. . . A single secretary served the whole of the College, including the Principal.*

If the appearance of the College came as something of a shock to the Principal, the appearance of the Principal came as even more of a shock to the College. As a *Sunday Times* profile of March 1955 put it:

*It would not be easy to guess Mr Darwin's profession – or, from his face alone, the age in which he lives. The moustache is Trollopian, the rapid and disrespectful glance nearer to that of*

---

### DARWIN'S DESTINY

The post of Principal was advertised in July 1947, and thirty applications were received. Darwin's was not among them. He was later to recall the circumstances of his appointment:

*There was at that time a young permanent secretary of the Ministry of Education . . . who, recognising the importance of industrial design in the modern world, particularly to an exporting country . . . decided that the College should be given one last chance, and . . . offered me, his cousin and close friend, the opportunity to make the best of that chance. He has often called this a case of inspired simony; it is certain at any rate that I took the job under the best of auspices.*

That "young permanent secretary" was John Maud (later Lord Redcliffe-Maud, a cousin of the Darwin clan), and he had left "an innocent message" at Robin Darwin's London club, asking him to look in on the Ministry the same afternoon. Professor Darwin arrived, only to find himself facing a formal appointments committee of eighteen people – most of whom he knew quite well from his discussions at the Ministry and the CoID – who proceeded subtly to hint that "his destiny had been decided".

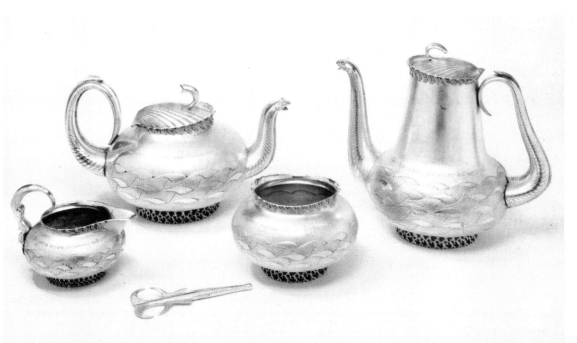

Above *Silver tea service, 1950-51, by Robert Goodden,
Professor of Silversmithing and Jewellery.*

an Edwardian schoolboy. The clothes give little
away (a sporting Archdeacon in mufti?) and the
peremptory voice was once likened to that of "an
inflammable colonel of Marines". There is, in
fact, nothing in the least "arty" about the Princip-
al of the Royal College of Art. And that he has
effected a radical change in the character of the
College is not due to any overriding aesthetical
ideal. But Mr Darwin knows how to pick the best
men and get the most out of them. His triumph is,
moreover, one of market-research as much as of
administration ... Yet there is more to Mr Darwin
than the very able invigorator. His own paintings,
for instance, reveal an extreme sweetness of
feeling which elsewhere in his nature would
seem to have gone underground ... And he is a
flautist who could have played with Loeillet (but
would probably have preferred to play with
Frederick the Great).

The description is confirmed by one of the
painting students who arrived in the early 1950s:

*Brooding with thick dark hair, heavy spectacles
underlined by an equally heavy moustache, a
piercing eye that stared one down, a merciless
tongue, an old Etonian tie and a dark double-
breasted business suit, a perpetual cigarette,
Robin Darwin looked anything but the popular
image of a painter. He could have been mistaken
for an ex-wartime senior officer who had re-*

*turned to life in the City ... He was also a great
dandy, affecting to run the College in the most
casual manner from "his" armchair in the Senior
Common Room. Not so well known, in fact kept
very dark, was his custom of returning late at
night after a social evening to his papers,
working on into the early hours, particularly in
the critical and formative days.*

## A DECLARATION OF INDEPENDENCE

The one and only secretary in the College – who
"mistakenly ... considered herself to be only half
employed" – was soon typing the verbal salvoes
which were to be fired in all directions, but
particularly at Curzon Street House. On 13
December 1947, in a memorandum on the
constitutional position and management of the
RCA which already suggested devolution of
powers to a new College Council, Mr G. D.
Rokeling of the Ministry had written:

*Sooner or later, we are bound to get a Chairman
of Council and Principal who do not hit it off so
well. It may be sooner, as I have some doubt
whether tact is the new Principal's strong suit.
Then the fat will be in the fire, and there will be
constant difficulties between them which we
shall be called upon to resolve. Such a situation
would not be good for the College. There is thus
a lot to be said for giving the Council the right to
appoint and dismiss the Principal, subject to the
Minister's approval, and for making the Principal
responsible to the Council.*

133

He was right: within a year, after preparatory work by a Committee under the chairmanship of Josiah Wedgwood (another Darwin relative, an ex-member of the Weir Committee and a member of the CoID), the College was established by Deed of Trust as an educational charitable foundation. In future, the Council would "share the broadest possible responsibility for finance, consistent with the use of public funds", and for the first time in living memory would get some terms of reference of its own. To celebrate the fact that the College was severing its direct connections with the Ministry of Education – which, in one form or another, went back 112 years – Robin Darwin characteristically suggested that there should be a grand symbolic party on College premises, to be paid for out of the Ministry's entertainment fund. This did not go down well; Mr W. B. Hamilton of the Ministry immediately wrote to Darwin:

*Government Departments' Entertainment Funds are quite sufficiently open to suspicion without giving that suspicion any ground by payments which would mean nothing more or less than the entertainment of Civil Servants or ex-Civil Servants by themselves.*

After a further acerbic exchange, Darwin finally riposted:

*One of the reasons why the College has found being part of the Civil Service to be irksome as you put it, is that it has thereby been subject to rules, regulations and procedures, excellent no doubt for the conditions for which they are framed, but inapplicable to those of an educational institution with a corporate life of its own. It is now evident that those governing entertainment provide an example of this . . . Before casting slurs on our good judgement – and that is putting it gently – I think you would have been well advised to find out how other comparable institutions . . . managed their affairs in this respect . . . I freely admit to a sense of confusion in all this: and envy you your robust if somewhat insensitive self-assurance.*

When *this* letter was circulated for comment within the Ministry, the handwritten messages appended to it included "I think we have cause to smile wryly at Darwin's letter", and "Admirable! You've evidently touched Darwin on the raw". It seems fair to conclude that, when the "severance" finally did happen, the Ministry of Education breathed a collective sigh of relief. The eccentric, and often difficult, little institution in South Kensington could in future organize its own drinks parties.

Having asserted the College's relative auton-

omy, Robin Darwin then proceeded to launch an internal enquiry as to the best way of creating a new structure in the Design School, with the closest possible relationship to specific areas of industry:

*I therefore set up half a dozen* ad hoc *committees to consider each primary subject into which I thought the old design school should be subdivided. These committees were composed of a handful of the most outstanding industrialists in the country, a few designers and a member of the Ministry of Education, and in each case they were chaired by a member of the College's Advisory Council, as it was then. I asked these committees to answer three simple questions: first, how many young designers the industry in question could expect to absorb over the next ten years; second, in the broadest outline, what their training should comprise; and third, what that training demanded in terms of accommodation and equipment.*

The resulting reports were used to determine the *scale* of provision in the various design areas. The division of the School into a series of discrete and specialized "primary subjects" had originally been suggested by Hambledon, Weir, and members of the Art Inspectorate. In the final version of Darwin's plan, following the abolition of the general School of Design (which had somehow survived, unscathed, since the reforms of 1901), there were to be new Schools of Ceramics; Textiles; Typography and Design for Publicity (which the first Professor, Richard Guyatt, re-named Graphic Design); Silversmithing, Metalwork and Jewellery; Fashion Design; and Light Engineering and Furniture (later re-titled Woods, Metals and Plastics). It was also hoped that there would be Schools of Theatre and Film Décor, and Industrial Glass, but it was recognized that these would have to wait for "extra studio and workroom accommodation". Surprisingly (in the light of the commitment undertaken by Darwin, at the Ministry, six months before taking office) the Schools of Painting, Engraving, Sculpture and Architecture were to "continue as before".

The philosophy behind these changes had been clearly articulated by Robin Darwin, and he was in no doubt that it was poles apart from either the Victorian concept of "general design principles", or the Edwardian concept of the "fine art workman":

*It is the same with art and design as it is with general education. Only in a fairly narrow and concentrated field will a student's interests be sufficiently aroused to evoke his deeper creative instincts, and only then . . . will he come up*

*against the essential difficulties which must be faced. It is far better to learn through one subject the values which will be found later on to apply to many others.*

Later, he would conclude that "of the academic changes, much the most important was my decision to pursue a policy of rigid specialization in all fields of design, to discard responsibility towards the teaching profession and to provide courses of a thoroughly practical nature in all primary industrial fields". The policy depended, as Darwin said in a lecture to the Royal Society of Arts on 16 February 1949, on art schools elswhere continuing to offer a broad training in "design". It also depended on exact intelligence of the number of young designers "the industry in question could expect to absorb". Darwin continued:

*A broad training both at the beginning and at the end* of [a student's career] *will do little to fit the young designer for the urgency of industrial life today. As far as the College is concerned the most obvious result has been to force an absurdly large proportion of students into the teaching profession. I say* force *because I do not necessarily believe that this great army of students which year by year went out into the provinces to teach really wished to do so. But they had no alternative because they had no specialized knowledge.*

When art schools in "the provinces", also, started to specialize in industrial design (as some, such as the Central, Leicester and Glasgow, already had), this policy would begin to be questioned – especially as these courses were more than likely to be taught by graduates from the Royal College of Art. Robin Darwin never cared to admit that a significant proportion of his graduates *chose* to enter "the teaching profession" (especially, of course, in the Fine Art area, but also in Design), a factor which was to become increasingly important as the economic recession in manufacturing industries took hold, from the late 1960s onwards. And as early as his 1959 *Annual Report*, Darwin noted the possible disadvantages of the system of "narrow and concentrated" study which he had introduced a decade before:

*... the establishment of these departmental splinter groups may have led to undue specialization. It is certainly a fact that without that degree of specialization we could never have made so rapid an impression upon industry for we could not have hoped otherwise to have produced so many students acceptable to it. In the long term interests of education, however, and indeed in the long term interests of industry*

*itself, it is possible that our sights have been too narrow ...*

With these reservations in mind, he warmly welcomed the new activities in the College – "undoubtedly the most important academic development over the last ten years" since his reforms of 1948-9 – which served an integrative purpose: the Department of General Studies, under Basil Taylor, "a general library serving all schools and departments", and an increasing emphasis on long-term research.

But in the immediate post-war period, the full weight of College, Council *and* CoID was put behind the provision of specialized and professional instruction in all branches of industrial design with a direct bearing on the national economy. This meant going all out for public commissions and obtaining maximum publicity for them. The composition of the College Council – which was to include Jack Beddington (advertising manager for Shell UK in the 1930s), Sir Colin Anderson (the shipowner who had employed some of the brightest young "moderne" designers of the mid-1930s to plan the interiors for the SS *Orion* and the SS *Orcades*), Geoffrey Dunn (of the Good Furniture Group), Sir Michael Balcon (Head of Ealing Film Studios), Sir Francis Meynell (of Nonesuch Press fame), and Gordon Russell (whose appointment as Director of the CoID was announced in *The Times* on the very same day, in the same column, as Darwin's appointment as Principal) – directly reflected this policy. Where the College's relationship with the CoID was concerned, Gordon Russell wrote that

*The work of the Royal College of Art is an essential buttress to the work of the Council of Industrial Design. This has been recognized by the appointment of the Principal as a member of the Council, and myself as a Council member of the Royal College of Art. Perhaps, if the truth were known, we have both enjoyed the maelstrom into which we were launched so decorously by The Times ...*

Darwin's hope was that, as a result of this policy, the cosy old days of the Design and Industries Association would soon be left far behind. As he explained in an open letter to R. D. ("Dick") Russell (who was Darwin's first Professor of Wood, Metal and Plastics) in 1950:

*William Morris's ideas were all confused with the "dignity of labour" and so on. The whole thing has got mixed up with the world's yearning after "integrity" which will one day be seen, perhaps, as the distinguishing characteristic of this century, leading to Divorce Law Reform, general education, women's suffrage, a reverence for the*

135

*Windsor chair (which is almost becoming a joke) and Lord knows how many other results of questionable value. Honesty in most contexts is all very well, but surely in art it is neither here nor there. How can it matter how a certain effect is produced? ... I think this whole attitude is muddle and bunk. It would excite the liveliest derision from any designer from the Renaissance to Morris ... Today there is a danger that if the English work really hard they will succeed in doing what the Danes and Swedes did equally well twenty years ago. Can't we aim a little higher? Can't we ever again take the offensive? ...*

But although many of Darwin's public statements during the early years concerned the College's contribution – in association with the CoID and the new Design Council – to "the training of the industrial designer", he equally emphasized (in private or internal documents, at first) that studies in Fine Art at the College were not merely continuing on sufferance "for the sake of tradition" but as a necessary adjunct to studies in design: it was unthinkable, he said, to have an institution devoted to "teaching and research" in design, in isolation from the practice of the plastic arts. No further justification was necessary. True, the College had not been founded, as the Ministry never ceased to remind him, to "train professional easel-painters". True, he had agreed in February 1947 that the right places for Fine Art Studies were" the Slade School or the Royal Academy". But, as the years went by, he began publicly to promote the key role of Fine Artists in the design context of the Royal College of Art. The College Council did suggest one major distinction between the new Faculties of Fine Art and Design: the old diplomas granting Associateship of the Royal College would continue to be awarded to graduates in Fine Art, while graduates in the branches of Industrial Design would be awarded the title of Designer of the Royal College of Art, Des RCA, to be confirmed and conferred after the final examination plus a specified and monitored period of time (usually nine months) in the appropriate industry. This was to come into force in 1951, although the plan had to be made more flexible almost immediately.

The way Darwin used the reports he had commissioned on "each primary subject" – by giving the six new Schools maximum control over their own affairs – was a neat way of "releasing the most energy, activity and new ideas", and, combined with his new staff appointments, was also a way of gaining the confidence of industry in the shortest possible time. But, even so, the reforms of 1948-9 were not likely to

take effect overnight. When, at the beginning of April 1948, a letter arrived from Bevin's Private Office asking for a copy of the new College Prospectus so that it could be used as a "model" to help with the restructuring of art schools in Bavaria, Darwin thundered back:

*It is obviously ludicrous for the Bavarian Minister of Education to base any reforms for their art schools on the Royal College of Art, which itself has been unreformed for the last 30 years. I am not prepared myself therefore to send a copy of the Prospectus as requested. I enclose one, however, with this letter and if you care yourself to send it, let it be on the Ministry's head.*

## SHACKS AND MANSIONS

One problem which had to be resolved, and fast, was the state of the College buildings. Darwin wrote to the Ministry on 27 October 1948, explaining that "the ability of the College to discharge its national obligations to Industry" was dependent on alterations to existing buildings, and a firm commitment to the construction of new ones:

*If these conditions are not fulfilled, whole departments of the College must be closed down and their students dispersed, while teaching in others will be gravely impaired. If for any reason these building operations were suspended altogether it would be necessary seriously to consider whether the College itself should continue to exist. This might depend on how important its teaching of the Fine Arts was considered, and on the contemporary significance of ornamental vases, hand-beaten christening mugs and such like crafts, which together with the Fine Arts are adequately catered for in other schools and colleges. It might well be the view that in such a context the Royal College of Art was redundant and that since it was unable to train designers for industry, the latter had better be trained in the centres of industry themselves. I speak in all seriousness ... As Lord Capel said on following Charles I to the block, "This will not do the business. God Almighty find another way to do it".*

Since there was no hope, in the foreseeable future, of putting up a new building on the Kensington Gore site which had been earmarked as an indirect result of the Hambledon Report, it had to be a question of rehabilitating and expanding such buildings as the College did possess, and buying the leases of three large houses in the near vicinity, converting them to College use: within seven years of becoming

Above *Jacket by John Minton for the book* Time Was Away, *1948, by Alan Ross.*

Principal, Darwin had managed to persuade, cajole and bully the Ministry (with help from the Darwin clan) nearly to double the total floorspace available to the RCA. The College was still "a collection of shacks and mansions", but at least that was an improvement on the 1948 situation of "all shacks and no mansions".

In 1949, the College successfully negotiated for the long leases of 21 and 23 Cromwell Road, which were used to house the Junior Common Room, the Senior Common Room, the Department of Stained Glass, the new Department of Interior Design, and, eventually, the College Library. The enlarged Queen's Gate "shack", or as Darwin preferred it "drill hall", was taken over by the School of Ceramics. The School of Fashion Design came of age in a large Edwardian house, 20 Ennismore Gardens; the annual shows took place in the drawing-room. Some of the remaining Design Schools were located in the Western Galleries of the Imperial Institute, which they shared with the aeronautical collection of the Science Museum, and, for a time, in part of the Indian Gallery of the Victoria and Albert Museum.

In the end it wasn't the fact that the College's "shacks and mansions" were unsatisfactorily sited in five main groups – some of them over a

quarter of a mile from each other – which persuaded the Government to allow the development of the new site: it was the expansion of an academic neighbour, the Imperial College of Science and Technology, in the technological optimism of the 1950s (design *might* solve the country's economic problems, technology *would*) that suddenly gave the whole issue a new urgency. The decaying Imperial Institute was to be demolished to make way for Imperial College's new buildings – sad to say, architecturally inferior to the building they replaced – and this would mean the closure of "three of the most important Design departments of the College", unless they could be rehoused in the near future next to the Albert Hall. The trouble was, that the *whole* Kensington Gore site would not be available for rebuilding for "at least twenty-five years" (quite apart from the question of whether the Government could afford to develop it), so the College was faced with the decision between "a building large enough merely to hold those three departments; developing to the full that part of the new site which already was in the College's hands"; or waiting until the whole site was available to move the entire College on to it (a concept which had first been discussed, with reference to the island site, in the years just before the First World War). Since the waiting option was by now ruled out, it was decided that

137

**1945-1987**

"all the departments of industrial design and the administrative offices of the College should be concentrated on the single site, while leaving space also on it to be occupied later by the general accommodation of the College such as a Hall, Common rooms and so on". This would still leave the School of Painting, as well as Graphic Design, in the Exhibition Road building, and the School of Sculpture in its by now beloved Queen's Gate shed – causing an unfortunate geographical separation between the two main Faculties of the College – but future generations could resolve that problem when the balance of the Kensington Gore site, one block away from the Albert Hall, became available in 1973. As Darwin prophetically put it, in 1959:

*It will only be by the most determined self-discipline and sense of purpose that the Fine Arts will be able to bring their vital influence to bear on the College's other activities. Under these very difficult conditions it may, indeed be hard to combat that sense of superiority which can only too easily be nurtured by enforced isolation.*

Robert Goodden, the Professor of Silversmithing and a qualified architect, had already engaged in "the very interesting but protracted exercise" of discovering the future needs of the Design School, and forming these into a schedule of accommodation for an architect's brief. The architectural press was lobbying for a National Competition (as, indeed, it had lobbied way back in the days of Beresford Pite), given the size and importance of the building on such a site. But within the College it was held to be a matter of honour that it should demonstrate the confidence and ability to design its own building: above all, the RCA should know its own needs far better than "any outsider".

The staff team was chosen: Professor Robert Goodden, Professor Sir Hugh Casson and H. T. Cadbury-Brown. When the proposed demolition of the Imperial Institute was publicly announced, the Design Schools, and whatever else the partially-developed Gore site might allow, had to be rehoused within five years. Approval to go ahead was reluctantly granted by the Treasury (when Darwin spoke of "the struggle to convince them" – *despite* support from the Ministry of Education – he meant it), but the Government, in a by-now typical gesture, immediately proceeded to cut the schedule of accommodation, based on the *atelier* (or studio and workshop) rather than the classroom, by twenty-five per cent. In his *Annual Report* of 1957, Robin Darwin expressed, somewhat pointedly, his gratitude to officers of the Ministry for helping to achieve the economies which they were forced to impose upon the new building while announcing that the position had been improved by a generous grant from the Gulbenkian Foundation, the most important single benefaction in the history of the College until then, to enable a main Hall to be built on the site for Convocation, exhibitions, lectures, a theatre and entrance examinations. It had become clear, said Darwin, that the Government would not pay for such a Hall, although it was included in the agreed schedule, unless the College was prepared to wait "for a very long time indeed". The Gulbenkian Hall became part of the first phase, for completion in 1961.

The terrace of Regency, stucco houses along Kensington Gore was demolished, with the mews behind. Staff and students who had occupied the site as "semi-official residences", had to move out. The purposes of the new building, an austere construction of reinforced concrete, brick and glass, by necessity "without frills", were later explained to the students by Cadbury Brown:

*That the inside of the building should be spare. Money should be spent on space rather than finishes. That as a place where art is in continual process of being made the interior especially should be plain, and that one of its principal functions being to act as a background to art and not to assert itself as an "art thing", but that outside it should be more positive in character . . .*

The new building looked even starker then, as a single slab on a muddy building site, until the Hall, Library and Common Room Block were completed. The Library was, and is, one of the most attractive spaces on the site, over-looking what must be some of the most expensive plane trees in London. Already fully grown, the College was built around them.

138

1945-1987

The interior of "the main workshop block" (as Robin Darwin prosaically christened it) was intended to be "as flexible as possible". In spite of awkward steps and columns in the wrong places, this aspect of the original plan has worked very well. Nearly all the Design Schools and Departments housed in it have undergone alterations, installed new equipment, or moved, and the architects' concept of a space where "in place of the usual divorce of teaching accommodation into a block of several floors and separate single storey workshops, here studios and workshops lead out of each other on every floor" has survived intact. The only major problem (and this may be something the architects could not have seen) is that the one floor = one School equation has never actively encouraged students to explore the disciplines which surround them: the interior of the main building is a bit like a Department store made up of shut-away Departments, with only a lift to link them. It is now known as "the Darwin Building", in honour of the man who fought for it.

*Below The new home of the RCA in Kensington Gore came to be known as "the Darwin building".*

## KEEPING IT IN THE FAMILY

Looking back on the achievements of the first ten years, in his 1959 *Annual Report*, Darwin observed that:

*the* real *contrast between the College as it was under the old dispensation and as it is under the new one lies in the area, as it would be called in America, of human relations. In the old days, owing to a variety of circumstances of which the war must be counted as the most important, there were unfortunate rivalries and jealousies between the then Heads of Department, of which there were only four.*

Darwin did have a tendency, in order to prove his point about the place being "dead as a Dodo", rather to overdo his story about the atmosphere in Ambleside – "an experience", as he would often put it "which the College only just survived". Nevertheless, his statement of 1959 is an important one: for in spite of all he had achieved, without the senior staff of his choice, the RCA would never become the "living organism" he associated with his Cambridge youth. Where the new Schools were concerned, he managed to

persuade the Ministry, in a long memorandum of 19 March 1948, to establish five extra Professorships "the duties of which will be as much research as instruction. In assessing teaching ratios therefore, the contribution of the Professor will be rated at one half". In future, each Professor would expect to have one full-time Senior Assistant for each distinct branch of Design, and a number of craftsman-demonstrators and craftsmen "to enable students to avoid much repetitive work of no real educational value and to increase greatly their creative activities".

It was expected of all teaching staff that they would continue in practice and give regular evidence of practice – the equivalent (by shows, marketed designs or publications) of scholarly work at a University. To this end, there would be a cadre of full-time members of staff (the Professors and Senior Assistants) for purposes of policy and implementation, with a large number of part-time and visiting staff. To avoid the inevitable comparisons with "officers" and "other ranks" (or gentlemen and players, perhaps), the part-time staff would be given a contract of parity with the full-timers but for a *pro rata* fraction of time per week. No contract, however senior a member of staff might be, could hold for more than five years, nor would it be renewed automatically. This was, as Darwin said, in order to give a small College by any standards the ability to keep the average age of its staff young, and to keep itself up to date with change: he was well aware that the College *could* suffer through being unable to retain the accumulated experience of its senior members (who might have to leave for a more secure future), but was prepared to take the risk. It was on this basis that all the key appointments were made in 1948-9.

Richard Guyatt (Graphic Design) arrived in 1948 – as the youngest Professor, until the present writer, ever to be appointed to the College: Robert Baker (Ceramics) and Robert Goodden (Silversmithing) joined in the same year. Allan Walton (of Walton Textiles, ex-head of Glasgow School of Art) was appointed Professor of Textiles, but died before he could take up his post: in 1949 James de Holden Stone replaced him, bringing ex-Bauhaus student Margaret Leischner to the School, to teach weaving. Dick Russell (in the first instance, Professor of Light Engineering and Furniture) took over, when Ernest Tristram retired in 1948 – after 42 years of working at the College. Where the longer-established Professorships were concerned, Frank Dobson (Sculpture) took over from Richard Garbe, who retired in 1946, and brought John Skeaping with him; Robert Austin (Engraving)

took over from Malcolm Osborne (who retired in 1948 – the last remaining link with the days of Lethaby and Frank Short); and Basil Ward became Professor of Architecture in the same year, assisted by Mrs Margaret Macdonald Taylor who possessed an ARCA, an Honorary ARIBA and an astonishing array of hats. Mrs Macdonald Taylor did conducted tours around the stately homes, and lectured the students on standards of etiquette: she was one of the very few remaining links with the College of pre-war days.

Despite the Principal's concern about the possible lack of "accumulated experience", these appointments of 1948-9 were to be the foundation of a new series of dynasties at the Royal College of Art: the Darwin Professors tended to be succeeded, in turn, by the tutors and ex-students of the Darwin era, and the tradition of "keeping it in the family" lasted over twenty-five years, for the key Professorships from 1948 right through to the late 1970s were usually part of an "invisible college" with Robin Darwin at the centre of it. Richard Guyatt remained on the staff as Professor, Professor and Pro-Rector, and Rector for 34 years, when he was succeeded by Herbert Spencer – who had been in Guyatt's School since 1966 as Research Director of the Readability of Print Unit. Robert Baker was succeeded in 1959 by David Lord Queensberry, who in turn was succeeded in 1985 by his tutor in charge of ceramics, David Hamilton. Robert Goodden served as Vice Principal then Pro-Rector from 1965 onwards, and was followed in 1973 by two of his ex-students Gerald Benney (as Visiting Professor) and Philip Popham (as Head of Department). James de Holden Stone resigned in 1954, when Wyndham Goodden replaced him as Professor, to be succeeded by Roger Nicholson, wartime student in the Painting School, in 1958, and Bernard Nevill, an ex-student of the Darwin

era, in 1985. Dick Russell was succeeded as Professor of Furniture Design in 1964 by his tutor in woodwork, David Pye, who in turn handed over to two ex-students Robert Heritage (in 1974) and Floris van den Broecke (in 1985) with a third ex-student Frank Guille as Head of Department from 1974 onwards. Frank Dobson retired in 1953, to be followed by Sculpture tutor John Skeaping, who was retired seven years later to make way for Bernard Meadows, ex-student of the Jowett era and ex-assistant in the studio of Henry Moore. Meadows was in turn followed as Head of Department by Bryan Kneale (a tutor in the School since 1964) and as Professor by Philip King.

After Robert Austin's retirement in 1955, the School of Engraving (under its new name of Printmaking) became a wing of the School of Graphic Design (initially under Edwin La Dell, one of Austin's tutors), until 1985 when Printmaking became a separate Department under Alistair Grant (Painting student of 1947-51, and tutor in Printmaking from 1955 onwards). The School of Architecture, under Basil Ward, offered courses to all students – in an attempt to make a grounding in the Modern Movement an essential part of the RCA experience – until 1953. In Festival of Britain year, the Department of Interior Design was set up (School as from 1952) with Sir Hugh Casson as Professor and Lady Casson as tutor; by 1972, when the concept of "Interior Design" had become too strongly associated in the public mind with "Interior Decoration", the name had been changed to Environmental Design, and in 1976 John Miller took over – with the ambition of achieving professional recognition of the School by the RIBA: this he had successfully achieved by 1985, and the term "architecture" was soon to be re-introduced to the School's title. Basil Taylor, lecturer in the History of Art for Ward's School, became the College's first Librarian (since the days of Henry Cole) and founded the Department of General Studies: he was succeeded as Librarian by Joseph Rykwert, then Hans Brill, and as Head of General Studies by Christopher Cornford (the Department's first Professor, and a distant member of the Darwin clan).

Above *Dish in English walnut by David Pye, Professor of Furniture 1964-74.*

Left *Salt and pepper set designed by Philip Popham about 1959 for the Senior Common Room. Popham was a student of silversmithing in the early 1950s and later a long-serving tutor.*

Right *Stacking chairs, 1983, by Floris van den Broecke, who was one of David Pye's students and is currently Professor of Furniture at the RCA.*

141

Many observers of the staff changes which took place in 1948-9 were surprised that there was to be no Professor of Engineering, or indeed Industrial Design, in a College which professed to be centrally concerned with the subject, and were even more surprised that "Light Engineering and Furniture" were to be awkwardly paired together. These questions were put to Robin Darwin, at the Royal Society of Arts, on 6 May 1949. He replied:

*I thought I was tempting the Treasury rather far in asking for five new Professors. If I had asked for six or seven, I might have got none at all . . . . the simple question now is how many professors you can afford for the number of students you want to teach.*

Already, the unprecedented expansion in the number of Chairs at the College had occasioned much comment, "of which a comparison to the Cuban Army – all generals and no soldiers – was one of the more friendly".

But that didn't begin to answer the question. The plain fact was that the kind of industrial designer who knew about engineering – as opposed to the kind of designer who had emerged from the craft tradition – was still part of a very rare species in the post-war years: Darwin had appointed some of the most distinguished designers of the 1930s, including Robert Good-den (designer of exhibitions, houses, furniture, pressed glass and wallpaper), and Dick Russell (designer of exhibitions, furniture and Murphy radio cabinets) – both of whom had close connections with the Council of Industrial Design – and it hadn't occurred to the Hambledon Committee, the Weir Committee, or the Board of Education even to mention engineering in the context of the RCA. Since most of the Schools and Departments which were set up in 1948 were devoted to activities which had been happening in the College at least since 1901 (and most of the *new* activities arose from suggestions made in the mid-1930s), it is scarcely surprising that the very latest developments in the design world were not yet included among them. The great exceptions were Graphic Design and "Light Engineering and Furniture" – both of them a distinct advance on the thinking which associ-ated "good design" with London Transport post-ers and Cotswold cabinet-making.

In his report on the College for 1953-4, the Principal found himself again replying to the criticism levelled at the "School of Woods, Metals and Plastics", this time by HM Inspectors, that the School was biased towards craft furniture, by saying that it would take a long time to formulate new courses "for the engineering industries": in any case, six out of the eleven Des RCAs of that year had "gone into industry", and, he later added, there had been a tutor in the School, Naum Slutzky from the Bauhaus, who looked after industrial applications. Nevertheless, in the following year the Department of Engineering Design (later Industrial Design (Engineering)) was listed as a separate unit, though still within the School of Furniture Design for administrative reasons, and it was already proposing recruit-ment from two sources – Art Schools and Engineering or Architectural Colleges and Schools: Darwin made a point of stressing that designers educated in the Department should not expect to be autonomous in the sense that silversmiths or furniture designers may be inde-pendent designer-craftsmen, but would be re-quired to work as team members with other specialists "of whose work the students must have some cognisance". The first Head of *this* Department was William Woods (an aeronautical designer), followed by Fred Ashford (best known for his re-design of the Colchester lathes series): it was Ashford who, realizing that the "Art school" environment was not necessarily the only, or even the best, place to seek industrial designers at that time, introduced a "direct entry" course for school leavers with University entrance qualifica-tions – as a positive alternative to the traditional schools of architecture and engineering. Students took a year studying basic design (under Denis Bowen, then Bernard Myers), before moving on to the College's three-year course. This scheme was reluctantly abandoned when the RCA be-came a wholly postgraduate institution of uni-versity status, and it remains the one and only time (since the reforms of 1901) that the College has attempted to look after the designer's educa-tion from school to professional qualification.

The dramatic staff changes of 1948-9 were, without doubt, perceived at the time to be an outward and visible sign that the new regime meant business. In later years, Darwin would proudly claim that on his arrival, he had asked every single Professor to submit his resignation, while the Principal and Council decided whether or not to re-appoint them. In fact, where most of these appointments were concerned, it was a case of replacement or of filling a new post. The great exception was Painting, the professor of which was Gilbert Spencer, who had held that position since 1932.

Spencer went on to become Head of Painting at Glasgow School of Art (where Douglas Bliss was now Director), but he appears to have complained to the Ministry about his dismissal – in effect saying "they already had their knives out for me". For Darwin wrote to Paul Odgers at Curzon Street House:

Above Portrait Group: *the staff of the Painting School in 1951, by Rodrigo Moynihan.*

*Before I came I imagined that such changes should begin at the top. But during my first week or two of office I saw a lot of Spencer at the Entrance Examinations: and in spite of – or more probably because of – the most lively discussion and arguments, I got to like and respect him ... I dispute entirely therefore that I was gunning for him from the start. On the other hand, a subsequent interview ... caused me soon to return to my former view ... I remember him [Jowett] telling me that for fear of the reactions which would ensue he had never dared to propose that Paul Nash, perhaps the most distinguished English painter of the last 25 years, who taught in the Design School, should be allowed into the Painting School. I think this sidelight illumines the position clearly enough.*

Spencer was replaced by Rodrigo Moynihan, from the autumn term of 1948, who in turn was succeeded by Carel Weight in 1957. Paul Nash had died in 1946, but where his brother John was concerned, Darwin wrote to Odgers on 6 April 1948 that he was "exceptionally valuable as a distinguished individual with a roving commission but who may not fit into the new structure as planned. I should like to keep on Nash for his one day a week, *at any rate for a year*". (In fact, John Nash continued to work in the School of Graphic

---

A New Broom

In his *Memoirs* Gilbert Spencer recalled what happened to him, shortly after Darwin's arrival, when summoned to the Principal's office:

*My reception was cool, amounting to studied indifference and he was highly discouraging about my staff, adding that he only knew Rodney Burn.... Now, with his shirt sleeves rolled up, Darwin conveyed to me at that unhappy meeting that he was in fighting mood, and with his parting shot he asked me to have a lay-out of my Department.*

According to Spencer's account, he then prepared a detailed timetable which he gave to the head janitor, to pass on to Darwin.

*Next morning he happened to join me in the lavatory, but he did not appear to see me. I felt a little uneasy, and thought, as from one porcelain to another, he might have passed the time of day with me ... In fact they already had their knives out for me. Now I was asked to present myself before the Governors who had never so much as seen me before. They had arranged themselves carefully ... Away to the west sat Darwin casting his shadow like the setting sun, over my future. It was left to Sir Charles Tennyson from the wings in a kind of echo voice to tell me that I had been retired. That was all. In less than five minutes I had left the room.*

Design until 1958.) This generosity was exceptional, for all other tutors (as distinct from Professors) appear to have received a general notice in March 1948, signed by Josiah Wedgwood, "terminating their appointments and indicating that reorganization was to take place". Mrs Gibson, who had been Head of Dress Design since 1936, complained about this to her local MP – when she discovered that she was to be replaced by "a Mrs Garland, who had been Editor of *Vogue*". Madge Garland, had, in fact been Chair of Darwin's "Fashion Design Committee", and she was also a member of Council at the time: despite the complaint (which seems to have led nowhere), she became the first-ever Professor of Fashion in Britain, in summer 1948, and considerably raised the profile of the School.

*Picture Post* celebrated the appointment with an article, the tone of which was fairly predictable: "what seemed once a feminine priority is now dignified by University status . . . London has just made fashion history". Madge Garland was replaced in 1956 by Janey Ironside, who was succeeded in 1968 by Joanne Brogden – a star student of the early 1950s and Janey Ironside's assistant in the 1960s.

The changeover from direct Government control to the status of an independent national College – a College consisting of a series of small, independent departmental units (ranging in size from five students a year to twenty-five students a year) – brought with it the need for efficient self-administration by a Registrar's Department which was wholly integrated with the academic life of the College. Part of the problem with Government control, Darwin thought, was the feeling of "them" and "us" that inevitably accompanied it. An early senior appointment (as one of "us") was that of John R. P. Moon as Registrar. After surviving his first face-to-face meeting with the Principal – who as one old schoolfellow to another told him "an old Etonian *never* wears a brown bowler hat" – Moon was to become Darwin's "trusted and adroit" right-hand man. His quiet firmness was the perfect foil to Darwin's impatience and impetuosity, and, until his untimely death in 1969, it was John Moon who enabled Darwin to state:

*I think personally that the Principal's duties should be rather less than is commonly supposed . . . he should provide a general and if possible equal inspiration to all the departments within his care . . . But beyond this, the Principal's responsibilities are chiefly to support his staff and to act as a guardian and a watchdog of their freedom.*

Moon was succeeded by Brian Cooper, his

Above Country Lane *by Carel Weight, Rodrigo Moynihan's successor in the Painting School.*

deputy (assisted by Harry Denyer and Joan Catlin).

By 1959, Darwin could add that there were sixteen central and Departmental secretaries (a measure of his policy of decentralization), and that the Registrar's Department administered all College buildings and the examinations that went on in them, as well as running two Common Rooms, two publishing houses, acting as an agency for College commissions "of every description" and taking on "the great new building programme".

## THE OBLIQUE APPROACH

During Robin Darwin's first two years as Principal, the appointment of energetic and talented young people, to key posts, (many of whom he knew, and whose company he enjoyed) was an essential part of his strategy. Indeed, in later years he was to admit that it *was* his strategy. He wrote in 1964:

*Not long ago, an African post-graduate who was preparing his thesis wrote to ask me how to run an educational institution successfully. I replied briefly that this was a perfectly simple proposition – all you had to do was to appoint the best senior staff in the country and then leave them to get on with their job without interference. I said nothing, of course, about those wayward currents of experience which throw people together and seem in retrospect to have made a pre-ordained pattern of our lives.*

This wasn't exactly an educational philosophy – Darwin's pragmatic reaction to "philosophical" questions asked of him at the Royal Society of Arts shows that he did not have any time at all for abstract speculation about the purposes of art education – but it certainly created an atmos-

phere of collective energy which was just what the institution needed in the optimistic post-war years. It was an atmosphere that the students seem to have picked up as well. Geoffrey Clarke, who reached the Stained Glass Department in the first year of the new regime, was to recall:

*The old gentle era under Jowett ceased and a new era exploded. Those who began in 1948, staff and students, mostly ex-service, had mutual sympathies. Newcomers together being perhaps the strongest link. All responding to discipline, and resenting it ... We, the bristles of the new broom (not fully realizing our part at the time) had little reason to complain. Encouragement and backing were forceful and positive. The next decade saw the establishment among students of the belief that denial of previous standards was the rule rather than the exception unless proved otherwise. The staff became correspondingly adept on the trapeze ... The governors probably closed their eyes as the momentum grew and prayed most sincerely that their man in Kensington had a fierce enough look in reserve to put on the brakes when necessary.*

For Darwin, the teaching in the various Schools and Departments was a question of appointing lively Professors and "leaving them to get on with their job". The *style* of teaching varied, of course, from specialism to specialism, and each subject was developed in a different way: but there is a consistent theme running through all the various Professors' statements about teaching at this time. The tension between this theme, and the rigid structure of "narrow and concentrated fields" which contained it, was to become one of the defining features of the College. Professor Richard Guyatt expressed it very well:

*If art itself is not susceptible to a direct approach, yet there are teachable disciplines which lead towards it, and which are essential for its manifestation. There are the intellectual disciplines, such as the analysis of problems, and the understanding of function, which can be taught directly, almost always round the single question "Why?". There are the disciplines of skill and technique which again can be taught directly through practice and imitation, and by setting of standards. But neither of these on its own can produce art, nor indeed can they do so even if they can combine. The missing link, or the catalyst, lies in the emotions, in the interest, or the delight, or the love, which infuses a work. A good teacher can indeed arouse interest: it is perhaps his most important function. And he can encourage a student to free and deploy his emotions. But in the last analysis emotions are a* private, personal affair, which each of us must come to terms with for ourselves. In this the teacher's role can only be *oblique ...*

In other words, the experience of being at the Royal College of Art could educate both the "head" and the "hand": where the "heart" was concerned, well, that tended to be more a question of the survival of the fittest. If the medicine was too strong, then the patient had come to the wrong doctor.

A comparison between this approach, and the approach advocated by the Ministry of Education's pamphlet on *Art Education*, issued in 1946, is most revealing: for, beyond all the rhetoric, it shows the real significance of the "Darwin revolution". The contrast between them could scarcely be more striking: "*The art school*", argued the pamphlet,

*deals with a group of students who are in the main very much like any other group of young people, but it is certainly as true of students in art schools as of those in any other kind of school that they will vary greatly in temperament and outlook and that too much thought cannot be given to their individual idiosyncrasies by those who are put in charge of them. The "genius" who is "born but cannot be made" is bound to crop up from time to time in art schools, as in other institutions, and it will be the duty of the school to recognize him when he appears, to give him the best opportunity he can be given in that school and to see to it that he is passed on to a more advanced institution for further study when necessary. But the main business of* any *school is to cater for the average student.*

The *oblique* approach outlined by Guyatt, and shared by his colleagues, gave a lot of time to "individual idiosyncrasies", encouraged the students to develop an image of themselves as potential geniuses (or at least market leaders), and hoped that "the average student" would go elsewhere. It didn't accord with many educational theories of the day, it didn't invariably work in practice, and from the 1960s onwards it was to come in for some fairly heavy criticism from educationalists: but when it *did* work, the results were spectacular. The results of this approach were certainly to change the face of British art and design.

For Robin Darwin, it was symbolized by the Phoenix. It could also have been symbolized by the College facility which was (and is) located at the very top of the building which was named after him – a greenhouse, full of free-flying birds with exotic plumage. Not creatures of myth this time, but real ones ...

**1945-1987**

## THE ORIGIN OF A SPECIES

In 1951, the year of the Festival of Britain, inaugural lectures by eight of the new Professors at the Royal College of Art were published, under the title *The Anatomy of Design*. Although the individual presentations varied enormously – from Madge Garland finishing her lecture with the confession "Dieu, comme j'aime la mode", to Basil Ward encouraging the new generation of designers to come to terms with the techno-logical implications of the Modern Movement, to Robert Goodden describing in great detail the design of a de-mob hat (a "cross between a somewhat hat-like saucepan and a somewhat saucepan-like hat") – there were certain themes which kept recurring: the College existed to build a bridge between the "world of the studio" and "the world of industry"; one of its main purposes was to convince industrialists that if they wanted quality, then they should treat their young design-ers better; the College should become a "pilot plant", to develop new ideas and sometimes test them out. The imagery which was used to express these themes – cricket matches, fly fishing, Windsor chairs and the general "rubbish dump of overstatement" which littered the high-streets – was very characteristic of the design establishment in the post-war years: a time when Gordon Russell, as Director of the Council of Industrial Design, could be reassured that all was well with the world when he received through the post the pink wine list, illustrated by Edward Ardizzone (tutor in Printmaking 1953-61), of the RCA's Senior Common Room.

Robert Goodden captured perfectly the ethos of the early Darwin days, when he challenged the conclusion of countless post-war reports that the main purpose of "design" was to help Britain buy its way out of the age of austerity:

*In talking of industrial design, it has been the practice in recent years sedulously to avoid this uncompromising (or comprising) word* [art]*, this well-known irritant, and to try to catch the industrialist napping by whispering repeatedly that good design is good business, or that bad design is a kind of immorality unaccountably overlooked by Parliament, or something of that sort. These pieties may or may not be respect-able, but would, in any case, take many long years to* prove *respectable. A much more forth-right description of good design is that it is design in the creation of which true art has played a part. Following this train of thought I have found (belatedly, you will think) that the name of the Royal College of Art was by no means carelessly decided.*

In his *Introduction* to the lectures, Robin Darwin preferred the concept of "experimental research" to the concept of "art" – after all, he had been a party of discussions at the Ministry of Education which had made quite clear what the College's paymasters thought of "easel painting" and at the time he appears to have agreed with them – but he shared the optimism of the "lively and distinguished designers of the younger genera-tion" who had recently filled the vacant chairs:

*In spite of its 114 years of distinguished history, everyone connected with the place thinks of it, I believe, not as an old institution, but as a very young one with much of its growing still to do . . .*

All (with the possible exception of the architects) were agreed that the College existed for "the promotion of *art* in design". The question of whether the promotion or the design came first on the College's agenda, was sometimes a matter for debate.

In retrospect, the history of the RCA in these years has gone into popular memory as if the palace revolution of 1948 was accompanied by a major shift of emphasis from the "Fine Arts" of the Rothenstein era, to the "Design" of the Darwin era – at the expense of the former. This was not in fact so. True, the old battles between art and design – which had involved, in the words of a Painting student of the early 1950s, "the protagon-ists belabouring each other with bladders and strings of sawdust sausages in public" – were gone. Somehow, they had ceased to be fashion-able. The heart of the College seemed, in most students' memories, to lie in the Principal's red damasked office in the Painting School at Exhibi-tion Road. But a large part of the mind of the College was preoccupied with putting its plans – so easy to outline on paper – into practice, the evidence for which would take the form of goods delivered, promotions, and annual reports. In any reading of the College documents, the words industry, design and experimental research far outnumber the words painting, sculpture or art, and photographs of commissions, prototypes, inventions and innovations emerging from the studios and workshops year by year occupy a privileged position in pictorial records that exer-cises in figure drawing do not. The Design Schools would proudly list the number of stu-dents who went "into industry" – either as consultants or as employees – while the Fine Art Departments would seldom do so, possibly because a fair proportion went into teaching, and Darwin was not about to tell the world that the Royal College still trained art teachers. On his retirement, in 1971, a close friend was quoted by the College magazine *Ark* as saying:

*Robin Darwin was an unstoppable publicist. When the College held its first post-war exhibition in February 1950 – it was much too early to have had an exhibition really – he organized what he called a* conversazione *in the evening, just to make a speech drawing everyone's attention to what the College was doing at the South Bank exhibition.*

The big change was that, in the post-war era, so many members of the design establishment *wanted* the College to succeed. It is one of the great paradoxes of Robin Darwin's career that he devoted a lifetime to the promotion of modern art and design, and yet personally he was seldom enthusiastic about either of them.

The industrial designer Misha Black was to write of the pre-Darwin history of the RCA:

*The fine artists were the aristocrats, and* [the] *industrial artisans in the useful arts began to escape from their supposed servitude by moving from industry-based design to the hand crafts of ceramics, silversmithing, weaving, stained glass, furniture-making, bookbinding and those other crafts which share a historical relationship with the fine arts. By the mid-1930s the process had been completed. A few schools of art and crafts paid lip service to the needs of industry and of "commercial art"; none in Britain proved an effective education in design.*

By the time he wrote this, Misha Black had become the first Professor of Industrial Design (Engineering) – a School which was founded in 1959, from within the catch-all School of Woods, Metals and Plastics. There had been criticisms, to which Robin Darwin regularly replied in his *Annual Reports*, that the original School was not sufficiently directed towards the engineering industries, that it produced "artist-designers" rather than "artist-engineers". Perhaps the new School would help to remedy this. But, as Misha Black pointed out, it would take much more than a palace revolution at the RCA – and a few changes of label, however energetically these changes were promoted – to counter the age-old hierarchy, deeply embedded in English culture, and in particular in the English education system, of fine artists first, craftspeople second, communications designers third and industrial designers a poor fourth.

## TO GAIN A REPUTATION

One way of launching the College's new interest in "the promotion of *art* in design" was to involve both staff and students in a series of high-profile public commissions. The first of these, in the

Above *Misha Black, the first Professor of the new School of Industrial Design, by Gordon Lawson.*

Darwin era, was the Lion and Unicorn Pavilion for the Festival of Britain on the South Bank. Over the years, Robin Darwin was to become convinced that this important commission had been given directly to the Royal College of Art. In fact, it was given to the design team of Dick Russell and Robert Goodden, both of whom had recently contributed, as architects and designers, to *Britain Can Make It*. Hugh Casson invited Russell and Goodden to design the exterior and the interior of a Pavilion dedicated to "the British character". This off-beat suggestion was appropriately given a site in a by-pass off the main circulation.

Clearly, the whole project would take up a great deal of time, so they asked the Principal's permission: "of course you must do it", was his characteristic reply, "and you must do it well enough for the College to gain a reputation from it". Richard Guyatt joined the team, to work on the interior display, and Darwin expressed the hope that as many students as possible could also be involved. Half-way through the planning stages, the rather formal title of "The British

Character and Tradition" was changed into "The Lion and the Unicorn" – a decision which was not officially attributed to the Principal, but certainly sounded as if he had had a hand in it.

Since the building would come late in the sequence of construction on the South Bank, the architects had more time than some to think about it. The problem was that they had to be ahead of the graphic and display designers, when they had no idea as to what the contents of the Pavilion might be. The answer was to design, in Director-General Gerald Barry's words, "a shed" – recalling Inigo Jones's reply to the Duke of Bedford, his patron, who asked that St Paul's, Covent Garden should only be a barn: "you shall have the handsomest barn in England". The handsome shed of 1951 was to be a single hall with fifty foot span and an elegantly curved roof: it was largely prefabricated – bolted together, not welded or cemented. The Eastern and Northern aspects were fully glazed: the original concept of the Festival had been a celebration of the centenary of 1851, with its Crystal Palace, and this may have been a reference to it. Where the interior display was concerned:

> We are the Lion and the Unicorn
> Twin symbols of the Briton's character
> As a Lion I give him solidity and strength
> With the Unicorn he lets himself go ...

And, in the Entrance Hall, a corn-dolly Unicorn, made by Fred Mizen of Great Bardfield, was seen lifting the latch of a giant white birdcage hanging from the roof and releasing a flock of white doves which swooped the whole length of the Pavilion, as a symbol of Freedom. The Lion and the Unicorn set the tone for exhibits on the English Language, Eccentrics, Skill in Workmanship, Country Life in Britain – and Christianity, the Law and the Constitution (with a carved inscription in limestone masonry by Barry Hart.) There was to be no reference to the British at war.

It was highminded and whimsical, as British as London Transport Posters and the films of Ealing Studios: full of long quotations and captions (some specially written by Stephen Potter and Laurie Lee), the prevailing genius of the Pavilion seems to have been Lewis Carroll – whose White Knight, a life-size figure in white plaster, had a back-pack machine which broadcast messages of "encouragement and self congratulation" from the Knight himself. When *Harpers* published an article about the Lion and the Unicorn, in May 1951, it explicitly associated the construction with the renaissance of the RCA: the doves (by Robert Goodden), the murals showing scenes from British history (by Kenneth Rowntree, tutor in Painting) and British County Towns (by

Edward Bawden, tutor in Graphics); the group of garden tools, arranged in facsimile of Eric Ravilious's designs for Wedgwood; Richard Guyatt's display for "British Freedom – of worship, democracy and under the Law"; the portraits of British writers, poets, scientists and statesmen, the models, display details, and lettering displays done by some forty College students; and, as part of the wider Festival, the Frank Dobson sculpture in Battersea Park; the Geoffrey Clarke iron sculpture by the South Bank's Link Building; the Festival Symbol by Abram Games (tutor in Graphics); the collection of "popular art" – in the Enid Marx sense, but with a new emphasis on mass culture as well – arranged by ex-student Barbara Jones at the Whitechapel Gallery unde the title *Black Eyes and Lemonade*.

After it was all over, Hugh Casson concluded

---

"OFF-DUTY BRITAIN"

Some of the original South Bank team – including Misha Black and Hugh Casson – did reassemble for the Brussels World Fair of 1958, when design co-ordinator James Gardner entrusted the "off-Duty Britain" area (or "the Garden Section") to the staff and students of the Royal College of Art. In many ways, this project was to be a variation on the theme of the Lion and the Unicorn, as Hugh Casson wrote at the time:

*The ideas varied from the arch to the desperate. Why not just have the Lion and Unicorn snoozing under a tree against a recorded background of music and poetry? Why not put the space at the disposal of foreign artists and ask them to put on show what they think of us? Why not have the courage to do nothing – just plant the whole place out with grass and flowers, fill it with seats, run up the Union Jack, get the Guards Band to play there twice a day and leave it at that? But time pressed ... areas were allotted, briefs drawn up, artists nominated. Country pursuits, from fox-hunting to motorcycle rallies, were entrusted to Leonard Rosoman. In a setting by Kenneth Rowntree the English were to be seen At Home through the eyes of Osbert Lancaster, Ardizzone, Ronald Searle and Giles. Literature displayed its riches in the packed shelves of an open-air library crowned by the busts of Engand's most famous authors, poets and dramatists ... But misgivings mounted. Was it all too upper-class, or alternatively far too "pop"? Were we comfortably on the right side of that razor line that separates art from whimsy? What would the Belgians make of Maudie Littlehampton or John Osborne or even Titus Andronicus? Would it all be just a public puzzle, or, worse still, a private joke?*

Above *Mural by Edward Bawden for the Lion and Unicorn Pavilion at the Festival of Britain, which was held on London's South Bank in 1951.*

hat "there was general agreement that the Lion and the Unicorn ... was one of the most successful pavilions with all visitors to the South Bank Exhibition, a result which we must attribute principally to the qualities of imagination and high standard of design which were shown in the presentation of the theme". There was little doubt that Darwin's hope that the College would "gain a reputation from it" had been realized.

The trouble was that the building was only a temporary monument. Undaunted by this – and encouraged by the fact that it had been constructed to be easily dismantled – the Principal tried to arrange for a re-enactment of the history of the Crystal Palace, by proposing on behalf of the College that the Pavilion be put up again on the island site opposite the Victoria and Albert Museum, as an annex for temporary exhibitions arranged by the RCA, the CoID and the Arts Council, at least until a permanent solution had been found for the use of the site. Passers-by, visitors to the Museum, even local residents had long thought the condition of the site was the

result of the war: in fact, the demolition was pre-war, the first step by the LCC in the building of a National Theatre, the building that never was. Later, the College was to bid for the site yet again in one phase of its never-ending struggle to re-house and expand. But that too, like the Lion and Unicorn proposal, came to nothing. Darwin wrote to *The Times*, talked to his cousins, and tried to mobilize the national museums; but on this occasion the Lion got in the way of the Unicorn.

He had also hoped to acquire for the College the silver tea and coffee service, designed by Robert Goodden for the Royal Pavilion at the Festival, and made by two other members of the College staff – Leslie Durbin and L. A. Moss – which he thought was "the most original and important set of silver made in this country" for decades; but it was purchased by the V & A instead. It remains a splendid example of the fine craftsmanship (and the eccentricity) which characterized the Colleges design commissions in the Festival era.

Public puzzle or private joke (and one imagines that the Euro-visitors must have reckoned it was a bit of both) it's unlikely that the "off-Duty Britain" garden did much for the export of British

industrial designs – although (like so many British pavilions from the 1930s onwards) it probably did wonders for brogue shoes and tweed jackets. In any event, it was awarded a gold medal by an international jury and Hugh Casson concluded that all involved in its conception and making had "been called upon to use our *eyes*", which was something. After the British contribution to the Brussels World Fair was dismantled, the College would have liked, again, to inherit many of the exhibits it designed and made, but the Department of Trade insisted on selling them back at such an exorbitant price that only one item – a large Lion and Unicorn cut in linoleum by Edward Bawden – could possibly be afforded: at every annual Convocation in the Gulbenkian Hall, the heraldic display (the only surviving piece of College work from Brussels) still hangs above the speakers' platform.

Other commissions – which, as Robin Darwin put it, "made the College more generally known" at this time – included a christening present for Prince Charles (a nursery bed, designed by Frank Guille, with silver enamel escutcheons by Philip Popham and bedspread by Frank Howell, students of Furniture, Silversmithing and Textiles respectively); coat-of-arms street decorations, and the damask used to decorate Westminster Abbey (for the Coronation of 1953, again designed in whimsical Festival style, and in the case of the damask, commissioned "after a competition between the College and the Braintree silk-weavers who had always done them"); and a silver electric kettle, designed by Robert Godden from an idea by Prince Philip, for the Queen's Christmas present in 1956. Through the College's connection with Sir Colin Anderson, there were commissions for important sections of the interiors of the two large liners *Canberra* and *Oriana*; and, much later, thanks to James Gardner, both staff and students were involved in some of the interior design of the *QE2* (the coffee shop and the children's room for example, were both the work of the Interior Design students under Hugh Casson, while Lord Queensberry, by then the Professor of Ceramics, was responsible for the tableware).

But the commission which attracted the most attention of all was the design and construction of the stained glass windows for the nave of Coventry Cathedral. This was carried out under the supervision of Lawrence Lee, who had taken charge of a new and independent Department of Stained Glass on the death of Martin Travers in 1948. Travers, an architect by training and a designer of stained glass and church furnishings of all kinds who often involved his students in the work which came to his practice, had joined the

Above *Bed for Prince Charles, 1951, by Frank Guille, as a student in the School of Wood, Metals and Plastics.*

College in 1925 at the request of Ernest Tristram. Lee had been one of Travers's students, and a partner in his studio. When, in February 1950, the College held its first comprehensive exhibition of current students' work in the galleries of the Royal Society of British Artists, one of the largest rooms was set aside for the display of stained glass, and it was the new generation of designers from Lee's Department who attracted some of the most favourable comment: an article on "Secular Stained Glass" in the student magazine *Ark*, by Keith New, one of the students, encouraged Basil Spence to visit the Department, where he was impressed by the work-in-progress of Lawrence Lee, Keith New and another student Geoffrey Clarke, and this led to an invitation to submit designs and a tender for the windows of the new Cathedral at Coventry.

Taking care to give a realistic estimate of costs and overheads in order not to appear to be unfairly undercutting professional tenders, the College, with a price "somewhere midway", was eventually given the commission. After the team of Lee, Clarke and New had worked together for four years, six of the ten windows – on the theme of "man's progress from birth to death and from death to resurrection and transfiguration" – were exhibited at the Victoria and Albert Museum. It was the first time that the designers had seen them complete, instead of in sections, and they caused a sensation. The remaining windows were completed over the following two years. When they were installed in the Cathedral, the "Royal College of Art windows" (as they came to be known) led one of the earliest *Sunday Times* colour sections to remark "one would have needed uncommon discernment to pick Geoffrey Clarke and Keith New to work on the stained glass at a time when they were barely past their

student days". *Design* magazine wasn't nearly so convinced:

*the results* [of the College's commissions in general] *have probably been as good as any which could have been obtained elsewhere in Britain, but the standards should have been exceptionally high and uncompromising. A number of clear successes apart, too much that has been done suffers from our most pernicious national failings – from eclecticism, lack of originality, sloppy detailing and the pomposity that might be called Coventryitis. To be fair, this criticism does not apply to the commission that the College actually* did *carry out for Coventry. In all that complex of mixed metaphors and confused good intentions, the stained glass windows stand out as genuine – if esoteric – contributions.*

R. D. Russell's 2,000 oak stacking chairs for the Cathedral were greeted by *Design* with fewer reservations: it was the Cathedral itself – a shopping mall for artists – that really upset the magazine.

## THE RISE OF THE CONSULTANT DESIGNER

Most of these commissions dated from the first ten years of the Darwin regime, and they were effective. But in 1959 Robin Darwin wrote that "the requirement for industrial designers may be less than is generally supposed": in all the excitement and optimism of the post-war era, he added, the College had made strenuous efforts to demonstrate to both students and industrialists the advantages of improved design in manufactures, and these efforts had borne fruit where small design practices were concerned, but it was by no means clear – given the state of British industry – that educational establishments (particularly one establishment of only five hundred students) and government agencies alone could predict the scale of the required provision of young designers for industry.

The RCA from the mid-1950s onwards had benefitted from the consumer boom, and from the growth of "the affluent society" – which had enabled it to fulfil the original aims of 1837, themselves the product of another period of economic optimism – and its Professors had tried hard to match the design courses to "our forecast of the industrial need". But these forecasts had sometimes been based upon "rather short-sighted advice from official circles", and the recent recession in industries such as Textiles had "affected the employment of designers: I have decided indeed to reduce slightly the overall numbers in future". The implication was, that if the official information on which it based its student numbers proved to be "short-sighted",

then the College was very publicly being placed in an untenable position – which Darwin, temperamentally, found even more untenable.

He was sounding a warning in the *Annual Report* of 1959, a document intended "to solicit public interest in the activities of the College", that the new-found status of designers *might* not have the effect on Britain's manufacturing performance which "official circles" hoped: it might even be taking place in a different world.

There was no doubt at all, by the time he wrote this *Report*, that the College had contributed effectively, ever since 1948, to the rise of the professional consultant designer. As early as 1952, the year in which the first Des RCA students graduated, the RCA could report that out of the 59 of these students, 44 had gone on to posts "in industry" – either as consultants or as in-house designers. An exhibition held in the Western Galleries of the Imperial Institute in the summer of that year, called *Art for the Factory* and opened (to much press coverage) by the Queen Mother, showed work by silversmiths David Mellor, Robert Welch and Gerald Benney, by textile designers Pat Albeck and Audrey Levy, by ceramic designers Hazel Thumpston and Peter Cave, and by furniture designers Alan Irvine, Ronald Carter and Robert Heritage. It was billed as "the first-ever College show entirely devoted to industrial design". Three years later, the *Pottery Gazette* could report in an article entitled *Training Pottery Designers* that:

*the industry can now look forward to a steady supply of trained designers of both sexes. It will be a slow process, for the neglect of many years cannot be put right in a few years. But the future is bright and full of interesting possibilities.*

Below *Part of the RCA's first exhibition devoted entirely to industrial design, held in the Western Galleries of the Imperial Institute in 1952.*

The article went on to list the destinations of twenty-four recent graduates. Most of them had become designers for Wedgwood, Bullers, Poole Pottery, Wades, Ridgway, Doulton and Royal Worcester; a few had become studio potters or teachers in art schools – although, interestingly enough, already there was a discernable trend for graduates to start their careers in the industry for the first year or two after graduation, then to move on to "potting on their own account" and/or teaching part-time.

A year later, the Society of Industrial Artists' publication *Designers in Britain* – which, at the time of Darwin's arrival at the College, had been complaining of the acute shortage of young British designers – was dominated by illustrations of work by recent Des RCAs: including David Mellor's cutlery, Robert Welch's stainless steel, and Frank Guille's and Robert Heritage's furniture.

Most of these designers – as well as Gerald Benney, Pat Albeck and Audrey Levy, and Ronald Carter – had by then set up practices on their

Left *Stained-glass window for Coventry Cathedral designed by Geoffrey Clarke, Keith New, and project leader Lawrence Lee.*

Below Pride *cutlery by David Mellor, originally designed in 1954 and still in production.*
Bottom *Kettle by Mellor, 1953.*

own, since leaving College, to produce one-offs as well as prototypes for industry. And in 1957, with the introduction of the Design Centre Awards, this élite group of consultant designers began to sweep the board. The first year's judging was done by Robert Goodden, Dick Russell, the architect Brian O'Rorke, Astrid Sampe and Milner Gray, and, as Fiona MacCarthy has observed, it turned into "an accolade for Royal College of Art training":

*Robin Darwin wrote a letter to* Design *magazine in 1958 pointing out that 35 per cent of the 20 "Designs of the Year" was the work of designers who had studied at the RCA during the previous seven years. Besides – he added, to be fair – "two other winning designers belong to an earlier generation".*

One of the "earlier generation" people was the textile designer Lucienne Day, who had been at the College from 1937-40, and had designed the Festival print *Calyx* for Heals: by the mid-1950s

Above *Radiogram designed in 1952 by Alan Irvine, who was at that time a third-year student in the School of Wood, Metals and Plastics.*

Right *Liverpool bench in English ash designed by Ron Carter and manufactured by Miles Carter. The former also designed the dining chairs used in the College's Senior Common Room.*

153

**1945-1987**

---

THE HEALS STABLE

Eddie Pond, who was a Textiles student at the RCA in the mid-1950s, recalls those years:

[Heals] *created a virtual stable of designers with Lucienne Day as front-runner and Britain's answer to the famous Swedish designer, Astrid Sampe. To have a design in the Heals Fabric Collection was just about the finest accolade for any young designer. Among those to achieve it were Barbara Brown, Althea McNish, Robert Dodd, Fay Hillier, Doreen Dyall, Margaret Cannon, Nicola Wood and myself. In 1956, we all worked together as students in the same studio above the old Aeronautical Museum in Imperial Institute Road. We were followed later at the RCA by Natalie Gibson, Howard Carter (with his famous "Sunflower" and "Pansy" designs), Zandra Rhodes borrowing David Hockney's "medals", and Peter Hall, now in South Africa running Tongaat Textiles ... The teaching in the RCA Textile School – or, more accurately, the lack of it – did produce some amazing results. John Drummond and Humphrey Spender encouraged us, along with Margaret Leischner, a former Bauhaus student and Head of Weaving, who was succeeded some years later by Eileen Ellis (yet another ex-RCA student from that 1955-8 vintage). Weaving was still considered a bit arty crafty ...*

---

even popular women's magazines were beginning to feature articles on her work and her "lifestyle" – a new addition to the vocabulary of design. One special angle was that she was married to the furniture designer Robin Day, who also had been at the College, from 1934-8, and who since 1950 had been a design consultant for Hille. Clearly, the life and times of the young designer were no longer the exclusive preserve of *Design* and *Architectural Review*.

In fact, Heals was to be just the tip of the iceberg: other firms which produced ranges by ex-RCA students from the early 1960s onwards included Liberty, F. W. Grafton, Tootals, Cavendish, Hull Traders, Bernard Wardle and David Whitehead, and eventually the design direction within some of these firms came from the RCA as well – Shirley Craven at Hull Traders, Eddie Pond himself at Wardles and Colleen Farr at Liberty.

Zandra Rhodes (Textiles 1961-4) has said, concerning her career at the College:

*I was proud to be a textile designer and did not feel I was inferior to a painter or sculptor; it was my métier. I loved it and enjoyed the mental challenge of taking an art form into another stage ... When I left the Royal College, it was fashionable to design furnishing fabrics; and, in fact, my degree print was bought by Heal's as a furnishing fabric. But it was during my second year at the Royal College that I became interested in the different discipline of dress fabrics. I was the first in the College's Textile School, for a long time, to turn away from furnishing textiles to doing dress fabrics ... Furnishing fabrics tend to be large-scale, and in the early 1960s frustrated would-be artists designed furnishing fabrics, painting such things as abstract landscapes ... My last major project and the theme behind my diploma show was medals. This was originally sparked off by David Hockney's Generals. From the way the picture was painted it was the medals that first caught my eye and must have subconsciously also been linking in my mind with the current Pop Art/Union Jack craze.*

Janey Ironside, who took over as Professor of Fashion in 1956 after Madge Garland's resignation – "we disagreed", said Robin Darwin, cryptically, and that was that – found that her School was almost constantly in the newspapers; if the first generation of post-war consultant designers had prepared the ground, the entrepreneurs and the journalists began to hunt for the second generation before it had even left the College studios:

*I was accused of allowing my students to become swollen-headed due to the amount of publicity they received, but as publicity brought all sorts of assets with it in those early days, it was a risk I had to take ... Although when I first took over the School it was taken for granted that a student leaving would try to get a job in a manufacturing firm, this changed after Sally Tuffin and Marion Foale set up on their own, with a lot of courage and two hundred pounds loaned to them by Mrs Joy Bentall, and finally with success. Biba opened her shop and other boutiques appeared. After a year or so as a milliner, James Wedge, a contemporary of Sally and Marion, opened his successful boutique "Countdown" in the Kings Road, and Pauline Fordham opened "Palisades" in Carnaby Street, which the menswear designer John Stephens had already made famous. All these places used students both as freelance designers and as labour during the vacations. From the point of view of most students it was much more fun than going into a manufacturer's design or work room, which I tried to arrange for them ...*

By the mid 1960s, Janey Ironside added, the young designer had never had it so good. Magazines such as *Tatler* ran gushing articles on:

Above *Shirley Craven printing one of her designs in the RCA Textile Studios in 1957.*

Below *Trouser suit, 1966, by Marion Foale and Sally Tuffin, who studied in the Fashion School 1958-61.*

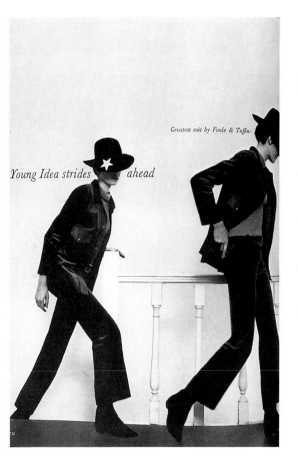

*Young Idea strides ahead*

*Greatest suit by Foale & Tuffin*

Above Calyx – *screen-printed linen, 1951, by Lucienne Day for Heal and Son Ltd.*

*Two very young ex-students of the Royal College of Art who pioneered the near-impossible task of interesting buyers in their kooky and original clothes. Now London stores sell out of Marion Foale and Sally Tuffin clothes as fast as they come into the departments.*

They didn't want to be *chic*, they said, they just wanted to be ridiculous.

The era of students wearing white gloves into the studios – no jeans or trousers allowed – *Sabrina Fair*, and Paris Kensington was well and truly over, and the era of ex-RCA students Janice Wainwright (also featured in *Tatler* in her final year), Ossie Clark and Bill Gibb, and all "the fashion designers who made London swing", was about to begin. Brian Godbold was fairly unusual in his generation of fashion students, in that he became a very successful in-house designer for a large firm – Marks and Spencer.

Reading through the *Design* magazines, the lists of prize-winners, the press reports of exhibitions and shows, and the countless "human interest" stories about the College in the press

155

from the mid-1950s to the late 1960s – even *The Times* got in on the act, with a *MUSEUM WARDER SAMPLES PRINCIPAL'S GIN* story of May 1955 – one thing comes over loud and clear: the promotion of the new breed of consultant designers (or of ex-students who "set up on their own") had become inseparable from the promotion of the Royal College of Art. For, as Margaret Leischner said in 1956 (and as Robin Darwin confirmed, in his *Annual Reports* for these years) "our job at the RCA is to sell designers not designs . . ."

## "A TWO-WAY TRAFFIC"

A key development in the College, which at one level made its presentation of itself possible during these years, was the rise in significance of the School of Graphic Design. It had grown out of the half-formed idea of a School of "Typography and Design for Publicity" in 1948. As Richard Guyatt, who master-minded the transformation, recalled:

*In the early days of the reorganization, when Committees were drawing up the terms of reference for each of the new Schools set up within the College, the name "Graphic Design" was never mentioned and this particular new Department was thought of as a School of Publicity Design. It was only after an article had appeared in* The Times, *welcoming the reorganization of the College but rapping it over the knuckles for the vulgarity of such a concept as "Publicity Design", that a serious quest for a name was made. With a certain sense of relief, but not much conviction, the name "Graphic Design" was chosen. No-one was quite sure what it meant, but it had a purposeful ring, avoided the associations connected with the words "Commercial Art" and promised a wider scope in training than that allowed by the use of the limiting word "Publicity"* . . .

He wrote this in the catalogue to a major exhibition *Graphics RCA* (1963), which toured Europe and which was intended to celebrate the work of the intervening fifteen years. By then, the School included, as well as a core of Graphic Designers, Departments of Illustration, Printmaking and Film and Television, the *Lion and Unicorn Press* and the student magazine *Ark*. Exactly what was meant by "a wider scope of training", in the context, was explained by Guyatt:

*Inherent in the reorganization of the College was the tenet that the fine arts are the inspiration of the applied arts. Hence the importance, within the School of Graphic Design, of the Printmaking*

*Department which deals with graphic media as a fine art. It is through the fine arts, the "useless" arts, that the "useful" arts of design are invigorated, in much the same way as researchers in "pure" science affect the work of "applied" science . . .*

So, although the training was "specialist and professional . . . the study of aesthetics is its main preoccupation". The catalogue which followed looks like a full-blown history of British

Below *Final-year student work by Zandra Rhodes, inspired by a Hockney painting.*
Bottom *Rhodes's "Punk Chic" look, autumn 1977.*

Above *Designs by Ossie Clark in* Vogue, *1965, his final year as a fashion student.*

graphic design from 1948-63: posters by David Gentleman, Michael Foreman, and Brian Tattersfield; book covers and advertisements by Alan Fletcher; a cookery strip by Len Deighton; the set for BBC television's *Quatermass and the Pit* by Cliff Hatts; and a still from Ridley Scott's student film *Boy on a Bicycle*. One of the most striking aspects of the section on student projects, is the number of designs which were intended to promote activities currently going on in the College: the student magazine, prospectuses for the *Lion and Unicorn Press*, College dances, the Jazz Society, the Film Society and the Diploma show. As Robin Darwin wrote in his *Foreword*, the School had become a focus for – and a way of getting into focus – the entire College, and its particular atmosphere was directly attributable to "Professor Guyatt's own ruminative imagination". Amidst all the jazzy graphics and the grainy blow-ups, if ever Darwin wanted an impressive-looking College document – such as a Prospectus, a Report, or even a Senior Common room menu – with a crest centred and an aura of Cambridge-style tradition, he could always rely on the School of Graphic Design.

By the mid 1960s, the equally traditional lines between "useless" and "useful" (to adopt Guyatt's terms) had become temporarily blurred – both inside and outside the College. Zandra Rhodes adapted motifs from David Hockney's student paintings, while Hockney was photographed by David Bailey as if he was a rock star in his gold lamé jacket; while the painter Derek Boshier did the lettering for Pauline Fordham's boutique "Palisades"; while the work of the Archigram architectural group referred to the visual language paintings of Peter Phillips and Joe Tilson; while Barbara Brown designed her op-art inspired "Caprice" fabric for Heals; while some students in the Furniture School experimented with throwaway paper furniture which looked like sculpture; while the fashion designer Ossie Clark claimed to have been influenced by his study of buildings at technical college; while *Queen* magazine, under proprietor-editor Jocelyn Stevens, in its never-ending search for "the young", allowed the staff and students of the RCA to design a complete issue in June 1967. Almost this entire cast of characters came from the RCA, and, indeed, this blurring of the lines appears to have been a distinctive feature of the College between the early and mid-1960s. Carel Weight, the Professor of Painting since 1957, was quoted by *Illustrated London News* as saying in November 1967:

*A lively Fine Art Department sparks off ideas. There is a strong two-way traffic. A lot of our students work in plastics, and the Textiles students gave an exhibition of their work recently which looked like an exhibition of paintings...*

Not everyone was happy about this: in June 1964, *The Scotsman* admitted that "many of us get a bit sick of the endless talk of 'RCA young designers', some of whom do seem to market themselves more expertly than their wares", and Bridget Riley actually sued the American producers of "op

Below Reciprocation – *printed furnishing cotton for Heal Fabrics by Barbara Brown, 1963.*

**1945-1987**

dresses" which were directly derived from her paintings.

## TOWARDS ART?

With this two-way traffic in full swing, it was not always easy to disentangle the College's "promotion of art in design" from the College's promotion of "professionalism" in art proper. Coincident with the arrival of Robin Darwin, there had been a sustained attempt to present the work of "RCA painters" to the exhibition-going public, for the first time in the history of the institution. The influential *Young Contemporaries* show had started life in 1949, when Carel Weight (a tutor in the Painting School at that time) suggested that the empty galleries of the Royal Society of British Artists, 6½ Suffolk Street, could perhaps be used for a show of student work. That first year, the exhibition was dominated by the work of Royal College students – which led *The Times* to note that "painting has become a great deal too interesting and attractive an occupation for the good of the state or of those who produce it . . ."

Below *Joe Tilson's* A-Z Box, of Friends and Family. *This mixed-media piece from 1963 includes works by Auerbach, Blake, Hamilton, Hockney, Kitaj, and others.*

In future years, the paintings of successive generations from Exhibition Road had their first professional showings at *Young Contemporaries:* the neo-Bomberg paintings of Frank Auerbach and Leon Kossoff; the kitchen sink paintings of Jack Smith, Edward Middleditch and John Bratby; the Abstract Expressionist paintings of Richard Smith, Robyn Denny and William Green; the work of the so-called "Pop" generation, heralded by the autobiographical paintings of Peter Blake (RCA 1953-6) and the Literary Symbolist paintings of Ron Kitaj (RCA 1959-61): David Hockney, Peter Phillips, Allen Jones, and Derek Boshier – exhibiting at the same time as Patrick Caulfield and "Billy Apple". The historian of *Young Contemporaries* has written of this generation:

*Perhaps the traditional College connections with design influenced these particular students, perhaps also they picked up on a new feeling in the air and drew it into their work, adopting a career commitment which underlay all their actions. Patrick Procktor, who was a student at the Slade, identifies the difference between the two Colleges. The Slade tradition placed emphasis on painting as research while the RCA stressed the importance of the display object . . .* The Times *called the 1961 exhibition "an unusually well-managed, professional-looking affair". Perhaps this was because Peter Phillips and Allen Jones rehung the entire show, grouping the Royal College work on one wall, facing the Slade "struggle" art on the other . . . Lawrence Alloway was a selector and wrote the catalogue introduction. In this he claimed that the initiative required to send work in for the* Young Contemporaries *was what distinguished the artist from the majority of art students. The logical conclusion of this, that all real artists develop young and are both ambitious and careerist, is the destructive extreme of professionalism applied to students . . .*

By then, Auerbach and Kossoff were both exerting a strong influence on the students of the Slade, through their teaching and their practice – so although much was made of the Slade *versus* the RCA at the time, it was really the 1952-6 RCA people versus the 1959-62 RCA people. Ron Kitaj has recalled what happened when the "Pop painters" met the Bomberg disciples at Suffolk Street in 1962:

*Hot gospel carried through the ether from 8th Street to Exhibition Road, encouraged by activists like the ballsy critic Lawrence Alloway, who was one of the judges I think. Alloway left a trail of blood, whatever else he did, and I remember a crowded evening at the* Young Contemporaries

*where he fought loudly with the Bomberg people while the audience waited about an hour for David Sylvester, who was always late but worth waiting for. Sylvester (who was a tutor of ours) told me the price of one of my paintings – £100 or £200, I think – was shocking for a student work. I was so ashamed of myself I sold it to a man for £60.*

On one wall, were the uncompromising and heavily impastoed expressionist paintings, usually in earth colours, of the neo-Bomberg school. On another, was the third in a series of David Hockney's paintings of a Ty-Phoo tea packet.

The exhibition of 1962 has been called "the high-water mark of the *Young Contemporaries*", and, as if to imply that it represented some sort of full-stop, the Arts Council immediately compiled a touring show called *Towards Art?* – which catalogued the contribution of the RCA to the Fine Arts between 1952 and 1962. Robin Darwin insisted on the title – "I say there *is* to be a question mark" – much to the annoyance of the Painting staff, who felt it was "something of a slur on their efforts". The generation which exhibited in 1962 certainly made waves in the studios of Exhibition Road, the effect of which Carel Weight described five years later:

*With all this going on . . . the scene by about 1965 must have appeared chaotic to a student desperately looking around for new means of expression. It must have seemed as though everything had been done . . . At present, there is a student in the Painting School constructing a launderette containing washing machines made of hardboard. Art has come a long way since Pope expressed his universe in rhymed couplets and Nicholas Hilliard put the poetry of the Elizabethan age into a few square inches of ivory.*

By that time, Carel Weight was wondering whether students had become too obsessed with "technique" and "novelty" – at the expense of "personal identity" – and whether "the art of the future will come from older and more mature people who have had a chance to assimilate the complex problems of existence in our modern world". The contours of the art world in the 1960s had certainly changed, but he was not sure how substantial the changes would prove to be:

*"If you haven't hit the jackpot by the time you are twenty-five you've had it", said the ambitious young painter, and I could not help thinking back to the thirties when I was a student, when London was an artistic backwater boasting about a dozen dealers' galleries, none of which would seriously consider giving an exhibition to a young painter emerging from art school. The*

Above *A study after Delacroix (1963) by Patrick Caulfield, who studied painting at the College 1959-63.*

*sixties have produced a very different picture; there are at least a hundred galleries and the hunt for the young genius has until recently been the order of the day.*

In his introduction to the Arts Council's *Towards Art?* show of 1963 – which originated in the Royal College of Art galleries, and which included a life painting by Richard Smith, student works by Blake, Boshier, Bratby, Green, Hockney, Kitaj, Kossoff and Phillips, recent paintings by Denny, Alistair Grant, Middleditch, Riley and Tilson, and drawings by Frank Auerbach – Carel Weight pointed out that although in retrospect certain "styles" had become associated with the RCA, at any given moment there was likely to be "a great variety of work which reflects the policy which has encouraged every student to develop his art in his own way":

*When Mark Rothko recently visited the College he seemed astonished that students painting in such contrasting styles could work together in such complete harmony, often stimulated and inspired by one another . . . These ten years have been a period in which the influence of the*

**1945-1987**

*College has had its effect upon the course of art in this country. Many artists represented in the exhibition have already achieved reputations: two major art movements, New Realism and "Pop" art, have been generated within its walls, while the Neo-Bomberg School had its beginnings among students here, and developed elsewhere. It was a College student, Ivor Fox, who organized the first* Young Contemporaries Exhibition ... [But] *this exhibition cannot give a complete picture.*

Robin Darwin wrote about this generation, in 1959:

*Students were older than they are now, the sequence of their education had been interrupted by war or National Service; they had known experiences and discharged responsibilities far outside the orbit of their interests, and returning to them they were primarily concerned in the rediscovery of themselves as individuals. As artists they were less self-confident, but in all other ways they were more mature.*

Frank Auerbach, who arrived at the College from David Bomberg's Borough *bottega*, and St Martin's College of Art, was to make (in 1978) a clear distinction between the attitudes and interests of his generation and the late 1950s/early 1960s students:

*I was a really silent student. I just managed to escape that thing of being told what books to read and take lectures on philosophy ... I really didn't talk to people when I was a student. I disdained to write a clever thesis or anything like that because I was taken up with what I was trying to do in this other language, which was certainly engrossing enough. And when I left the College ... I think I was quite interested to hear what I had to say.*

Auerbach felt that his fellow-students Jack Smith and John Bratby, who were championed – after graduation – by the art critics John Berger and David Sylvester, and by Helen Lessore of the Beaux Arts Gallery, "were aiming at . . . a sort of young artist's passionate illustration, while I was born old and I wanted to make a dignified perverse image, a formal image".

But at least they didn't have too much interest "in trends" – a fact which definitively separated them from the later generation of RCA students:

*I think it's possible to show an early talent, but unless one has the sort of speculative imagination that makes one reinvent oneself, which is really what reading a book does, I don't think one can last as a painter. Everybody I know, who paints, Lucian Freud or Leon Kossoff, or anybody*

---

**"PAINT EVERYWHERE"**

Inevitably, "the major art movements" referred to by Carel Weight attracted the most attention. New realism and "Pop" art, in particular, had happened in reaction against the English Neo-Romantic paintings of Keith Vaughan, John Minton, and Alan Sorrell – at a time when Minton's "extraordinary magnetic personality" still exercised a fascination for the Painting students, and when the mature students of the post-war years, with their hard-won "bohemianism", their baggy jumpers, and their jazz clubs, rediscovered the romantic excitement of behaving like artists are expected to behave while painting unromantic subjects. Joyce Carey's *The Horse's Mouth* (for the film version of which John Bratby did the paintings) had recently been published, and there was paint *everywhere*.

---

*who seems to me to have shown some sort of sustained level of artistic invention, has read books. I'm not at all certain that the reason that people have stopped coming up with any sort of authority since Hockney came up (and he also reads a great deal), is because they've simply stopped reading ...*

The 1959-62 generation, the second generation of "Pop painters" at the RCA, preferred to derive their imagery from "urban commercial material, press advertisements, road signs and motorcycles" – as Carel Weight put it: the generations which followed them were to produce semi-abstract Pop, with ideas deriving from Hard Edge, Kandinsky and Dada. It was a time when Peter Blake told his students at St Martin's and Walthamstow "don't do a painting of a bottle of wine and a piece of camembert – do a painting of something that means something to *you*", when being different meant *not* behaving like fine artists are expected to behave, when British blues singers (rather than British jazz musicians) tried to sound like the black originals and when the line between fine art and graphic design was becoming increasingly difficult to draw. Tony Hancock's film *The Rebel* (with paintings by Alistair Grant) had satirized the baggy-jumper generation, and there were pin-ups of Elvis Presley and Marilyn Monroe all around the studio. Robin Darwin wrote about *this* generation, the product of substantially increased access to art education in the 1950s:

*The student of 1959 is less easy to teach because the chips on his shoulder, which in some instances are virtually professional epaulettes, make him less ready to learn; yet this refusal to*

*ake ideas on trust, though it may not be congenial to the tutor, may in the long run prove to be a valuable characteristic. The students of today are on the whole much more extraordinarily dressed and a lot dirtier and this no doubt reflects the catching philosophy of the "beat" generation ... This revolt against a managerial revolution which offers the possibility of material welfare and mass extinction with equal generosity, and which denies increasingly the opportunity for the ordinary person to express a choice between these alternatives and still less propose a third, is a powerful stimulant to the young ... Denied responsibility, denied as they suppose the opportunity of carrying any burden, they are making not illogically a virtue and a philosophy of travelling light ...*

These sentiments – so wise and so paternalistic at the same time – explain a lot about the attitude of the College towards the post-1959 generation, and vice-versa. In retrospect, the coincidence of Carel Weight's arrival as Professor of Painting and the rise of "Pop art" has led to the myth that the 1959-62 generation gained immediate acceptance and understanding from all concerned. This was, in fact, far from the case. Allen Jones (who was not even represented in the *Towards Art?* show) parted company with the College after just one year, to return to Hornsey College of Art and a course in teacher training.

## "DEAR HOCKNEY . . ."

Shortly after he arrived in autumn 1959, David Hockney became a close friend of Ron Kitaj – an older student who was studying under the US Government's GI Bill of Rights. Kitaj came from a course at the Ruskin School in Oxford, where he had studied under Percy Horton, and where:

*One was not only able to, but required to work from the figure and could do that every day, all day, with minimal interruption from other studies ... Horton was a gentle English Cézannist who could bear down if needed on rough-hewn American ex-soldiers.*

At the RCA, too, Kitaj "spent two years drawing in the life rooms", and, as an older, more experienced painter than Hockney – and, incidentally, the first American the 22-year-old Bradford student had ever met – Kitaj had a significant

Above right *Richard Smith's* Yellow, Yellow, *1957. Smith exhibited in* Towards Art? *of 1963, the impetus for which came from the RCA's galleries.*

Right *Figure drawing by Frank Auerbach, a student in the Painting School in the early 1950s, when, in Carel Weight's words, the "neo-Bomberg School" began.*

influence on him. As Hockney has recalled:

*He's about four years older than I am, which when you're twenty-two is a lot of difference, in experience anyway ... Ron was a great influence on me, far more than any other factor, not just stylistically ... but in his seriousness too. Painting was something that you were studying seriously. A lot of people thought art students were serious in that way, but they weren't; they just gassed around, and I always thought that was silly. The painters teaching at the College then were Carel Weight, Ruskin Spear, Ceri Richards, Roger de Grey, Colin Hayes, Sandra Blow ... They taught me for many years; some of them had been there twenty, twenty-five years. They left you fairly free, as long as you did drawing, because in those days that was still compulsory – which was fine with me ... The one student I kept talking to a lot was Ron Kitaj.*

It was Kitaj who re-assured Hockney that figure paintings were not "anti-modern"; that he wasn't "doing anything that's from me" when he worked at big abstract expressionist pictures in his first few months at the College; and that he should paint from his "own interests" – such as (at that time) vegetarianism and politics. It was also Kitaj who purchased two drawings of a skeleton – "two very academic, very accurate drawings of a whole skeleton, half life-size" – from Hockney, during the first term. But relationships with the College authorities were a lot less amicable:

*The staff said that the students in that year were the worst they'd had for many, many years. They didn't like us; they thought we were a little bolshy, or something, and so they threw out Allen Jones at the end of the first year – they said he was no good at all ... It was strange. A lot of students were told their situation would be reviewed in six months; although it didn't happen to me. I think it was simply because of my drawings, which they always liked.*

Hockney's real quarrel with the College authorities was over the fact that "there were too many lectures and it was taking you away from painting . . . in the first term of my first year I did all the work they set, then I just stopped going. I thought, painting comes first, I'm a serious student here".

The conflict must have made a deep impression on him, for he has talked about it, at great length and whenever the opportunity arises, ever since. Here is a vintage example, dating from shortly after he left:

*I went to Bradford Grammar School. At Bradford Grammar School their attitude to art is that it is*

*something to do with your hands – it's not an intellectual process at all. That's their attitude. Well, that's all right for them ... But if an art school takes that attitude it's a different matter. I think that anything that suggests that painting itself isn't enough is rather a terrible thing to have in an art school. I assume they have it in an art school because they think "we don't know how to look at pictures. What we had better have is something in writing". Well, it's their loss, not mine ... I should think that at 22 I had some reasonable idea of what I wanted to do and I just sat down and did it. And anything I thought was a waste of time, I ignored ... I think perhaps I did half an essay for them. It simply finally resulted that in the final year they said "You have FAILED AT THE GENERAL STUDIES COURSE" which in a way was probably right ... But of course what happened in the end was they passed me. I couldn't care less whether I had the diploma because a diploma is worth nothing.*

General Studies had been given Departmental status, by Robin Darwin, the year before Hockney arrived – as part of his policy to provide artists and designers with "amused and well-tempered" minds. When he took over in 1948, he had discovered that there wasn't even a College Library, and, as for the concept of a "broad education", that consisted (as it had since 1901) of a compulsory course in the School of Architecture which involved the submission of a 6,000-word thesis before any student could proceed to he final examination: there were Departmental collections of books (most of them housed in cupboards for which the Departments had long since lost the keys), and he discovered that a presentation copy of the complete works of Randolph Caldecott, signed by the artist and the printer, had recently been rescued from a college dustbin.

In 1951, the well-known art historian Basil Taylor (ex-Slade, BBC Radio and the National Art Collections Fund) had become lecturer in the History of Art, with responsibility for supervising and marking the students' theses: in the next ten years, Taylor was to found the College Library, develop the concept of "General Studies" (rather than Architecture), and provide a model for theoretical studies in art education which, for better or worse, became national policy after the first Coldstream Report of 1960.

Taylor himself was much more at home in front of a BBC microphone (for example on *The Critics*, when he felt absolutely face to face with his audience) than in the Lecture Hall. It was a standing joke among students that when he appeared before them he took great pains to

recapitulate last week's lecture, rehearse next week's lecture, but this week's lecture was lost in between: on one occasion, a student gave a show-stopping imitation of Basil Taylor as commentator on the Derby; after describing the scene in detail – the colours, the horses, the weather, the crowds – he apologized for running over time and said he would give the results next week. But he did bring his connections from the worlds of art history and broadcasting into the College – including, in the early years of the Department, Isaiah Berlin, Kenneth Clark, Julian Huxley, John Betjeman, John Summerson, Joseph Rykwert, and Iris Murdoch – and he saw it as his mission to encourage students to reflect on the "why" of art and design (since he reckoned that the studio Departments spent most of their time on the "how"). In this, he was constantly supported by the Principal, who year after year in his Annual Reports, complained about the standards of general education among the students "if a knowledge of spelling and language usage is any criterion": eventually, in spite of strong opposition from both colleagues and students, Darwin proposed that no student would be allowed to gain a diploma without showing, by attainment in General Studies, that he or she was intellectually equipped to do so; and in this way, as he put it, academic achievement *during* the course would compensate for lack of pre-entry qualifications, however attractive administratively emphasis on the latter might be.

Half-way through David Hockney's course, Basil Taylor left the College to become the first London Director of the Mellon Foundation for Studies in British Art. There was a brief interregnum, during which Michael Kullman, lecturer in philosophy, became Reader in General Studies.

David Hockney – who thought that, personally speaking, Kullman was a "marvellous bright guy", but "in his official capacity we never got on" – wrote an illustrated thesis on *Fauvism* which was failed by the Department of General Studies. The thesis was evidently written at great speed, and was chaotically argued. On 11 April 1962, he received his regulation letter from the Registrar:

*Dear Hockney,*
*You will have noticed from the Results Lists which have been posted on the School's notice board that you have failed the Final Examination in General Studies which means that irrespective of the result of your professional work you will not be eligible for the award of the College Diploma at the Convocation Ceremony to be held on the 12th July.*

By the time Hockney took his College Diploma,

*he* was convinced, as he later said, that "I always had the upper hand there":

*I really never had much trouble with the Painting School. They're very easy going in a way and don't go around often . . . The point is the things they said would go in one ear and out the other. Of course people kept saying they're painting terrible pictures. But I just didn't believe it, you see. It went straight through. You only become upset if you believe it yourself or believe them, don't you?*

To celebrate his triumph, he appeared at the Convocation Ceremony in a gold lamé jacket. "In a way", he remarked some time afterwards, "I regret buying that Bloody Gold Coat. For I think people thought I had worn it every day. In actual fact I only ever wore it twice. I wore it for that Gold Medal and my mother thought it was an official coat. And I wore it for some photographs Snowdon took."

In retrospect, the *Young Contemporaries* shows of 1961 and 1962 were probably the most significant moments in Hockney's student career. The 1961 show was, he remembers, "the first time that there'd been a student movement in painting that was uninfluenced by older artists in this country, which made it unusual. The previous generation of students, the abstract expressionists, in a sense had been influenced by older artists who had seen American painting. But this generation was not". By his second year, Hockney had (with Kitaj's encouragement) at last come to terms with the figure:

*The problem for me was the figure; not wanting to paint the figure in. I've said this many times before, the thing Cézanne says, about the figure being just a cone, a cylinder and a sphere: well, it isn't.*

So, when he submitted his four pictures to the *Young Contemporaries* of 1962, they were all figure paintings "in different styles": each was entitled *A Demonstration of Versatility*, followed by a subtitle (to get more space in the catalogue). There was *Painting in a Scenic Style* (now known as *Flight into Italy-Swiss Landscape*), which was based on a journey to Berne in a mini-van, with Michael Kullman, in December 1961: because Hockney was sitting in the back, he didn't actually *see* the Alps, so he had to "just make it up" – with the caption (based on the long-running *Shell* campaign) *That's Switzerland that was* coming out of the exhaust pipe. There was *A Grand Procession of Dignatories in the Semi-Egyptian Style* ("'semi-Egyptian' because there is a true Egyptian style with rules. All styles in a sense have some rules, and if you break them it's

163

A STATISTICAL SOLUTION

Between April and July 1962, although Hockney had resigned himself to "leaving quietly by the V&A exit", the College authorities were trying hard to find a way of squaring the circle into which they had penned themselves. After all, the Painting School had achieved a lot of extra-mural publicity during 1960-1 and several members of the staff had never supported the concept of "General Studies" in the first place. In the end, Hockney was awarded a Gold Medal for his studio work, and the Academic Board ruled that something must have gone wrong with the marking system for the final year theses. As the Registrar John Moon wrote:

*A sub-committee of the Academic Board examined the marks of all students in this examination. Following their report the Board took the view that deviations had occurred in the computation of the numbers of this examination. It therefore ruled that all the results be set aside and that all the students, including David Hockney, be adjudged to have passed the examination.*

The sub-committee appears to have consisted of the Principal, Carel Weight and Michael Kullman; they agreed, on Darwin's recommendation, that for some inexplicable reason they must have miscounted the marks. During the course of its meeting, Darwin muttered something about standards of numeracy in South Kensington.

It was an "amused and well-tempered" way out of the dilemma, but it hadn't reflected particularly well on *any* of the participants. Either they supported the system or they didn't. The "recount" story didn't convince anybody.

a semi-style, I thought"); there was *Figure in a Flat Style*, in which the shape of the canvas (with wooden legs like the base of an easel) *became* the figure. And there was *Tea Painting in an Illusionistic Style*, which referred to his day-to-day experience in the Exhibition Road studios:

*I was usually in there about seven, seven-thirty in the mornings, before Lyons had opened in South Kensington, and I used to make my own tea in there, because they couldn't serve a cup of tea till eleven o'clock. I had a little teapot, and a cup, and I bought a bottle of milk, and packets of tea – it was always Ty-phoo tea, my mother's favourite. The tea packets piled up with the cans and tubes of paint and they were all lying around all the time and I just thought, in a way it's like still-life paintings for me . . .'*

When he had completed *Tea Painting*, he noticed

that he had wrongly spelt the word "tea" on the left-hand section of the packet, where it appears in perspective (Ty-Phoo TAE). But he left it in. The Principal's reaction – with his strong views on "spelling and language usage" – has not been recorded.

Together, these four contributions to *Young Contemporaries* were, it seems to Hockney in retrospect, "the works when I became aware as an artist. Previous work was simply a student doing things . . ." Amongst the previous work was Hockney's version of the RCA diploma, which showed a "two-faced" student bumping his head on the College crest, while a rotund figure who looks very like the Principal (complete with flapping Old Etonian tie) sits beneath him – propping up the student with his hand.

Four years after Hockney's departure, the *Observer* colour magazine featured an upbeat "swinging London" style article, on the Royal College's "art of success . . . hand in glove with industry and publicity":

*The whole phenomenon of Pop Art was hatched within the RCA's walls (to the bewilderment of some of the staff) and by the time the leading practitioners had left the College they were already familiar figures in leading art galleries. At the moment Pop Art has waned, and the painting school is heavily in the throes of Op Art, its best known exponent being the former student Bridget Riley.*

Already the process of myth-making had begun; for the whole phenomenon of Pop Art was, in fact, hatched at the Institute of Contemporary Arts several years before the generation of 1959-61 even came on the scene, and Bridget Riley gave very few hints in her work as a student (1952-5) that she would become the leading exponent of British Op Art – except, perhaps, in her studies after Seurat. But the article has some historical interest, in that it is illustrated with a photograph of "third-year student Ian Dury . . . working on his 'spiv'" – consisting of the word SPIV painted three times in different colours.

A month after the *Observer* article appeared, in June 1966, Jean Rook wrote an article about the College (and in particular the Fashion Show) in one of the tabloids. She waxed eloquent "as a ratepayer" on the subject of what she called the "x-certificate" garments worn by the models: Why she asked, did Professor Janey Ironside, head of the RCA Fashion School, and probably the brightest fashion brain in Britain, let these kids run riot? "'They're sick of Courrèges, they're sick of mini skirts, they're sick of everything but colour and movement.' They're sick all right."

From the staid atmosphere of the life-room

during the Rothenstein era, to Peter Blake discussing the finer points of Jayne Mansfield with Ian Dury, must have seemed at the time to be a change as complete and dramatic as any in the College's long history: certainly, it was perceived to be so in the popular press. But in fact, with hindsight, one can see clear lines of continuity: from the brown realism of Euston Road (and the AIA members of the early 1930s) to the "kitchen sink" of the early 1950s; from "kitchen sink" to the everyday figuration (usually autobiographical with working-class settings) of Peter Blake; and from this to the "pop" of the throwaway package.

In parallel to this, the development of Rodrigo Moynihan's work in the mid- to late 1950s – from large group portraits of the staff of the Painting School and the Directors of Allen Lane publishers, to a sudden reversion to his earlier abstract painting of the 1930s – a development which coincided with his departure from the

*Below Lucian Freud's 1948 study of John Minton, an influential painting tutor in the late 40s and early 50s.*

College, in 1957, to devote more time to his work, also mapped out a route which generations of students would take. The lines of continuity came from the staff rather than the students: painters such as Percy Horton, Rodrigo Moynihan, Carel Weight, John Minton, Ruskin Spear, Robert Buhler, and Leonard Rosoman. The politics of the 1930s generation had steadily given way to

*Below David Hockney's Mr and Mrs Clark and Percy (1970-1). Hockney entered the School of Painting in 1959 and, after some acrimony in his final year, received his diploma in 1962. His The Diploma (bottom) of that year encapsulated his feelings.*

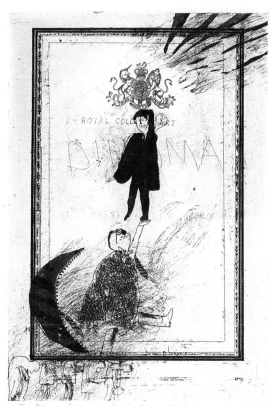

1945-1987

the pop imagery of the 1960s: and one explanation of this phenomenon is contained in Robin Darwin's comments on the "beat generation" (quoted above), and in his prediction that the students who came to the College post-1959 would have an attitude which combined tolerance of individual frailty with a deep cynicism about the deceits of human conduct, and above all which questioned the possible advantage of *any* collective action. They were on their own, and they liked it that way. Particularly if there was an audience.

From the late 1950s to the late 1960s, the School's reputation and conduct were much affected by the immediate success of students. Entrants arrived expecting to be experimental and innovative, and to attract attention with their work. The post-war generation had not, on the whole, expected to achieve instant success on leaving the College – and even that limited success, to be able to live by one's art, seemed a rare achievement. The mid-1950s generation (of male students, anyway) was markedly different. The products of National Service rather than of war experience, they still, on the whole, had left school by the age of sixteen, had spent four years at their local art school and a year to 18 months as reluctant conscripts, and then the Royal College. They were the generation of Lucky Jim and Jimmy Porter: John Minton, in fact, combined his work at the RCA with work at the Royal Court theatre. Whereas the post-war male students wore demob suits and second-hand homespun, this generation wore Italian suits, went to expresso bars, rode Lambrettas and collected French and Italian girlfriends.

By the late 1950s, the School was already beginning to attract extra-mural interest. William Green, abstract expressionist extraordinaire, made temporary headlines by riding a bicycle with the tyres let down and driving a motor-car over his canvasses: as a critic in the *News Chronicle* of 9 January 1957, wrote, with some bewilderment, most painters used paint to "express the human condition . . . But to 23-year-old William Green, still a student at the RCA, it is something to be trodden in". The success of David Hockney, and fellow-students, raised the profile of the School even more. Students could expect the *right* to practise, after leaving – and, since art education was expanding nationally, there were often more part-time teaching positions than applicants, with fast promotions. This expansive era (where both the art market and art education were concerned) reached saturation point very quickly, as Carel Weight noted in 1967, and the successive student generations found themselves shut out.

### A POP PAINTER

Ian Dury had come to the College from Walthamstow School of Art: Peter Blake had taught him at Walthamstow, and, from 1964, at the RCA as well. Later, Dury (who by then was a well-known rock singer) remembered:

*Art schools at this time were either death-beds of numb academic bullshit or hot-beds of creepy conceptual horseshit. Walthamstow subscribed to the former tradition which at least tried to provide students with skill in draughtsmanship and painterly technicals, but it took Mr Blake to show my generation of Essex layabouts how to convert our lifestyle and private obsessions into artistic energy. Easels were soon creaking with real culture. Art suddenly became a living thing. I once showed Peter a flash-harry collage of 100 pairs of naked bosoms snipped from Jean, Nugget, Monsieur and Playboy magazines and he correctly identified every tit either from memory or by print colour. He is the master of wonderful seriousness and he guided my mates and me through Walthamstow and the RCA with large amounts of hard encouragement.*

By the time he wrote this, Ian Dury had in fact recorded a song called *Peter the Painter* as a way of showing his gratitude – the first rock song ever to concern itself with the experience of being at the RCA.

### AFTER ME, THE DELUGE

One very sensitive barometer of all these changes in the atmosphere of the College, during the Darwin era, was the student magazine *Ark* – which operated from within the School of Graphic Design. The first issue appeared in October 1950, just before the Common Room moved to Cromwell Road. The editorial side was an entirely student venture – the first editor was its founder Jack Stafford – while the art director and advertising manager were overseen by the School. The name was something of an enigma, born of a compromise that wished to have RCA somewhere in its title, but eschewing ARC as an acronym, and finally concluding that once afloat, it might include one of everything by the time it came to rest or sank, if not two. *Ark*, with a print run of about 3,000, depended not upon grant aid (at least not until 1966) but upon the sale of advertising space – and it built up a body of advertising supporters (who often allowed students to design the ads, as an exercise) that kept it afloat through not very thick and sometimes very thin times: in May 1957, when *Ark* had run up a considerable overdraft, Jack Beddington of the

College Council launched an appeal "to the advertising industry" and managed to raise more than enough to bale it out.

The early issues had in their ancestry something of *Penguin New Writing*, the *London Magazine* – whose editor, John Lehmann, was a contributor to the first issue – and the pre-war literary magazine *Night and Day*. From the beginning, there was little of the "college magazine" about it: if there was an RCA precedent, it was *Gallimaufry* in the 1920s (which had far less ambitious literary aspirations) rather than the *RCA Students' Magazine*. *Ark* was highly "professional" in content (usually the intelligent enthusiasms of the moment) and production right from the start. Students edited, art edited, sold space and bullied the contributors and the booksellers: after the establishment of the Senior Common Room, outside contributions were often culled from among the visitors who could be cornered after a good lunch. A part-time professional office manager kept accounts and correspondence. It became the custom for a leaving student to take on the rotating editorship for an extra fourth (paid) year: one such editor was John Blake, who later went on to edit *Design* magazine. Early art editors included Len Deighton and Alan Fletcher.

*Ark* began with an album format, like the *Penguin Modern Painters*, and revived Spartan Bold for its logo. Its early editorial style can best be described as worthy, reminiscent of the informative copy writing of London Transport Underground posters. Issues in the first five years included a John Minton story about working for a film company (Ealing Studios, actually, whose posters were often designed by RCA people such as Ardizzone, Bawden, Boswell, Freedman, Kestleman, and Piper, and whose *Eureka Stockade* poster had just been designed by Minton himself); John Nash and Basil Taylor on Illustration; Keith New on contemporary Stained Glass; a special on the Lion and Unicorn Pavilion; Herbert Read on De Stijl; Bernard Myers on Victorian Locomotive Design; Len Deighton on old English chap-books and new American comics – an early (spring 1954) example of *Ark* taking "Pop" obsessions seriously; Joe Tilson's lithographs of calypso singers in London clubs – complete with their names and addresses ("Tilson has since", said the editors, "disappeared into Spain on his Lambretta"); Douglas Cleverdon on his radio production of *Under Milk Wood* (a transcribed Library Society talk); Spike Milligan on *The Goons*; Margaret Leischner on the formation of Ulm College of Industrial Design and Robin Day on Swedish furniture; Robyn Denny on mosaics and countless articles on canal barges, tattooing, street decorations, wet English summers, and the

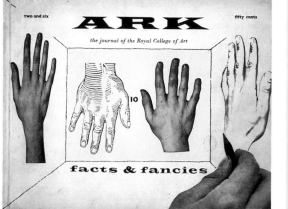

Above *Cover of issue number 10 of the RCA students' magazine* Ark *by Len Deighton.*

various "popular arts" which were fashionable in the aftermath of the Festival of Britain.

Up until *Ark* 18, the visual emphasis was on line drawings (successive art editors tried to avoid smudgy photographs, not always successfully) and on three-colour stone lithographs: the album format was retained. But in 1956 – the year of *Look Back in Anger*, Colin Wilson's *The Outsider*, "Free Cinema" at the National Film Theatre and the Independent Group's *This is Tomorrow* show at the Whitechapel Gallery – the magazine changed to portrait format, the normal magazine shape and size, and photographs began to edge out drawings: this, despite the fact that Robin Darwin believed, then and later, that "only when allied to another discipline, did Photography have a proper function in life", and despite what was almost a moral precept at the time that everything in the School of Graphic Design had to be done by hand. Roger Coleman took over as editor for the issue of November 1956, determined to "do anything to keep out the people from the weaving department", as he has put it, and to link up with the concerns of the Independent Group at the ICA. The magazine would, in future, aim to "stimulate criticism". Reyner Banham had already contributed an article to *Ark* on cruiserweight motorcycles, and Lawrence Alloway on sex in science fiction, but under Coleman's editorship (and in particular after he became a member of the ICA's exhibitions committee in January 1957), *Ark* became the bridge between the first generation of "Pop" artists, their discussions, and the studios of the RCA; *Ark* 19, for example, included pieces by J Christopher Jones (on "design methods"), Frank Cordell (on "gold pan alley" – an abridged version of a paper delivered to the Independent Group two years before), John McHale (on

167

technology and the kitchen), Lawrence Alloway (on mass communication and the "collapse of old-hat aesthetics") and Roger Coleman himself (on the imagery of fashion magazines). Alloway's article, in particular, gives a clue as to how the College staff viewed this new orientation:

*I have been accused (by Basil Taylor among others) of being Americanized and, since I am English, thus becoming a decadent islander, half-way between two cultures. I doubt that I have lost more by my taste for the American mass media (which are better than anyone else's) than have those older writers who look to the Mediterranean as the "cradle of civilisation". The pressure of the mass media and the fashion of traditional aesthetics (have) combined to unsettle fixed option and hint at new pleasures . . .*

In fact, earlier issues of *Ark* had discussed the Americanism of American art (and mass media) long before it was widely accepted that the scene had shifted from Paris to New York. But, from 1956 onwards, this became allied with a mission to convert *British* artists and designers – and young RCA painters such as Richard Smith, Robyn Denny, Bernard Cohen and William Green were at that time part of the same mission. A little later, it was to be Richard Hamilton (then a part-time tutor in the School of Interior Design) who gave "quite a boost" to the 1959-62 generation, as David Hockney has recalled, by recognizing their work "instantly as something interesting". Meanwhile, articles on and drawings by Peter Blake appeared in *Ark* as another link between early and mature "Pop".

From then on, *Ark* became glossier, more extravagant, and more experimental: some pages of *Ark* 22 were printed in invisible lettering on brown wrapping paper and "dayglo" ink on cellophane, with an eye to the work of Sandbag in Amsterdam; *Arks* 24 and 25 – called the *Leaning Tower of Venice* issues – went conceptual; images by Ceramics tutor Eduardo Paolozzi and a romantic strip cartoon by Peter Blake ("in Ark's tender breathtaking love stories all your dreams come true") appeared side by side with pieces on Kerouac and Burroughs fragmented like chunks of poetry; and there was an article on Kurt Schwitters which even referred to Ambleside.

As Bernard Myers later recalled:

*"People were beginning to complain that they couldn't understand what Ark was all about. Worried staff would anxiously ask each other if they'd seen the latest issue, feeling that they were being left behind. The exclusive excluded, and not liking it."*

And Robin Darwin, who was a firm supporter of the magazine – "with a constantly expanding international circulation . . . the overseas reputation of the College in the past has largely depended on Ark" – was beginning to wonder what would happen next. He wrote in the early 1960s:

*The current issue has its carefully hand-torn cover, in "dayglo" ink, shorn of name, price or origin. But these exercises in fractured wording and the cult of the incomprehensible are as much part of contemporary design as are action painting or "beatnik" literature; and what is significant is that the more generally unintelligible* Ark *becomes both in matter and presentation, the better it sells. Vitality is indeed an attraction in itself.*

With issues 26 and 27, *Ark* became more verbal again (under the editorship of Ken Baynes), with articles on mass observation (by Humphrey Spender) and city planning (by Lionel Brett). And, over the next few years, there were to be important discussions about the teaching of industrial design (Reyner Banham again, on "the anti-Pop and anti-American prejudices of English design punditry") and the nature and art of furniture design (by David Pye). But, by the late 1960s, it was becoming difficult to find editors for the magazine. The problem was eventually solved when two members of the staff – John Hedgecoe and Alistair Grant – took it over (one of their issues had to be typeset in College, because the printers objected to some illustrations to *The 120 Days of Sodom*), and *Ark* 50, of July 1971, was a hymn of praise, in broadsheet format, to the retiring Rector Sir Robin Darwin. *Ark* was eventually sunk by a series of alternative issues, and rival student broadsheets, dissolving into a cloud of punk glitter some time before punk was on the streets: it went down with a review of the RCA drag queen contest, which began with the words "life is decomposing in front of our eyes . . . the first to be corrupted are bound to be artists because they are the ones who are aware and will accept first".

For over 25 years, the magazine – together with the College's own imprint, *Lion and Unicorn Press*, which produced fine books for collectors, subscribers and university libraries – had provided valuable experience for students in Graphic Design, and, as the College Council noted in May 1957, they "were of great educational value, as well as being important for public relations". It is certainly true that until the mid-1960s, *Ark* also reflected the "intelligent enthusiasms" of members of the student Common Room in which it was based.

Above *Cartoon by Peter Blake for* Ark *number 25.*
Right *Blake's portrait of 1981 of the then Rector of the College, Richard Guyatt. Blake entered the RCA in 1953, gaining a First Class Diploma in 1956. He returned as a teacher between 1964 and 1976.*

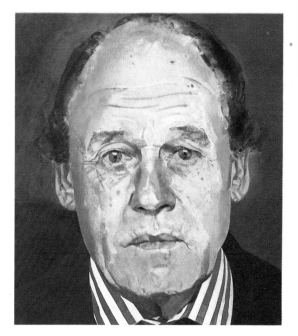

## "A PLACE TO HANG THEIR HATS"

The students had had a Common Room of their own since the turn of the century, but, when Robin Darwin took over, the staff had none. The Common Room was housed in a Queensgate "hut" and was autonomous: the students kept their accounts, ran their catering and employed their catering manageress who also doubled as Lady Superintendent to look after the "special needs" of the female students (with direct help from the Ministry of Education). Miss Mackinnon, still in office in 1948 and not retiring until well after the Cromwell Road Common Room was in operation, dated back in title if not in seniority to the Victorian age. She lived well into her nineties.

In spite of protests, the Common Room had to go. Over the years, student funds had accumulated to a respectable sum, enough to make "a considerable contribution" to the move. The Ministry of Education approved the acquisition of the lease of a very large corner house in Cromwell Road, which boasted a magnificent music room and ballroom located in a first floor extension. The ballroom, with its black, gold and white ceiling and stylish wood-block floor, became the students' main Common Room; it included a full rig to carry a portable theatre grid designed by Richard Southern, which was immediately put to use. At first, the students were overawed by their new surroundings, but soon found means to decorate and otherwise convert their Common Room with no vandalism and little damage. An annual feature was the Royal College Charity Ball, a very expensive affair which rivalled the Chelsea Arts Ball, for which the students lent their ballroom, decorated by themselves and members of staff, to the Senior Common Room.

The SCR – a concept very dear to Darwin's heart – was housed in two large rooms on the ground floor, with marbled and gilt columns, two very fine eighteenth-century fireplaces, Ron Carter-designed and College-made dining furniture, a set of salt, pepper and mustard pots in the form of silver chessmen designed by Philip Popham, also made at the RCA, and traditional leather club armchairs. It came to play an important part in the life of the College. At last the staff – greatly increased in numbers and scattered all over South Kensington – were able to meet regularly and (despite rationing, in the early years) have a respectable lunch: Darwin, as one might expect, was something of a *gourmet*, who took regular gastronomic trips to France, and knew a great deal about wine. Draught beer was considered "vulgar", and the wearing of ties was obligatory.

On one occasion, a member of the Ceramics staff dared to appear at lunch without a tie: Darwin seemed to ignore this flouting of convention, but after lunch "phoned up an acquaintance

169

1945-1987

---

**THE "HUT"**

The "hut", described in writing by Darwin as inadequate, but as a pig sty directly to the students, was regarded with great affection. In turn it was canteen, cinema, film studio, discussion room, ballroom and theatre. Students held wedding receptions here. Walls were put up and knocked down: it was regularly transformed into a jungle, a Western set, an elegant Vanbrugh interior – whatever was required for the moment. The dances held there attracted students and artists from all over the London area. A post-war feature, in common with other London art schools such as Camberwell, Croydon, Ealing, Hammersmith, Harrow, Hornsey, Sidcup and Walthamstow, was the traditional jazz revival – later to be followed by Modern Jazz – although, inevitably, College music had less of a "grassroots" feel than other London schools with their nearby jazz and rhythm clubs. Most dances were fancy dress, and decorations followed the theme. The "pig sty" dance, with an elegant pink pig ticket and programme was matched, it was said, by "a fetching décor". The dances were famous for their interval burlesques in which students would caricature their Principal and staff with devastating accuracy – in a student version of above-stairs life (rather like, as one student put it, Christmas in the NAAFI), "Gorilla" warfare was declared upon the Principal, who was depicted all over the Common Room walls as a bespectacled and moustached gorilla with a none-too-subtle reference to his distinguished great-grandfather swinging through the trees.

---

of his (who happened to be the man's uncle) and said 'tell that bloody nephew of yours to wear a tie in future'." And if ever a guest who had anything to do with the Ministry of Education was invited to lunch, without the Principal being warned well in advance, the unfortunate member of staff who had invited the man from the Ministry was certain to get an ear-full immediately afterwards. Darwin invariably sat at what he was pleased to call "the Painters' Table", and had his own leather armchair in the drawing room next door to the Restaurant. The College was to become very proud of its Extraordinary Members of the SCR – scholars, artists, designers and industrialists (though seldom administrators and educationalists) whose interests ran parallel to its own. An invitation to a five-shilling lunch persuaded many busy and influential people to give time, advice and even material help to the College over the years. By 1959, Robin Darwin was in a position to report to Council that "the most ordinary perquisite of any secondary school – a place where members of staff could hang

their hats" had developed, spectacularly, into "surroundings which no college in Oxford or Cambridge would despise".

Meanwhile, the student Common Room had played host to a regular series – two or three major productions a year – of theatrical events. The small unit dealing with Theatre Design within the old Design School had been closed in 1948 (although Darwin had told the Ministry that he hoped one day to revive it), so the students took it over. A number of them became professional designers in the theatre and, as soon as transmissions recommenced, television (with its "Interlude", featuring the hands of an RCA Ceramics tutor), as well as art directors in the film industry. When the Common Room was not available students and ex-students regularly combined to form their own company, London Artists Theatre Productions at the Toynbee Hall. Peter Bucknell was to become Head of Theatre at the Guildhall School, Cliff Hatts Head of Design at BBC Television, Peter Newington director of the first *Monitors* on BBC, John Brason a television designer, Richard Macdonald a film designer (for, among other productions, Losey's *The Criminal*), Bernard Lodge a title designer (for *Z Cars* and *Dr Who*, among other TV series) and Julia Trevelyan Oman, an interior design student of the early 1950s, a distinguished theatre and opera designer. This generation laid the foundations for more recent graduates, from the "Television and Film Design Department" (within Graphic Design), and the Department of Film and Television, including the designer-director (for film) Ridley Scott, (*The Duellists, Alien, Bladerunner* and *Legend*), his brother the film director Tony Scott (*The Hunger, Top Gun*, and *Beverly Hills Cop 2*), and the director of photography, Stephen Goldblatt (*Breaking Glass, Outland, Return of the Soldier, Young Sherlock Holmes*).

In the early Darwin years, the last productions to take place in the Queen's Gate Common Room were a five-hour *Peer Gynt* in which the changes of scene took almost as long as the play, and a *Tempest*, for which the back wall had to be completely demolished. The new Common Room at no. 21 opened to a double-bill of Cocteau's *Orphée* and Fielding's *Tom Thumb* – the latter in baroque *trompe l'oeil* with gold and silver costumes, Louis XIV style. This was followed by an uncut revival of Gay's *Beggar's Opera*, from the British Museum manuscript, directed by Bernard Myers with sets by David Gentleman.

Later developments from the Common Room *ambiance* were to include *A Monster Rock Revue* (which Darwin, in 1959, called "an advanced mixture of contemporary noise and gloom"), the

Temperance Seven, British Rubbish, and Anti-Ugly Action (from 1958 onwards) which eventually recruited architecture and design students from all over the country, to hold protest meetings and demonstrations showing that "something has gone wrong with our environment", in particular "the lack of nerve and confidence in modern architecture". Demonstrations at Kensington Town Hall, Emmanuel College, Cambridge, Peacehaven, Sussex and "the Monico site" in Piccadilly were aimed at pressuring the authorities into launching public enquiries and intended to "promote co-operation between artists and architects in the future".

Another way in which the interest of successive generations of students in theatre, fancy dress, and performance art could express itself was provided by the annual Convocation ceremonies. Convocation was originally held in the V&A Lecture Theatre, then, from 1948 until 1962 in the hall of the Royal College of Music: since 1962, in the Gulbenkian Hall, Kensington Gore. By tradition, Convocation was the occasion for elaborate practical jokes, as if temporary cap and gown gave licence for a feast of fools. At the last ceremony held in the V&A, students dressed as

*Below* Alien *(20th Century-Fox, 1979) directed by Ridley Scott, one of the RCA's first film students.*

firemen burst in during the Principal's address and pointed a hose at the platform: it was turned on, and a small trickle of water emerged. In 1946, the Duchess of Kent was presented with a magnificent bouquet of fresh vegetables. Students would hire the coach and horses still available from the livery stable in Queen's Gate Mews: once, they drove it through South Kensington Underground Station, forgetting that the far end of the concourse has columns across it.

In the Royal College of Music, the Principal was unstrategically placed at the front of the stage with the graduating year behind him: his appearance and manner readily lent themselves to parody. At a signal, all students donned heavy-rimmed glasses and moustaches, and imitated his gestures in unison. On another occasion, they held up cards with "Applause", "Laughter" and other prompts written on them – always at the wrong moment. The body of the hall was large enough to seat all College students as well as graduates, family and friends. One of the most spectacular gestures was arranged for the Duke of Edinburgh: as he took his place at the rostrum to speak about the importance of "artist-engineers", every single student and graduate released a red plastic toy helicopter, which filled the skies of the hall.

All this (which tended to make the staff, and in

171

particular the Principal, very nervous indeed) was effectively brought to an end by the move to the Gulbenkian Hall. Architecture won where threats, and even disciplinary action, had failed. The graduates are seated to one side – isolated from everyone else: restricted seating is for staff and families only. Occasional gestures – such as the fashion students wearing nothing but their gowns and· bunny tails, or every graduating student giving a silver balloon to Richard Guyatt, on the occasion of his retirement in 1982 – seem, to everyone's relief, to lack the sense of danger which accompanied earlier ones.

There is little doubt that, for the twenty years following 1948, the attitude of the performance artists at Convocation had expressed a real tension within the College – a disjunction between the new image of the anarchic "art student", and the Cambridge-style protocol which launched the "art student" into the world. As *Design* magazine acutely noted in 1964:

*To the students there is a yawning gap between the conditions of their own lives in Earls Court or Notting Hill and the quasi-traditional trappings which surround the Convocation ceremony, the dinners and the inevitable sonorous vapourings that go with any institution. Nor is this simply being "agin the government", for it is indeed a bit ludicrous to go through the motions of ancient pageantry when the pageantry itself is only 15 years old. Of course, these activities were introduced intentionally to give the College an acceptable public focus . . .*

## THE ART AND DESIGN PYRAMID

With so many extracurricular activities available throughout the 1950s, it may be wondered that the student found any time for College work at all, and the evidence of such activities in College records is so plentiful as to suggest an extraordinary amount of student-led practice at any one time. In fact, there were a large number of regulations, and the authorities, on the whole, insisted that they were observed. All students signed on every morning. Darwin may have torn up the staff book, but persistent lateness or absenteeism by students resulted in a note from the Registrar asking for an explanation. The next step was a call from the Principal: students could be (and were) expelled for infringements of discipline and absenteeism. Most buildings closed at six o'clock sharp, and the College also closed at lunchtime every Wednesday to allow "one afternoon's recreation per week".

The entrance examination – all entrance to the College was by competition, never by right of matriculation – was a week-long event. After submission of a portfolio, chosen candidates were invited to the College to sit essay and drawing exams – life and composition – during which they were called for interview. The Principal was present at each board. Applicants were perhaps eight to one for every place, candidates two to one. The first year seems to have been quite heavily timetabled, with set hours for life drawing, calligraphy, bookbinding or whatever was appropriate, but subordinate to the student's main study. Before the rise of General Studies, architecture was a compulsory and examinable requirement for all first year students, as were weekly lectures in the history of art.

The first year was looked upon as probationary, and each had its crop of failures. Second-year examinations were less formal, with a monitoring of the year's work: a major thesis of 6,000 words had to be submitted and passed before a student was allowed to proceed to the final examination. Achievement in Common Room activities did not absolve a student from following the letter of the law, although it might well lead to a fourth year or silver medal. Individual schools also had their own requirements: Madge Garland, for example, set her fashion students compulsory reading from Jane Austen to Aldous Huxley, with a monthly essay to write. It was perhaps in reaction to this that a decade or so later the Fashion School became the focal point of resistance to the concept of "General Studies".

The academic programme of the College must also be seen from the point of view of art and design education in general. Together with other educational reforms under the 1944 Act, the old art examinations and curriculum were revised: the old Drawing Examinations of the Board of Education (which had existed since the First World War) became the Ministry Intermediate Examination followed by the National Diploma in Design – in retrospect a misleading title, because the NDD Fine Art students always far outnumbered those in design, which itself bore little resemblance to "design" in today's sense. All schools and their students followed a national syllabus. All examinations were invigilated locally, then marked and graded centrally.

The first two years of study were strictly timetabled with a high teaching input, regularly inspected and monitored. The hours spent in the listed subjects were specified and checked; these included, for the intermediate course, drawing from the cast followed by life drawing (when the student was deemed ready to cope with things that moved), composition or picture-making on a given theme, lettering and calligraphy, modelling

and casting, anatomy, geometrical perspective, history of architectural styles, textile design, pottery, poster and (following the College's change of the name) graphic design.

The National Diploma, for which success in the Intermediate was the entry, was just as tightly controlled: a student could choose a major subject – such as painting, sculpture or textile design – but had to take a minor subject in a related craft, and write essays (under examination conditions) on the history of art, the history of materials and technique, and the history of the craft. The student made sketches for major and minor projects, again under examination conditions. These were collected up. He or she was allowed to keep a tracing, and then had to complete the project within a set time. A rigid form of visual censorship was applied, through the central bureaucracy: all fine art had to be figurative; abstraction was failed outright; even a degree of formalization that hinted at "modernism" jeopardized the students. It was held that formalism in so young a student with limited experience could only be construed as half-understood plagiarism. The real thing could only come with maturity and the ability to reflect on the basics.

Although a large number of students who went through the NDD system – which certainly bore a family resemblance to its Victorian counterpart in the days of the Department of Science and Art – were to look back on it with nostalgia rather than anger, the new breed of post-war "art students" were not always so sentimental about it at the time. The playwright David Halliwell expressed this well, through his rebellious "art student" hero Malcolm Scrawdyke, in *Little Malcolm and his struggle against the eunuchs*:

*Finals, N.D.D., what's that? Nothing! Nothing Doing Diploma which will earn you the glorious privilege of designin' dog food wrappers or keepin' a roomful of delinquents in order. Where's* art *in that? Where's life?*

But then again, Scrawdyke's outburst could have applied to just about any of the centrally-organized systems which had been introduced since 1837.

Those students with the necessary credits in School Certificate could proceed to a postgraduate teaching qualification which gave them degree status for purposes of pay and promotion. The most ambitious tried for further study at the Royal Academy Schools, the Slade, or the Royal College of Art. The first two were primarily Fine Art schools. It was the College that taught design, looked down upon as "applied" or "commercial" art by those at the purer institutions. At the RCA,

---

THE HAND OF BACON

A College circus had an audience waiting in line as far as the Brompton Road: it featured Len Deighton as a juggler, Bruce Lacey sawing a woman in half, a ventriloquist's dummy played by a future University Professor, and it climaxed with the future Principal of a leading art school being fired from a cannon. As *Time and Tide* reported, in December 1953.

*This burlesque circus included a most convincing chimpanzee who refused to be trained and insisted on eating the chrysanthemums, and a juggling act by the most terrifyingly inane monster. The monster had obviously stepped out of the paintings of Mr Francis Bacon.*

This was not surprising, really, since at that time Francis Bacon was resident in an Exhibition Road studio – the most eminent artist to use College facilities in this way since Holman Hunt finished *The Shadow of the Cross* in Richard Burchett's studio back in the early 1870s – and, although he didn't come into much contact with the students, they seem to have been very aware of his presence.

---

students could specialize for the first time in their chosen fields of art and design. It was more than a postgraduate extension of an undergraduate course, and academically perhaps less. Teaching staff at the RCA knew exactly what all their students had been taught, and what they were at least supposed to be able to perform. The first year at the College (the most structured year) was a year for re-assessing a student's potential and making good deficiencies: the tradition of blaming the NDD courses for pushing students in the wrong direction (matched by the NDD courses blaming the secondary schools for doing the same, and so on – right back to the cradle) appears to have begun with Darwin. Then, as the student progressed through the College, the course became more student-led, until the teaching became critical advice ("the oblique approach") from a tutor who was more senior colleague than art or design teacher.

Naturally, the teachers of the National Diploma courses watched events at the College, from the early 1950s onwards, with increasing interest. Many of them were RCA graduates, and as the Design Schools moved more and more towards "narrow and concentrated fields", with a new emphasis on professionalism, so they tried to persuade their authorities to follow suit. Above all they found the academic restrictions imposed by the Ministry and the Inspectorate increasingly irksome (as of course had Darwin, in 1948-9),

particularly when artists with national reputations, who taught part-time, found their best students failing for following too closely the advice and example they offered. Schools clamoured for their independence, first for the right to be at least parties to the examinations, and then for freedom from the rigid syllabus dictated by examination requirements.

Under pressure, the Ministry at last gave way. Schools were allowed to examine their own work, with examiners from other Schools to ensure parity of standard. The Coldstream and Summerson Committees of the early 1960s were set up to inquire into art and design education, and one model which was before them (although it was never stated explicitly) was the Royal College of Art – which was represented on both Committees and on the joint committee. Not only was art and design education to be brought into line with professional developments in art and design, but the joint Summerson/Coldstream Committee made a further plea that art and design education should be considered not merely as professional training towards a vocation but should be treated as an alternative form of higher education in its own right, the equivalent to reading the Humanities at a university.

Philosophically, the Coldstream people seem to have had at the back of their minds the Slade as a model for fine art teaching (still the centre of the curriculum), the Courtauld as a model for scholarship, and the Royal College as a model for professionalism. The NDD was replaced by a Diploma in Art and Design – Dip AD – which was held to be equivalent to a first degree and validated by an independent board, the National Council for Diplomas in Art and Design. This board, the NCDAD, born of protest in colleges of art and design, became the model for the CNAA – the national validating body for all degree courses outside the university sector.

The restructuring of schools at diploma level was initially accompanied by expansion. The existing teachers, seeking validation for their courses, looked to the RCA as a model for "upgrading", and this was reinforced by the number of post-war College graduates entering the schools as specialist teachers, often holding positions of responsibility quite early on. The inevitable result was that RCA teaching practice ("the oblique approach") fed along the line. Staff wanted their students to specialize much earlier. The "diagnostic" period was cut to a year – with the new foundation courses at local schools, which were intended as a bridge between secondary education and degree level courses, and which prepared students for the alternative universe they were about to enter. Students were

encouraged to develop their own programmes and choose their own projects as soon as possible. Freed from the Ministry's controlling syllabus, staff were delighted to change their approach from detailed instruction to critical advice. The introduction of the Dip AD on the one hand gave art schools the independence to evolve their own teaching methods (after validation – in the first wave of applications, of the 87 colleges which applied, only 29 were granted Dip AD status), and on the other implied that students (with a few exceptions) would be judged by university-style academic criteria. This proved particularly controversial, and the controversy was eventually to turn on the College itself. As Reyner Banham wrote as early as 1963:

*The real tragedy of the consequences of the Summerson Committee is not that it has deprived some schools of recognition (i.e. snob status) but that it has deprived all students of a really full and flexible training; yet another urgent reason for finding some way of creating a crack-hot school outside the academic pyramid over which the RCA balefully broods – unless the RCA should decide to stir its stumps and give itself a curriculum.*

In the same year, the Government's Committee on Higher Education under the chairmanship of Lord Robbins reviewed the position and performance of the Colleges of Advanced Technology – the "super-polys" – and the National Colleges. Robbins recommended that the CATs should become universities, and that the Royal College of Art should also be brought into the university sector. The University Grants Commission and the Committee of Vice-Chancellors and Principals swallowed the CATs whole, but couldn't quite bring themselves to digest the RCA. Since some (but by no means all) of the College's activities in art and design could be found in university departments elsewhere, albeit scattered around, the UGC's reluctance was difficult to understand at the time – although observers reckoned that the Commission had drawn the line at the first university Professor of Fashion, fearing for the consequences.

An advisory committee was set up under Lord Redcliffe-Maud (the John Maud who had appointed his cousin Robin Darwin in 1948), which recommended that the College should be an independent institution of university status, established and protected by Royal Charter, and be granted the power to award degrees when courses were considered to be of an appropriate academic nature. However, funding was to continue directly from the Treasury through the Department of Education and Science, main-

taining (as far as possible) parity with the universities.

The College degrees now became MA (RCA) and M.Des (RCA), and its Diplomas were retained to meet special circumstances. One such special circumstance, arising immediately, was the Fashion School – which of course gave some weight to the rumours about nervous Vice-Chancellors. The College continued to award a Diploma in Fashion, an act of discrimination which much exercised the Fashion students in general and Professor Janey Ironside in particular. It soon reached the papers, with headlines such as FASHION STUDENTS ONE DEGREE UNDER. Eventually, either Fashion was brought into line or the Academic Board came into line, and it was agreed that the students could, after all, get their degrees.

Since the new Dip AD was supposed to be "at first-degree level" – having apparently equal status with the RCA's old diploma qualifications – there had been much debate in the College, from 1961-3, about how the institution could best remain one step, or even several steps, ahead. It was, during the early stages, proposed that the RCA should operate its own Dip AD course – which would have involved teaching the students for a total of six years – but this was rejected on the grounds that it would have overbalanced the whole programme and "prevented the institution from expanding its research". In July 1963, therefore, the Academic Board approved the wording: "From 1966 onwards the RCA will provide postgraduate courses only. These will normally last three years, and will aim to produce qualified professional artists and industrial designers in certain specialized fields".

The Royal Charter came into effect in 1967. HRH Prince Philip, the Duke of Edinburgh consented to be College Visitor. The Principal became Rector and Vice-Provost, supported by Sir Colin Anderson as Provost and Sir Duncan Oppenheim as Pro-Provost, with Professor Robert Goodden as Pro-Rector.

A splendid ceremony marked the granting of the Charter, a ceremony which matched the preamble from her Majesty the Queen: "To all to whom these presents shall come, greeting!" The Rector and Senior Officers certainly looked the part in their designer-robes embroidered in gold and silver by Joyce Evans (the designer, appropriately enough, of the altar frontals in King's College, Cambridge). The procession was led by the Chief Steward carrying the College Yardstick, with a silver phoenix arising at the top and an earth-bound dodo at the bottom – designed by Robert Goodden and Philip Popham. A silver-smithing student, Charles Hall, designed the

Top and above *The RCA received the Royal Charter in 1967, Prince Philip becoming College Visitor. Joyce Evans designed the ceremonial robes worn by the Rector and the Senior Officers and the College banner accompanying Charles Hall's silver gilt trumpet.*

silver College Trumpet (presented by Boosey and Hawkes) with a banner or tabard of the College Phoenix Ascendans worked in silver by Joyce Evans. A fanfare, military style, was played on it. The iconography – Cambridge, the Dodo and the Phoenix, the guardsman, all watched over by Edward Bawden's Lion and Unicorn – was and is vintage Darwin.

The ceremony was followed by a soirée, which

saw the staff of the College (even the sculptors) in white ties: it was attended by the Queen and Prince Philip, with the Queen Mother. The honours done to the College that Charter Day marked the zenith of Sir Robin Darwin's career. His reforms had been fought for and carried out, the College was rejuvenated, it had its new building, it had achieved its independence, it was talked and written about, and his contribution to all this had been recognized at the highest levels. One hundred and thirty years after its foundation, the central institution for art education in Britain had achieved university status. Fifty-six years after a government report had first recommended the idea, the RCA had become wholly postgraduate. From now on, it would be consolidation of achievement. The heroic age was past. Some students quoted in a College broadsheet "happy is the land that has no need of heroes".

The Royal College was to be called a university. All it had to do was to make up its collective mind what exactly a university was.

## NATURAL SELECTION

In an after-dinner speech of 6 May 1971, during which he said goodbye to the small group of professors with whom he had worked for over 20 years, Sir Robin Darwin took the opportunity of offering "a word of caution":

*I believe that Professors and Heads of Department will be wise to determine that their personal prerogatives are not infringed and do not become imperceptibly transferred to others or to Senate and other committees having remote and anonymous control. I hope that legalism and "rights" will always be subservient to personal responsibility which does not always happen in other universities. I remain wholly convinced that artists and designers are best handled as individuals in small units by those who know them well . . .*

Towards the end of his Rectorship some of the *disadvantages* of university status had begun to emerge within the College. For a start, the Royal Charter – based as it was on a standard pro-forma provided by the Privy Council – had introduced into the place a committee structure, a structure of staff-student meetings, academic boards, sub-committees and a Senate which were originally intended for institutions at least ten times the size of the College. The results, which coincided with the arrival of the post-Coldstream students of the late 1960s, were endless meetings, cyclostyled broadsheets from "the student administrative committee" and, in the case of the retiring Rector, some last-minute reflections on the nature and

value of paternalism. He had written to the student *Newsheet:*

*Paternalism . . . has become no longer viable as an administrative technique within the College now that its interests have spread so widely. But the alternative is not trade union procedure, which is not necessarily satisfactory, nor is it oligarchy or dictatorship, it is the slower, more patient, usually safer, but often less enterprising result of common debate . . . This will not suit the hasty idealism of students and students cannot have it both ways.*

To his successor, Lord Esher, Darwin wrote in August 1971:

*There is in fact a lot to be said in my view for paternalism however out of fashion it may be today. It is a great deal more efficient and achieves results far more quickly than does committee work, which as we all know . . . is safe-playing and time-wasting.*

He concluded with the hope that "coming as a new broom you will now exert more personal authority than I have done or thought it right to do myself over the last five years or so. This may go slightly against your grain . . ."

Darwin had discovered that it was all so much more *complicated* than when he took over in 1948. The pioneering ideals of the 1940s and 1950s had seemed so clear: almost whatever was done was right when one was starting from such a low base-line. But, at a time of economic recession, a general questioning of the status of designers and architects as "experts", and a widespread move by fine artists way from the world of Bond Street galleries, much of what had been achieved during his Rectorship was now being openly debated. Shortly before he left, the Committee of the Junior Common Room launched a document called *RCA Redefined* with a brass band playing funeral music "to create a special atmosphere". "It cost £45," noted Darwin, ruefully. "I only wish we had as much money to spend whenever *we* wrote a report!"

*RCA Redefined* was about student representation on committees, about the social obligation of the designer and about the *remoteness* which students felt from the College staff – particularly those members who had been there for a very long time. It had extremely rude things to say about absenteeism, the Senior Common Room and, by implication, about "the Darwin myth". Whether or not its allegations were true, it revealed a new atmosphere of uncertainty within the College and it was immediately leaked to the national press. As Sir Robin Darwin wrote, "I personally say every night the opening words of

Above *Leonard Rosoman's portrait of Lord Esher, who succeeded Robin Darwin as Rector of the College in 1971 and remained in that post until 1978.*

the *Nunc Dimittis*" (Lord, now letteth thou thy servant depart in peace . . .).

Darwin retired in 1971, looking forward to an active life as a painter and prepared, if necessary, to reform the Royal Academy. It was not to be, and he died quite suddenly and unexpectedly in 1974. As one of the valedictory articles which marked his retirement put it, "the College *was* his work of art".

Whereas Darwin had arrived (like Dyce and Cole) as the direct result of a Report in which he was highly critical of the College, Lord Esher arrived at the age of 58 with the intention of holding the fort until a new man and a new vision could be found. Knowing as he did the strength of "the Darwin myth" among many of the staff, he sincerely hoped that his few years would not be seen as an anti-climax. As Lionel Brett, he had been at Eton at the same time as Robin Darwin (whom he remembers as "a formidable, hirsute fellow who produced powerful cartoons for stained glass in the Drawing School"), had served in the Royal Artillery during the war, and had been a leading figure in post-war low-cost housing and the new towns: his architectural work ranged from urban planning and university buildings, to cottages and follies. He was planning architect to Hatfield New Town and a major contributor to housing at Stevenage and Basildon.

Lord Esher brought to the College a liberal mind, considerable political skill (he had been President of the RIBA), a large measure of tolerance, a knowledge of the corridors of Whitehall and the committee rooms of Town Halls, a firm belief in the social role of architects and an equally firm belief, not always borne out by experience, in reason. Above all, he seemed to

be the man needed to solve the College's own housing problem, only temporarily solved by "the Darwin building" (as it was beginning to be called) which in any case was merely Phase One of the building programme – and was already overcrowded by College, if not by DES, standards. Years of work, and considerable sums of money, had gone into preparing Phase Two – which had been carefully designed, in red brick, by Hugh Casson and H. T. Cadbury-Brown. The site, which had been chosen over 30 years before, consisted in the main of some not very special Victorian mansions – considerably less interesting than the entire terrace of Regency houses which had been demolished to create the space for Phase One. But, since 1960-2, South Kensingtonians had become much more aware of conservation and the buildings on the College site which occupied the corner of Queen's Gate were by then listed Grade II. The College appealed to an independent tribunal – with evidence from Mark Girouard on the "mediocrity" of the buildings Phase Two would replace – and won the case, but direct intervention from Environment Minister Tony Crosland over-ruled his own specialist inspectors. When asked for his specific views on the Casson/Cadbury-Brown scheme, Crosland stated categorically that "the quality of the proposed replacement building is not material" – to which the College administration replied that it would have saved an awful lot of time and money if he'd made that clear in the first place. The Minister's ruling was a serious blow to the College and to the Rector, who himself was a well-known supporter of the conservation of *important* buildings (not only for historical reasons but for environmental reasons as well).

Having failed to achieve the original Phase Two, Lord Esher resuscitated the "island site" idea (which had been mooted, off and on, since the days of Beresford Pite) but the College scheme, designed by Cadbury-Brown, was in competition with the Ismaili Centre, designed by Casson and Conder, and the Aga Khan won at a canter. Finally, the Rector suggested that the RCA might move to a series of five warehouses at the London Docks, near St Katharine's, which had just come on the market. The College Council was in favour – this could be exactly the sort of dramatic move which was needed to bring the Design Schools down to earth, and the "revival of Dockland" was very much in the news at the time – but both staff and students rejected the idea. A building at Kensington Gore might not be the ideal location (there were no shops, no design studios, no industries, and you always had to say to taxi-drivers, "You know, that College next to the Albert Hall"), but *East London*! Suddenly,

everyone was concerned about the RCA's history and its long-term association with the South Kensington Museums.

Lord Esher approached the questions raised by *RCA Redefined* in a conciliatory way. His first act was to call a mass meeting of staff and students, organized like a university conference, with a plenary session followed by small seminar groups. He published a series of *Proposals*, in the form of open questions, as a basis for discussion:

*The RCA is universally respected. So were John Brown and Rolls Royce when they started on QE2 and RB 211. The greater the prestige the more ignominious the possible tumble ... Our context is changing. The Royal College is part of the Arts and Crafts,* Werkbund, *Bauhaus succession, which was concerned with fitness for purpose rather than the merits of the purpose itself. We are now moving into a period for which Ruskin seems a more relevant spokesman than Olivetti ...*

*Second, since the brave days of the Festival of Britain, when the College was reborn, some of the industries on which we have hitherto depended have been through a period of traumatic decline. Our entry into Europe may give us opportunities to help lead the world in new directions.*

*Third, post-graduate education is now under official critical scrutiny. It may be justified if it produces people that society needs or industry wants. It will certainly be justified if it manifestly enables creative imagination to grow, or adds to knowledge. It cannot be justified if it merely allows students to go on doing the same thing for a few more years ...*

His level-headed (but in the context, provocative) conclusions – that courses ought to be reduced from three to two years "to get ... a head of steam", that the College should be more concerned about "the betterment of ... underprivileged human lives", that there should be more *thinking* about design and the built environment, and that the number of Departments should be reduced to six (to avoid the general Balkanization which had occurred in Darwin's time) – would, he hoped, be discussed by *everyone*. Above all, the assembled company should reflect on whether they wanted the RCA to be "with it" when a University's job was partly to stand outside it. Clearly, Darwin had been correct: it was plain for all to see that paternalism *was* against the new Rector's grain.

Lord Esher had declared what sort of College *he* wanted – but what sort of College did *they* want? The trouble was not that they didn't think

that they knew, but that they *all* thought they did – as individuals, which in the case of the students was how they had always been expected to react in the past. The long-sitting Professors talked of "the College" – hadn't Darwin always referred to "the College" as an élite community of like-minded people? – and the more radical students replied that they used to award degrees in publicity in those days. The rest of the students (the vast majority) "just wanted to get on with their work".

But what *sort* of work? In a lecture at the Royal Society of Arts (1973) called *Easy Does It*, Lord Esher spoke of "the half-truths" promoted by the anti-design movement:

*... a sense of futility in making minor design improvements in machine products like type-writers or telephones when the world is running out of raw materials, a sense of guilt in helping vast international corporations to promote, write off and replace luxury goods when half the world population doesn't have enough to eat ... It is a half-truth that we should or could stop improving our products or our productivity. The other half is that we know no other source except economic growth from which to draw the wealth we need to build hospitals and care for one another ... The trend in art schools away from industrial design and towards personal expression and the crafts should not be obstructed, but it needs to be balanced by stronger spirits with the guts not to run away from industry, but to get in there and steer it ...*

A *leitmotif* of the lecture was that art colleges might *appear* radical but were actually a great deal more conservative than they realized.

The concept of "anti-design" had been launched within the College by Misha Black, Professor of Industrial Design (Engineering), in his controversial contribution to the issue of *Queen* magazine devoted to the RCA in 1967. "The atmosphere in professional offices and schools of industrial design", he had written, "is thick with ominous question-marks, as menacing as incipient schizophrenia": the likely results would be that students would in future "want to apply their talents to the socially useful" and that there would be a turning-away from mass-production manufacturing industry.

Misha Black had been appointed Professor of the new School of Industrial Design (Engineering) in 1959, following the resignation of Fred Ashford, bringing with him Frank Height, ex-RCA student, as his right-hand man. In 1954 there had been nine students specializing in the subject (within "Woods, Metals and Plastics"); by 1965 there were 42, plus two research students and

1945-1987

four members of the College's Research Unit. The partnership of Black and Height had at last begun to orient that School towards small- and large-scale industry (by helping to gain the confidence of industrialists) – notable students of their era were to include industrial designers Nick Butler, Stephen Bartlett, Roy Gray, Peter Isherwood, Peter Ralph and Ken Sadler – and had introduced two key developments into the College: Design Research and Automotive Design.

In 1955 the Nuffield Trust published *Studies in the Functions and Design of Hospitals* and in 1961 funds became available for a research unit within the RCA to investigate some of the deficiencies noted in the Nuffield report, particularly in the design of non-surgical hospital equipment. The research unit was directed by Bruce Archer, a painter-turned-mechanical engineer, who had spent a decade in industry and caused quite a stir in the design world by publishing the first major series of articles on "a rational design method" or "principles of procedure" in Design magazine, under the editorship of John Blake, which are probably the most influential series of articles ever to appear in that publication. The unit established its reputation with Kenneth Agnew's design for an optimal hospital bed – the research for which was funded by the King Edward's Hospital Fund for London – and with the publications which emerged from that project. One of the purposes of this investigation was to provide a logical step-by-step account of "the design process" which could serve as a model for future projects. As Archer expressed them at the time, the original intentions were to provide:

*1. A report describing how equipment schedules and specifications are prepared, how the selection of equipment is made, where equipment deficiencies are, and where future research and development effort would best be directed.*
*2. The classification and preliminary evaluation of types of equipment as part of the procedure for the selection of equipment for a new hospital.*
*3. Some equipment designs offered as better solutions to some of the more pressing needs.*

These functional considerations were a long way away from the "styling" with which many design students were concerned, and, indeed, the *look* of the optimal hospital bed was intended to affect the observer and the user as little as possible: "The colour is light stone to give a neutral background for the patient's colour, etc., and to assist cleaning and hygiene."

Despite the reservations of a few design critics (who thought the "minimal aesthetic" a little off-putting), well-deserved publicity resulted in

---

ROYAL DESIGNER FOR INDUSTRY

Professor Misha Black was knighted in the Birthday Honours of 1972. In pre-war days he had been a besandalled artist-turned-graphic designer in Charlotte Street and Fitzrovia: the earliest meetings of the Artists International (in its Marxist phase) had taken place in his studio. A founder-member of the Industrial Design Partnership (with Milner Gray) in 1933, he co-founded (again with Milner Gray) the Design Research Unit in 1945 – the slightly misleading title for a commercial design practice pioneering the total design package for the client, and not to be confused with Design Research at the RCA – of which he became Senior Partner in 1964.

In the meantime, his prodigious output had included design work for Beagle Aircraft, public rooms for the liner *Oriana*, architecture for London Zoo, interiors for the BEA terminal at London Airport, machinery for Mather and Platt, and the design of both diesel and electric locomotives for the newly nationalized British Rail. He had been responsible, with Hugh Casson, for the layout of the South Bank for the Festival of Britain, and designed the Regatta Restaurant (molecules and crystals all over the place) as well as the cafeteria; in retrospect, at a discussion among "survivors" of the Festival at the RCA in 1975, he concluded that "it released a flood of the worst kind of brutalized modern architecture which the country had ever seen, and from which we have been suffering ever since . . .". In 1957 he was elected a Royal Designer for Industry: today, his best-known work (to Londoners, at least) must be the co-ordinated design of the Victoria Line on the Underground.

---

the expansion of the unit, which at one time employed more than 30 researchers and advisers – who came and went with each individual project – in addition to a core of permanent staff: eventually the unit offered courses in research techiques and in 1972 became the independent Department of Design Research under Professor Archer. The emphasis was always on "socially necessary" design work.

It is to the College's credit, though not to its advantage, that research in such underfunded and neglected areas was done on a shoe-string, without a structure of reinvestment into a more commercially viable research company, and research activities of this kind were to be among the first victims of inflationary costs and public spending cuts. "Research" had gone out of fashion, within art education, ever since the Arts and Crafts people took over in 1900-1, and its reappearance on the scene in the 1960s rather

RETROSPECTIVE

In 1969 the School of Industrial Design (Engineering) held a major exhibition, *IDE(10)*, in the Gulbenkian Hall, which marked its first ten years and featured a range of professional work done by ex-students: an electrically-propelled wheelchair by Ken Sadler, hi-fi amplifiers by Roy Gray, the Reliance 1000 tractor by Peter Ralph and the hospital bed by Kenneth Agnew. Misha Black's close involvement with the International Council of Societies of Industrial Design (of which he became President), with the Faculty of Royal Designers for Industry (of which he became Master in 1973-4), and his many public lectures on design education, had brought great prestige to the College. He retired in 1975 and died two years later at the relatively early age of 67. When Frank Height (who was also involved with ICSID) took over as Professor, the name of the School became just "Industrial Design" – since that had by then become the internationally recognized generic term for the subject – and since the "Engineering" in brackets had caused confusion (especially among engineers).

took the College by surprise: although many thousands of "optimal hospital beds" were in fact produced for the National Health Service, the RCA derived very little financial benefit from the project, and not much publicity either. As an institution, it still preferred to present itself in Darwinian terms. This was short-sighted, for in the early 1970s it looked for a brief time as though design research of one kind or another might eventually take over the entire place; while Bruce Archer was directing his study of the hospital bed, David Bickmore (then cartographer to the Oxford University Press) was directing the "experimental cartography unit" – making maps based on computerized information – and Dr Herbert Spencer (soon to be Professor of Graphic Arts) was directing the Readability of Print research programme – starting with Post Office telephone directories (one can only wonder what the results were) and moving on to the British Library Catalogue, microforms and computer-generated letters. In 1976 the Department of Design Research completed a three-year study of design in general education, funded by the Department of Education and Science and under the direction of Ken Baynes. An indirect consequence was the setting up of the Design Education Unit (headed by Baynes) within DDR. For some five or six years, the Education Unit provided opportunities for research and further study by practising design teachers (in the broadest sense) – on the purposes of design teaching and

its role across the curriculum. It came as something of a shock to the College, and particularly the Darwin generation, to see small groups of primary-school teachers discussing, with great intensity, the multi-coloured products of countless art rooms: indeed, to see school teachers back in the Royal College at all.

During the transport boom of the 1960s Misha Black and Frank Height had a series of meetings with the Chief Stylist of the Ford Motor Company – who ran his own small design school at Dagenham – and had agreed that in future the School of Industrial Design (Engineering) was better placed to take on this educational role. The Automotive Design Unit was the consequence – under the direction of Nigel Chapman, graduate architect from McGill University, Montreal, and a post-graduate of Industrial Design in the early 1950s Western Gallery days. Graduates from the Automotive Unit, over the next ten years, were to include Peter Stevens (Chief Designer for Lotus Cars), Graham Hull (Senior Staff Designer for Rolls Royce), David Arbuckle (Chief Designer for the Austin Rover Group), Geoffrey Matthews (Chief Exterior Designer for Citröen Cars), Martin Smith (Design Team Leader for the Audi Quattro, Audi NSU), David Evans (Chief Industrial Designer for Land Rover), Gerry McGovern (Chief Concept Designer at Austin Rover, Team Leader on the MG EXE show car and the Rover Concept Coupé CCV), Richard Oakes (Design Consultant to JCB and others), Ranjit Bhambra (Design Team, Porsche 959) and Jong Suh Park (Chief Designer of the Hyundai Motor Company, South Korea, where he leads a team of four RCA-trained designers). An extraordinary track-record – and one which, in a country which tends to associate the products of transport design with the company that produced them (or, more often, in the case of trains and boats, the famous persons after whom they are named) rather than with the designer who conceived them, has never made the headlines. The course continues, heavily supported by the industry, and graduate design students work side-by-side with mid-career designers to produce models and concept drawings which sometimes look as though they are intended for some elaborate science fiction movie.

In his inaugural lecture, "*. . . and cheap tin trays*", Height tried to capture the spirit of student idealism which had been growing during the Esher era by suggesting that design should be directed more overtly "towards the problems of human need":

*Industrial design is now fifty years on and has grown out of its heroic period. All movements lose the early impetus of excitement and certain-*

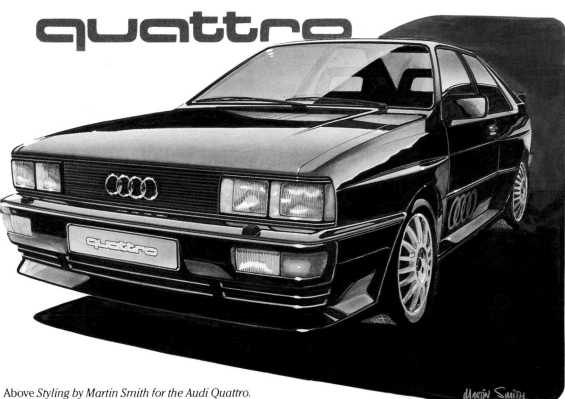

*quattro*

Above *Styling by Martin Smith for the Audi Quattro. Smith was a graduate of the Automotive Design Unit.*

ty which smothers doubt and must discover a maturity to sustain them in a period where problems suddenly seem to be more difficult. *This period of doubt in design, as in other fields, coincides with three crises – there is the world crisis of resources, food, minerals and energy; there is a crisis in our faith that our organizations are capable of dealing with the obvious defects of modern society... and there is the domestic United Kingdom crisis of the economy. Design is inevitably involved in all this.*

With these "crises" very much in mind, Frank Height (jointly with Professor Christopher Cornford of the Department of General Studies) devised an international symposium and exhibition, *Design for Need*, which opened at the College in April 1976. Fifty-two papers were presented to an audience from the First, Second and Third Worlds – on *Resources*, *Environment*, *Aid* and *Development*, which together made up the useful acronym READ – and, ever since then, READ studies have become part of the school syllabus in secondary education. Maybe *this* could become the focus for rediscovering the ideals of the College, which Lord Esher had called for. If the consultant designer of the 1950s and 1960s had been a visual entrepreneur ("concerned with fitness for purpose rather than with the merits of the purpose itself"), perhaps the

designer of the 1970s would be a missionary: if so, Victor Papenek was the prophet, and small was definitely beautiful. Parts of the College responded, took the Rector seriously, and became more thoughtful.

## ARTISTS AND THINKERS

The Painting School, under Professor Peter de Francia, began seriously to consider the social role of the artist: "under Darwin", he told the press, "we were geared up to produce stars. We're not in a period of stardom now. It's far better to work without the illusion of a Bond Street show just around the corner". And in his inaugural lecture, *Mandarins and Luddites* (much of which was concerned with the Works Progress Administration projects which grew out of the American Depression of the 1930s), he added that he hoped to attract students who would work together in a new Institute for Visual Studies: "... as an alternative to the idea of the artist seen as a kind of two-man circus horse made up of Lucky Jim at one end and Neanderthal Man at the other ..."

De Francia's appointment in 1974 had already enraged the establishment at the Royal Academy and his suggestion that art might be about *research* brought a bit of that rage into the Senior

1945-1987

Common Room. "Where some people are concerned", he told one of his students, "teaching ideas is like peeing in church". With his explosive temper, his *marxisant* approach to social problems, and his tendency to wear a jacket which looked as though it once belonged to a French railway porter, the Professor didn't exactly seem at ease amongst the "Painter's table" generation. In the event, some Painting students went out into schools and involved the children in collaborative murals, while others painted the gable ends of derelict buildings in run-down inner cities. The College Project Office (a unit within the School of Environmental Design) undertook the rehabilitation of derelict buildings – not so much restoring them as finding a new purpose for them – on the model of the RCA Abingdon Gaol project, which turned the gaol into a recreation centre. A College-wide event of 1978, called *Inside Out*, celebrated the institution's well-intentioned advances towards the "outside world": as one of the student organisers, Susie Allen, put it: "we want to show that the College has moved away from the world of fashion and fancy-dress parties and fashionable easel-paintings". With this in mind, among other "art events", a row of designer-chairs was placed on the pavement opposite the Darwin Building; it provided a resting-place for commuters and caused a lot of confusion in the national press. But most of the Painting students stayed put in their Exhibition Road studios (seldom even visiting the Darwin building, symbolically

Below Athena Nocturna – *brooch by Kevin Coates, 1983. Coates is a tutor in Metalwork and Jewellery.*

enough), while work in the School as a whole swung towards figurative expression and the Professor's own interest in Beckmann and the *Neue Sachlichkeit* – a rather more passionate form of deep-toned kitchen-sink, seeming to confirm that ideologies may come and ideologies may go but education goes round in circles.

At the *Design for Need* Symposium, Gui Bonsieppe, who had taught industrial design at Ulm before working in Latin America, expressed concern that European designers were beginning to think seriously about designing *for* the Third World, rather than about the problem of design *in* and especially *by* "dependent countries". Missionaries, he implied, are not always welcomed with open arms, and people do not always like being given things that they haven't actually asked for; this may have been true of the design world – where "design for need" could so easily become a search for new markets – and it was certainly true in the smaller world of the Royal College of Art, where some Professors and tutors were beginning to hold bootleg meetings outside the mission hut ("some sort of protection association", Lord Esher assumed) and where one tutor actually strode into the Rector's office to inform him that he was reckoned, by some of his colleagues, to have been "a disaster for the College". As Lord Esher later mused, ". . . a conversation stopper if ever there was one".

On one thing all could agree (even the "protection association") that both the Rector – with his predictions about "the trend in art schools . . . towards personal expression and the crafts" – and Professor Misha Black – with his predictions about the swing away from manufacturing industry – had been proved right. There *was* a widespread, and very significant, craft revival going on among the design students of the College. Not so much a *return* to the crafts – it was far too sophisticated for that – as a *turn* to the crafts. *The Craftsman's Art* exhibition (1973) at the Victoria and Albert Museum had shown just how much the concept of "craft" had been redefined since the days of Lethaby and ye olde Art Workers' Guild: in addition to pieces by respected designer-makers such as David Pye, the show included objects in wood which played with the language of furniture, ceramic forms which weren't meant to contain anything, and jewellery which aspired to the condition of body-sculpture. Perhaps *this* was what "postgraduate work" meant, in Schools and Departments (such as ceramics, glass, textiles and, to a lesser extent, furniture) which had traditionally been based on a single material: not so much craft as a *solace* (that was what they got up to in St Ives and the Cotswolds) more like craft as a

*challenge* (which was what they hoped to get up to in the inner cities). For the first time ever, an *avant-garde* would evolve from within the craft disciplines.

In summer 1965 the Design Council had mounted a major exhibition on the theme "Can craftsmanship help to raise the standards of industrial design?", which had included work by some of the 1950s generation of RCA design students such as David Mellor and Robert Welch and had explored the proposition that "a degree of manual ability frees the designer from absolute dependence on the productive and prototype resources of industry", in other words that "the crafts" *could* become a form of research for industry in addition to their "distinctively valuable qualities". Most of the designers represented in the show had a foot in both camps.

Three years later, David Pye, the Professor of Furniture Design at the RCA, published his seminal book *The Nature and Art of Workmanship* – a book which took a few well-aimed shots at "the flock of duck-billed platitudes" which tended (and still tend) to surround contemporary thinking about the crafts: platitudes such as "craftsmanship must be about function", "truth to materials" and "free workmanship is better than regulated worksmanship". The arguments were grounded in Pye's own practice as a maker of carved dishes and bowls, as well as in his experience of teaching many of the young designer-makers in wood who were to emerge in the *Craftsman's Art* era of the 1970s – some (like David Field, Floris van den Broecke and Desmond Ryan) with an emphasis on the design and some (like Fred Baier and Richard La Trobe Bateman) with an emphasis on the art.

Looking back on this *rapprochement* between craft and design from the perspective of the late 1970s, David Mellor contrasted those (like himself) who "in the 1950s . . . had generally wanted to design for industry" and those (like the *Craftsman's Art* people) who "became more interested in trying to control their own tiny bit of life and to want actually to make things themselves": in retrospect, Mellor was prepared to concede that the 1950s may have been a period of "naive optimism". He attributed the contrast to changes in the art school curriculum which had happened in between. They must certainly have been dramatic changes, if the work was anything to go by.

In the tenth anniversary issue of *Crafts* magazine, published by the Crafts Council in April

Right Comfy Chair *of 1984 by Freddie Baier, a student of the Department of Furniture Design 1972-5.*

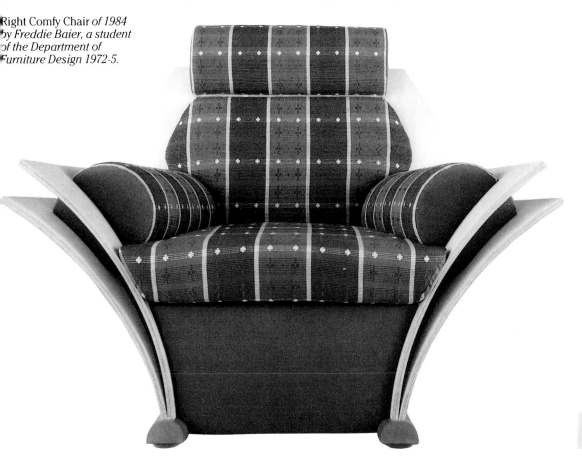

1983, several well-known artist-craftspeople (as they had come by then to be called) were asked "Which books have influenced your thinking and work during the last ten years?" Amongst the many replies, the writings of John Ruskin, William Morris, C. R. Ashbee, W. R. Lethaby and Bernard Leach were not mentioned once. Instead, the ex-RCA furniture designer and maker Fred Baier (whose reply was the first to be quoted) wrote:

*I'm not a great reader of books, especially not ones without pictures... As far as books and work go, the first one that springs to mind is Groucho Marx's* Letters... *At college we were spoon-fed Nikolaus Pevsner and Herbert Read but they never really got to me.*

For the generation which had been at art college, or had just left art college in the early 1970s, the "brown and grey" aesthetic of the latter-day inheritors of the Arts and Crafts tradition was of little interest – except, perhaps, as the subject of the occasional ironic reference. The crafts weren't about improving society any more – they simply provided a "language" (to use the then fashionable terminology of structuralism) through which young artists could express themselves. Pevsner and Read were old-fashioned moralists. Fred Baier's extraordinary *Tartan Chair* and his *Whatnot* in wood were "where it was at".

This happened when developments in the fine art world – notably conceptualism and minimalism – had created a new space in the galleries for the artist-craftsman to inhabit, as Misha Black's important lecture on *Craft: Art or Design?*, in April 1976, was to suggest. Black argued that the development of the crafts from the late 1960s onwards had a lot to do with three graduates of the Fine Arts from Leeds Polytechnic who had walked 150 miles in East Anglia with a ten-foot yellow pole tied to their heads; the exhibition-going public (and the collectors), he concluded, were beginning to look elsewhere for the values they used to associate with fine art. The result was the paradoxical renaissance of the crafts.

Where the young RCA avant-gardists of the *Craftsman's Art* generation·were concerned, the "rules" which had been taught in, craft or design faculties of post-Coldstream art colleges in the late 1960s and early 1970s – that "less was more", that "the pattern should fit the form", and above all (following Leach and Cardew) that "there was no beauty without utility" – were all open to question. The ceramicist Jacqui Poncelet, for example, started her career by making bone china pots in moulds, and, after visiting New York, gradually developed towards the production of angular ceramic sculptures which resem-

bled brightly coloured crustacea or serpents: at first her work functioned as a "comment" on the craft world which surrounded her (complete with references to Brecht and Robbe-Grillet) but by the mid-1980s it was being exhibited as sculpture on the floors and walls of fine art galleries. At this point she stopped referring to herself as a "craftsperson" at all.

Alison Britton – who, like Poncelet, approaches her material as something that arrives on the doorstep in a polythene bag rather than something which should be dug out of the soil of the West Country – now refers to the clay "as background and as canvas: all I need is something that holds together". Unlike Poncelet, she has continued since RCA days to produce pieces which are vessels and containers, but has moved on from "pictorial pottery" to three-dimensional shapes which increasingly resemble multi-plane abstract paintings:

*Being a vessel is not very demanding. Once the functional requirements of "holding" are fulfilled, there is still plenty of room for interpretation and variety of outer form. I ... hang around on the fringes of making usable things...*

By the early 1980s it wasn't unusual to hear (at private views of craft exhibitions, or in intense seminars on the subject "are you a craftsperson or not?") conversational gambits such as "I make small sculptural pieces in non-precious metals which subvert the traditional values and meaning of jewellery". With the almost simultaneous appearance of ceramic sculpture, fine art textiles, also known as soft art or fibre art, redefined jewellery and wooden sculptures bearing the message "do not sit on this", things were becoming thoroughly confusing. What if ... the crafts went *conceptual*?

One reason why conceptualism, minimalism and performance art never developed solid roots within the existing *Fine Art* Schools at the Royal College of Art, was that, from 1975 onwards, the Department of Environmental Media had been created to teach the more *avant-garde* students who were emerging from post-Coldstream Painting, Sculpture and Film courses. This catch-all Department started life as "the Light Transmission and Projection unit" under Bob Hyde, rather uneasily sharing studios with Hugh Casson's interior designers. But, as the Unit came of age – and, in particular, as it proved to be more expensive than anticipated, with the increasing use of video (or rather "time-based media") – no one seemed to be sure whether it had more in common with Stained Glass (coloured light) or Sculpture (spatial art). Eventually, Lord Esher was landed with the problem:

184

*What was my opinion of Environmental Media, Light Transmission and Projection as an artform, let alone an academic discipline? I hadn't the foggiest idea, except that this avant-garde ghetto, with one part-time tutor, ought not to be isolated in a Kensington Gore attic but down the road with the rest of the artists. But neither Carel Weight in "painting" nor Bernard Meadows in "sculpture" had the space, nor the slightest desire, to take it on board . . .*

The Department of Environmental Media (for the solution, in the end, was to turn it into yet another separate Department) remained in Kensington Gore, as an "avant-garde ghetto", drawing off performance artists, video artists and others into a special reserve, leaving the traditional Fine Art Departments to function largely as before. But the circumstances of its birth – a kind of avant-garde version of pass the parcel – had not been auspicious. From the word go, the Department was the subject of regular, inconclusive meetings concerning "what shall we *do* about Environmental Media?". On one occasion, a member of the staff was asked by the College Senate what it was the Department actually did. He replied that he couldn't say until it had been going for ten years and had an archive. In the circumstances, the quality of many of the students' "art works" and installations was remarkable. Among the early students of the department was Richard Deacon, later to become a distinguished sculptor whose work to develop from the conceptual concerns of the 1960s into the figurative style of the 1970s.

## A SEDENTARY OCCUPATION

Amid all these earnest, and important, struggles, on the 23 February 1977 some students, led by members of the socially-conscious Film School, took "direct action" by occupying all the College's administrative offices in the Darwin Building, their "administrative committee" sitting in the Rector's office with their feet on Darwin's black leather Phoenix-stamped desk.

The RCA had somehow escaped the upheavals of '68 and after, except for one or two isolated incidents. It had sat, rather smugly, on the fence while undergraduate art students held sit-ins over the Coldstream-Summerson reforms and matters arising, and while Robin Darwin wrote to *The Times* (in August 1968) generously offering *de haut en bas* "to give shelter to a proportion of Hornsey students until their own college reopens". In France and America, the student revolutions of '68 tended to happen on University campuses; in Britain, they tended to happen in the more volatile environment of the art schools.

Above Big Spouted Pot, *1985, by Alison Britton, a student of ceramics 1970-3 and now a tutor.*

Below *Motorized bicycle wheel by Richard Seymour (RCA 1974-7) and Dick Powell (RCA 1973-6) who formed the partnership Seymour Powell Ltd in 1984.*

1945-1987

### THE LEGACY OF COPER

The most successful of the young RCA ceramicists has, perhaps, been Elizabeth Fritsch – whose austere hand-built pots, with matt finish and coloured fresco effects seem to owe a great deal to the work of her tutor at the Royal College of Art, the sculptor and studio potter Hans Coper and his friend and associate, the Viennese potter Lucie Rie, who settled in London just before the Second World War. After Hans Coper died (at the age of 61) in 1981, David Queensberry wrote:

*When I became Professor of Ceramics in 1959, I knew that Hans was the most important person in this country that I could possibly get to teach in my department, and in 1966 I persuaded him to come. I consider that this is the most important thing that I have done in twenty years' work at the College.*

As important, even, as also having the printmaker and sculptor Eduardo Paolozzi as tutor in ceramics: an imaginative decision, and one which has been applauded by generations of students who enjoy "thinking on the wing".

*Above A selection of hand-built pots by Elizabeth Fritsch, who was strongly influenced by the work of Hans Coper, her tutor in the Department of Ceramics and Glass from 1968 to 1970.*

But all had seemed quiet on the Kensington front. A couple of years later, some students had burst into one of Darwin's Senate meetings and read out a statement on "course assessment", but Darwin had barked back "if you can't *say* it, leave the room" and they did. At the time of the changeover from Darwin to Esher, the students of '68 had become postgraduates, the "Hornsey Affair" had long ago achieved the status of myth, and Darwin had come to realise that the new generation was not likely to be quite so "compliant". By the mid-1970s, the first generation of post-1968 students had found new ground to break, this time at the centre of the system. The immediate occasion for the present "sit-in" was the Government's announcement that student fees were to go up – a fact which would not effect three-quarters of the students, since they were supported by DES bursaries: but it was, said the occupiers, a question of "showing solidarity". It was also a question of the students having "more of a say" in the affairs of the College. As Lord Esher was to recall:

*I sat down at my desk and told the assembled mob that it could never win, then left for the Senate. Here we were invaded by a delegation and a statement was read to us in a barely intelligible accent. David Queensberry asked the man to take it more slowly, which caused deep offence. We were told, inter alia, that students had been mandated to boycott all future Senate*

*and other meetings. This set the tone for the coming weeks...*

The sit-in seemed to be the result of confusion, and a diffuse sense of alienation from "the outside world", rather than of any specific grievances (about which something practical could be done) within the College. After all, Lord Esher had *offered* the students "more of a say" when he first arrived. There were wild rumours that Industrial Design was producing policemen's helmets and riot shields, that the Experimental Cartography people were working for the CIA, that the revived School Forums, or staff-student meetings, had been invented to spy on the Students' Union (as it was now called). I can well remember a seminar that I was running for the Film students, as a part-time tutor, in the middle of all this, on the subject of "signs of the times". I'd scarcely opened my mouth when a tall and very angry Glaswegian, wrapped in a tartan scarf and brandishing a copy of Lenin's *Materialism and Empirio-Criticism* started reading out the section called *Ten Questions to a Lecturer*:
"What's your theoretical position . . .?"
"Do you acknowledge Engels's fundamental division of philosophical systems into *idealism* and *materialism* . . .?"
"Do you acknowledge as correct Engels's argument concerning the conversion of 'things in themselves' into 'things for us'?"
And so on. It was like a nightmare version of

*Mastermind* with me getting all the answers wrong while at the same time trying to explain that things weren't quite as simple as that. "In which case," yelled the Glaswegian, "you're like a surrealist painter trying to paint a picture of someone trying to paint a picture of someone trying to paint a picture ... If you're not a dialectical materialist you're not in the picture at all." At that point he stormed out of the room, muttering about the secret police. The thing was, I reckoned, never to give up and admit that all lines of communication had become blocked: always to try to bring the seminars back on course. Eventually, they were to turn into some-

thing quite valuable for all of us.

Where the College was concerned, after endless meetings, communiqués, forums, delegations, and even a personal appeal by the Rector – who, miraculously, retained his belief in sweet reason and conciliation – in front of the entire student body, the original demands were forgotten and the immediate problem for the occupiers came to be how to extricate themselves without retribution. On 23 March, exactly one month after it began, the sit-in was over. Ten days later the term was as well, and everyone went home.

Throughout the occupation, most of the students – and the staff – went into the studios to "get on with their own work". At best they were indifferent, at worst their prejudices were confirmed either way. From Lord Esher's autobiogra-

*Below Fabrics by Sue Timney and Graham Fowler,*
*who studied, respectively, tapestry and printed textiles.*

phy it is clear that he felt he was not getting the kind of support he needed from the non-political staff and students: "The College" (in the Darwin sense) had ceased to exist. The unforeseen effect of the sit-in was a temporary but quite serious split in the College between "academic" and "administrative" – and the undeserving Rector suffered most. He had supported and sympathized with student ideals which he believed they should hold, but found himself, quite irrationally, the chief victim of them. Leaders of both sides were left with an empty feeling of betrayal. The College was soon back to normal, but personal wounds do not heal so quickly, and as an institution it never quite seemed to understand the consequent feelings of one person – its Rector. "My second Students' Union President," he recalled in tranquillity, "one of the moving spirits of *RCA Redefined*, was a radical idealist who wrote essays with titles like 'The Bitter Taste of Living' and whose show of work for his degree consisted solely of Agitprop, yet whose last words to me when he came to say goodbye were: 'You know, I love this place!'"

## WORKING PARTIES

Lord Esher retired hurt in 1978, after his seven years of office were up. A joint appointments committee of Senate and Council – consisting of ten people, representing all College interests including those of the students – had been meeting since September 1977, unable to make up its collective mind. According to the newspapers (which were hugely enjoying the spectacle), the committee's deliberations were "protracted and painful" – the result, among other things, of a split between "insiders" (who wanted a return to the good old days) and "outsiders" (who wanted to bring in someone who would remind the College of its industrial obligations). In January 1978, the committee *almost* made a recommendation, but the candidate withdrew (saying that he was by no means sure that the College as a whole would back him), and the Senate met to discuss whether they should ask him to withdraw his withdrawal, and if they would support him if he did. As a way out of this dilemma, Senate decided that the post should be offered to Richard Guyatt, Lord Esher's Pro-Rector, who was within three years of retirement. One of the tutors noted that, evolution being what it was, it was a great mistake to keep looking for the *genus Darwinius* when the species had already become extinct.

As the longest-serving Professor in the College, within three years of retirement, and as a very popular colleague, Guyatt's appointment was

seen as a sensible way of stabilizing the institution, and bringing it back to a sense of its own identity. He had run a complex set of Departments ("the Graphic Arts") since 1948, had founded *Ark* and the *Lion and Unicorn Press*, had regularly taught in the Graphics area at Yale University, had designed a series of elegantly witty souvenir mugs (in the Ravilious tradition) for Wedgwood – the Coronation of 1953, the Investiture of 1969, the Royal Wedding of 1973 – as well as dinner services for embassies and colleges, commemorative stamps for the GPO and coins for the Royal Mint, he had produced package designs and corporate images for several important companies, and was made CBE for services to design in 1969. He chose the energetic Reg Gadney – thriller-writer, expert on Constable, and senior tutor in the Department of General Studies – as his Pro-Rector, who was to become the first full-time Pro-Rector since the post was instituted. Gadney had been an effective "student welfare tutor", and the student constituency had become, since the "occupation", an important consideration.

But if anyone really thought that the new appointment meant some sort of return to the "Darwin days", then they could not really have thought very hard at all. The time was past. All public sector institutions were being badly hit by inflation at the same time as having their recurrent grants cut by the government. There was a lot of unfinished business, left over from both the Darwin and Esher years. And, most of all, Dick Guyatt was determined not to "tread water" for his last remaining years at the RCA. "Since the war years," he said, the College has flourished in what might be described as 'an expanding universe'. Recently, that universe has begun to shrink."

---

LOW-BUDGET FILM-MAKING

In its early days the three-year film course was described as being suitable for "prospective directors, editors and cameramen". As there was little or no film or television training at Dip AD Level at that time, there were a lot of preliminary seminars on "the first principles of observation" and "the potential of the medium". By the third year, students were allowed to undertake "a major project" on film. The closest the Department could get to television cameras, at the beginning, were four wooden mock-ups on broomstick tripods, and, where film was concerned, Ridley Scott was later to recall, "when I was at the Royal College, the film school was a cupboard with a Bolex camera in it".

He immediately set up a series of working parties – involving members of the College staff and specialists from outside – on the vexed question of the Film School (which concluded that it should be "predominantly *practical* with an emphasis on creativity and experiment" – certainly a great change from the preceding years); on "the role of General Studies" (which concluded that the Department should in future aim to integrate with, rather than compensate for, the studio areas); on "the governance of the College" (which Bruce Archer directed like an elaborate exercise in design research); on "the College and education for leisure" (a euphemism for unemployment); and on the implications for RCA industrial design work of the new technologies. The working parties' methods – genial discussion over several months, followed by reports which genially recommended changes of emphasis within the Darwin framework – were characteristic of the Rector who commissioned them.

Film-making at the RCA had begun, in 1959, in a back room of the School of Graphic Design, when three graphic designers, four painters and an interior designer enrolled for a one-year course in "film and television design" under George Haslam. It was described as a "preliminary training in basic principles" and was intended to cater for the increasing number of graduates who wanted to work in the film and (especially) television industries. By 1962 the course had grown into a Department of its own, based in the Queen's Gate Common Room, which had recently been vacated by Ceramics. Sadly, George Haslam died suddenly while planning the new full-time course, but under Keith Lucas (ex-RCA Painting) it managed a steadily increasing emphasis on actual production.

By the time Keith Lucas left, in 1972, to become Director of the British Film Institute, first-degree courses in film and video were beginning to emerge in polytechnics and art schools. Stuart Hood – ex-Controller of Programmes, BBC, Head of Programmes, Rediffusion, and pioneer of "media studies" – was appointed Professor: increasing emphasis was placed on the social influence of film and television, on the politics of the visual image. The (by then) long-established links with what came to be known as the "dominant" industries took second place to "independent" work. There was much talk of "laying bare the device" – which took the form, in student films, of reminding the audience (as if they both needed reminding) that they were watching a film. There had been two members of staff in 1965: ten years later there were 18.

Dick Guyatt's working party strongly recommended a return to the *craft* of mainstream film –

The Architects' Journal Update: industrial refurbishment 8 August 1984/80p

Above *Magazine cover by Peter Grundy and Tilly Northedge, graphic design students in the late 1970s.*

although the perennial question of how a fully-fledged film studio might be funded was left wide open – and Professor Richard Ross (ex-BBC Television News) was appointed on the basis of it in 1980. Since then the international student festivals have been deluged with films bearing the RCA credit – although the basic dilemma of "education or training?" has yet to be satisfactorily resolved by the art education sector as a whole, and, where funding is concerned, the "partnership with the industry" recommended by the Working Party has, for obvious reasons, been slow to get off the ground.

Outstanding students, over the years, have included – in addition to the designers mentioned earlier – Paul Watson (*A Year in the Life*, *The Family*), Richard Loncraine (*Brimstone and Treacle*, *The Missionary*), Patrick Uden (BBC's *The Body in Question* and, later, senior producer of BBC's *Horizon*), Paula Milne (creator of BBC's *Angels* and writer of *Bunch of Fives*), Giles Foster (director of Alan Bennett's television plays), Judith Williamson (author of *Decoding Advertisements*, film critic and director of *A Sign is a Fine Investment*) and Sue Clayton (*The Song of the Shirt*). One of the problems with the Film School,

when the Guyatt working party was set up, was that it seemed to be producing students who had both feet planted firmly in the air, which was where his second working party came in.

Almost immediately after it was founded, the David Hockney incident had put the Department of General Studies under the spotlight, and the attitude of some students towards "the Department of words" (as they insisted on calling it) in the 1960s was epitomized by the folkloric occasion when an eminent philosopher from Oxford came to give a series of four lectures on aesthetics to the painters. His lectures were neatly typed, well footnoted – but they were *not illustrated*. At the first lecture there were 50 students, at the second, 20 students, at the third five students, and at the final lecture, one solitary student. The philosopher turned to the solitary student and said: "There isn't much point in going on with this; why don't we just have a cup of tea and talk about aesthetics?"; to which the student replied, "I do wish you *would* go on with the lecture, I've been trying to draw you for four weeks!"

Since that time, under Professor Chistopher Cornford, the Department had successfully offered a range of courses – on philosophy, psychology, literature and art theory – which were intended to help the students think, talk and write about general issues which ultimately had a bearing on their studio work. It was a model – variously known as "Liberal", "Complementary", "Supportive" and "General" Studies – which always had a slight sense of "three wise men bearing gifts" about it. Darwin had wanted the Department to attract students of its own (students from the art education sector who could study "art and artefacts") to give General Studies a greater sense of identity and to break down some of the barriers between "theory" and "practice" which by the 1960s had become well-nigh insurmountable. He felt that a university institution *should* be able to offer such opportunities. By the late 1960s this had begun to happen – another initiative which was later taken up by the undergraduate colleges – and a handful of students (including the critics Andrew Brighton and James Faure-Walker, the art theorist John Tagg and the cartoonist Christopher Williams) graduated with an MA by thesis. But it was becoming increasingly clear within the College that the whole concept of "General Studies" was based on a series of ambiguities: if too "general" it could be accused of educating students merely to be able to answer questions on *Mastermind*; if too "liberal" it tended to become a branch of the entertainment industry; and, as for the notion of "supportive studies", that unfortunate name

simply gave the impression that the Department consisted entirely of intellectuals who wore the post-Coldstream equivalent of design briefs. Darwin's concept of the "well-tempered mind" was becoming a little out of date in the bad-tempered 1970s.

The Guyatt working party concluded that "the aim of the Department should be to bring about a *closer relationship* between complementary studies and the professional work of the student" and to focus on a number of clearly defined research areas such as the history of design.

Professor Christopher Frayling, the present writer (ex-Cambridge, and lectureships at the RCA and the University of Bath) was appointed in 1979, with the broad brief to implement these recommendations. The result has been the foundation of the Department of Cultural History – which now offers courses on "the history, philosophy and criticism" of each studio activity in the College, and every student has to take one of these courses, before writing about matters arising, in order to qualify for a degree. In addition to the MA by thesis (which has developed apace) the Department runs a joint MA course with the Victoria and Albert Museum on its research specialism, the history of design. In 1980, when the idea of the course was first mooted, relationships with the V & A were at an all-time low: this was symbolized by the fact that the door linking the two institutions in Exhibition Road had been sealed off since 1975 when an RCA student fell through the ceiling of the V & A lecture theatre after "a wild party" on the roof – and, miraculously, lived to tell the tale. The door was finally sealed off during the mutual recriminations which followed: V & A security men, said the College, tended to gatecrash the life classes (the few that still happened) and put off the students by standing about in uniform and making suggestive noises; College students, said the V & A, tended to drift into the Museum to seek stylish decorations for their student hostel. Such bizarre rumours merely illustrated what had happened to the dream of "Albertopolis" since Robin Darwin declared independence from *all* other institutions, government or academic. The joint RCA/V & A course has not only re-established these historic links, at many levels, and tried to build bridges between "College" and "Museum", but has also produced several generations of young design historians whose services have been much sought after by galleries, colleges, and journals.

Frank Height's report on "the development of industrial design", also completed in 1980, recommended the establishment of another joint course, this time with the Imperial College of

Science and Technology. This course – which since then has grown from four students to 30 students – was intended to break down the barriers between the education of the engineer (in the university sector) and the education of the industrial designer (on the other side of the "binary line") which had existed for as long as anyone could remember: in future, graduate engineers would work side-by-side with graduate designers and, in the process, develop their ideas in a more visual environment. From the start, this joint course represented a revolutionary development in design education – perhaps the most significant innovation in RCA industrial design since the foundation of the School. When presenting the concept to the College Senate, Frank Height referred to Misha Black's view on the "Victorian hierarchy" which had placed Fine Art at the centre of things: perhaps, in the 1980s, the industrial designer would acquire the status once given (in the days of Samuel Smiles and *Self-Help*) to the great engineers, but since lost.

At the start of his first term as Rector, Dick Guyatt had told the assembled staff and students:

*I don't expect I'll turn out to be a new broom, and see no valid reason to be one. In fact, I'm fairly obviously a mature broom – though I'm happy to report that my bristles are in good shape and standing firm – should they be needed.*

Instead of adopting what Darwin had always called "new broom tactics", Guyatt preferred "a light touch, without stuffy pontification, but with a certain easy zest and sparkle". If this sounded like the description of a soft drinks campaign by a seasoned graphic designer, it helped the College to regain part of its self-confidence – at least until the Rector's final year.

Two areas which effervesced, in a fairly dramatic way, in the Guyatt years, were Illustration and Sculpture. Quentin Blake – well-known freelance illustrator, notably of children's books – was made a Royal Designer for Industry in 1981. He had become Head of Illustration (within the "Graphic Arts") in 1978, 13 years after joining what was then a new Department, and under his gentle guidance successive generations of illustrators had established new professional standards in Britain: they included Michael Foreman (freelance book, magazine and advertising illustrator, also an RDI since 1985), Dan Fern (himself Head of RCA Illustration since 1986), Linda Kitson (of Falklands drawings fame), Nicola Bayley (book illustrator), Su Huntley (consultant to Wolff Olins; designer for magazines and advertising), Chloe Cheese (printmaker, illustrator and advertising designer), Ian Pollock (pioneer of "the new illustration"), Christopher

Corr (book illustrator and printmaker) and Russell Mills (cover artist, designer for Brian Eno's performances, and painter). The Natural History Illustration Unit (under John Norris Wood), in the same years, launched Stephen Nash (designer for the World Wildlife Fund, now Professor of Zoological Illustration at New York State University), Richard Bell (illustrator of *Bell's Britain* and for numerous wildlife programmes on television) and Clare Roberts (illustrator of *Oak Tree and Company*, 1983) on to their professional careers. The Unit has always spent much of its time in the College Greenhouse, perched on the top floor of the Darwin building, or at the London Zoo: it must be the only university activity in the world which advertises among its facilities "fish, terrapins and free-flying birds".

Philip King became Visiting Professor of Sculpture in 1980, with Bryan Kneale as his Head of Department. He succeeded Bernard Meadows who, in 1960, had at last removed all the modelling stands from the Queen's Gate hut and encouraged the students to experiment with the place and space which surrounded them: during his 20-year term of office, the School had moved on from figurative sculpture (Ralph Brown, Robert Clatworthy), to absorb the reaction against carving and modelling and the rise of coloured plastics, metals and *constructed* sculpture (Roland Piché's space-frames, containing disembowelled pathological specimens cast in polythene wrappings; John Panting's minimal fibreglass constructions), and to house careful assemblages of man-made objects (Tony Cragg) and assorted earth-works.

In his first two years as Rector, Dick Guyatt had not seen it as a priority to answer, or indeed ask, the basic long-term questions about the institution – what *is* the RCA's national role? And what *does* a "university of art and design" really mean? – but he had, nonetheless, quietly launched the most substantial changes at departmental level since Darwin's retirement, and laid some of the foundations for the College of the 1980s. The trouble was that not everyone associated with the College – in particular, on the Council and at the Department of Education and Science – was as patient and "ruminative" as the Rector. And in his final year, 1980-1, there was a series of much-publicized confrontations – not between staff and students this time, but between staff and Council, and even staff and staff.

The year began with the Rector asking the Professor of Painting to submit his resignation, on the grounds that the Painting School was showing an alarming tendency to declare independence from the rest of the College. As Guyatt observed:

191

**1945-1987**

*In the old days there was no question but that the fine arts set the pace. They infused aesthetic standards and values for the designers. They were the great "bloods" of the College. I'm not sure it's like that now. It's the poor old designers, and I think wrongly, who have to support ideas of craftsmanship and all this, which painters don't any more ...*

And, in an open meeting with angry staff and students of the Painting School, he stressed that they should spend more time on life drawing and the "craftsmanship" of painting: the reply, which came over loud and clear, was that the notion that fine art could be "applied" to design in this way – studied for its "aesthetic standards" and then put to practical use – was very out of date both where art *and* design were concerned. After all, wasn't the Department of Design Research beginning to think about design as *science*? The confrontation, which was also a clash of personalities and generations (crudely presented in the newspapers as "Britain Can Make It" versus "Continental Marxism") raised age-old fears that the fine arts in general were "under attack", and led to an unexpected degree of solidarity among staff and students in the Faculty. In the end, the College administration stepped down, and there was yet another Working Party – on "the role of the fine arts within the College". The original title was "the *future* of the fine arts", but this was thought to have unfortunate implications. Its conclusion, after a series of long meetings over luncheon, was that no substantial changes were necessary after all.

Next came a major confrontation with the Department of Education and Science, in March 1981. Ever since the RCA became a "university institution" in 1967, it had been subject to periodic inspections by a Committee of Visitors appointed by the DES: their role was to report to the Department, who would use the report as a basis on which to assess the College's financial needs. Shortly before he retired, Robin Darwin pointed out that, whereas most Universities could expect one "visitation" every five years, the RCA was being visited, with ominous regularity, at least once a year: as he concluded, it seemed anomalous, but then again the College's direct relationship with the Ministry (without a University Grants Committee as intermediary) was also anomalous; it was, he was very much afraid, an anomaly which his successors would have to sort out. In spring 1981, the Visiting Committee reported that, although many areas of College activity were thriving, the institution as a whole was neglecting the duty enshrined in its Royal Charter to concentrate on the design needs of

Above *Detail of silk shawl (1986) by Cressida Bell, a recent graduate in textile design.*

industry, and "some departments have let their links with industry slip". The Charter had, in fact, been very carefully worded:

*The objects of the College are to advance learning, knowledge and professional competence particularly in the field of fine arts, in the principles and practice of art and design in their relation to industrial and commercial processes and social developments and other subjects relating thereto through teaching, research and collaboration with industry and commerce.*

The report acknowledged the ambiguities in this passage ("particularly in the field of fine arts"), but stressed that "the relationship between fine art and design has not been clearly put into practice" – which was precisely the basis of the autumn row from which the College was just recovering – and that the RCA was not contributing effectively enough, through its "teaching, research and collaboration with industry", to the revitalization of the British economy. In particular, there was too much emphasis on "the creation of the unique and unrepeatable object", rather than on "design for function and repeatability with a view to actual production". Apart from the clumsiness of expression, much of the document could have been lifted wholesale from the Select Committee Report of 1836. Only this time, there was a slight note of panic since by the early 1980s everyone was looking for a scapegoat.

The Under-Secretary for Higher Education, Dr Rhodes Boyson, took the unusual step of sending a copy of this Report to the College administration – it was usually kept secret – with the threat that "unless the College can be seen to be responding effectively to national needs and

priorities, I fear that the future may hold for it the prospect of . . . less recurrent grant". Since the RCA had already suffered the same level of public expenditure cuts as other higher educational bodies, in the late 1970s, it was clear that the College was becoming a test-case *pour encourager les autres*. The Students' Union cried "blackmail", the Professors (when they eventually saw the document) denied "that we live in a world of academic whimsy", and a series of protracted and acrimonious meetings of the Council eventually led to the much-publicized resignation of six of its members.

The Chairman of Council since June 1979, "Cob" Stenham (financial director of Unilever, and Chairman of the Institute of Contemporary Arts), together with members of his Finance and General Purposes Committee, had produced a paper which was highly critical of the College's attitude towards "pressures from without", and had discussed this in person with Dr Rhodes Boyson (without consulting the Rector and academic staff). After assorted votes of no confidence from the Professors, and mutual recriminations involving everyone, "Cob" Stenham reluctantly resigned – followed by Terence Conran, Michael Grade and four others. "The Professors are feudal", said one of the resigning Council members. "They are individual barons running individual empires. They always manage to repel the invaders and it looks as though they have done so again." And, like most feudal barons, they wanted as little contact as possible with "trade". To which one of the "individual barons", Professor Lord Queensberry, replied that asking for a close partnership with industry was a bit "like asking someone to go to bed with you. If they say no it may be something to do with you *as well as* with them . . ."

In Dick Guyatt's valedictory speech at the 1981 Convocation – a very emotional event – he referred to "the squalls and storms" which had hit the College in his final year:

*But they did not capsize us; they only strengthened our resolve to stand by our right to the freedom to decide our own future through informed academic discussion, rather than giving way to uninformed outside pressures, largely determined -by considerations of financial expediency.*

And he expressed the hope that the RCA would sail through "the winds of change" with its hull intact. The sentiments, and the imagery, from the days of sail, were the last public statements to be made on behalf of the College by a member of the Darwin generation: they revealed how much had changed – in the College's relationship with "the

FIGURATIVE REVIVAL.
As late as 1959 the Inspectors had complained that students were neglecting their carving – the *craft* of sculpture – because they found it "too slow and laborious". What they would have thought about later assemblages and constructions is a matter for conjecture. Philip King's arrival in 1980 coincided with a new interest in figurative sculpture – and students of the early 1980s, including David Mach (submarines constructed out of rubber tyres, huge constructions out of man-made objects), Dhruva Mistry (mythical creatures out of Indian bestiaries) and, most recently, Nicola Hicks (animal forms in plaster, straw and resin) have reacted against the machined finishes of 1960s constructions, to re-establish the subjective, and tactile, qualities of their sculpture. This seems to have put them back in touch with critics and the exhibition-going public.

world outside" – since the optimistic post-war era, and how much of the "Darwin experiment" would *have* to change in the future. Guyatt was consoled, in the end, with the thought that the RCA had recently been involved in a very public occasion just like in the old days:

*And then of course there's the Royal Wedding! We are proud to have presented the royal couple with a wedding present designed and made by two students in the School of Furniture Design, Peter Akass and Tony Wills – a gorgeous kite which was first revealed in the "Blue Peter" programme – while two former students, David and Elizabeth Emanuel, are designing the official wedding dress . . .*

## A THEORETICAL ADVANCE

In autumn 1981, Professor Lionel March took over as Rector – the first complete "outsider" to be appointed since 1948. His appointment had been announced five months before – right in the middle of the "squalls and storms" over the Visiting Committee Report, with which it became confused by the press. This time, the appointments committee of nine members had actually succeeded, after several months of lively deliberation under the Chairmanship of "Cob" Stenham, in making a recommendation to the Senate which was acceptable. The new Rector's background was partly in design research, and one of Rhodes Boyson's criticisms had been that the College was not raising enough money through industrially-sponsored research. He also

knew about computer-aided design, which, in an era when the phrase "the new technologies" had yet to become a cliché (but was about to do so), was also an advantage. Lionel March had assisted Sir Leslie Martin in the Department of Architecture at Cambridge before becoming a Harkness Fellow at Harvard and MIT, a Professor of Systems Design at Waterloo, Ontario, and he came to the RCA as Professor of Design in the Faculty of Technology at the Open University. In the first week of his first term he announced to the students that, when he had told his colleagues that he had become Rector of the Royal College of Art, they replied that the term "Rector" reminded them of a parish church in the home counties, and as for the Royal College of *Art* – what had that got to do with his academic specialism of design?

In reply, one of the Professors misquoted Oscar Wilde: to have *one* architect named Lionel as Head of the College was quite normal, but *two* – that might be tempting fate. As it turned out, their models of the RCA were quite different: if Lionel Esher's view was that it should become a centre of excellence dedicated to serving the community outside the institution, Lionel March's view was that it should become a re-search centre for advanced studies in art and design, an All Souls of the Arts, the results of whose soul-searchings would spread outward in neat concentric ripples to and through the com-munity. As Rector he would be leading theoreti-cian to the College, a Platonic example to his colleagues.

With this in mind, he encouraged the RCA to establish an "Institute of Advanced Studies" (on the model of MIT), brought in a specialist in algorithmic aesthetics from California, George Stiny, as his Dean and catalyst and – a startling innovation to the old guard – conducted high-level seminars on abstract design theory in the Senior Common Room, of all places. One of these seminars concerned the value of "shape grammars" – computerized type forms – to the practising artist and designer: the method had, apparently, been applied to Chippendale chair-backs, Palladian Villas and Frank Lloyd Wright houses with fascinating results. Designers could study all the shape variations before producing new designs within the same grammar. "What," said a bemused Fine Art student, pointing to a Francis Bacon painting which hung in the Com-mon Room, "What about that? Could your system produce one of those?" "One of those?" replied

the Dean, "it could produce thousands of 'em". The inevitable collision between the two cultures – at its very broadest, the "craft" culture of the late-nineteenth century and the "design" culture of the mid-nineteenth century – was immediate and complete.

As if to draw attention to the historical implica-tions of his model of design teaching, Lionel March entitled his inaugural lecture *Systematic Research into Possibilities* – a quotation from Lethaby's book *The Architecture of Adventure*

Right *Sweater and fitted skirt in cashmere, black moiré hat and satin gloves, all by David and Elizabeth Emanuel, students of fashion in the mid 1970s.*

1910): like Sir Leslie Martin (in his "Lethaby Lecture" at the RCA, 1982), he was claiming the first Professor of Design at the College as a pioneer of the "systems" approach to design. Lethaby *had*, indeed, in his hit-and-miss way, attempted to reconcile the two competing traditions of design teaching in Britain – the rational (William Dyce, Owen Jones, Richard Redgrave) and the romantic (Morris's disciples, the Art Workers' Guild); the normative ("grammars", "rules", "systems") and the critical ("craft", "self-fulfillment", even "social change") – and in doing so, roughly from 1910-20, Lethaby was building on a precedent first established by Gottfried Semper in the early 1850s. The two traditions had battled it out at the turn of the century. In the end, the craft tradition won hands down and, ever since 1901, the Royal College of Art had been suspicious of *any* design theory which had the remotest connection with the old "South Kensington system". From then on, the College had also pledged itself to promote the "romantic" view of the individual artist – from the Bohemians of the pre-First World War period to the Beats of the 1950s and the 1960s.

It isn't too far-fetched to interpret the shock-waves which Lionel March brought with him to Kensington Gore in these broad historical terms – for March himself frequently cited Owen Jones, the art botanists, and those who believed in "the evolution of designs" in support of his case. When an elaborate exhibition devoted to *Prince Albert* took place at the College in his second year as Rector, he took personal charge of the section on "Albert and art education" – which displayed, prominently, banners depicting some of the illustrations from Jones's *The Grammar of Ornament* (courtesy of the Textiles Department) all around the walls. His inaugural lecture told the story of the "Land Use and Built Form" Unit, celebrated some of the buildings of Milton Keynes and welcomed the spread of the new technologies, to the strains of upbeat variations on the National Anthem.

To assist him in his enterprise, Lionel March selected Professor John Hedgecoe of the Department of Photography, as his Pro-Rector. Hedgecoe recalls that when March asked him to take on these duties, he replied that he had been one of the few people who had spoken against the new Rector's appointment at Senate. So the relationship was likely to have its ups and downs. But they agreed that, for the first year at least, they would together see a new "systematic" planning strategy through the various College committees.

The Department of Photography had existed since the mid-1960s, in the first instance within the School of Graphic Arts as provider of short

Above *Photograph by Graham Smith, a widely-exhibited specialist in documentary work.*

training courses in photography for students specializing in other disciplines: this seems to have been Robin Darwin's view of the function of photography ("allied to another discipline") within the Royal College of Art, as it had been the view of many design teachers at the Bauhaus. However, from 1968 onwards, the Department began to admit its own students – the first two were Henry Moore's daughter and a Fulbright Scholar – and under John Hedgecoe (ex-*Queen* magazine, as Tutor in charge, Reader, then Professor in the Esher years) and Michael Langford (as Tutor, Senior Tutor, then Head of Department) many of its graduates were to become extremely successful commercial photographers: Albert Watson (fashion and portrait photographer for US *Vogue*), Ken Griffiths (editorial and advertising photographer), Bob Carlos-Clarke (advertising and art photographer – with airbrush and camera), Rolf Gobbits (advertising photographer in the surrealist tradition), Graham Smith (documentary work in still and film images) and Pete Lavery (stills photographer for numerous films and colour supplements).

In 1973 John Hedgecoe had publicly stated the aims of his Department:

*What we try to teach the students to do, is to have something to say and make him aware visually and intellectually . . . one of the best photographs I ever saw was from an illustrator and was a series of pictures that he'd done of a love affair between a potato and a carrot.*

195

By 1981, when he became Pro-Rector, Hedgecoe was one of the longest-serving members of the senior staff and he was well known by everyone for "getting things done" in a no-nonsense way. The Students' Union newspaper had dubbed him "the fixer", an intriguing contrast with the new Rector, who may, perhaps, be described as a mainly theoretical rather than a mainly practical architect – and who was intrigued with the intellectual problem he had set himself when he accepted the post of Rector.

In the event, although there was much discussion of research funding, of the links between the RCA and other universities, of the College presenting itself in a much more "systematic way", and even of evolving a "foundation course" – on basic design principles – for the entire sector, the short-term problems facing the institution began to take over from the cosmic debates of the early months. Lionel March's "research institute" model – the RCA as think-tank – was the third attempt since 1967 to answer the question "What *is* the national role of a university of art and design?" And it was a genuine attempt. But the postponed problem of the College buildings – aggravated by further public expenditure cuts, a Byzantine decision-making structure, and the Minister's ultimatum (which was still "on the table") – developed from a problem into a crisis, and the March policy, which went against the grain of eighty years of educational history, would take at least a generation to implement.

Disappointed that he could not persuade many of the senior staff to his way of thinking, and bewildered by the College's hostile reaction to his Dean, George Stiny (which had ended in Stiny's furious departure), Lionel March resigned to become a Professor of Architecture once more at the University of California, Los Angeles, in a more favourable intellectual and physical climate. During his final months, he had spent more and more time in his newly-furbished Rector's lodge – away from the main College buildings. When he announced his resignation to a stunned College Senate, there was a short silence, followed by John Hedgecoe saying "we wish you the best of luck in your future life . . .".

Lionel March had discovered that the great strength of the College structure since 1948 – the autonomy of its Departments – the concept of "narrow and concentrated fields" for which Darwin had fought – was also a weakness to anyone looking for a centre of activity, or a consensus, where curriculum change could be made. Although it was (and is) a small and fiercely independent College, with only 600 students or thereabouts – about the size of a Cambridge college – this did not mean that

Above *Block print for summer 1987 fashion collection by The Cloth, a group of four ex-RCA students who studied printed textiles and graduated in 1983.*

radical change was proportionately easier. On the contrary. One great virtue of the College, post-Darwin, had been the ability of individual Departments to continue running, sometimes spectacularly, through successive Rectors, and successive "crises", apparently unaffected by what was happening outside their disciplines and the professional worlds which surrounded them. If the "crises" were those of fashion, all well and good. If they were real, then this virtue could seem very frustrating. Meanwhile, like the State of Texas, the College continued to strike oil.

## THE SHAPE OF THINGS TO COME

The dilemma was almost the exact opposite of the one which had faced Robin Darwin in 1948. Events had come full circle. John Hedgecoe stepped into the breach, for most of the academic year 1983-4, to be greeted with a leading article in *Art Monthly* which stated in no uncertain terms: "The RCA lives on an outworn reputation, its flagging morale boosted occasionally in public by a sentimental attachment to the glories of the early sixties in the field of fine art . . ."

The "image" of the College in the press had certainly taken severe dents since the days (roughly 1948-1968) when the RCA couldn't do anything wrong if it tried. Actually, the "flagging

morale" of the institution *was* a key issue facing the Acting Rector, as was its apparent inability (as a College, rather than as a series of independent Departments) to present itself to "outsiders" in ways which were convincing in the mid-1980s. 'The place has been called ungovernable", he said, "when the fact is that no one has *tried* to govern it for a long time". The first priority was to demonstrate – and dramatically – that some difficult decisions (which by now had become inevitable) *could* be made within an unwieldy College structure: the Department of Education and Science had suggested that the RCA was by now incapable of "robbing Peter to pay Paul" (as it insisted on putting it) and so, to disprove the assertion and to save a lot of money at the same time, Hedgecoe created and pushed through a new contract structure which would put all part-time tutors on a *per diem* rate – rather than Darwin's "contract of parity", which had survived (uniquely to the RCA) since 1948. It was passed by the Senate – many of whom were part-time tutors – unopposed. He also persuaded all Departments to pool their budgets in order to purchase expensive solid-modelling computer equipment for the Industrial Designers. Together with the present writer, and after a series of all-night meetings, we evolved a more workable decision-making structure – involving a small Academic Policy Committee and an even smaller Management Group, who would initiate and react to policy suggestions – in order to focus debate (which had always been diffuse) and concentrate on longer-term issues.

But the main priority of the "interregum" was to find a new Rector who would be acceptable to the College, and who would have the necessary managerial skills to make full use of the new structure. The problems which had faced the College for a very long time – including its buildings, its national role where both education *and* industry were concerned, its research policy, its corporate identity in the post-Darwin era – still needed to be resolved. Now that "the Darwin generation" had retired (some of them early), there was an opportunity for changes of personnel and direction which could be every bit as substantial as the revolution of 1947-8. An appointments committee, under the Chairmanship of George Howard (one of his last duties, after an association with the College which went back twenty years) made a unanimous recommendation to the Senate in spring 1984. It was the first time there had been unanimity on this issue since 1971. Jocelyn Stevens, who had devoted an issue of his *Queen* magazine to the work of the RCA's staff and students in the heady days just before the College achieved University status, was to be the new Rector. Maybe, at long last, the Phoenix would stop burning its own tail feathers and take off.

In summer 1983, HRH Princess Alexandra had asked me – at a private view – where I worked as a Professor. "At the Royal College of Art", I replied. "Oh," she said. "How very brave of you . . ."

# Afterword

## FORTUNE FAVOURS THE BRAVE . . .

Looking back over the 148 years of the College's history, an incoming Rector could have been forgiven for deciding his most useful role would be to provide a benevolent and gentle leadership for the teaching Departments whilst keeping one eye on the administration and the other on the College's relationship with the Department of Education and Science from which virtually all funding flowed. Indeed the "balkanisation" of the teaching Departments each under their separate Professors or Heads of Department which was a long-term consequence of Robin Darwin's reorganization of the College has been described as having turned the Rector into King John and the Professors into his feudal baronial bosses. The situation had been made worse by the proliferation of Departments until they numbered twenty.

I was encouraged in this view by the late Lord Howard of Henderskelfe who chaired the interview Board which selected me. "You'll need to look in once or twice a week for lunch" he told me in a conversation preceding my appointment. I knew more and so did the Department of Education and Science in the shape of Mr Peter Brooke, the then Parliamentary Under Secretary of State in the Department and the Minister responsible for Higher Education. For upon my arrival at the College to take up my post on 1 September 1984, I found a letter from him which demanded answers to six questions and informed me that failure to provide satisfactory solutions to each one would lead immediately to the College incurring financial cuts greater than those which had already been imposed and possibly to its closure.

The gentle approach was clearly out, even if I had contemplated its pursuit. Nor has such a policy ever been my style. If the College was to be saved, the existing method of dividing the funds available, as well as the economic cuts, equally between all Departments like a children's party where everyone has to get a present and no one says too much if they notice one of the bigger boys taking two presents, had to stop. Peter (and I do not mean Peter Brooke) was going to have to be robbed to pay Paul, and Peter and Paul, because they were both members of the Senate, the College's ruling academic body, were both going to have to agree about it.

The introduction of the new academic pay structure and the tough policy decisions leading to the closure of three Departments taken by Senate in November 1984, as well as a number of other subsequent decisions, enabled me by the end of the year to provide Mr Brooke with the answers that led to the withdrawal of the threatened financial cuts and the beginning of plans which have resulted in a capital investment by Government in the equipment and buildings of the College which already total over £12 million. For the first time in its long history the College will be housed on a single site.

More important in the long term, the academic heads of the College accepted that instead of being incapable of making changes or even "becoming ungovernable", as the previous Rector had described them, they were well able to say goodbye to old heroes, to eliminate old rituals and routines, and to develop surprisingly rapidly in new directions.

The continuing implications of this discovery, however uncomfortable, are fundamental to the future role of the College as the country's leading institution of higher education in art, design, and communication whose Royal Charter binds it to relate closely its activities to manufacturing and commerce. In the age of information, in a world where for all intents and purposes national frontiers have ceased to exist and in an industrial country with an anti-industrial culture the role of such an institution as the College has to be on the very sharpest forward edge of every technical and philosophical development in every discipline that we teach. Not only because that is what is reasonably expected of us but because we, as the acknowledged flagship of the art and design sector of higher education, owe it to all the other Colleges and above all to all our students. To

stand still is not an option.

It follows therefore that, with recurrent funding from Government declining in real terms and industrial funding under pressure from innumerable sources, the money for the new and relevant developments essential to our future has, in the immediate future, to be found by losing or at least reducing existing activities year on year. The College will have to continue to make such decisions, however hard.

Another policy which has been made easy by the seriousness and ambition of the students has been a rapid raising of the standards of the College. In 1986 and again in 1987 the number of applications for places has risen dramatically. Since the selection of candidates for the Masters Degree is entirely on merit, Heads of Departments have been able to offer places to brighter and brighter students. Whilst it is harder to get into the College it is also easier to get out. Positive Interim Assessments are already required for each student at the end of his or her first year if he or she is to go forward to the second year and the required standard in order to pass the Final Examinations has also been raised. The Degree with Distinction was introduced this year.

The College has been fortunate in that it has overcome its internal problems and emerged from its mood of isolation just at the moment when Government, industry, and the rest of the art and design sector of education are awakening to the necessity of achieving more effective relationships with each other. Here is an area in which the College can, with its new aggressiveness and flexibility, lead in establishing links with industry and so develop its teaching programmes. Already the introduction of Business Studies for all students and second language courses for those who wish has been eagerly received. Now we are developing post-experience programmes where students, having graduated, can work in teams with others of mixed experience and skills on specific project-lead schemes closely linked to and financed by industry and commerce. The post-experience programme is a perfect example of new demand-led educational activity.

Internally, the walls between the disciplines are crumbling and I believe that within a short time the departmental structure will have been replaced by a course structure which will enable students to benefit from far more interdisciplinary teaching and better administration.

I believe that the present number of 650 students and the balance between the disciplines we teach is roughly correct for 1987, which is the opposite of saying that this pattern should not under the pressure of market forces continue to evolve. Meanwhile Fine Art, with just over 100 students, remains highly respected as well as a provocation and inspiration to the whole College.

Will the College remain independent of the new funding blocks proposed in the latest Government White Paper on the future of Higher Education. The Council have unanimously agreed that we should opt to continue our separate and special relationship with the Department of Education and Science, aware that we shall thereby continue to have to live on our wits and on the perceived success of our artistic endeavours. The remarkable history of the College told in this splendid book gives me the confidence to believe that the Council should have made no other decision.

But when all is written and done, the future of the College will continue to depend, as it always has, on the experience of all the people at all levels who work for it. Looking around me, I have no doubt that the many exceptional talents of the present staff will combine with the enthusiasm and originality of our students to provide unexpected solutions to the challenges of the twenty-first century and lift the work of the College to new levels of excellence over the next one hundred and fifty years.

Jocelyn Stevens
Rector and Vice Provost
Royal College of Art

June 1987

# APPENDIX

## SOURCES

**Part One: "God help the minister that meddles with Art"**
The primary documents relating to the early history of the
Royal College of Art (under its various names) require a lot of
detective work. There is very little in the Public Records Office
(under *Works* 17/26/11 and 33; Ed. 23 and 24; BT 1) and the
most useful material is to be found among the papers of Sir
Henry Cole in the V&A Library. Of equal value in that Library
are the printed minutes and reports of the School of Design
from 1836 to about 1850, the reports and evidence of the
various committees of enquiry, Cole's *Journal of Design*, and
the annual reports of the Departments of Practical Art, and
Science and Art, from 1853 to 1899; also, the printed lectures
of Dresser, Dyce, Jones, Moody and Wornum – dating from a
time when design teachers still gave publishable lectures,
and circulated them around local art colleges – and the
occasional student essay in *The Builder* and *The Journal of
Design*. No early history of the RCA could be written without
acknowledging the debt due to Quentin Bell's *Schools of
Design* (1963), Stuart Macdonald's *History and Philosophy of
Art Education* (1970) and Susan Beattie's *The New Sculpture*
(1983). Even as early as 1858, it was proving difficult to trace
students once they had left, but in that year the South
Kensington Museum managed to put on an exhibition of their
work, and the V&A Library owns a (probably) unique
catalogue. In 1884, South Kensington staged another exhibi-
tion of students' work from 1882 onwards, for some reason as
part of "the International Health Exhibition"; among the
literature of this, there is a detailed catalogue, together with a
complete list of National Scholars, and students trained as art
teachers.

ed. Amery, C and Richardson, M  *Lutyens* (catalogue,
London, 1982)
Arts Council  *Great Victorian Paintings* (catalogue, London,
1978)
*Art Union* (subsequently *Art Journal*), 1839-1912
Ashwin, C  *Art Education documents and policies* (London,
1975)
Aslin, E  *The Aesthetic Movement* (London, 1969)
Aslin, E and Atterbury, P  *Minton 1798-1910* (catalogue, V&A,
1976)
Beattie, S  *The New Sculpture* (New Haven and London,
1983)
Bell, Q  *The Schools of Design* (London, 1963)
Bonython, E  *King Cole* (V&A, 1983)
Brett, D  *Qualities and Quantities: design theory in the
nineteenth and twentieth centuries* (RCA PhD thesis, unpub,
1984)
Brown, F P  *South Kensington and its Art Training* (London,
1912)
*The Builder* (1843-1966)
Callen, A  *Angel in the Studio* (London, 1979)
Clausen, G  *Recollections of the Old School* (RCA Students'
Magazine, May-June 1912)
Cole, Sir H  *Fifty Years of Public Work* (London, 1884)
Cole, Sir H  *Lecture on education in art* (London, 1852)
Conway, M D  *Travels in South Kensington* (London, 1887)
Coulson, A J  *A bibliography of design in Britain 1851-1970*
(London, 1979)
Dresser, C  *The Art of Decorative Design* (London, 1862)
Dresser, C  *The Development of Ornamental Art* (London,
1862)
Dresser, C  *Unity in Variety* (London, 1860)
Durant, S  *Aspects of the work of Dr Christopher Dresser*
(RCA MA thesis, unpub, 1973)
Dyce, W  *The Drawing Book of the School of Design*
(London, 1843)
Dyce, W and Wilson, C H  *A letter to Lord Meadowbank*
(Edinburgh, 1837)
Engen, R  *Kate Greenaway* (London, 1981)
Fildes, L V  *Luke Fildes RA* (London, 1968)
Fine Art Society  *Christopher Dresser* (catalogue, London,
1972)
Frayling, C J  *Queen Mab's Chariot Among the Steam
Engines* (V&A Album, 2, 1983)
Gaunt, W  *Victorian Olympus* (London, 1953)
Haydon, B R  *Autobiography and Memoirs* (London, 1926)
Haydon, B R  *Correspondence and Table-Talk* (London,
1876)
Haydon, B R  *The Diary* (Massachusetts, 1963)
Herkomer, H von  *Autobiography* (privately printed, 1890)
Herkomer, H von  *My School and My Gospel* (London, 1908)
Hermann, W  *Gottfried Semper im Exil* (Stuttgart, 1978)
Hermann, W  *Gottfried Semper In Search of Architecture*
(Massachusetts, 1984)
Hobhouse, H  *Prince Albert* (London, 1983)
Hussey, C  *The Life of Sir Edwin Lutyens* (London, 1950)
International Health Exhibition  *Catalogue of Manufactures,
Decorations and Designs* (London, 1884, intr. Wallis, G)
*Illustrated London News* (1842-1900)
Jones, O  *The Grammar of Ornament* (London, 1856)
Jones, O  *Lectures on the articles in the Museum of the
Department* (London, 1855)
*Journal of Design and Manufactures* (1849-52)
Lunn, R  *Some Recollections of the National Art Training
Schools* (RCA Students' Magazine Jan-Mar, 1912)
Lutyens, M  *Edwin Lutyens* (London, 1980)
Macdonald, S  *The History and Philosophy of Art Education*
(London, 1970)
Minihan, J  *The Nationalisation of Culture* (London, 1977)
Minutes and Reports of the Schools of Design 1836-1847
Moody, F W  *Lectures and lessons on Art* (London, 1880)
Pevsner, N  *Academies of Art Past and Present* (rept. New
York, 1973)
Pevsner, Sir N  *Studies in Art, Architecture and Design*
(London, 1968)
Pevsner, Sir N  *Victorian and After* (London, 1968)
Physick, J  *The Victoria and Albert Museum: The History of
its Building* (London, 1982)
Poynton, M  *William Dyce* (Oxford, 1979)
Redgrave, F M  *Richard Redgrave, a memoir* (London, 1891)
Redgrave, R  *Autobiography* (London, 1891)
Redgrave, R  *Manual of Design* (London, 1876)
Report of the Department of Practical Art, 1853
Reports of the Department of Science and Art, 1854-99
Rossetti, W M  *Pre-Raphaelite Diaries and Letters* (London,
1910)
Rycroft, E  *Lewis F Day* (RCA MA thesis, unpub, 1980)
Semper, G  *On Metalwork – history, collections and types*
(ms, V&A Lib, 1852)
Sparkes, J C L  *Schools of Art: Their Origin, History, Work and
Influence* (International Health Exhibition, London, 1884)
Spencer, I  *Walter Crane* (London, 1975)
Stannus, H  *Alfred Stevens and his work* (London, 1891)
Towndrow, K R  *Alfred Stevens* (London, 1939)
Wiener, M  *English Culture and the Decline of the Industrial
Spirit* (Cambridge, 1981)
Wornum, R N  *Report of Twelve Lectures on the History of
Ornamental Art* (London, 1855)

**Part Two: "It would, I fear, be out of the question to appoint Dr Gropius . . ."**

For the period 1900-1939,the primary documents in the PRO – mainly memoranda, minutes, papers, reports and letters of the Board (later Ministry) of Education – amount to a vast archive of material about the RCA: they are filed under Ed 23, 24 and 46. These, together with the *Reports* of 1911, 1932 and 1936, references to Treasury papers, and College Council minutes (from 1937 onwards) provide us with an accurate and sometimes surprising picture (for example, the Gropius affair) of College life. The extraordinary thing is that no-one seems to have gone through them before. Autobiographies and biographies of staff and students (the well-known ones, at least) help to colour the picture. Interviews with Henry Hammond (on Staite Murray and Reco Capey) and Leslie Duxbury (on the late 1930s and Ambleside) filled some gaps – but there is still a lot of oral history to be done, for this period.

ed. Abbott, C C and Bertram, A   *Poet and Painter – Gordon Bottomley and Paul Nash* (Oxford, 1955)
*Apollo* (1924-present)
*Artist and Journal of Home Culture* (1880-1902)
Arts Council   *Thirties: British art and design before the War* (London, 1980)
Ashbee, C R   *Should We Stop Teaching Art?* (London, 1911)
Barnes, J   *Percy Horton* (catalogue, Sheffield, 1982)
Binyon, H   *Eric Ravilious, memoir of an artist* (London, 1983)
Bliss, D P   *Edward Bawden* (Surrey, 1979)
Board of Education   *Hambledon Report on Advanced Art Education in London* (London, 1936)
Board of Education   *Report of the Departmental Committee on the Royal College of Art* (London, 1911)
Board of Trade   *Gorrell Report on Art and Industry* (London, 1932)
Camden Arts Centre   *Enid Marx* (catalogue, London, 1979)
ed. Chappel, W   *Well, dearie! the letters of Edward Burra* (London, 1985)
Child, H, Hechle, A, Jackson, D   *Irene Wellington, Calligrapher* (London, 1986)
Christie, G   *Embroidery and Tapestry Weaving* (London, 1906)
Clegg, S   *Drawing and Design* (London, 1920, intr. Rothenstein, W)
ed. Compton, A   *Charles Sargeant Jagger* (catalogue, London, 1985)
Crafts Study Centre   *Hand Block-Printed Textiles* (catalogue, Bath, 1978)
Crane, W   *An Artist's Reminiscences* (London, 1907)
Crane, W   *The Claims of Decorative Art* (London, 1892)
Crawford, A   *C R Ashbee* (New Haven and London, 1985)
Crozier, G Beattie   *Where to Study Art* (Everywoman's Encyclopedia, London, 1911)
Duckworth, J   *Arts and Crafts in the Suffragette Movement* (RCA prize essay, unpub, 1985)
Eastbourne Art Gallery   *Eric Ravilious* (catalogue, Eastbourne, 1986)
Elderfield, J   *Kurt Schwitters* (London, 1985)
*Gallimaufry, The* (RCA, 1925)
Gropius, W   *The new architecture and the Bauhaus* (London, 1935)
Hammacher, A M   *Barbara Hepworth* (London, 1968)
Hammond, H   *A magnetic teacher* (Crafts, May 1975)
Haslam, M   *William Staite Murray* (London, 1984)
Hawkes, V   *Edward Johnston at the RCA* (Alphabet and Image, i, London, 1946)
Hepworth, B   *A pictorial Autobiography* (London, 1970)
Hodin, J P   *Barbara Hepworth* (London, 1961)
ILEA   *Utility Furniture and Fashion* (catalogue, London, 1974)
Ingrams, R and Piper, J   *Piper's Places* (London, 1983)
Isaacs, R R   *Walter Gropius: Der Mensch und sein Werk* (2 vols, Berlin, 1983; abridged version of unpub ms in English)
Jack, G   *Woodcarving* (London, 1903)

Johnston, E   *Lessons in Formal Writing* (ed. Child, H and Howes, J, London, 1986)
Johnston, E   *Manuscript and Inscription Letters* (London, 1906)
Johnston, E   *Writing and Illuminating and Lettering* (London, 1906)
Jones, R   *John Nash* (Sheffield Polytechnic MPhil thesis, unpub, 1979)
Kennedy, M   *Some aspects of the Educational Ideas and Achievements of W R Lethaby* (Essex Inst of Higher Education, MPhil thesis unpub, 1986)
Lago, M and Beckson, K (ed)   *Max and Will, Max Beerbohm and William Rothenstein* (London, 1975)
Lethaby, W R   *The Artistic Crafts Series of Technical Handbooks*  (10 vols, London, 1901-16)
Lethaby, W R   *Form in Civilisation* (London, 1922)
Lethaby, W R   *School Copies and Examples* (London, 1904)
MacCarthy, P   *British Design Since 1880* (London, 1982)
MacCarthy, P   *A History of British Design* (London, 1979)
MacCarthy, P and Nuttgens, P   *Eye for Industry* (London, 1986)
Mahoney, D   *The Craft of Calligraphy* (London, 1978)
*Mandrake, The* (RCA, 1926)
Massé, H J L T   *The Art Workers' Guild* (Oxford, 1935)
Morris, B   *Inspiration for Design* (V&A, 1986)
Morris, L and Radford, R   *The Story of the AIA* (Oxford, 1983)
Nash, P   *Outline for an autobiography* (London, 1949)
Naylor, G   *The Arts and Crafts Movement* (London, 1971)
Naylor, G   *Lethaby and the myth of modernism* (catalogue, London, 1984)
Niall, I   *Portrait of a Country Artist: Charles Tunnicliffe RA* (London, 1980)
Packer, W   *Henry Moore, an illustrated biography* (London, 1985)
Pankhurst, R   *Sylvia Pankhurst* (London, 1979)
Parkin Gallery   *Percy Hague Jowett* (catalogue, London, 1974)
Pevsner, N   *Pioneers of Modern Design* (rept, London, 1975)
Pite, A Beresford   *Discussion of W R Lethaby* (Jnl of RIBA, Feb 1932)
Post-War Export Committee   *Weir Report on Industrial Design* (London, 1943)
*RCA Students' Magazine* (1912-17; 22-4)
Read, H   *Art and Industry* (London, 1934)
Rhead, J Woolliscroft   *Modern Practical Design* (London, 1912)
Rooke, N   *The work of Lethaby, Webb and Morris* (Jnl of RIBA, Mar, 1950)
Rose, M   *Artist-potters in England* (London, 1955)
Rothenstein, W   *Men and Memories, 1900-22* (London, 1932)
Rothenstein, W   *A plea for a wider use of artists and craftsmen: a lecture* (London, 1917)
Rothenstein, W   *Since Fifty . . . men and memories, 1922-38* (London, 1939)
Rothenstein, J   *Albert Houthuesen* (London, 1969)
Rothenstein, J   *Edward Burra* (London, 1973)
Rubens, G   *William Richard Lethaby* (London, 1986)
Service, A   *Edwardian Architecture* (London, 1977)
Simons, A   *Edward Johnston und die Englische Schriftkunst* (Berlin, 1937)
Snowden, K   *International Drawing Congress Illustrated Handbook* (London, 1908)
Spalding, F   *British Art Since 1900* (London, 1986)
Speaight, R   *William Rothenstein* (London, 1962)
Spencer, G   *Memoirs of a Painter* (London, 1974)
*The Studio* (1893 – the present; *Studio International* since the 1960s)
*Studio Yearbook* (from 1906)
Themerson, S   *Kurt Schwitters in England* (South Wales, 1958)
Victoria and Albert Museum   *British Art and Design 1900-1960* (catalogue, London, 1981)
Whall, C   *Stained Glass Work* (London, 1905)
*Who's Who In Art* (1927-48)
Wilson, H   *Silverwork and Jewellery* (London, 1903)

201

## Part Three: The Dodo and the Phoenix

The documents in the PRO – under Ed 23, 24 and 46 – contain useful material on Ambleside, and the arrival of Robin Darwin (especially relations with the Ministry of Education 1947-1950). The Royal College of Art archives, RCA Library, include Annual Reports 1949- 1987, calendars, prospectuses, year-books, catalogues, inaugural lectures (up to 1980, the last one to be given), College publications, and scrapbooks of press cuttings from Ambleside onwards: since this collection of College-related papers originated during a period, the late 1950s, when "history" was considered ideologically unsound at the RCA, it is far from complete. Thankfully, it is now expanding. The Calendars for 1949, 1953, 1967; the Annual report for 1959; and the Yearbook 1976-7 are particularly interesting. Taken together with recent publications, catalogues, and runs of *Crafts* and *Design*, a detailed story ("top down" *and* "bottom up") emerges.

*Anatomy of Design* (RCA) inaugural lectures, 1951)
*Ark* (RCA, 1950-78)
Armitage, E Liddall    *Stained Glass* (London, 1959)
Arts Council    *Drawing Towards Painting* (catalogues 1 and 2, London, 1962 and 1967)
Arts Council    *Towards Art?* (touring exhibition catalogue, London, 1963)
Ashwin, C    *The Professional Education of British Artists, 1968-72* (Institute of Education, London, MPhil thesis, unpub, 1976)
Baker, R W    *Training Pottery Designers* (Pottery Gazette, July 1955)
ed. Banham, M and Hillier, B    *A Tonic to the Nation* (London, 1976)
Baynes, K    *The Royal College of Art* (Design, December 1964)
Baynes, K and K    *Gordon Russell* (London, 1980)
Bernard, B    *Fashion in the 1960s* (London, 1978)
Black, M    *The Black Papers on Design* (ed. Blake, A, Oxford, 1983)
Boswell, J    *The Artist's Dilemma* (London, 1947)
Brett, L (Lord Esher)    *Easy Does It* (RSA lecture, 1973)
Brett, L (Lord Esher)    *Our Selves Alone* (London, 1985)
ed. Cornford, C    *Theoretical Studies and Art Education* (RCA Papers 1, 1977)
Council of Industrial Design    *Annual Reports 1 and 2* (London, 1945-7)
*Crafts* (1973 – the present)
Crafts Advisory Committee    *The Craftsman's Art* (catalogue, London, 1973)
Crafts Council    *The Maker's Eye* (catalogue, London, 1981)
Dartington Hall Trustees    *The Visual Arts: an enquiry* (Oxford, 1946)
Darwin, R    *The Dodo and the Phoenix* (Jnl of RSA, London, Feb 1954)
Darwin, R    *The Training of the Industrial Designer* (Jnl of RSA, London, May 1949)
*Design* (1949 – the present)
Design Council    *Designerly Making* (Design, July 1965)
*First Report of the National Advisory Council on Art Education*, 'the first Coldstream Report' (London, 1960)

*First Report of the National Council for Diplomas in Art and Design*, 'the Summerson Report' (London, 1964)
Frayling, C J    *Introduction to David Pye: wood carver and turner* (London, 1986)
Frayling, C J    *The Schoolmaster and the Wheelwrights* (RCA inaugural lecture, 1980)
Frayling C J and Snowdon, H    *Perspectives on Craft in the Twentieth Century* (Crafts, Jan-Dec 1982)
Francia, P de    *Mandarins and Luddites* (RCA inaugural lecture, 1985)
ed. Guyatt, R    *Graphics RCA* (catalogue, RCA, 1963)
ed. Guyatt, R    *The Royal College of Art Special Issue* (Queen, June 1967)
Guyatt, R    *Inaugural address as Rector* (RCA, 1978)
Harris, J Hyde S & Smith, G    *1966 and All That* (catalogue, London, 1986)
Height, F    *. . . and cheap tin trays* (RCA inaugural lecture, 1977)
Heskett, J    *Industrial Design* (London, 1980)
Hockney, D    *David Hockney* (ed. Stangos, N, London 1976)
ICSID    *Report on the education of Industrial Designers* (1, UNESCO, 1964)
Institute of Contemporary Arts    *Fast Forward: new directions in British ceramics* (catalogue, London, 1985)
Ironside, J    *Janey* (London, 1973)
Lambirth, A    *Young Contemporaries Past and Present* (catalogue, London, 1986)
ed. Lampert, C    *Frank Auerbach* (catalogue, London, 1978)
Madge, C and Weinberger, B    *Art Students Observed* (London, 1973)
March, L    *Systematic Research Into Possibilities* (RCA inaugural lecture, 1981)
Ministry of Education    *Art Education* (pamphlet 6, London, 1946)
*Picture Post* (1938-49)
ed. Piper, D Warren    *Readings in art and design education* (2 vols, London, 1973)
Pye, D    *The Nature and Aesthetics of Design* (London, 1978)
Pye, D    *The Nature and Art of Workmanship* (Cambridge, 1968)
Read, H    *Education and the designer* (Architectural Rev., Dec 1944)
Rhodes, Z    *The Art of Zandra Rhodes* (London, 1984)
Russell, G    *Designer's Trade* (London, 1965)
Seddon, R    *A Hand Uplifted* (London, 1963)
Shannon, J (and others)    *Kitaj-paintings, drawings, pastels* (Washington, 1981)
Skeaping, J    *Drawn from Life* (London, 1977)
Smithsonian Inst.    *Objects USA* (catalogue, Washington, 1969)
ed. Sparke, P    *Did Britain Make It?* (catalogue, London, 1986)
Sparke, P    *Theory and Design in the Age of Pop* (Brighton Polytechnic PhD thesis, unpub, 1975)
Tate Gallery    *Peter Blake* (catalogue, London, 1983)
Till, R    *Reginald Till archive* (National Archive of Art and Design, V&A Museum)
Times Newspaper    *The Royal College of Art, a special survey* (Nov 2, 1967)
White, G    *Edward Ardizzone* (London, 1979)

# Index

# Acknowledgements

Lion and Unicorn Press and Mobius International Limited would like to thank the following for their kind permission to use their photographs in this book:

Audi UK Ltd p181 (and back cover); Cressida Bell p192 (and back cover); British Museum p11 centre left; Floris van den Broecke p141 right; Dean and Chapter of Canterbury Cathedral p102; The Cloth p196; Country Life magazine pp11 bottom right, top right, 47, 49 top, centre left, 56, 57; Crown Copyright p46; Design Council p33 top, bottom; David and Elizabeth Emanuel p120 far right; Elizabeth Fritsch p120 top right; Grundy Northedge Ltd p189; Barbara Hepworth Museum pp95, 99; David Hockney pp120 top © 1962, 165 top right © 1971, 165 bottom right (and cover) © 1962; Hulton Picture Library p123; Illustrated London News p14 bottom; Imperial War Museum p100 top; Liverpool Art Gallery p86 right; Liverpool City Libraries p11 top left; London Transport Museum pp91, 113 centre right; Lord Chamberlain's Office p61 bottom; Manchester City Art Galleries p65 far right; Minton Museum/Royal Doulton Ltd pp11 centre right, 26 left, 29 bottom right, 36 bottom, 63, 83; David Mellor p152 top right; Henry Moore Foundation pp65, bottom left, 96, 97 (and back cover); National Portrait Gallery pp12, 13, 20, 27 right, 29 top right, 31 top, 59; Dr R. Pankhurst p77; Royal College of Art Slide Collection/Archive pp14 top, 23, 29 left, 30 top, bottom, 36 top, 37 bottom left, 37 bottom right, 43, 51, 60 top (and back cover), bottom, 61 top, 65 top right, bottom right, 67, 71, 73, 78, 85, 86 left, 87, 89, 100 bottom, 103, 105, 113 top, bottom, 117, 120 bottom left, top right, 133, 135, 137 (and back cover), 139, 140, 141 left, 144, 147, 149, 150, 151, 152 bottom left, bottom right, 153, 155 top left, bottom left, 156, 157 (and back cover), 159, 161, 165 left, 167, 169, 175, 177, 182, 183, 185 top, 186, 195; Seymour Powell Ltd pp120 bottom right, 185 bottom; Sheffield City Museum p26 top; Shell pp65 top left, 101; Tate Gallery pp143, 165 top right; Joe Tilson p158; Timney Fowler p187; Towner Art Gallery, Eastbourne p104; 20th Century-Fox p171; Victoria & Albert Museum pp11 bottom left, 19, 22, 31 bottom, 35, 37 top right, 41, 45, 155 right; Wedgwood p65 centre; Woodmansterne/Jeremy Marks p26 bottom.

Lion and Unicorn Press and Mobius International Limited would also like to thank Nigel Partridge for designing this book, Claire Legemah for design assistance, and Angela Jones for picture research.

207

The objects of the College are to advance learning, knowledge and professional competence particularly in the field of fine arts, in the principles and practice of art and design in their relation to industrial and commercial processes and social developments and other subjects relating thereto through teaching, research and collaboration with industry and commerce.

From The Royal Charter